THE ELOQUENCE OF SYMBOLS

THE ELOQUENCE
OF SYMBOLS

Studies in Humanist Art

EDGAR WIND

EDITED BY JAYNIE ANDERSON
WITH A BIOGRAPHICAL MEMOIR BY
HUGH LLOYD-JONES

CLARENDON PRESS · OXFORD

Oxford University Press, Walton Street, Oxford OX2 6DP

London New York Toronto Delhi
Bombay Calcutta Madras Karachi
Kuala Lumpur Singapore Hong Kong Tokyo
Nairobi Dar es Salaam Cape Town
Melbourne Auckland
and associated companies in
Beirut Berlin Ibadan Mexico City Nicosia

Oxford is a trade mark of Oxford University Press

Published in the United States by
Oxford University Press, New York

First published 1983
Reprinted with corrections 1985

British Library Cataloguing in Publication Data
Wind, Edgar
The eloquence of symbols.
1. Arts—Addresses, essays, lectures
I. Title II. Anderson, Jaynie
700 NX65
ISBN 0-19-817341-5

Library of Congress Cataloging in Publication Data
Wind, Edgar, 1900–1971
The eloquence of symbols.
Bibliography: p.
Includes index.
1. Humanism in art—Addresses, essays, lectures.
2. Arts—Addresses, essays, lectures. I. Anderson, Jaynie. II. Title.
NX650. H8W56 700 81-18719
ISBN 0-19-817341-5 AACR2

Printed in Great Britain by
Butler & Tanner Ltd
Frome and London

Editor's Preface

MANY years ago Edgar Wind had contemplated publishing a collection of his essays with the title *The Eloquence of Symbols*, but as he was always preoccupied with new research he never carried the project beyond its early phases. The essays chosen for republication have been divided between two volumes. The present book is primarily concerned with art and humanism in the Renaissance. It also contains a study of the relationship between traditional Catholic doctrine and twentieth-century religious art, and two early theoretical writings, translated into English for the first time. One of these, Wind's first essay on Plato's philosophy of art, deals with a theme of moral and aesthetic interest that was to concern him throughout his life, while the other, his paper on Warburg's conception of cultural history, remains a primary source for an understanding of Warburg's theories. Wind's articles on Michelangelo, which are among his most important contributions to Renaissance studies, have of necessity been excluded from the present volume, for these form part of a further project, his unfinished book *The Theological Sources of Michelangelo* on which he was engaged at the time of his death. His studies on English eighteenth-century art and philosophy are to be found in a companion volume, *Hume and the Heroic Portrait*.

For many of the essays that Wind considered for republication he left offprints with annotations and revisions, as well as notes with references to further sources and more recent bibliography, and these have been incorporated when they seemed appropriate. Some comments and additions are my own. When they pertain to bibliographical matters they are indicated by the expression 'see now', but occasionally square brackets have been used, even though Wind might have considered them ungainly intrusions.

I am deeply grateful to Professor Hugh Lloyd-Jones, who not only wrote the biographical memoir but most generously gave advice on many matters concerning the volume. He also suggested that a translation of the essay on Plato's theory of art, begun by Dr Thomas G. Rosenmeyer some thirty years ago, should be included; and he advised on its revision together with Professor Michael Podro. On questions concerning the translation of many problematical passages, Dr Peter Hacker, Professor Raymond Klibansky, Mr Peter Parsons, Mrs Joyce Reid, and Mrs Olive Sayce have made many invaluable suggestions. The first draft of the translation of the Warburg article was generously undertaken by Professor P. F. Ganz and Dr Christian Gooden, while the passages quoted from classical authors were kindly translated by Mr Ewen Bowie and Mr Donald Russell. Grateful acknowledgement is also made of the generous help of Professor John Boardman, Mr D. M. Davin, Professor Austin Gill, Professor Klibansky, Dr Donna Kurtz, Dr Lotte Labowsky, Dr David Landau,

Professor Charles Mitchell, Lord Quinton, and Dr Richard Pau, who have been frequently consulted about diverse problems. I am further indebted to Mr Bowie, Professor Klibansky, Mrs Reid, Mr Russell, and Mrs Sayce, and also to The Revd Professor Henry Chadwick, Mrs Winifred Davin, Dr David Fleeman, Mrs Susan Hall, Dr Martin Jesinghausen-Lauster, Professor James McConica, Mr Michael Maclagan, Dr Nicholas Mann, Dr John Penney, and Professor John Shearman for a critical scrutiny of parts of the manuscript. The Delegates of the Clarendon Press and its editors have shown endless patience and kindness throughout the production of the book.

My most outstanding debt of gratitude is to Mrs Margaret Wind. She initiated the project and has followed it with infinite care, at every stage of the work, until its completion.

Permission to reprint these essays has been kindly given by the editors of the journals in which they were originally published.

JAYNIE ANDERSON

Wolfson College, Oxford

Contents

The Delegates of the Oxford University Press are grateful to Miss Louise Crane and the Josephine B. Crane Foundation for a generous grant towards the costs of publication

List of Illustrations

Where no source is given in brackets the photograph has been supplied by the owners, to whom grateful acknowledgement is made for permission to reproduce works of art in their collections.

Diagrams within the Text

A Biographical Memoir
by Hugh Lloyd-Jones

EDGAR WIND was born in Berlin on 14 May 1900, the son of Maurice Delmar Wind and his wife Laura, born Szilard. His father was a well-to-do Jewish merchant of Russian origin, who was engaged in exporting optical instruments from Europe to South America. He had been born in Argentina and so had Argentinian nationality. Edgar Wind was therefore Argentinian by German law but German by Argentinian law, and the ambiguity was not resolved until 1930, three years before he left Germany. His father, to whom he was devoted, was a cultivated man who had built up an excellent library; but his mother did not share her husband's sympathetic interest in their son's studies.

The family was nothing if not cosmopolitan. Maurice Wind was often absent in South America, and he had many connections in Paris, where he had once thought of establishing his European business; his wife, who was of Romanian origin, was related by marriage to the celebrated French art-historian Henri Focillon. Wind began French early with a governess; later he had an English governess, and as a boy made his first visit to England.

In 1906 he entered the Kaiser-Friedrich Schule in Charlottenburg; he found its strict discipline somewhat uncongenial, but it provided the sound education typical of a 'human-istisches Gymnasium' of the time, and he obtained a good grounding in the ancient classics that was afterwards of great value to him. He was musical and became a good pianist. He enjoyed mountain holidays and developed a passion for climbing. At first the only pictures that greatly struck him were those of the French Impressionists in the Nationalgalerie, then new and controversial acquisitions, and modern works exhibited by the Berlin Sezession, a society for the encouragement of contemporary German art. He had no eyes for the Old Masters at the Kaiser-Friedrich Museum. But one day on a visit to Schwerin, in Mecklen-burg, he became fascinated by a romantic painting, a sleeping sentry with a dog and a curious picture of St. Antony half-visible in the background, by Rembrandt's most gifted pupil, Carel Fabritius, whose teasing *trompe l'œil* creations rival the interiors of Vermeer— leading him to wonder whether there was not more to the art of the past than he had thought. Many years afterwards, an old friend from the period remembered him as 'a tall, young, serious and attractive student'.

This memoir could not have been written without the collaboration of Mrs Margaret Wind, to whom I am deeply indebted for making available to me the papers in her possession. I wish also to express my gratitude to the Editor and to the friends and colleagues of Edgar Wind who have generously given advice on many matters.

Maurice Wind died suddenly in Hungary in 1914. He had wished his son to go to Oxford or Cambridge, but it was lucky this project was not realized, for the German universities had more to offer to a student with his particular interests. At Easter 1918 he entered the University of Berlin, where for three semesters he studied art history with Adolf Goldschmidt, the expert on medieval ivories and manuscripts. He heard the lectures of Ernst Troeltsch, the Protestant theologian and social historian of the Reformation, and of the Neo-Kantian philosopher Ernst Cassirer, then still a Privatdozent. He attended lectures by the great Hellenist Ulrich von Wilamowitz-Moellendorff, and on one occasion travelled to Munich to hear Heinrich Wölfflin on Rembrandt. During his second year he spent a semester in Freiburg im Breisgau, where he did not relish the lectures of the eminent philosopher Edmund Husserl. He also preferred the famous skiing parties of Husserl's later still more celebrated pupil Martin Heidegger to his philosophy. He spent another term in Vienna attending the lectures of Julius von Schlosser and the competing seminars of Josef Strzygowski and Max Dvořák. Schlosser was the author of the classic work on the sources of art history, *Die Kunstliteratur*, and a disciple of Croce; Strzygowski emphasized the Oriental sources of Western art; and Dvořák taught the history of art as *Geistesgeschichte*.

Finally, according to a letter written at the end of his life, Wind decided he had had enough of the 'reigning sovereigns' and wanted to spend his last three semesters with the historian, then twenty-eight years old, who had written *Dürers Kunsttheorie, vornehmlich in ihrem Verhältnis zur Kunsttheorie der Italiener*. Wind had heard by chance that Erwin Panofsky was about to become a Privatdozent at the University of Hamburg, at that time a new foundation. He had not yet habilitated, that is to say, completed the longer and more detailed piece of work with which a German scholar must follow up his dissertation if he is to acquire the right to lecture in a university, but by a private arrangement he was allowed to supervise Wind's dissertation, so that Wind had the rare experience of listening to the *Probevorlesung* of his instructor. He was Panofsky's first pupil.

He continued his studies with Cassirer, by then professor at Hamburg, who also helped supervise his thesis. He met the eminent Hellenist Karl Reinhardt, and Bruno Snell, senior to Wind by a year and also to become an eminent Hellenist. It was more significant that Hamburg was the home of Aby Warburg who initiated a new method in art history which was to determine Wind's own interests. But when Wind was studying in Hamburg Warburg was a patient in the Swiss clinic where he remained from 1918 to 1924, recovering from a mental illness, so that they did not meet until 1927.

Born in 1866, the eldest son of a Jewish banker, Warburg had been taught at Bonn by Carl Justi and Hermann Usener. Justi had written an important study of El Greco and the standard biography of Winckelmann; Usener was the pioneer of new methods in studying the history of religion, mythology, and superstition. From the time of his dissertation, on Botticelli's *Primavera* and *Birth of Venus*, Warburg had closely examined the way in which ancient art and literature were made use of by the artists of the Renaissance. His notion of antiquity was far removed from the classicism of the age of Winckelmann, since from the start of his career he had been conscious of the irrational forces which the ancients

had brought under control in order to win their triumphs of rationality. Warburg saw that the classical influence on Botticelli and his contemporaries had led them to represent not noble simplicity and quiet grandeur, but violent movement and passionate emotion; Friedrich Theodor Vischer's theory about the consequences in religion and in art of the identification of the symbol with the thing it symbolized provided Warburg with an essential clue. The interest in magic and superstition he had acquired from Usener led him to travel to the North American West to study the Pueblo Indians; later in life it was to enable him to interpret a hitherto unintelligible band of frescoes in the Palazzo Schifanoia in Ferrara by references to Abū Ma'shar's ninth-century introduction to astrology. The work in which he did so was only one of a series of remarkable publications, in which he drew on a wealth of new documentary evidence to reveal the symbolic meaning of pictorial images by starting from an examination of the social, moral, and religious forces which underlay them.

Such an approach was by no means congenial to the prevailing school of art historians, led by Alois Riegl and Heinrich Wölfflin. They preferred to study the form of a work of art in virtual isolation from its content, and by doing so gained notable successes in the revaluation of the art of the seventeenth century. By concentrating on form without allowing themselves to be distracted by historical or emotional connotations, they had established a kind of grammar of style, which in their hands was an instrument as powerful as the new methods of studying style and language were in the hands of contemporary students of literature. Nor was it congenial to men like Berenson and Beazley, who in their respective fields applied with triumph the method of attribution that had been rationalized in the nineteenth century by the great Italian amateur Giovanni Morelli; his minute examination of characteristic details had been suggested to him by his study of comparative anatomy. In opposition to the prevailing trend, Warburg returned to the view of Jacob Burckhardt that art should be studied in the light of its historical and cultural context, adding an entire dimension by means of his investigation of popular beliefs and superstitions.

Panofsky was already moving towards a break with the formalist tradition in art history, while Wind was beginning to question the philosophical assumptions on which it rested. In 1922 he obtained his doctorate with a dissertation entitled *Aesthetischer und kunstwissenschaftlicher Gegenstand. Ein Beitrag zur Methodologie der Kunstgeschichte.* During the financial inflation of that period the rule that dissertations must be printed was in abeyance, so that Wind published only part of his, and that not the most significant. But the thesis is of great interest, for even its chapter headings reveal the outline of a theory which leads directly to the author's later thought. Wind recognizes that for an aesthetic judgement there are no objective criteria; but he points out that a work of art has been created for a purpose, which must be understood if it is to be fully appreciated. Its understanding demands a process which is independent of aesthetics. In the dissertation the part of that process with which Wind is most concerned is the study of style, which, he maintains, is what lends objectivity to the study of art. The break with formalism is not yet complete, for his later theory was to emphasize content no less than style; but the postulates on which formalism rested are already being questioned.

After obtaining his doctorate, Wind returned to Berlin and set to work to prepare the longer paper required for his habilitation. From March 1922 till March 1924, when the inflation was at its height, he stayed in the family flat in the Bismarckstrasse, working and doing a little private teaching. But in March 1924 he left for the United States, where he was to remain until the end of 1927. At first he stayed with a cousin of his father, a well-known lawyer in New York, teaching French and mathematics as a substitute teacher in the local high schools; but in 1925 he went to Chapel Hill, North Carolina, as Graham Kenan Fellow and Instructor in Philosophy, and remained there for two years. He spoke at meetings of the American Philosophical Association, and published several short articles and reviews on philosophical and aesthetic topics, including a general account of the schools of philosophy which then dominated the German scene. During this American sojourn he acquired a knowledge of and an interest in the British and American tradition of empiricist philosophy which had a powerful effect upon his later thinking. This interest apparently stemmed from his discovery of the writings of the pragmatists C. S. Peirce and William James. Before leaving America he also took part in an educational experiment conducted at Cooper Union, New York, by Scott Buchanan, Richard McKeon, and others, which was to have important consequences both for American education and for his career. It was later to be carried further at the University of Chicago under the presidency of Robert Hutchins, and at St. John's College, Annapolis.

During a visit to Hamburg in the summer of 1927 Wind made the acquaintance of Warburg. The two men formed an immediate sympathy for each other, and a close association followed. 'Ich vergesse immer', said Warburg, 'daß Sie ein geschulter Kunsthistoriker sind; Sie haben es so nett mit dem Denken.' At the end of the year Wind returned to Hamburg as an assistant in the great library which Warburg had built up to serve the needs of those who studied what in German is called 'Das Nachleben der Antike'. No English rendering of that term is fully adequate. 'The Survival of Antiquity' will not do, since that might suggest the study of the books, manuscripts, and monuments in which antiquity survives: the term really means the way in which the ancients continue to exert their power upon subsequent generations. Warburg was concerned with the survival of the classical inheritance and its never altogether extinct vitality, which persisted through the Middle Ages and awakened into efflorescence during the Renaissance. This study led him to strange and unexpected quarters, and he skilfully planned his collection so as to serve the needs of any who might follow him in this new and not easily calculable direction. Although he died only two years later, in the autumn of 1929, his friendship played a decisive part in Wind's career. A year later Wind prepared, as an introduction to the study of an exhibition designed to illustrate Warburg's methods to the participants in a congress on aesthetics, an important study of Warburg's concept of cultural history.

At a philosophical congress at Harvard in 1926, presided over by A. H. Smith, who later welcomed him to Oxford, Wind had read a short paper dealing with the subject he was to treat at full length in his book *Das Experiment und die Metaphysik*, with which he habilitated in 1929. He was concerned with the problem of the cosmological antinomies dealt with in

the second part of the Transcendental Dialectic in the *Critique of Pure Reason*. Kant conceived of space and time as forms of our sensible intuition, and viewed the propositions of Euclidean geometry as synthetic a priori propositions about the structure of physical space conceived of in these terms. However, now that non-Euclidean geometry had not only been formulated without inconsistency but had been given a physical application, Kant's assumption that geometry was a pure theory of space had become difficult to maintain. Wind applied to this problem in the philosophy of science the method of implicit definition foreshadowed in the mathematical discoveries of Gauss and Riemann: a method which defines the relation of part to whole in such a way that any proposition concerning the structure of the whole can be tested in terms of the behaviour of the parts. In this way questions about the infinity or finiteness of space or time, or about natural causality, become real and legitimate questions, capable of resolution by experiment. Wind's thesis that 'symbols are real only to the extent in which they can be embodied in an *experimentum crucis* whose outcome is directly observable' did not please the amiable Ernst Cassirer, and what Wind later called this anti-Kantian book led him to remark that Wind was 'in einem sehr geläuterten Sinne' really an empiricist.[1] When the book appeared in 1934, Wind said, echoing Hume, that it 'fell dead-born from the press'. But by this time its author had left Germany, and had transferred his interests to a very different subject.

The last course of lectures which he gave in Hamburg was entitled *Grundbegriffe der Geschichte und Kulturphilosophie*. During the late twenties he had spent some time in London, where his attention turned to Hume. The subjects on which he lectured as Privatdozent in Philosophy between 1930 and 1933 lend some colour to Cassirer's diagnosis; they were eighteenth-century English philosophy, the history of scepticism, and the history of science. He published an examination of the philosophy of A. N. Whitehead; but his most important publication of this period continued the investigation of the relationship between aesthetics and art theory begun in the dissertation, and opened up a line of enquiry that was to lead directly to that of his Reith Lectures of 1960. This was the article on Plato's 'divine fear'.

He starts by drawing attention to what was then a neglected aspect of Plato's attitude to art. Plato's fear of the possible destructive effects of art, and also his advocacy of a strict censorship, could not, he argues, be dismissed as due simply to the kind of metaphysical snobbery expressed in the tenth book of the *Republic*, where art is said to lie at two removes from ideas which represent the highest reality. In the *Laws*, where Plato is legislating for a community which though imaginary is real, he makes it clear that the soul's dependence on reason alone must be ensured by a training designed to teach it to withstand both pains and pleasures, and that this dependence is threatened by the power of art to overwhelm its contemplators by the vivid representation of desires and thoughts likely to weaken the soul's resolution to follow the dictates of reason. The artist maintains and even enhances those

[1] See Wind in *The Times Literary Supplement*, 30 May 1958, p. 295, also *Das Experiment und die Metaphysik* (1934), p. 33, and now Bernhard Buschendorf, who examines Wind's relation to Cassirer's philosophy and to pragmatism, and discusses the influence of a realistic theory of symbols (*Verkörperungstheorie*) on Wind's later work in iconography. See his 'Nachwort' to Wind's *Heidnische Mysterien in der Renaissance* (1981), pp. 396–415.

tensions and impulses in the soul which the legislator must repress; and Plato was a convinced believer in the power of art to move the soul. Despite the plea of Aristotle that art by allowing us to work off our emotions helps us to control them, Wind agreed with Plato that by giving the emotions rein art helps them to gain mastery over us.

Wind then turns to eighteenth-century authors, Lessing, Kant, and Schiller, who in different ways contended that the artist's depiction of tendencies and impulses making against the harmony of the human mind are not necessarily a danger to that harmony. He argues that none of them convincingly disproved the existence of the dangers Plato feared. All these writers renounce the hope of the human personality attaining the kind of harmony that Plato desired. Goethe, Wind concedes, attained a kind of harmony; but he did so by reducing each reality to a symbol, by a flight from life to the image that involved a renunciation of a kind that became common during the succeeding age. In Romantic writers like Friedrich Schlegel, who employed fragmented notions to gain mastery over the infinite field that a systematic philosophy can never attain extensively—rendering the material manageable by the solvent of irony and so abolishing all true seriousness—Wind discerns the divorce between art and life which set in at the beginning of the industrial age. In the field of art history, as a reader of his article on Warburg of a year before will have reflected, the effect of that divorce was shown by the attitude of Riegl, for example, who created a grammar of artistic forms that took no account of the emotions which works of art were intended to inspire. Not many earlier writers can have explained the nature of the predicament into which Romanticism has led European thought with such precision as this writer in his early thirties; and in later life he was to carry this line of thinking further.

At about the same time Wind brought out the first and one of the most important of his contributions to art history, the remarkable study of the rival schools of portraiture headed by Reynolds and Gainsborough, in which for the first time the new method of art history was applied to the study of English art. Making full use of his philosophical training, Wind examined the theoretical presuppositions determining the attitudes of both artists. Reynolds, who in youth had studied Plato with his mentor, the Revd Zachariah Mudge, saw his sitters in a dramatic and heroic light, and through his brilliant use of visual wit in quoting attitudes borrowed from earlier Italian masters, endowed his sitters with allegorical significance; Gainsborough saw them as they appeared in their ordinary lives. Reynolds's attitude to life had much in common with that of his friend Samuel Johnson and also, unfortunately, with that of James Beattie; Gainsborough, if so untheoretical a painter had been willing to justify himself in terms of any kind of theory, might have done so in the terms of the philosophy of David Hume. Wind firmly placed the portrait-painters of eighteenth-century England in their contemporary intellectual context, showing already the comprehensive learning and penetrating intelligence that mark his mature work in the same field. This paper, in which he applied his principles to the practical problems of iconography for the first time, marks an important stage in his development.

During the final years in Hamburg, Wind was obliged to devote a good deal of time to his duties as one of the principal editors of a critical bibliography of 'Das Nachleben der Antike',

to whose first volume he contributed an admirable introduction. Fritz Saxl, by then Director of the Warburg Library, attached much importance to this project, which was its first major international undertaking. The bibliography listed and briefly reviewed current works which treated the classical tradition as a whole, or dealt with it within one subject or within one particular epoch, culture, or person. Many scholars contributed to this ambitious project, but after the second volume it had to be abandoned.

Soon after Hitler came to power in January 1933 Wind was dismissed by the University. That spring he went privately to London in the interests of the Warburg Library. Its removal from Germany had become an urgent necessity and, though Leiden offered hospitality, it could not promise supporting funds. Wind stayed with the Hon. Mrs Ernest Franklin, with whom he was distantly connected; she introduced him to Sir Philip Hartog, who in turn introduced him to Dr C. S. Gibson, Professor of Chemistry at Guy's Hospital and soon to become Secretary of the Academic Assistance Council. After these preliminaries Wind sent a cable to Fritz Saxl asking him to come to London. In June Gibson accompanied W. G. Constable, then Director of the Courtauld Institute of Art, to Hamburg, where Sir Denison Ross, Director of the School of Oriental Studies, later followed them. Soon after that visit Samuel Courtauld made the Library a grant sufficient to maintain it for three years, and a committee was set up with Lord Lee of Fareham as its chairman. It was at this time that Wind first met Maurice Bowra, at lunch in Corpus Christi College, Oxford, with Sir Richard Livingstone and Professor E. F. Jacob, whose lively interest in the fortunes of the Warburg Library dated from their own lectures in Hamburg two years before. Kenneth Clark, an active and influential friend of the Library who had met Warburg in Rome, was then Keeper of Fine Art in the Ashmolean Museum. Afterwards in London Wind was to meet Isaiah Berlin, who twenty years later was to be instrumental, together with Sir Maurice Bowra, in founding the Oxford chair he was to be the first to occupy.

The transfer of the Library was effected only just in time. Not long after the books had been removed all decisions regarding emigration were transferred to the central party office in Berlin. Later, the first volume of the Bibliography, and in particular Wind's introduction containing his critique of *Geistesgeschichte*, which appeared in 1934 after the Library had left Germany, were violently attacked in Goebbels's paper, the *Völkischer Beobachter*. At the same time an edition of the German text was published in London by Cassell with a new introduction in English which set Warburg's ideas in a more familiar context. Wind pointed out the affinity with Frazer and Jane Harrison shown in Warburg's approach to mythology and anthropology, the debt to Carlyle and Darwin shown in his theory of symbols, and the interesting link between his theory of memory and Samuel Butler's defence of Eduard Hering's thesis in the controversy with Darwin.

From January 1934 until August 1939 Wind remained in London as Deputy Director of the Warburg Institute and Honorary Lecturer in Philosophy at University College. War-burg's collection of literary and pictorial sources provided English scholars with a new instrument for historical research, and the presence of a few academically trained German and Austrian art historians, together with the newly founded Courtauld Institute of Art,

helped to establish the history of art as an academic discipline in this country. It was a period of intense activity. First at Thames House and later at Imperial Institute Buildings, lectures and classes were given by members of the staff about their special subjects. Lectures on broader themes (in which Wind had a hand) were given by specially invited scholars of international standing—Niels Bohr, for example, on 'Some Humanistic Aspects of the Natural Sciences'; Huizinga, Focillon, and others on 'The Cultural Function of Play'. In 1937 the *Journal of the Warburg Institute* was founded, at first as a slim quarterly with Wind and Rudolf Wittkower, who had joined the Institute in London, as its two founding editors. By skilful arrangement the contents of the first issues, articles and notes by English and foreign scholars, illustrate Warburg's approach to one aspect or another of humanist study. Wind was an active editor, and the style of the early numbers bears his stamp; he contributed to the early numbers a series of articles and notes that show a wide knowledge both of art and of the material relevant to its subject-matter, seen in the light of the principles which his philosophical studies had helped him to establish. These included his first articles about the iconography of the Renaissance, in which Warburg had encouraged him to take an interest; and it was now that he began the work on Raphael's frescoes in the Stanza della Segnatura, and on the Sistine Ceiling and other works by Michelangelo, which was to occupy him all his life. Wind took full advantage of the resources of the British Museum; he travelled extensively on the Continent, and was able to pay three visits to Italy during his London period.

Later, in his book *Art and Anarchy*, Wind was to choose Raphael's *School of Athens* as an example of a work of art whose understanding and aesthetic enjoyment were greatly furthered by an understanding of its content. He pointed out that Raphael started from a doctrine, current in the philosophical circle to which he belonged, that any proposition in Plato might be translated into an equivalent proposition in Aristotle, provided one remembered that Plato spoke the language of divine enthusiasm but Aristotle that of cool reason. The figures that fill the great hall dominated by the statues of Apollo and Minerva are representatives of natural and moral enquiry, who, like Plato and Aristotle themselves as they walk down the central aisle, are conducting conversations which illustrate this notion. In the 'encyclopaedic' programme of the Stanza the harmony of all branches of knowledge culminates in the 'concordance of Plato and Aristotle'. Once this is understood, Wind pointed out, many visual features of the painting which would otherwise escape notice will become apparent; and just as our appreciation of the *School of Athens* is heightened by a knowledge of the classical and Renaissance sources on which the figures are based, so the painting itself helps to show how these texts were understood in the Renaissance.

Wind made the remarkable observation that the paintings of the Sistine Ceiling were not literal representations of biblical stories arranged by Michelangelo as he wished, but that a prophetic programme based on the medieval system of types and concordances dictated their sequence and gave the individual scenes their significance. According to the doctrine of concordance originating with the early Fathers, scenes from the Old Testament were typologically related to stories in the New, for what Moses had called the Generation of

Heaven and Earth reappeared in the gospel of St. Matthew as the Generation of Jesus Christ: the Passion was foreshadowed in the Creation. In studying the interpretation of the Scriptures of the theologians of the early sixteenth century, Wind came upon the vast *Summa* of the mystical interpretation of the Scriptures assembled by Sante Pagnini, which shed new light on the puzzling figures of the Ancestors of Christ painted in the lunettes of the Chapel; he thus refuted the notion that Michelangelo had nothing but the names to go on. In a course of lectures given at the Warburg Institute during May of 1936 he first advanced a typological interpretation of the ceiling as a whole.

In 1939 Wind welcomed the change of the Journal's title to *Journal of the Warburg and Courtauld Institutes* and the accession to its board of editors of Professor T. S. R. Boase and Anthony Blunt; he continued as an editor and regular contributor until 1942. But in 1939 he left England, not to reside there permanently again until his appointment to the Oxford chair in 1955.

His old friend Scott Buchanan, now Dean at St. John's College, Annapolis, had invited him to lecture there during the fall term, and he arrived in New York on the SS *Normandie* on 28 August. One of his lectures was attended by Mrs Robert Woods Bliss and, at the invitation of her and her husband, he later gave three lectures at Dumbarton Oaks. He spent the spring term as Visiting Lecturer at the Institute of Fine Arts, New York University, where Professor Walter W. S. Cook had built up a graduate school of high quality. In his lectures on Renaissance iconography at the Pierpont Morgan Library the originality of his approach and the new light it shed on familiar works of art powerfully impressed scholars and laymen alike. He lectured also at Harvard, Columbia, Princeton, and other institutions in the East, as well as in Chicago and the Far West, and he lectured for the first time at the Frick Collection, an occasion that became an annual one. After the fall of France he received a cable from Saxl, Wittkower, and Gertrud Bing asking him in the interests of the Warburg Library to remain for the time being in the United States. After negotiations in New York, Cambridge, and Washington, in which he was greatly assisted by Mrs Bliss, the founder with her husband of the institute for Byzantine studies at Dumbarton Oaks, a joint offer to house the Institute for the duration of the war was made by the National Gallery of Art and the Library of Congress, and was communicated to Lord Lee through Lord Lothian, then British Ambassador in Washington. The invitation was declined—rightly, in view of later events—but it was of great assistance to the Institute, since it helped to bring about its eventual incorporation in the University of London.

In the autumn of 1940 Wind gave the Trowbridge Lectures at Yale on Leonardo, Raphael, and Michelangelo, and continued as Lecturer at the Institute of Fine Arts for another two years. He gave a course on English Art at the Morgan Library in the spring of 1941 and seminars on Renaissance topics at the Institute. He worked steadily on Michelangelo and lectured in many places, somewhat inconvenienced by the awkwardness of his legal position as an enemy alien, a problem not finally solved until he acquired United States citizenship in 1948. In the spring of 1942 he examined the mythological paintings in the Jarves Collection in his Ryerson Lectures at Yale, concluding the series with two lectures on

Elizabethan imagery; and at the Museum of Modern Art in New York he was invited to apply to modern art the same principles of historical analysis that had led to his remarkable expositions of Renaissance ways of thinking and seeing. At this time he married Margaret Kellner, daughter of Dr G. A. H. Kellner, a distinguished physicist and watch collector who was an authority on lenses, and a musical mother, and so gained for the rest of his life a companion whose sympathy and understanding of his work were perfect.

It was obviously desirable that he should obtain a permanent appointment, and in the autumn of 1942 he became Professor of Art in the University of Chicago. But he was not happy there; the climate had an adverse effect upon his health, and the controversies occasioned by President Hutchins's radical views on the place of the humanities in university education made the intellectual atmosphere no more congenial than the physical. He was a member of the Executive Committee on Social Thought, founded by Hutchins to foster inter-departmental studies. In 1944 he departed for a term's leave, never to return. While in Chicago he worked on Michelangelo's lost designs for the Julius Tomb and the Medici Chapel, which he made the subject of a lecture at the Morgan Library in New York; and he was invited by the National Gallery of Art in Washington to lecture on what was then called their 'iconographical enfant terrible', Giovanni Bellini's *Feast of the Gods*, a lecture which later developed into a monograph on the subject which he published in 1948. Wind made one of the first attempts to interpret the perplexing humanist creations commissioned by Isabella d'Este and her brother Alfonso, altering the conventional notion of Bellini's art by showing the unsuspected presence of a facetious pagan subject in one of his last and most remarkable paintings. Wind convincingly identified the source of this as two comic passages in Ovid's *Fasti* which the humanist adviser, whom he conjectured to have been Pietro Bembo, must have had in mind. From this starting-point he argued that the picture was a pagan fantasy designed to celebrate a wedding, as Mantegna's *Parnassus* was a humorous portrayal of the jealousy of Vulcan, placing it in the context of the introduction of classical subject-matter to North Italian painting by Mantegna and Titian. His interpretation of Mantegna's *Parnassus*, and his thesis that Bellini's *Feast* was originally commissioned by Isabella d'Este for her Grotta but later purchased by Alfonso, has not won general assent and it is hardly strengthened by Wind's own attractive identification of the gods and other personages represented in the picture with Alfonso, his wife Lucrezia Borgia, and other members of the court of Ferrara. But he treated the subject with characteristic learning, intelligence, and wit, handling the interesting topic of Isabella's relations with the painters she employed, particularly Mantegna and Bellini, in a manner that recalls his frequent insistence that enlightened patronage can exercise a benevolent effect upon the artist.

Wind went for his leave from Chicago to Smith College, Northampton, Massachusetts, where he was welcomed by the then President, Herbert Davis, the well-known editor of Swift, and ended by remaining there for the next eleven years. After the Warburg Institute's incorporation in London University in 1944, he could have returned to England, and Smith College extended its original invitation for a year to give him time to make his preparations. But in 1945 Saxl visited America for the first time, mainly in order to find support for his

great project for an encyclopaedia of the Middle Ages and the Renaissance. Wind shared Panofsky's doubts about the value of this enterprise, and had misgivings about the direction which the Institute was now taking. A week of talks with Saxl in Northampton led him to decide to stay in America, and he reluctantly severed his old link with Warburg's foundation. Smith College extended his tenure of the William Allen Neilson Research Professorship for another three years, and during 1946/7 he shared the chair with Professor David Nichol Smith of Oxford. When his term expired, he was appointed Professor of Philosophy and of Art, and held the post until he returned to England in 1955.

Smith College provided Wind with very favourable conditions for his work. The delightful surroundings and congenial atmosphere were greatly to his taste, and the small college museum was noted for its unusual collection. Courbet's so-called *La toilette de la mariée* was the best-known painting. A good classical library was also available in the college; and an old-fashioned town library allowed him to take home the precious volumes of Migne's *Patrologia* needed for the study of the Fathers which became his leisure reading. For the fifteenth- and sixteenth-century sources upon which his Renaissance studies depended, the Widener and Houghton Libraries were fortunately close at hand in Cambridge, where he often went for a week or two at a time to read. At this time also he began to add Renaissance texts and emblem books to a remarkable library of his own. It could be said of him, as it was of Celio Calcagnini, that his usual habitation was his library.

At Smith College he lectured on Plato and the Platonic tradition; at this time he made a close and continuous study of Plato, the Neoplatonists, and the Platonists of the Renaissance, and read extensively in the works of modern classical scholars devoted to the study of late antiquity. He also gave courses on Kant and Hegel and spoke on Renaissance and Reformation iconography, on Dürer, Grünewald, and Holbein, and on eighteenth-century English art. He took part in an interdepartmental series where he dealt with 'The Traditional Conflict between Reason and Myth', which examined the shifting boundaries between science, imagery, and superstition. He worked systematically on Raphael, the subject of his Colver Lectures at Brown University in 1948, and produced a rough draft of parts of a book on the *School of Athens*, dealing with the philosophical sources of the fresco. The more extensive and important drafts for his work on the theological sources of Michelangelo, on which he published several important articles, also date from this period at Smith College.

At this time he began to return regularly to Europe. During the summer of 1949 he spent several weeks in England before going on to Paris, Venice, Florence, and Rome, where he enjoyed the hospitality of the American Academy with its society of artists, scholars, and musicians. The following year, after a month in Aldeburgh where he completed an article on the revival of Origen in the Renaissance, he returned to Rome with a Guggenheim Fellowship, and remained until September 1951, using the opportunity to visit Greece for the first time. His work on Egidio da Viterbo and the humanists of early sixteenth-century Rome required him to study manuscripts in the Vatican Library and the Biblioteca Angelica, and the quarter surrounding the latter and the neighbouring church of Sant'Agostino became, so to speak, his parish.

In 1949 he gave the Martin Classical Lectures at Oberlin College, Ohio, on *Pagan Mysteries in the Renaissance*. He spent the remaining years in Massachusetts preparing the manuscript for publication under that title, for it was his normal practice to write his lectures only after he had delivered them,[2] and the first edition appeared in London in 1958. In this work Wind demonstrated that certain Renaissance artists were deeply influenced by the symbolism of the Neoplatonic philosophy as it had developed in the hands of Marsilio Ficino and Giovanni Pico della Mirandola. These men conceived of Platonism as entirely reconcilable with Christianity, encouraged by the belief, generally held during the Middle Ages, that a synthesis of Neoplatonism and Christianity made at the beginning of the sixth century AD was the work of Dionysius the Areopagite, said in the Acts of the Apostles to have been converted by St. Paul. Much that on the surface appeared pagan bore a symbolic meaning to be apprehended only in terms of the philosophy in question; for Pico held that pagan religions, without exception, had used a 'hieroglyphic' imagery so that divine subjects and secret mysteries would not be rashly divulged. A richly ambiguous Neoplatonic philosophy infuses works of art of this period and shows how the essence of creative ambiguity lies in the simultaneous revelation and concealment of ideas in images. It was not necessary to credit the artists themselves with a deep knowledge of philosophy or theology: these ideas formed part of the conversation of cultivated men at that time. Besides, artists were often instructed by scholars who might be their patrons or have been deputed by their patrons. Wind used his profound learning, and also what was a poetic insight unusual among learned men, to throw light on many works of art, including masterpieces of Botticelli, Raphael, Michelangelo, Titian; bearing in mind that texts and images illumine each other, he makes constant use not only of Ficino and Pico and the wealth of classical authors Renaissance writers drew upon, but of the *Hypnerotomachia Poliphili*, the *Symbolicae quaestiones* of Achille Bocchi, the *Hieroglyphica* of Pierio Valeriano, and the works of Gyraldus and other Renaissance writers. The method is eclectic: many different strands of evidence are brought together in suggestion or comparison, and one may ask here and there whether the relevance of a literary text to the work of art it is alleged to illuminate has been established beyond doubt; but as Focillon remarked with regret, iconography is an unavoidable *détour*, and the historian and the critic have to learn more about the argument than the painter needed to know, if they wish to show schematically what the painter knew by nature and instinct. In the Renaissance the poetic conceit and the verbal emblem or metaphor were closely related to their counterparts in the iconography of painting, and both poets and painters took such an interchange for granted.

He illustrated the significance of the group formed by the Three Graces, first from the Stoic philosopher Chrysippus, quoted by Seneca, and then from Neoplatonic allegories taken up by Ficino and Pico. Botticelli's *Primavera*, which had been discussed by Warburg in his dissertation, is explained as showing first (starting from the right) an Ovidian metamorphosis: we see first the rape of Chloris by Zephyrus, described by Ovid in the *Fasti*, then Chloris transformed into Flora, who is identified with her by Ovid. The allegory of

love is patent: through the sacrifice of her virginity, the maiden becomes the goddess who gives birth to the spring flowers. In the centre of the picture Venus presides; on the left the Graces dance together. Amor aims his arrow at the central Grace, Chastity; Pleasure and Beauty are her companions. Chastity looks despairingly at Mercury, guide to the mysteries, who with his caduceus moves away a cloud. The allegorical significance of these figures is precisely documented in Ficino's *Theologia Platonica*. Lord Clark, although approaching the problem from a different standpoint, has written that the interpretation is the most convincing so far offered. The interpretation of the *Birth of Venus* justly estimates the influence of the lost Venus Anadyomene of Apelles, the poem of Politian, and the allegory of the philosophers, while never forgetting what Wind calls 'its freshness and successfully feigned naïveté . . . It is as if the high spirits of Politian', he writes, 'had for once outdistanced the prolixities of Ficino and Pico.'

Wind is equally effective in interpreting Michelangelo, whose own poetry proves beyond doubt his strong sympathy with Neoplatonic philosophy, and here again in the chapter on 'Amor as a god of death', with its suggestive correspondence between Michelangelo's *Leda* and the figure of *Night* from the Medici Tombs, his understanding of the allegorical conception of love entertained by the philosophers of the time helped him to make a great contribution to the understanding of its art. Wind's critical temperament is ideally suited to perceiving the paradoxes and contradictions that are essential features of Renaissance imagery, and of Michelangelo in particular. He grasped and explained with startling clarity the complex notions of the link between sacred and profane love, of love as a god of death, of the god who is cruel that he may be kind, of the search for Pan, standing for the whole, in the ever-changing Proteus, of the union of contraries in the concealed god.

The Smith College period also saw the publication of several important articles in *The Art Bulletin*, *The Burlington Magazine*, and the volumes of studies offered to Henri Focillon and Belle da Costa Greene. In 1947 Harvard organized a symposium on 'Music and Criticism' at which Wind replied to an address by E. M. Forster on 'The *Raison d'Être* of Criticism in the Arts'. Rather surprisingly for an author whose reputation owes so much to the English and American love of moralizing literature, Forster reiterated the Romantic doctrine of the complete separation of the critic from the artist. Wind pointed out that one can hardly be a considerable artist without being a considerable critic, and any art which has power has also its attendant dangers against which the critic should be our defender. The disagreement did not prevent him from establishing friendly relations with his amiable antagonist. Later, at a Smith College symposium on 'Art and Morals', he debated with another famous English writer, W. H. Auden, who wrote in his honour the delightful poem 'The Truest Poetry is the most Feigning'.[3] In this discussion, which took place in 1953, at the height of the activities of Senator Joseph McCarthy, Wind defended the right of the artist to be taken seriously, and effectively resisted the anti-intellectualist arguments of some of his opponents. In 1952 he attended a congress in Paris devoted to Masterpieces of the

[3] '. . . this swift business / I must uneasy make, lest too light winning / make the prize light.'

Twentieth Century, where Stravinsky's *Oedipus Rex*, with the composer conducting and with Jean Cocteau as the narrator besides being responsible for the settings, was the most significant event during a vast spectacle of musical, artistic, and literary offerings. In a brief but striking paper delivered in French he called modern painting 'an art of caprices, an art of experiments, an art that is on the margin of life', a description that he was to justify in his Reith Lectures of 1960.

From 1949 Wind made occasional broadcasts for the Third Programme of the BBC. In the spring of 1952 in New York he broadcast for them three talks on Leonardo da Vinci which attracted much attention; a transcript which he had not had the opportunity to check was published in *The Listener*. The first talk was entitled 'Mathematics and Sensibility'. Starting from the famous inscription over the door of Plato's Academy 'Let no one ignorant of mathematics enter', which Leonardo copied into his notebooks,[4] Wind examined a curious group of engravings representing interesting knots and bearing the legend ACADEMIA LEONARDI VINCI. He deduced that such an academy existed, that no person ignorant of mathematics was admitted to its membership, and that it met in the Sala delle Asse in the Castello Sforzesco in Milan, where frescoes on the ceiling show similar knots entwined among the knotted branches of trees; and he went on to use the knots as 'a key for developing Leonardo's whole approach to the relation between intellectual and imaginative procedures'. The other talks were about the *Last Supper* in Santa Maria delle Grazie and about the relation of Leonardo's work to physiognomic theories the origins of which lie in antiquity and which are known to have been current in his time. In 1960 a more developed version of the first address was given to the Royal Institution, where scientists showed much interest in Wind's account of Leonardo's construction of the five Platonic solids, and of his definition of force and its application in geology, biology, and physiognomics: force, Leonardo said, 'is born in violence and dies in liberty'.[5] But unfortunately Wind never finished the small book on Leonardo which he had in mind.

In the late summer of 1951 Wind dined at Trastevere in the company of Sir Maurice Bowra, then Vice-Chancellor of Oxford, who told him that if ever a chair of the History of Art were to be established at Oxford he would let him know. In November 1954 Wind gave the Chichele Lectures at All Souls College on 'Art and Scholarship under Julius II', dealing with the paintings of the Stanza della Segnatura and the Sistine Ceiling. In the following January he was told that the chair was in fact to be set up and it was suggested that he might apply; in due course he was appointed as its first occupant. At first there was some question of its being attached to All Souls College, but Trinity had precedence, and it was impossible to regret this happening, for it was desirable that a professor whose personality and whose discipline were both new to Oxford should belong to a college which had tutors and undergraduates. Wind found the small and agreeable society of Trinity highly congenial. After his retirement he was elected to an Honorary Fellowship, and an obituary notice in

[4] Windsor Castle, Royal Library, *Quaderni d'Anatomia*, IV, fol. 14ᵛ. *The Notebooks of Leonardo da Vinci*, arr. and trans. by E. MacCurdy (1939), p. 85.

[5] Paris, Bibliothèque de l'Institut de France, MS. A, fol. 34ᵛ. MacCurdy, p. 520 [Richter 1113 B].

the annual college report spoke not only of his intellectual brilliance but of 'real consideration, tact, and tenderness towards others'.

Wind did not hesitate to grasp the opportunity to become professor at a famous university in whose curriculum art history had so far played no part; but he found that the excitement of the move to Oxford was equalled by the magnitude of the problems that awaited him. Little money and little help were available; there were no slides or photographs at all; and the professors of archaeology and art stood in undefined relation to each other and to the Ashmolean Museum, which with its libraries and collections formed the centre of their activities. Moreover, Oxford, like most ancient institutions, contained some people who tenaciously resisted change.

Wind became a member of the Committee for the Fine Arts, which was responsible for the supervision and instruction of degree candidates and for the administration of the Ruskin School of Drawing and of Fine Art. From 1956 the Committee at his instigation published its own lecture list, giving particulars of all lectures concerning archaeology, ancient, medieval, or modern art, and aesthetics, a list which he compiled personally each term. As a first step towards the encouragement of advanced study, the following year he persuaded the General Board to agree to the revival of the Diploma in Medieval and Modern Art, which had been suspended in 1934. A number of well-qualified senior members in various faculties were persuaded to help with the teaching for the Diploma in the History of Art, as it was now called, and graduates were encouraged, along the lines that Ruskin had once proposed, to learn to draw well enough to sketch monuments and to understand the processes involved in the use of various materials. In 1961, when the administration of the Ruskin School was returned to the Trustees, the Committee for the History of Art assumed responsibility for the Diploma and other matters concerning the subject. At that time also the Hebdomadal Council allotted the entire ground floor of 35 Beaumont Street to the Professor, and the Department of the History of Art was established by the Committee as an instrument for research and teaching, available to members of the University who might wish to use the growing collections to pursue their own studies in relation to art history.

During Wind's tenure of the chair, both the relation of the Ruskin School of Drawing and of Fine Art to the University and the part which the Ashmolean Museum should play in teaching were the subjects of controversy; and Wind strongly insisted on the need for both institutions to make an effective contribution to the University's work. He may have been too outspoken in expressing his views; but he stood for professionalism in its resistance to dilettantism, and it is acknowledged that he made an effective contribution to the final settlement. Even his adversaries, looking back, have recognized that his only motive was this strong desire to promote the interests of art, learning, and education.

From the first his brilliant lectures made a powerful impact upon Oxford audiences; they were delivered without notes, but not memorized beforehand, and spoken with the highest degree of fluency and coherence. At first he spoke in the lecture-room at the Ashmolean but, during the winter of 1957, after a lecture on Leonardo had had to be repeated, he moved to the Taylor Institution to give three lectures on Matisse, Rouault, Picasso, and Klee, which

seem to have been the first lectures about modern art delivered in the University. Luckily it now became possible for him to use the Playhouse Theatre, which the University was then arranging to acquire, and he spoke there at noon so as to reduce the number of unauthorized attenders. He took the greatest trouble over the slides and photographs he used. He had no use for coloured slides, which he called 'les belles infidèles', and preferred the old $3\frac{1}{4}$ inch square plain slides, because they gave a better image. He showed only one slide at a time, never two unless he had a particular reason for doing so, and he often showed splendidly chosen details to illustrate his point. He used only good original photographs of works of art, never taking them from books, and often went specially to the Museum to explain his needs to the photographer. By the time of his retirement the Department possessed 33,000 slides and some 20,000 photographs; it also had an unusual library carefully built up by Wind himself and containing sixteenth- to eighteenth-century, and later, primary source books for the study of iconography, many not to be found elsewhere in Oxford.

On 29 October 1957 he delivered to a very large audience in the Examination Schools an unillustrated Inaugural Lecture entitled 'The Fallacy of Pure Art'.[6] He set out to present some of the main features of his conception of art history as a discipline in terms appropriate to this Oxford occasion. First he considered the famous lecture on 'Poetry for Poetry's Sake' with which A. C. Bradley had initiated his tenure of the Chair of Poetry in 1901. Bradley had cogently argued that the substance of a poem could not be distinguished from its form, 'just as in painting there is not a meaning *plus* paint, but a meaning *in* paint, or significant paint, and no man can really express the meaning in any other way than in paint and in *this* paint'.[7] Bradley was defending the territory won by what in its day was a great and liberating victory, the triumph of the Romantics who set out to purge art of all irrelevant excrescences and to liberate it from the Philistines. He was too intelligent not to realize that he still had to explain what was the connection between poetry and life; and his answer was that it was a 'connection underground',[8] which must by no means be looked for on the surface. Poetry and life were parallel developments, and might be related to each other as analogues, but never in terms of a direct relation.

In opposition to Bradley, Wind set out to show that the relation between art and life is not underground, but on the surface; that they are not parallel, but do meet; and that the meeting-point is the point that is crucial for the historian of art. At that point, he argued, the art historian can show how things which lie outside art can illuminate the perception of art itself in a way far more satisfying than any use of analogues; the use of analogues, he thought, opened the door to the very verbiage which art theory had been developed in order to reduce.

His first example of the kind of thing he meant was a portrait of Simonetta Vespucci by Piero di Cosimo, painted some time after she had died in the flower of her beauty, and

[6] The Inaugural Lecture remains unpublished, and its content can only be suggested here. Wind was in the course of writing it, and also his Rede Lecture on Classicism, when his work was interrupted by the Reith Lectures, and he was never able to return to it.

[7] A. C. Bradley, *Oxford Lectures on Poetry* (1909), pp. 15 f.

[8] Ibid., p. 6.

inscribed with her name (Fig. 5). She is depicted wearing a necklace in the form of a serpent biting its tail. In the imagery of the Renaissance this was not an uncommon symbol of eternity (Figs. 3-4); but here its use becomes fully intelligible only in the light of passages in the long commentary written by Lorenzo il Magnifico to explain his poems about Simonetta's death. He writes that her death proves the truth of the belief shared by himself and his friends that beauty becomes perfect only through death. Earthly beauty is necessarily imperfect, so that when imperfect form touches perfection time closes itself to a perfect circle, and the end is the beginning: 'nelle cose umane fine e principio essere una medesima cosa'.[9] The serpent is not perfectly rounded, as in the usual image of eternity; it is about to close its mouth upon its tail, so that we seem to see it at the moment of Simonetta's apotheosis.

Roger Fry had been puzzled, Wind continued, by Raphael's picture of the Transfiguration, for the painter shows not one scene but two unrelated yet successive scenes in the Bible; the second presents the disciples who have remained at the foot of the mountain trying unsuccessfully to cure the epileptic boy whom Christ will cure immediately when he descends (Fig. 13). Fry's solution to the problem posed by the apparent incongruity between 'a very strong positive (pleasurable) reaction on the aesthetic side and a violently negative (painful) reaction in the realm of dramatic association' is to ignore the conflict and surrender himself to a purely visual appreciation of the painting.[10] Wind tries to find out what was thought about the Transfiguration in Raphael's time. '... ut si quis forte videndo / Tentet Apollineos demens comprendere vultus.' In Achille Bocchi's *Symbolicae quaestiones* (Fig. 12)[11] where these lines appear in an elaborate and useful if rather poor poem, the 'demented' attempt to reach perfection is illustrated by an engraving after the upper part of Raphael's *Transfiguration*, by Giulio Bonasone, who had worked closely with the master in his workshop in Rome. In Raphael's painting the miraculous apparition on the mountain and the healing of the lunatic boy appear as two opposed manifestations of madness, and Wind recalls here Plato's distinction between two kinds of madness in *Phaedrus*, 265A, one of which is a mortal infirmity, the other a divine release. If one bears this in mind one can appreciate the painting better, just as one can properly appreciate the work of Hogarth only if, unlike Fry, one is willing to pay attention to the stories which his pictures tell, the stories that lead the eye 'a wanton kind of chace'.[12]

In these and other examples of a political nature that he gave from the later Vatican Stanze, Wind was showing that his own observations were all extraneous to the work of art, yet made an intrinsic difference to our aesthetic perception of it; they were aesthetically relevant without being in themselves aesthetic observations and, conversely, the work of art itself threw light on the historical circumstances that conditioned its creation. In his view the history of art should be regarded not as an independent subject, self-contained and

[9] *Commento del Magnifico Lorenzo de' Medici sopra alcuni de' suoi sonetti*, in *Opere*, ed. A. Simioni, I (1939), pp. 24, 34. See H. Chadwick, *Origen: Contra Celsum* (2nd edn., 1965), p. 340 note 2; also Wind, *Pagan Mysteries in the Renaissance* (2nd edn., 1968), pp. 126 and 266 f.

[10] *Vision and Design* (1920), p. 198.
[11] Achille Bocchi, *Symbolicarum quaestionum de universo genere ... libri quinque* (1555), no. xcvi.
[12] Hogarth, *The Analysis of Beauty* (1753), v; see J. Burke's edn. (1955), p. 42.

parallel to the old, established schools, but as one that is vitally and indissolubly linked with them. Art, Wind had argued, has a significant relation to the basic laws of any community. He cited Plato's remark 'that when the modes of music change, the fundamental laws of the state always change with them'; but he compared Plato's belief that by preventing change in the arts one may prevent change in the state to the belief that one can prevent an earthquake by abolishing the seismograph. However unimportant a particular society may consider its artists, their productions might well throw some light on its condition; and he ended by quoting Reynolds's saying that 'the character of a nation is, perhaps, more strongly marked by their taste in painting than in any other pursuit, although more considerable; as you may find easier which way the wind sits, by throwing up a straw in the air than any heavier substance.'[13]

During his twelve years' tenure of the chair Wind lectured on many subjects—illustrations to Plato, various aspects of Botticelli, Leonardo, Michelangelo, Raphael, Venetian painters, humanists and humanist academies, the *Hypnerotomachia Poliphili*, Reynolds, Shaftesbury's *Characteristicks* and their influence on English art, 'Enthusiasm and Wit: Hogarth to Fuseli', the aesthetics of Romanticism, 'The Heritage of Manet'. Sometimes he joined forces with a colleague, in the spirit of his Inaugural Lecture, for a special class, as with John Sparrow for 'Some Renaissance Poems and their Visual Counterparts'; with Humphrey Sutherland for Renaissance medals; with Austin Gill for Manet and Mallarmé; with Stuart Hampshire for Kantian and Hegelian aesthetics. At that time Hegel was by no means in fashion, but Wind's views about him were unusual; he stressed especially the sceptical side of Hegel's thinking, argued that the importance of the dialectic had been exaggerated, and liked to dwell on his reflections on art and the alteration of its status. When K. B. McFarlane redated Memling's Donne Altarpiece by showing that Sir John Donne of Kidwelly was not, after all, killed at the battle of Edgecote in 1469, Wind persuaded him to lecture about Memling and provided him with photographs and slides. After McFarlane's death—not long before his own—he edited the lectures with the assistance of G. L. Harriss.

In 1960 he was invited to deliver the British Academy's annual lecture on aspects of art, founded in memory of Henriette Hertz, and took the opportunity to present what would have been an important chapter of the detailed study of Michelangelo's art in relation to its theological sources, on which he had been engaged since the London years. The lecture dealt with the Prophets and Sibyls depicted on the Sistine Ceiling, but the finely constructed paper he prepared for the proceedings was not published until after he had completed *Art and Anarchy*, in 1965. In 1960 he did however publish a remarkable article on the Ten Commandments, which he identified as the subjects of the painted bronze tablets held by the *Ignudi*; he drew attention to allusions contained there to the Books of Maccabees, pointing to their source in the 1493 illustrated edition of Niccolò Malermi's Bible, the most handy *Biblia vulgare* of the time in which Malermi had interpolated apocryphal lore from Josephus. Michelangelo's use of the Malermi Bible was in the bold tradition of the erudite

[13] Quoted from H. W. Beechey's Memoir, prefixed to his edition of *The Literary Works of Sir Joshua Reynolds*, I (1835), p. 294; see also the Seventh Discourse, ll. 582 ff., ed. R. R. Wark (1975), where Reynolds refers to ornament.

and poetically elegant theology of the late fifteenth and early sixteenth centuries, which followed Origen in reviving apocryphal traditions, and enriched the canon from popular sources.

His reputation as a lecturer had now spread far beyond merely academic circles, and in this same *annus mirabilis* of 1960 he gave the Rede Lecture at Cambridge on 'Classicism' and was invited by the BBC to deliver the six lectures given annually in memory of its first and most celebrated Director, Lord Reith. Although Wind was deeply engaged in the studies on which he was at work, he took up the challenge to put before a wide public the views about aesthetics, art history, and the appreciation of art which he had been working out ever since his doctoral dissertation. He regarded the lectures as a tract for the times; they were published in *The Listener*, and aroused more public discussion than any pronouncement by a distinguished scholar had in many years. In 1963 the lectures appeared as *Art and Anarchy*, with 78 pages of concise notes added to 104 pages of text. Into this small book Wind crowded the results of a lifetime of learning and thinking by a mind of singular acuteness, that was no less familiar with literature and philosophy than with art, and expressed them with uncommon wit, clarity, and eloquence.

In the first lecture, which gives its name to the whole book, Wind speaks once more of the 'divine fear' inspired by the power of the imagination of which Plato had written; to him the 'generous assumption' of 'eminent and intelligent' men that the widest possible dissemination of art can only have a benign and civilizing effect seemed highly doubtful. He admitted, however, that in our time the fear might have become superfluous: the large quantities in which art had become available tended to diminish its effect; modern art was inclined to over-emphasize, just as we incline to raise our voices when talking to people who are getting deaf. As Wind had already noted elsewhere, early in the nineteenth century Hegel had observed that art was losing its power, and was moving from the centre of man's activities to the margin, yielding its place to science. Wind illustrated this loss of power sustained by modern art by comparing Manet's *Dead Christ mourned by Angels* with the treatment of the same subject by Mantegna. Plato, he remarks, could not imagine art ever ceasing to exert the power that made it dangerous, yet during Plato's own lifetime the process had begun. Just so Hegel could not imagine art ever recovering its lost position; but Hegel's own thoughts about the survival of the past as a latent force might have warned him against making any such assumptions.

In the second lecture, called 'Aesthetic Participation', Wind set out to show that modern art was in a marginal position not simply because science had displaced it from the centre of our activities, but by a centrifugal impulse of its own; since the early nineteenth century many artists had assiduously tried to pull the observer away from his ordinary habits and preoccupations. He drew attention to the close relationship between the cult of pure art and that of barbarism. Modern art was also experimental; for, though in earlier times discoveries in art had arisen almost incidentally, now innovation had become an end in itself. He showed by the examples of Riegl and Wölfflin how art history had been affected by the prevailing mood of aesthetic purism. He spoke as always with admiration for the achievements of those

great scholars; but he pointed out how they, no less than Berenson and such English advocates of 'significant form' as Roger Fry and Clive Bell, had 'methodically developed an exquisite skill in skimming off the top of a work of art without necessarily making contact with its imaginative forces, often even shunning that contact because it might disturb the lucid application of a fastidious technique'.

At the opposite extreme from the doctrine of pure art one found that of *art engagé*, the notion that the artist must use his art to make propaganda for a view of life to which he is committed. Both attitudes, Wind argued, ignored the 'split of consciousness which enables the artist to live in two worlds: to sense what is real and to feign that he senses it, and thus to give to facts the authority of fiction, in which others can partake vicariously'. He who wishes to respond adequately to art must himself have something of the artist's dual nature. It is possible to acknowledge the high quality of an artist and yet reject his artistic character; one must judge a work of art on its own terms, but one has a perfect right to decide for oneself whether one finds those terms acceptable. It is permissible to respond to an artist as many people do, to take an obvious example, to Richard Wagner, 'acknowledging the power of a supreme artist, but recognizing it as the kind of power to which one should not surrender'. The theory of pure art had done good service at a time when sentimentalism was rampant, but it had been carried too far. It was tempting to embrace it, because it was so refreshing; 'since the imaginative forces embodied in a figure are likely to disturb our pleasure if we do not know how to respond to them, it is always encouraging to be told that they are irrelevant'.

The absurdities of a pretentious kind of connoisseurship had been amusingly pointed out as early as Hogarth; but we now had to reckon with a connoisseurship which could not be easily dismissed. In the third lecture, 'Critique of Connoisseurship', Wind illustrated this remark by giving an entertaining account of the great connoisseur Giovanni Morelli, thus initiating a notable revival of interest in his work. He connected Morelli's concentration on the personal idiom of the artist with the Romantic cult of freshness which had led so many people to value ruins more than complete buildings, and fragments more than complete works, with the 'degrading thirst for outrageous stimulation' diagnosed by Wordsworth as early as the year 1800. By doing so he shocked some people, who complained that Morelli's method was suggested to him not by Romantic theorizing but by his scientific study of comparative anatomy, and was designed to solve factual problems without having any theoretic overtones. Wind did not in any way depreciate the great value of Morelli's method, which he said art historians could no more give up than philologists could abandon palaeography; but he gave warning that 'if we allow a diagnostic preoccupation to tinge the whole of our artistic sensibility, we may end by deploring any patient skill in painting as an encroachment of craftsmanship upon expression'.

In the fourth lecture, 'The Fear of Knowledge', Wind spoke of the characteristic fear of the Romantics that reason and knowledge may do harm to the imagination. It is a mistake, he argues, to condemn all didactic poetry *en bloc*; like other kinds of poetry it can be good or bad. The prejudice against didactic art—poetic and pictorial—arose because art has

retreated so far into itself that the artist has become cut off from the reason and learning that are so visibly effective in our daily life. He showed by notable examples from the past how greatly in the past art had profited from a range of contacts from which it is nowadays excluded. He pleads here for a mode of vision that rests the sense of form upon the sense of the meaning. At the same time he made it clear that he was perfectly aware that the historical method required to recover lost modes of perception, if used without the necessary knowledge and discrimination, might lead to far-fetched and cumbersome interpretations, for he said that there is one—and only one—test for the artistic relevance of an interpretation: it must heighten our perception of the object and thereby increase our aesthetic delight.

The fifth lecture dealt with 'The Mechanization of Art'. While recognizing that one may go too far in distrusting new techniques, as Federigo, Duke of Urbino, went too far when he excluded all printed books from his great library, Wind argued that modern mechanization and mass production often result in our being given the shadow of art instead of the thing itself. The medium of diffusion tends to take precedence over the direct experience of the object, and the object itself is often conceived with this purpose in view. He also gave examples of the destructive use of mechanization in its illicit extension to the past, and offered as examples the unfortunate cleaning of many pictures and also the restoration of Wren's Sheldonian Theatre at Oxford, which he said 'may be studied one day as a monumental example of the naïve obstinacy and self-delusion that bedevil a mechanical age'.

The last lecture was entitled 'Art and the Will'. The range of the will's influence, Wind said, is limited; he quoted Pico della Mirandola's protest against the assumption of the papal inquisitors that it could control a man's beliefs. In forming a scientific hypothesis, he pointed out, one must often suspend, at least temporarily, some of its implications, and so also if one wishes to produce or to appreciate a work of art. True, the artist must exercise his will in order to acquire or to apply his skill; but, once he has embarked on the creation of a work of art, the will's action has to be suspended. The will is important for questions raised in the forecourt of the temple of art, but in the temple itself it has no place. It follows that, though we should leave the artist alone inside the temple, we should be with him in the forecourt; yet our modern veneration for the artist prevents us from entering the forecourt, often with unfortunate results. Wind quoted several instances of the effective contributions to art made by enlightened patrons in the past; from modern times he cited the case of Ambroise Vollard, to whom Renoir dedicated the sketch of a self-portrait with the words *à mon raseur sympathique*. How different was the behaviour of those who commissioned the painters and sculptors working on the Unesco building in Paris, who found that not even the architects were prepared to discuss with them the relation to the over-all plan which their work ought to have!

Summing up, Wind said that, though the artist could not be held entirely responsible for the isolation in which he now had to work, his own attitude had tended to perpetuate it. Also, an affinity had developed between so-called art and mechanization, for 'pure art' provided just the patterns that best lent themselves to mass reproduction. The cult of

psychology had encouraged us to mistake immediacy for concreteness; the preconceptual types of emotional life uncovered by depth psychology were in fact pre-artistic and, when applied to artistic creation, the psycho-analytical method 'tended to wipe out the difference between great art and mawkish art'. This did not please those critics who believe that psycho-analysis has made an important contribution to the understanding and appreciation of art. Wind made it clear that he was not deploring the consequences of popular education; what was wrong with the mass distribution of art was not that it served too many people, but that it served them badly. His quarrel was with those whom William James had called 'knights of the razor', who wielded Occam's razor so as to satisfy 'their passion for conceiving the universe in the most labour-saving way'. Their 'destructive tolerance', Wind suggested, was soaking up into nothing the 'anarchic energies of creation' which should animate the artist.

Witty, elegant, and learned, and delivered with Wind's usual skill, the lectures made a powerful impact; those who found fault with their technique were few and of the kind who know beforehand that all pronouncements made by academic persons must be boring. From the start there were some misgivings within the BBC about the wisdom of exposing the public to lectures that might turn out to be both learned and controversial. Three broadcasts in which other critics commented on the series were commissioned, and innumerable letters published in *The Listener*; many speakers and writers disagreed with Wind's opinions, but none effectively challenged his diagnosis. Clive Bell wrote to say that his views had altered since his book on *Art* in 1914; studying the windows at Chartres and Bourges, he realized that 'only by attempting to unravel the intricacies of the subjects, could one hope to appreciate thoroughly and in detail the beauties of form and colour'.[14] When these Reith Lectures were published and reviews appeared, some who felt that their complacent approval of modern art had been threatened denied that there had ever been a time when art had been at the centre of society. Such critics were fortified by their ignorance of the ancient and medieval worlds, an ignorance which helped them not to notice how in these periods art was connected with religion. One of them wrote that, since ancient Athens lacked the concept of art, the arts formed no evident unity for its citizens, and could not have been so important for them as Wind maintained. These critics also supposed that Wind thought the 'elaborate intellectual scaffolding' surrounding such a work as Raphael's *School of Athens* valuable simply because 'it permitted a certain kind of criticism which guides the eye'; they did not see that it is important because it guides the eye in the direction the painter wished, and heightens our experience of the work of art in the way the creator of the work intended.

After the publication of *Art and Anarchy*, he returned with relief to historical writing on Renaissance subjects. Lecturing disturbed the concentration he felt the written word required, and, beyond the University courses he was obliged to give, he never lectured elsewhere after 1960. In 1965 he published his British Academy lecture on 'Michelangelo's Prophets and Sibyls', an eloquent exposition of the significance of these great figures in relation to the painter's programme as a whole, which is more completely described here

[14] *The Listener*, LXV, 5 January 1961, p. 34.

than in any other place in Wind's work. The paper contains a rich account of the Sibylline tradition in the Renaissance and also very original observations on the figures of the *Ignudi*, which he conceived of as wingless Angels. He uses the fuller understanding of the purpose of the work which his theological studies had given him to describe the paintings in a way that shows keen visual as well as intellectual perception, and a profoundly sympathetic understanding of their impact on the spectator. This paper, together with his earlier papers on the Ten Commandments and on the legend of Noah, cause one deeply to regret that the book in which they would have been resumed was never finished. Wind's theory of the intimate relation between the paintings and the theology of the Renaissance scholars whom he studied enhances the appreciation of the paintings as works of art and constitutes a splendid example of his method at its most successful.

A revised and enlarged edition of *Pagan Mysteries in the Renaissance* appeared in 1967 and shows him constantly revising his earlier work; a new edition of *Art and Anarchy* with Addenda followed. When in October 1967 the age limit required that he vacate his chair, he welcomed the event and turned with happiness to the life of a private scholar; *latenter vivendum* were words of Epicurus that he often quoted as a motto. He spent a month in the French countryside, and then made a brief stay in Paris, where during the Oxford years he had gone frequently for short visits, to find refreshment in the busy alertness and in what he called the rationality of life there.

During the year after his retirement he finished a short but masterly book on Giorgione's *Tempesta*, a subject that had been in his mind for twenty years. As usual he took great pains over the illustrations and the printing, and his editor at the Clarendon Press acknowledged that he had learnt much from him. The interpretation of Giorgione's enigmatic picture, with its apparent lack of intellectual content, is a test case for Wind's approach. His solution was that the painting did not illustrate a text or a story but a pastoral theme, for which no narrative was needed. The painting was a poetic allegory that drew on a few well-attested Renaissance symbols juxtaposed in an evocative way. The gypsy nursing her child was emblematic of Charity, the soldier emblematic of Fortune, and the two broken columns signified Fortitude; they are placed in a landscape with a tempest, signifying Fortuna. His interpretation is more satisfying than those of others, because it does justice to the central truth that the landscape lends the figures their significance. The book also contains many of the eloquent and learned notes which are a feature of Wind's work; some illustrate the reflections of Renaissance humanists on the vanity of learning; and the book ends with two paragraphs about the vagueness of reverie which Walter Pater relied on for his synaesthesia.

In the late autumn of 1970 Wind visited Italy for the last time; a strangely beautiful 'primavera di San Martino' was spent in Florence studying the early works of Michelangelo; and he made an unsuccessful attempt to reach Egidio da Viterbo's monastery at Lecceto. The book on Michelangelo's theological sources, for which he had signed a contract with the Clarendon Press in 1968, was the preoccupation of his last years. His last trip to Europe, early in February 1971, was a visit to Paris, where he again worked at the Bibliothèque Nationale. He had been suffering from leukaemia since 1965, and his physical condition was

now deteriorating more rapidly; but as a matter of duty he reviewed Sir Ernst Gombrich's biography of Warburg. By May the state of his health was precarious, and in August he was attacked by pneumonia. He recovered briefly and in his large clear hand wrote down his observations on the sculptures of the Piccolomini Altar in the cathedral of Siena. He died in London on the twelfth of September.

Wind's foreign origin, the wide range of his learning, and the striking brilliance of his exposition were all calculated to provoke that envy which is encountered by all exceptionally gifted human beings, especially in the academic world. As the first professor of his subject in Oxford he was obliged to break new ground, and he was able to defend his views in a manner which, though it might not compel agreement, did command attention. What seemed to some people at the time an uncompromising attitude arose solely from his determination to do what he thought necessary for the advancement of art and art-historical scholarship in the University. Friends and colleagues found in him a delightful companion and a generous host, whose talk was enlivened by a wit and gaiety not always found in conjunction with such comprehensive learning. **As a lecturer** he was more successful than any Oxford scholar of recent times. Those who **were** privileged to hear him have vivid memories of a scintillating erudition illuminating the meaning of great works of art from new angles, and of philosophical argument deployed in the service of aesthetic understanding.

Wind's astonishing familiarity with art and its history was allied to a wide knowledge of literature in several languages, of philosophy, of music, and of scientific method. With vast erudition and an intensely visual approach to art he combined a marked capacity for abstract thought and a singular intellectual clarity. From the start of his career he set out to formulate the principles upon which the understanding of art must depend. He not only identified the theoretical weaknesses of the aesthetic formalism propounded by Wölfflin and Riegl (and in this country by Fry and Bell), but, by the example of his own researches, demonstrated its crippling limitations. By locating works of art in their social, cultural, and intellectual contexts, Wind made it possible for us to hear the voices of great artists speaking across the centuries in the unfamiliar language of Renaissance philosophy and classical symbolism, so that we come to see their paintings differently; for Wind's study of the history of art was always ultimately subservient to aesthetic appreciation. In his writings on the theory of art he drew on a lifetime of reflection and observation, bringing his philosophical understanding and historical knowledge, his aesthetic sensibility and psychological insight, to bear upon questions concerning the nature of art and its role in society, the irrational energies it harmonizes or releases. Every age must forge its own conception of its artistic heritage and fashion its own picture of the role and significance of art in contemporary society. Wind's writings powerfully contribute to the possibility of a more lucid and accurate conception, and a deeper as well as richer understanding.

I · Θεῖος Φόβος (*Laws*, II, 671D)

On Plato's Philosophy of Art

WHEN Plato sacrifices the rights of the artist to the claims of society, when he demands that the lawgiver should force the artist by threat of expulsion from the city to represent only such objects as will promote an admiration for heroic deeds and a desire to imitate them, and to employ only such means of expression as will invigorate the soul and not lull it to sleep, when in his anxiety to carry through this programme he wishes to delete from Homer and Hesiod all passages which might endanger the proper education of young men, his rigorous measures leave the modern interpreter rather at a loss. Most of us are not sufficiently open-minded to share the reaction of the American critic who openly confessed that he hated Plato and recoiled from his work because it seemed to him to foreshadow the activities of Anthony Comstock, the notorious Puritanical censor. We may be amused or shocked by the comparison; but how shall we answer him? Will our painfully acquired awareness that things are rather more complicated than this, or what we call, with a pride we ourselves are coming to question, our 'sense of history', enable us to do so? That a Greek philosopher who lived more than two thousand years ago cannot be judged by the same standards as an Anglo-Saxon bureaucrat of the nineteenth century, and that a decision which in Comstock is an indication of provincial narrow-mindedness is in Plato the product of a profound insight, is in general obvious enough. But our historical sense does not immediately explain the point of an insight that finds expression in the subordination of the artist to the state. Nor will it show us how we, who frown on such a verdict when it does not lie in the remote past, can account for Plato's judgement not merely in historical terms but in a way that is meaningful for us. On the contrary, the more certain we are that Plato's conceptual thinking was preceded by, and consummated, an impulse towards dramatic and mimetic representation, the more clearly we recognize from his own writings how difficult he found it to adopt such a verdict, how greatly he valued Homer's poetry before resolving to resist its spell; and the more strongly we sense in the style of his early and middle dialogues the power of that plasticity whose dangers he so vividly portrays, the more extraordinary it seems to us that this man, who evinced such great artistic gifts, should have turned against art.

'Θεῖος Φόβος. Untersuchungen über die Platonische Kunstphilosophie', *Zeitschrift für Ästhetik und allgemeine Kunstwissenschaft*, XXVI (1932), pp. 349–73, originally the subject of Wind's inaugural lecture as Privatdozent in Hamburg, with the illustrations and some further references added.

We are even more amazed when, for an explanation of Plato's conclusions, we are referred to the passage in the tenth book of the *Republic* where Idea and appearance are contrasted, and it is contended that, since art imitates appearance, it must, as a copy of a copy, be at three removes from truth, Plato's writings have resisted every attempt to extract a system from them, because even when arguments come to their didactic climax, they are inconclusive. Could he have intended so radical an intervention in the life of his people on the basis of an argument which now seems so easy to refute? It is even more incomprehensible when this paradox is rephrased in terms of an assumed 'Reason in History',[1] as though Plato with his mythic mode of thought had 'not yet' been able to distinguish between art and morality, but only able to draw attention to a problem whose solution was reserved for later generations. Then, indeed, our sense of history would stand condemned. For this would mean we had taken the problem Plato posed out of its context and transformed what was for him an issue of crucial importance to life into a technical problem of philosophy. Having thus diminished the significance of his claim, we are hardly entitled to look down on the historically naïve for pragmatically reducing the problem to crude proportions. But even more questionable than the short-sightedness of those naïvely censoring Plato as though he were a contemporary is the learned perspective of the scholar who seeks to account for what Plato regarded as a crucial issue by shifting the burden of explanation to the particular historical circumstances of the remote past.

I have deliberately set up these two extremes in order as far as possible to avoid both. If we wish to understand Plato's purpose in subordinating the artist to the state, we must understand the historical factors that conditioned his attitude. Plato's insistence was occasioned by particular circumstances, and must be understood as a remedy for the troubles of his time. But an essential feature of Plato's thought is that a particular event is seen as exemplifying a general type: What is necessary for this particular state and its art at this particular moment is rooted in the nature of the state and the nature of art at all times. It is this general thesis that we must examine critically, always bearing in mind that it is connected with a thesis related to the Greek state and Greek art. But we can come to terms with it only by separating what in Plato is indissolubly linked, not because we believe the connection involves a logical fault, but because we no longer live in a Greek state, and because the Greek way of thinking differs from our own. What for Plato was one problem has become for us two, which concern us equally, above all in their relation to each other. For the experience undergone at that time by the Greek state and Greek art is not merely of antiquarian interest, but has become part of the fund of historical experience on which we draw even today. That is why the tension which Plato saw between art and the state poses a significant problem for us, inasmuch as we wish to clarify in terms of our own situation the relation of aesthetic experience to the other aspects of the mind. Today, therefore, Plato's challenge poses two questions: (1) How far does it express a historical understanding, an understanding of a situation that existed at a particular moment, which we can understand

[1] [*Vernunft in der Geschichte* is a reference to Hegel's philosophy of history.]

and evaluate as a judgement upon that situation? (2) How far does it express a supra-historical understanding, an understanding of a conflict between two forces at work in man, which can be overcome in different ways at different times, but at all times only by means of a decision which at the same time represents a renunciation?

<div align="center">

I

</div>

Contrary to usual practice, I should like to begin with Plato's late work, the *Laws*, because here Plato has chosen a way of presenting his material which makes it impossible for us to escape from the logic of his conclusions in the way that comes most easily to us—by a mere criticism of his theory of Ideas. In the *Laws* Plato says almost nothing about Ideas. However one may explain this, what is decisive for our problem is that, although the theory of Ideas is not brought into play here, the demand that the artist be controlled by the state is advanced with the same intensity and conviction as before. This fact suffices to prove that we are dealing with a decision more deeply rooted than in the wish to accept the consequences of a favoured method of deduction as dictated by the schema of the theory of Ideas, a decision which cannot be undermined merely by abandoning that schema. Although in the early dialogues we are first led to contemplate Ideas so that we can derive insights about art and life, in the *Laws* the theory of art is developed from the start on the basis of considerations about the nature of man, whose first sensations are pleasure and pain and who must consequently be educated by means of his responses to them: 'But I say that the child's first sensation is pleasure and pain; and that it is in these that goodness and badness first come near to the soul. But wisdom and true opinions that are permanent are a gift of fortune to those to whom they come even in old age. A man is perfect when he possesses these things and all the benefits they bring him.'[2]

This enlightened conception is hardly to be found in the earlier dialogues; even so, I believe we should be guided by it without being afraid that our interpretation is too one-sided. I wish to illustrate this briefly in terms of the change in Plato's conception of the soul, and will start with the well-known image in the *Phaedrus*. There the soul is compared to a chariot[3] which has νοῦς, the intelligent element in us, as its driver, controlling an evil black horse (ἐπιθυμία, desire) and a noble white horse (θυμός, pride or spirit). If he masters the white horse he can, by guiding this horse, curb the black one; but if the black horse masters the white one, the charioteer loses control, and the chariot is thrown off its course. However strongly the image emphasizes the limitations of our power of reason, it still depicts it as strong enough to control the horses by itself.

[2] *Leges*, II, 653A.

[3] *Phaedrus*, 246. [The Platonic chariot is represented on a rare medal (Figs. 1–2) by Giulio della Torre (b. *c.* 1480), the eminent jurist and amateur medallist of Verona who was also the author of a tract *De felicitate* addressed to his sister and published in 1531. See G. F. Hill, *A Corpus of Italian Medals* (1930), no. 565, who notes that Giulio's work is full of original ideas and transparently genuine feeling in spite of obvious traces of amateurishness in style and lettering. For further representations of the *auriga Platonis* in the Renaissance, see R. Wittkower, 'A Symbol of Platonic Love in a Portrait Bust by Donatello', *Journal of the Warburg Institute*, I (1938), pp. 260 f.; and A. Chastel, 'Le médaillon du "Char de l'âme"', in *Art et humanisme à Florence au temps de Laurent le Magnifique* (1961), pp. 39 ff.]

But in the *Laws* we find a quite different picture. Here the soul is compared with a puppet made by the gods; we do not know whether they have made it as a mere plaything or for a serious purpose. This puppet is moved by wires, rigid wires of differing substances and colours, which jerk it in every conceivable direction, so that it falls from one posture into another. But there is one simple wire of gold, flexible yet unchanging, to which the soul must respond if it wishes to attain its equilibrium (εὐδαιμονεῖν, enjoy happiness). In comparison with the other wires, this one is weak, very weak, and the soul cannot respond to it unless some of the other wires are so placed that they pull it in the same direction as the golden cord.[4]

The contrast between these two images illustrates the change in Plato's conception. The shift of emphasis lies essentially in the different degree of confidence in the power of νοῦς, and the ideal of education changes correspondingly. First we are told that νοῦς must be trained to master pleasure and pain, later we are told that the soul must be directed by means of pleasure and pain so that it becomes able to respond to νοῦς. Between these two extremes there are many transitions. But despite all the changes one problem remains constant: the soul is in danger of being thrown off its course; and the puppet is in danger of tottering and lurching. The task is to unite these conflicting forces in the soul. Wherever this unity is in danger, Plato pauses to reflect on the nature of artistic activity as the means, when properly employed, of promoting it; but it is also the means, when abused, of endangering that unity. Plato never shows more clearly how the forces that promote and threaten the unity work together, and how they are nothing but two aspects of one and the same process, whose correct assessment constitutes the real problem of education, than in the discussion of drunkenness in the first two books of the *Laws*:

For you are the only people known to us, whether Greek or barbarian [says the Athenian who takes the lead in the conversation with his Cretan and Spartan companions], whom the legislator commanded to abstain from the greatest pleasures and amusements and never taste them; whereas in the matter of pains and fears he thought that anyone who from childhood had been accustomed to avoid them would, when he came to endure necessary toils and pains and fears, flee before those who had been trained to endure these things, and become their slave. He ought, I think, to have taken the same view about pleasures, saying to himself that, if citizens from their youth on have no experience of the greatest pleasures, and no practice in holding out against pleasures and in abstaining from the disgraceful acts to which pleasure compels, their delight in pleasure will cause them to suffer the same fate as those who are overcome by fear. They will be slaves, in a different and yet more degraded way, to those who can resist pleasure and to those who have acquired the appurtenances of pleasure. . . .[5]

The thought that this will cause courage to be 'lame' (χωλὴ ἀνδρεία), since men will be armed against toil and suffering but not against pleasure and delight, leads the Athenian to recommend indulgence in wine and the habit of drinking with friends, so that he shocks the

[4] *Leges*, I, 644D–645C. [In his paraphrase of this passage Wind refers to Plato's νεῦρα and ἀγωγαί (strings and cords) as *Drähte* (wires), sometimes used in German, as in English, in association with puppets.]

[5] I, 635B–D.

Cretan and the Spartan. He compares their indignation to that of a man who is excited when he is told that cheese is good, never asking by whom or how it has been made, to whom and under what conditions it is to be offered.[6] So we are given regulations for rational drinking. First, all boys under eighteen are excluded, 'so that they do not fuel their bodies and souls with fire upon fire'.[7] The others, however, must not drink in an uncontrolled and undiscriminating fashion, but under the direction of a choirmaster, who knows how to choose the appropriate songs and the appropriate modes. It thus gradually becomes clear that what is required under the name of regulated drunkenness is nothing but musical education, the development of the sense of rhythm and harmony in poetical expression and dance movements. Between the ages of eighteen and thirty or forty, all must take part in these exercises, so that by being exposed to the perils of drunkenness they may learn to be ashamed to show their nakedness, acquiring the 'divine fear' ($\theta\epsilon\hat{\iota}os$ $\phi\acute{o}\beta os$) which is familiar with the pitfalls of unrestrained joy, just as courage is familiar with terror and is only strengthened by the presence of danger.[8]

But old men, especially those over sixty, who are so dominated by and confirmed in this feeling of shame that they do not venture to dance and sing, believing their age forbids such things, ought to drink wine so that their reluctance vanishes and they can share the dangers. 'They must summon Dionysus to share in the old men's festivities ... for he is the giver of wine ... who makes a hard nature as soft as iron that has been put in the fire so as to make it malleable.'[9]

The soul, then, remains malleable and capable of excellence only so long as this holy fear remains alert within it, because it is this fear which teaches it the limits within which it can surrender itself to pleasure and pain. Pleasure and pain ($\lambda\acute{u}\pi\eta$ $\kappa\alpha\grave{\iota}$ $\acute{\eta}\delta ov\acute{\eta}$) are the 'two springs which nature lets flow, and whatever individual, whatever state, whatever living being draws from the right fountain, at the right time, and in the right measure, enjoys happiness ($\epsilon\grave{v}\delta\alpha\iota\mu ov\epsilon\hat{\iota}$), but whoever does so without understanding and without choosing the right moment has the opposite lot'.[10] This is why the legislator must regard pleasure and pain as the matter which he has to shape, the substance he has to mould; for children the means of moulding it is play, for older persons it is art.

They say that no young creature is able to keep its body or its voice still, but that they are always trying to move about and to give utterance; some leap and jump, as though dancing with joy and making sport, and others utter every kind of sound. And whereas other living creatures (so they say) have no feeling for that order or disorder in movement which is called rhythm and harmony, we have been given the gods [the Muses and Apollo and also Dionysus] to dance with us, and they have given us the feeling for rhythm and harmony together with delight by which they move us and direct our choirs, joining us together by means of songs and dances.[11]

This musical education aims to attune the soul early in life to what it will later recognize as virtue. For the highest goal of the legislator, the happiness of the individual and of the

[6] *Leges*, I, 638D.
[7] II, 666A.
[8] II, 671D.
[9] II, 666A.
[10] I, 636D.
[11] II, 653D.

society as a whole, is guaranteed only when this attunement, the harmony (συμφωνία) between insight and impulse, has been attained. The greatest ignorance (μεγίστη ἀμαθία) is that of the man who believes he can live in a state of discord, a διαφωνία between what insight ought to teach him and what stimulates him by way of pleasure and pain. This discord—and here we come to the crucial point—must ensue when the arts free themselves from the constraints of the state and proceed of their own accord to set up pleasure and pain as the final arbiters. For the charms the arts work upon the senses are manifold, the variety of forms they can reflect is infinite, and the soul which surrenders itself to them, instead of seeking support in the one truth and the one virtue, becomes shapeless and soft, and loses all sense of good and evil. For Plato art is a kind of magic. It permeates man and can transform him. That is why the state must use it as a means of shaping the soul. But it must also supervise it. For the same power which serves the state when controlled by it will, if it is not curbed, turn against the state and against the unity of man. This is why Plato fights not only against the release of art from its legal ties with the state, but also against the separation of the arts from one another, against the creation of a kind of music which has no connection with the word and of a poetry not accompanied by music, against all artistry which appeals to a part of man as though it were the whole, and so upsets the equilibrium of the human mind.

It is precisely this development of the part in isolation from the whole that, because of its inherently destructive force, and its impulse towards self-sufficient perfection, leads to disruption and discord. Once the arts have become free their balanced hierarchy of relationships with one another also begins to shift. Now a harmonious rhythm which is suited to a noble gesture may invest one that is ignoble, and we may be so enchanted by its magic that we either fail to notice that the gesture is ignoble or feel that it actually heightens the charm of the effect. Again, a heroic action whose natural rhythm ought to delight us can assume a grotesque form which repels us or makes us laugh. A lie can acquire a resonance that moves us by its depth and captivates us by its beauty. And a truth can address us in a tone that stupefies or bores us. A man who uses these syncopated rhythms to shape his dances must—even more than the man who abstains altogether from the dance—develop in himself a 'limping virtue'. For the more familiarity with such attitudes strengthens his sense of the brilliance of these paradoxes, the more must his capacity for responsible action wither away and die. So it is from his solicitude for the harmony of man and the maintenance of proper equilibrium in the soul that Plato derives a doctrine that refuses to distinguish between enjoyment and lawful order, between the beautiful and the good. For that is how he himself described his doctrine: ὁ μὴ χωρίζων λόγος ἡδύ τε καὶ δίκαιον καὶ ἀγαθόν τε καὶ καλόν.[12]

II

During the transition from the fifth to the fourth century, Greek art did, in fact, undergo that refinement of its several branches, and that assertion of the separate identity of each,

[12] *Leges*, II, 663A.

against which Plato directs all the resources of his logic and eloquence. Drama, abandoning its link with cult, pursued ever more psychological refinements. Sculpture changed from the Phidian style to the softer forms of Praxiteles. In vase painting, purely linear drawing was displaced by a freer brush technique, which blurred the precise contours and their silhouette effect, replaced them by polychrome treatment, and finally broke through the surface of the vase itself by simulating a stage perspective.

Plato contends that this shift affects not only art in the narrower sense, but all other spheres of life. It penetrates Greek philosophical and legal thinking in the doctrines of the Sophists, and Greek politics in the persuasions of the demagogues. The political counterpart of this instability in art may be found in the figure of Alcibiades. Already in the *Symposium* Plato portrays him at that stage of drunkenness when truth illuminates his mind just as he is threatened with the loss of self-control. He is a man who appears to be possessed by 'divine madness' ($\theta\epsilon\acute{\iota}a$ $\mu a\nu\acute{\iota}a$) without knowing 'divine fear' ($\theta\epsilon\hat{\iota}os$ $\phi\acute{o}\beta os$). Plato's words in the *Republic* about corruption which is nourished by the very greatness of man's aptitude for philosophy sound like a comment upon the conduct of Alcibiades.

The most surprising thing of all is that each of the qualities we have praised corrupts the soul that possesses it and draws it away from philosophy ... and all the so-called good things of life have the same effect, beauty and wealth and physical strength and powerful connections in the city and all that goes with them; you have the general idea of what I mean.... In the case of every seed and growth, whether vegetable or animal, the more vigorous it is the more it falls short of its proper form when deprived of the food, the season, and the place that suits it.... Should we not also say that the most gifted souls, if they are given a bad education, become particularly bad? Or do you think that great crimes and unadulterated wickedness come, not from a weak nature, but from a vigorous nature which has been corrupted by its upbringing, while a weak nature will never be the cause either of great good or of great evil?[13]

Just as Plato ascribes the magnitude of the politician's corruption to the fact that he had the makings of greatness in him, so too he depicts the danger presented by the artist as the greater in proportion to his power of shaping material, that is, his ability to transform things—his versatility.

And if a man with the skill to assume all shapes and imitate all things were to come to our city wishing to show off himself and his poetry, we should pay him reverence as holy and wonderful and delightful, but we should say that we have no such man in our city and that it would not be right for us to have one, and we should anoint his head with myrrh and crown him with a garland of wool and send him to another city; and we ourselves should for the sake of our own well-being employ the more austere and less delightful poet and story-teller....'[14]

The convictions expressed in these passages and in those I quoted earlier combine to form one consistent theory: the same forces to which Greek art owes its highest point of development are those which broke up and destroyed the Greek state. The same power of

[13] *Respublica*, VI, 491B f. [14] III, 398A.

language and versatility of form which enables the Greek as artist to attain perfection deprived the Greek as citizen and the Greek as statesman of his mainstay. And this proposition, which Plato, from the context of his own time and place, recognizes as decreeing the fate of his own nation, is generalized in his work into a universal principle destined to claim validity far beyond the confines of the Greek world: the principle that art and the state are by their very nature in conflict, since precisely those tensions between the powers of the soul which the legislator attempts to overcome and resolve are those which the artist maintains and intensifies. The passions the law forbids us are those out of which the dramatist creates his tragedies. The optical illusions the mathematician should see through are those the painter uses to create his forms. The verbal ambiguities the logician tries to expose by distinguishing concepts are used by the orator to seduce our minds. It is moreover of no avail to assert that the artist in pursuing illusions differs in his aim from the logician who pursues truth. For it is the same human being who goes to tragedies and lives in a community regulated by laws, who is deluded by *trompe-l'œil* effects and practices mathematics, who should weigh his decisions rationally and lets himself be swayed by orators.

It is in these terms that we can understand Plato's grand indictment that art corrupts man because it appeals to that element in him which is remote from the ordering intellect ($\pi\acute{o}\rho\rho\omega$ $\tau\hat{\eta}s$ $\phi\rho o\nu\acute{\eta}\sigma\epsilon\omega s$). Art strengthens our tendency to yield to domination by irrational forces, and is bound to exercise its most corrupting effect when we not only attend with sympathy to the artist's conjuring tricks, but adopt them ourselves. Hence Plato's hostility to mimesis. A man's gestures, his bodily attitudes, the sounds he emits, are part of himself, and they shape him just as he shapes them. That is why the comedian who, in order to amuse, habitually adopts grotesque attitudes and imitates contemptible figures must appear in his own life, if not grotesque and contemptible, at least distorted by these habitual actions. To remedy this distortion Plato calls for the use of indirect speech, which distances the speaker from what he says, and enables him to report things without being wholly carried away by them. What applies to speech applies also to the crafts and to activity in general. Mimesis is the uncontrolled process of depiction which is neither guided nor interrupted by reflection, but unconsciously takes effect in the act of imitation or representation, without regard to the nature or value of what is imitated or represented. What seems to Plato to be really dangerous about artistic creation and enjoyment, what makes it the antithesis of philosophical reflection, is the suppression of self-consciousness in the action of the moment, the complete identification with what is depicted. This is why, in making the value of an action depend on whether it is guided by the Idea (that is, by philosophical awareness), he condemns mimesis as the source of all that is worthless. But that does not prevent him from praising it as a means of preparing for future education, at the stage when reflection has not yet begun, that is to say, as a means of influencing the very young; always with the proviso that it must not be left uncontrolled.

In both cases Plato's verdict remains the same: the more art develops our aesthetic sensibilities for their own sake, the more it must destroy our sense of logic and morality. Therefore Plato demands the renunciation of art—a decision that seemed to him required

by the needs of the times and which is meaningful only in and for that time. But the question arises whether such a decision must not be taken in some form at all times, whether everyone who is confronted by conflicting values must not decide to make a sacrifice in one direction or the other—a sacrifice through which he defines the form of humanity in which he believes and to which he commits himself.

I shall try to prove the effectiveness and the inescapable nature of this decision by means of examples chosen at random from the last two centuries and the immediate present, and I begin advisedly with Lessing, who—in complete contrast to Plato—defended the autonomy of art and was concerned to protect it against the encroachment of any forces external to itself.

III

In 1755 the Prussian Academy set as the subject for a prize essay a philosophical examination of Pope's *Essay on Man*. Whatever their motives, the enterprise was thoroughly Platonic. A work of poetry was being made to defend its teaching before the tribunal of philosophy. And this was precisely the presumptuous demand against which Lessing and Moses Mendelssohn reacted in anger: 'Who is Pope?—A poet.... A poet? What is Saul doing among the prophets? What is a poet doing among the metaphysicians?'[15] Is not that very thing— so runs their argument—which is obligatory for the philosopher, forbidden to the poet: discursive breadth in the development of ideas, so that it is in the last resort a matter of indifference to the intellect whether it reaches its conclusion at once or belatedly, by means of one inference or twenty, so long as one idea supports the next and all together form one whole? Is not that very thing which is obligatory for the poet forbidden to the philosopher: the lively transition from one impression to another, so that the mind, constantly in a state of tension, is occupied and swayed by the most conflicting emotions in equal measure? The philosopher, if he is a Stoic, must beware of trains of thought which would cause him to lapse into Epicureanism, whereas the very reverse is true of the poet: 'He speaks with Epicurus when he wishes to elevate pleasure, and with the Stoa when he must praise virtue. Pleasure would cut a very sorry figure in the verses of Seneca were he always to abide strictly by his principles. Likewise would virtue, in the songs of a consistent Epicurean, look very much the strumpet.'[16]

That very versatility which Plato denies the poet is assigned to him by Lessing as his right, indeed his vocation and domain. It is the central concern of Lessing's whole struggle for the autonomy of art to prove that that which may be forbidden to one genre is not only permitted but positively required in another. He resembles Plato in that for him the conflict over art is a conflict over a particular conception of human nature. He fought with the

[15] Moses Mendelssohn, 'Pope ein Metaphysiker!', *Schriften zur Philosophie und Ästhetik*, ed. F. Bamberger and L. Strauss, *Gesammelte Schriften*, Jubiläumsausgabe, II (1931), p. 48.
[16] Ibid., p. 51

weapons of the critic for what Hume called 'the paradox of tolerance',[17] the ability to change one's viewpoint without losing one's character. Anyone who embarks on this venture must from the outset renounce any claim to that form of perfection which Plato designated 'happiness', the harmonious integration of the different levels of being at each moment of life. This harmony can only be achieved by curtailing the rights of the separate levels: by not permitting art to proceed beyond the point where it does violence to the capacity for logical thought, and by not elaborating a system of thought which exceeds the power of the artistic imagination.

On the other hand, someone like Lessing gives full scope to the rights of each type of activity, and entrusts himself to each one with his whole being; as a discursive thinker he seeks to be free of the flights of poetry; as a poet he seeks to be rid of the exigencies of logic. The result is that his mind becomes inflamed with the tension between the different functions. He has to live in a state of constant flux, which he formulates dialectically in polemics, or epigrams, or dramatic conflicts: he cannot—and indeed does not wish to—prevent his being from yielding to the syncopated rhythm which had been anathema to Plato. Goethe said of Lessing that 'he did not mind discarding personal dignity, because he was confident that he would always be able to get it back'.[18] Lessing knew, as his letters reveal, that this restlessness was for him a controlling law, which punished any relaxation into mere felicity as a defection and a sin.

The position adopted by Lessing reappears, somewhat modified, in the writings of Kant and Schiller. Kant's doctrine of moral autonomy and Schiller's doctrine of aesthetic freedom may have little in common in intellectual character with Lessing's tragic dialectic. Even so, they share the assumption that a man's self-realization must always be based upon the disproportion and the conflict of forces in his soul, and that an elimination of this conflict would cause him to lose sight of his objective. For each area in which the mind operates has, according to Kant, its own law. The manifestations of one function must not be gauged by the rules of another; within its limits we must, as it were, forget the laws of the others. In the realm of ethics, where freedom is the basic canon, we must forget the existence of natural laws which the agent cannot possibly defy. In the realm of science, sustained by the law of causality, we must forget that we arrogate to ourselves and to others the power of free choice. Finally, in the contemplation of art, where we evaluate what is formed for our sensibility through the 'reflective use of judgement', we must forget that we could take an interest in the logic or the ethics of what is represented.

Thus the mind, which performs so many different functions yet still recognizes its own nature as unchanged, moves between these different kinds of rule. It cannot be wholly

[17][Presumably Wind had in mind Hume's expression 'the paradoxical principle and salutary practice of toleration' (*The History of England*, VI, 1792-3, Appendix to the Reign of James I, p. 165), though Hume uses it in another context. I am grateful to Dr Peter Hacker for identifying the source of this notion.]

[18]*Dichtung und Wahrheit* (1811-14), II, vii (*Sämtliche Werke*, Jubiläums-Ausgabe, XXIII [1902-12], ed. R. M. Meyer, pp. 80 f.).

present in any one of them, because it can only be present in each one by excluding the others. Even Kant's gradation of the faculties, the primacy of practical over theoretical reason, cannot, and is not intended to, exclude this restlessness. The unconditional force which the moral law gives to its imperative must bring home to us the limitations of all those efforts which are bound by empirical conditions, such as the pursuit of knowledge or of happiness, thus castigating, as a misuse of reason, all attempts to abandon them.[19] To pursue happiness with the instruments of reason is to end up in hatred of reason. Anyone attempting to reconcile the principles of action with objective knowledge is doomed to failure. For however comprehensive a man's knowledge may be, its limitations will never allow it to rise equal to the unlimited authority of his moral dictates.[20]

To be sure, Kant, in the further elaboration of his system, mitigated this tension by assigning to aesthetic contemplation a mediating role between the conflicting standards of action and cognition. But basically this introduction of an intermediate level of mental order is by no means the same as an admission of the possibility of happiness. On the contrary, it is merely a further differentiation interposed between the terms of the original opposition. For this third level, too, in the end constitutes itself as a partial area of consciousness. Like the other levels, but distinct from them, it describes an orbit of limited activity which man, in order to fulfil the determinants of his own nature, must constantly seek afresh and constantly and forever lose again.

Schiller's doctrine of aesthetic freedom is likewise based upon the internal tension and splitting-off of a part of the self and the consequent activity of the mind. For him, in the 'play' of art the transition from the natural to the moral order is so characteristic of human nature, which is neither purely moral nor merely natural, that he says 'man only plays when he is in the fullest sense of the word a human being, and he is only fully human when he plays'.[21] And yet this aphorism suggests that to be fully human is possible only on extraordinary occasions, in the rare moments of, as he called it, 'aesthetic mood' (*ästhetische Stimmung*).[22] It is this state of indeterminacy, unlimited in its reach, which endows man with his freedom and makes him fully human. 'True, he possesses this humanity *in potentia*

[19]*Grundlegung zur Metaphysik der Sitten* (1785), 1. Abschnitt, 6. Absatz (*Kant's gesammelte Schriften*, Preußische Akademie der Wissenschaften, IV, 1911, pp. 395 f.). See also *The Moral Law or Kant's Groundwork of the Metaphysics of Morals*, ed. and trans. by H. J. Paton (1956), p. 61: 'In actual fact too we find that the more a cultivated reason concerns itself with the aim of enjoying life and happiness, the farther does man get away from true contentment. This is why there arises in many, and that too in those who have made most trial of this use of reason, if they are only candid enough to admit it, a certain degree of *misology*—that is, hatred of reason; for when they balance all the advantages they draw, I will not say from thinking out all the arts of ordinary indulgence, but even from science (which in the last resort seems to them to be also an indulgence of the mind), they discover that they have in fact only

brought more trouble on their heads than they have gained in the way of happiness.'

[20]*Kritik der praktischen Vernunft* (1788), 1. Teil, 2. Buch, ix: 'Von der den praktischen Bestimmung des Menschen weislich angemeßenen Proportion seiner Erkenntnis-vermögen'—'Concerning the limiting Effect of Man's Practical Nature upon the Dimensions of his ability to Know' (ed. cit., v, 1913, pp. 146 ff.).

[21]*Über die ästhetische Erziehung des Menschen in einer Reihe von Briefen* (1795), xv, 9, quoted with a few minor changes from Schiller's *On the Aesthetic Education of Man in a Series of Letters*, ed. and trans. by E. M. Wilkinson and L. A. Willoughby (1967), p. 106: 'der Mensch spielt nur, wo er in voller Bedeutung des Worts Mensch ist, und e r i s t n u r d a g a n z M e n s c h, w o e r s p i e l t.'

[22]xxi, 5 (ibid., p. 147).

before every determinate condition into which he can conceivably enter. But he loses it in practice with every determinate condition into which he does enter. And if he is to pass into a condition of an opposite nature, this humanity must be restored to him each time anew by means of his aesthetic life.'[23]

Thus the aesthetic life, precisely through this mobility, which Plato regarded as perilous to man and which he sought, with reluctant circumspection, to restrain within bounds has become the most important organ of education, and the only organ of liberation. It releases man from the fetters of his isolation, and becomes an indispensable support of civic consciousness. Unfortunately it can do this only for the man who, having lost wholeness of personality, seeks momentarily to recover it; that is to say, the man whose condition is the opposite of Plato's contemporaries; they still retained the wholeness of personality, but were on the point of losing it. Art, which Plato considered a source of danger, has suddenly become an instrument of healing, and this because of the very feature which Plato regarded as the most disturbing: the power to transform man through the enticement of his imagination. It is precisely through 'appearance' that you may capture (according to Schiller) the minds of those who will not listen to your theorems. 'The seriousness of your principles will frighten them away, but in the play of your semblance they will be prepared to tolerate them. . . . In vain will you assail their precepts, in vain condemn their practice; but on their leisure hours you can try your shaping hand.'[24]

That Greek unity which Plato sought to protect against disruption is, in the eyes of Schiller, irrevocably gone, nor is mankind the worse off for it. 'With the Greeks, humanity undoubtedly reached a maximum of excellence, which could neither be maintained at that level nor rise any higher.'[25] Only a specific degree of clarity is compatible with a specific fullness and warmth. 'If the manifold potentialities in man were ever to be developed, there was no other way but to pit them one against the other.'[26] He is so sure that this antagonism of faculties and functions is 'the great instrument of civilization' that he makes a statement which, from the Platonic point of view, must seem starkly paradoxical and blasphemous: 'One-sidedness in the exercise of his powers must, it is true, inevitably lead the individual into error; but the species as a whole to truth.'[27] 'Limping virtue', it appears, is the proper vehicle of objective progress; it may cripple the individual man, but it carries the cause which he serves towards perfection.

But according to Schiller's own view, that specialization of man, necessary as it had become, constitutes the most serious danger not only for the individual but also for the state. For the individual who devotes his own gifts to the development of a specialist skill, the idea of the whole is an abstraction without any real substance, and 'the state remains for ever a stranger to its citizens since at no point does it make contact with their feelings'.[28] It is here that the mediation of art must be called upon, to evoke at least in play the idea of

[23] *Ästhetische Briefe*, xxi, 5 (ed. cit., p. 147).
[24] ix, 7 (ibid., p. 61).
[25] vi, 11 (ibid., p. 39).
[26] vi, 12 (ibid., p. 41).
[27] vi, 13 (ibid., p. 41).
[28] vi, 9 (ibid., p. 37).

totality which is missing from reality. Nowhere is Schiller closer to the Platonic view than when, in seeming to reverse it, he praises imitation through play as the means by which to approach the 'idea'. Then, in a characteristic transformation of the doctrine of *anamnesis* (recollection), he proclaims that 'the symbol [that is, images or semblances] of excellence'[29] will give rise to actual excellence. 'Humanity has lost its dignity; but Art has rescued it and preserved it in significant stone. Truth lives on in the illusion of Art, and it is from this copy, or after-image, that the original image will once again be restored.'[30]

Schiller himself pointed out the shortcomings of his thesis and the dangers that spring from a disregard of 'the necessary limits in the use of beautiful form'.[31] The vividness with which beauty seizes us makes us forget the instruments whereby truth is found and tested and through which, alone, it can be identified as truth. Under its impact, the perfect duties which confront us as abstract and unconditional demands seem less attractive and less worthwhile than those imperfect duties which are happily reconciled with our desires. But even here, where he issues the warning very nearly in Plato's own words, Schiller uses an antinomy in the spirit of Kant. To bring beauty into questions of truth is, he thinks, dangerous enough when this means replacing the true ideas of obligation with a false one which does not stand the test of reflection. But—and this is where his opposition to Plato shows most clearly—the confusion of beauty and truth seems to him most dangerous when it reveals a complete agreement with reason, that is, the state of mind which Plato called happiness. Schiller rejected this kind of happiness, because it destroys conflict, the great instrument of civilization. 'Uninterrupted happiness fails to acquaint a man with his duty, because his aspirations, orderly and consistent as they are, always anticipate the call of reason. No temptation to break the law reminds him of the law's existence. Governed only by his sense of beauty, the vicar of reason in the world of the senses, he will go to his grave without ever experiencing the dignity of his being.'[32]

IV

Goethe did not subscribe to this low evaluation of happiness. What is more, the character of his work is bound to cast some doubt on the validity of our reflections so far. The doctrine of the conflict of forces, of the necessity of choice and sacrifice, may be applicable to Lessing, to Kant, to Schiller; but is it not out of place in relation to Goethe's life and ideals, which have so often been praised for their harmonious fulfilment? And yet Goethe's form of perfection has been bought at the expense of a renunciation which only serves to emphasize more clearly the serious and inescapable nature of Plato's warning. Goethe said of himself that he viewed everything symbolically. This is an admission that in his case imagination served to transform things into images, to divest them of their substantiality, enabling him

[29] *Ästhetische Briefe*, ix, 7 (ibid., p. 61)
[30] ix, 4 (ibid., p. 57).
[31] 'Über die notwendigen Grenzen beim Gebrauch

schöner Formen' (1793/5), *Schillers sämtliche Werke*, Säkular-Ausgabe, xii/2 [1904], ed. O. Walzel, pp. 121 ff.
[32] Ibid., pp. 148 f.

to escape the claims they might have had on him as things. He himself describes how in this way intense personal experience became the source of artistic creation, how art acquired the capacity to exercise a liberating and redeeming role in life. Referring in *Dichtung und Wahrheit* to the influence his portrayal of Werther had on his own mind, he writes: 'The old familiar remedy had an excellent effect on me this time.'[33] And the exercises by which, before the final composition of *Die Leiden des jungen Werther*, he overcame the suicidal thoughts weighing on him, provide a highly characteristic insight into the therapeutic power of the symbol, although in its extremity this incident was obviously unparalleled in his career.

He had come to feel that suicide is not a genuine experience unless it is carried out by the victim's own hands. But wherever he looked among the great suicides of legend and history, he found that they had used some stratagem to avoid performing the decisive act with total involvement in what they were doing. 'When Ajax falls on his sword, it is the weight of his body which renders him this last service. When the warrior enjoins his shield-bearer not to let him fall into the hands of the enemy, the force he enlists may be moral rather than physical, but it is external all the same.'[34] The only deed worthy of imitation seemed to him that of the emperor Otho who 'with his own hand thrust a sharp dagger into his heart'.[35] Every evening, therefore, he would place a dagger beside his bed, and before extinguishing the light he would set it against his breast. He was not able to drive it home, and yet, in this way, he experienced suicide symbolically, until in the end he realized that he was not only incapable of the real act, but indeed no longer stood in need of it.

It is clear that this means of escape, if through poetic expression it becomes a general habit of mind, must involve a corresponding renunciation. To the extent that the world of symbolic order, purged of accident, is extended, the world of particular incident ceases to precipitate decisions. If *Dichtung und Wahrheit* is read in this light, the impression is inescapable that the most important decisions take the form of a flight, the flight from life to image. I need only point to the episode at Sesenheim: at the very moment when new ties are about to be established, we are told the tale of the new Melusine which playfully transcribes and disposes of the real conflicts threatening the group. It has often been observed that Goethe's dramatic invention is controlled by a similar principle. The conflict between Antonio and Tasso is not resolved, or decided, but transposed onto a symbolic plane.

It is the business of art to carry out a symbolic transposition: Goethe has put this most vehemently and therefore most vividly in his discussion of English poetry, especially elegy, 'in which excellence goes hand in hand with sober melancholy'.[36] Much as he admires its human grandeur and its ability to move the spirit, he denies it the status of true poetry because of its sombre gloom.

[33] *Dichtung und Wahrheit*, III, xiii (ed. cit., XXIV, p. 170).
[34] Ibid., p. 165.
[35] Ibid., p. 166.
[36] Ibid., p. 160.

True poetry may be recognized by a special mark: a worldly gospel, able by its serene temper and its appealing form to free us of our earthly burdens. Like a balloon it raises us, along with the ballast attached to us, into the higher regions whence it affords us a bird's eye view of the confused labyrinths of the earth. The happiest works and the most serious have this common purpose, to moderate both pleasure and pain by the felicity and wit of their presentation.[37]

This appeasement of tensions, this cancellation in the symbol, becomes so much part of the purpose of artistic creation that that purpose must be regarded as unfulfilled if the tensions continue to be felt in the completed work. So the poet rejected his 'hurtful and humiliating experience',[38] his youthful insights into the 'strange turnings and twists undermining polite society',[39] the moment they began to assume dramatic form. 'To unburden myself, I conceived of several plays and wrote out summaries of the plots of most of them. But since in each case the complications were liable to cause anxiety, and since almost all these pieces threatened to end tragically, I gave them up one after another.'[40]

In Lessing and Schiller, the opposition between the distinct systems within the mind, and the conflicts arising from them, are open for all to see, because these conflicts and, indeed, the dialectic resolution of them, are the very material which poets articulate and clarify. In Goethe, on the other hand, these things can be sensed only as subterranean forces from which the poet must free himself. Thus Goethe believed in harmonious balance, and sought to achieve this by setting imaginative limits (limits which must not be destroyed dialectically) to artistic expression and so also to reflective thought and purposive action. But if happiness is to be secured by making experience imaginative in this way, then it cannot be found in an insight that loses itself among its deductions or in an activity wasted by its consequences. The 'dissolution' of real events by means of poetry brings not only a deliverance, but a renunciation. Only that reality is endorsed which knows itself to be semblance.

V

The elevation of this ideal of a symbolic existence which gained ground in the Romantic period led to a new kind of sophistry. Friedrich Schlegel sought to combine philosophy and poetry, to employ ideas and 'fragments', allegories and hieroglyphics, 'images of uncomprehended truth',[41] in order to master that vast infinity which the systematic philosopher cannot encompass. This meant that poetic ingenuity tried to grasp and penetrate all areas of life. To adapt the fragment, in itself a limited form, to range over the infinite, Schlegel fixes on irony, which playfully abolishes the finite, determinate meaning, and offers instead an infinite, indefinite significance. But the sole condition upon which irony can be effective is that all seriousness should be banished and thereafter nothing should be taken in the

[37] *Dichtung und Wahrheit*, III, xiii (ed. cit., XXIV, p. 161).
[38] Ibid. II, vii (ed. cit., XXIII, p. 86).
[39] Ibid., p. 85.
[40] Idem.
[41] 'Ideen', *Athenäum*, III, 1 (1800) 'An Novalis': 'Dein

Geist stand mir am nächsten bei diesen Bildern der unbegriffenen Wahrheit.' (*Charakteristiken und Kritiken I (1796-1801)*, Kritische Friedrich-Schlegel-Ausgabe, ed. H. Eichner, II, 1967, no. [156], p. 272.)

literal sense. When Schlegel praises the ambiguity of speech in order to discredit seriousness it sounds like a sophistical precept: 'Oh, my friend, it is true, man is by nature a serious beast. This harmful and disagreeable tendency must be opposed with all our strength and from all directions. For this purpose ambiguity is good....'[42] A 'mischievous aesthetic' becomes an essential part of the harmonious cultivation of the mind[43] and the education of man rises to its climax in the insight that 'morality without a sense of paradox is vulgar'.[44]

This claim to rise above ordinary morality by cultivating the sense of paradox was bound to appear obnoxious and unacceptable to the logical thinker, precisely because it involved insisting that the rights of the artist were to be held absolute in relation to all other claims: 'We no longer regard art as the highest way in which truth contrives to exist,' says Hegel in his lectures on aesthetics. With indescribable fury he develops a picture of the logical and practical consequences of self-destruction through irony. He rages against a decision which, in the form that Schlegel had given to it, exaggerated the privileges of the artist. And yet Hegel, too, had to make his choice, and he made it in a form whose stringency left nothing to be desired. In his system he located art on a level on which the spirit has not yet found itself, and he declared, with an explicit reference to Plato, that as soon as self-awareness has come of age it will, and must, turn its back on art:

With the advance of civilization a time generally comes in the case of every people when art points beyond itself.... Art in its beginnings still leaves over something mysterious, a secret foreboding and a longing, because its creations have not completely set forth their full content for imaginative contemplation. But if the perfect content has been perfectly revealed in artistic shapes, then the more far-seeing spirit rejects this objective manifestation and turns back into its inner self. This is the case in our own time. We may well hope that art will always rise higher and come to perfection, but the form of art has ceased to be the supreme need of the spirit. No matter how magnificent we find the statues of the Greek gods, no matter how nobly and perfectly portrayed God the Father, Christ, and Mary seem to be, it is no use: we no longer bend our knees before them.[45]

Curiously enough, this philosophical renunciation of art adduces exactly the same facts as the artistic renunciation of morality which Baudelaire voiced some decades later. He, too, confesses that the needs of the spirit are no longer satisfied by art, but his explanation of this fact differs from that of Hegel. It is not that the form of art has nothing more to say to us, but rather that it has wasted its resources on subjects which can only blunt its edge and

[42] *Lucinde* (1799) (*Dichtungen*, ed. cit., v, 1962, p. 34).

[43] Ibid., p. 28. It was a Romantic writer (though not a German) who turned his 'mischievous aesthetic' against Plato himself, introducing against his philosophy the same objection which Plato had raised against art, that it endangers the soul: 'Oh Plato! Plato! you have paved the way, / With your confounded fantasies, to more / Immoral conduct by the fancied sway / Your system feigns o'er the controlless core / Of human hearts, than all the long array / Of poets and romancers....' Byron, *Don Juan*, i, cxvi.

[44] 'Ideen' (ed. cit., no. [76], p. 263).

[45] *Vorlesungen über die Aesthetik* (1835), I, 1. Theil [Einleitung], 'Die Idee des Kunstschönen oder das Ideal' (*Samtliche Werke*, ed. H. Glockner, XII, 1927, pp. 150 f.). See now *Aesthetics. Lectures on Fine Art by G. W. F. Hegel*, trans. by T. M. Knox, I (1975), p. 103, also below, p. 96, and Wind, *Art and Anarchy* (rev. and enlarged edn., including Addenda, 1969), ch. i and pp. 199 ff.

restrict its power. For generations artists have done nothing but hymn the beauty of the good. Baudelaire, on the other hand, sets himself the task, more difficult and hence more seductive, of finding beauty in the corrupt and the evil. In the sketch of an introduction to *Les Fleurs du mal* he voiced this thought: 'This book is not written for any wife, daughter, or sister of mine, or for the wives, daughters, or sisters of my neighbour. I leave that task to those who see it as in their interest to confuse good actions with beautiful speech.' He himself refuses, in his own words, to mix ink with virtue—'à confondre l'encre avec la vertu'.[46]

It is almost as if the arrogance of the rigorous philosopher who consigns art to a subordinate plane of the spirit and, by turning away from it, shows that he has ceased to consider it as 'dangerous', is surpassed by the arrogance of the 'libertine' who boldly asserts the conflict between art and morality, in order to celebrate a vicious rejection of morality as the source of his artistry. The intellectual edge of this feeling is apparent in every line of Baudelaire's work, in each antithesis and juxtaposition. Pleasure, for him, becomes an instrument of castigation, boredom the wellspring of emotion. With the help of sinfully sacred rites, he cleanses himself for 'les saintes voluptés',[47] and in the consciousness of the evil of his passion he finds the true accents of his art. Thus he sings his 'Satanic Litanies';[48] he intones his 'horreur sympathique' which rings out like a cry of scornful triumph at his expulsion from Plato's Republic.

> —Insatiablement avide
> De l'obscur et de l'incertain,
> Je ne geindrai pas comme Ovide
> Chassé du paradis latin.
>
> Cieux déchirés comme des grèves
> En vous se mire mon orgueil;
> Vos vastes nuages en deuil
>
> Sont les corbillards de mes rêves,
> Et vos lueurs sont le reflet
> De l'Enfer où mon cœur se plaît.[49]

An ironic shift of accent was all that was required to transform this pride of self-destruction into a pose bordering on playfulness. Oscar Wilde took the conflict which Baudelaire had revealed between art and morality and applied it to the relation between art and truth. In his dialogue 'The Decay of Lying' he developed a thesis that the ever more ineradicable urge to seek and express the truth, and the firmly rooted conviction that facts are sacred, lies sinful, has led to a decay of the imagination which threatens the complete paralysis of art. 'The loss that results to literature in general from this false ideal of our time

[46]Baudelaire, 'Projets de Préface pour *Les Fleurs du mal*', I, 1859/60, *Œuvres de Baudelaire*, Bibl. de la Pléiade, ed. Y.-G. Le Dantec, I (1938), p. 580.

[47]*Les Fleurs du mal* (1861), i, 'Bénédiction'.
[48]Ibid., cxx, 'Les Litanies de Satan'.
[49]Ibid., lxxxii, 'Horreur sympathique'.

can hardly be overestimated.... Lying and poetry are arts—arts, as Plato saw, not uncon-
nected with each other....'[50] And in order to elevate the art of his time—the whole is
conceived as a polemic against naturalism—Wilde wants to school the capacity for lying. He
finds that 'something may, perhaps, be urged on behalf of the Bar. The mantle of the
Sophist has fallen on its members.... They can make the worse appear the better cause, as
though they were fresh from the Leontine schools.'[51] Even Society; 'tired of the intelligent
person whose reminiscences are always based upon memory ... sooner or later must return
to its lost leader, the cultured and fascinating liar'. And above all, 'art ... will run to greet
him, and will kiss his false, beautiful lips, knowing that he alone is in possession of the great
secret of all her manifestations, the secret that Truth is entirely and absolutely a matter of
style; while Life ... tired of repeating herself ... will follow meekly after him, and try to
reproduce, in her own simple and untutored way, some of the marvels of which he talks'.[52]

In this scintillating manner he developed the thesis that it is not art which imitates reality,
but reality which copies art. The free imagination of the artist transforms man and his
surroundings, so that in the end the pre-Raphaelite type of feminine beauty, once a particular
artist has captivated society with it, comes to be found in actual human beings. What is
frightening about these observations is that Wilde allows his wit to play paradoxically upon
the same circumstances in which Plato saw the immense danger of art: the fact that men are
changed by it. One and the same insight leads, in the one case to the divine fear, in the other
to the most reckless insolence. In his *De profundis*, Wilde, having utterly destroyed himself,
gave plaintive voice to this recognition. Man's being instinctively forms itself after the
pattern of the deft play of his art: 'What the paradox was to me in the sphere of thought,
perversity became to me in the sphere of passion.'[53]

Wilde's fate, extraordinary as it appeared to his contemporaries, did not remain isolated
but came to represent a choice which is found among artists of greater genius. We remember
how Verlaine, in *Mes prisons*, calls out to the French policeman: '[les poètes] ne vous regardent
pas, dans les deux sens du verbe!'[54] The artist who puts himself entirely outside the law, to
follow only his own genius, will have to obey it even when it casts him into the most
conflicting moods. In his later phase, Verlaine tried to explain to himself and to his friends
how he was able to write, side by side, poems of the most profound religious feeling, filled
with religious fervour and sense of guilt, and light poems of worldly sensuality: 'l'HOMME
mystique et sensuel reste l'homme intellectuel toujours.'[55] And who is this 'homme intel-
lectuel'? The pure poet who perfects his art for its own sake, and therefore must become one
of the damned. 'Poète absolu', hence 'poète maudit'.[56]

The χωρισμός, the division within the mind which Plato tried to combat, could hardly be
carried out more radically than by this artist who seeks his perfection by turning his back on

[50]'The Decay of Lying, an Observation', *Intentions*
(1891), p. 9.
 [51]Ibid., p. 6.
 [52]Ibid., pp. 28 f.
 [53]*De profundis* (1905), p. 23.
 [54]*Mes prisons* (1893), xix, conclusion (*Œuvres complètes de*

Paul Verlaine, ed. O. Nadel, J. Borel, and H. de Bouillane
de Lacoste, II, 1960, p. 785).
 [55]*Les Poètes maudits* (1888), vi, 'Pauvre Lélian' (ibid., I,
1959, p. 887).
 [56]Letter to Mallarmé, 16 août 1882 (ibid., p. 1154, also H.
Mondor, *L'Amitié de Verlaine et Mallarmé*, 1939, p. 59).

all the claims his age may make on him. In fact, the age has even lent its legal support to this stand. It is quite customary today, in cases at law, to justify a work of questionable moral value by extolling its artistic merit. As if the struggle between the two forces could be settled by a neat differentiation of terms! As if danger to morality ceased where the power of artistic creation begins! As if art merely idealized its object, without also intensifying it! Only an age in which the power of art is unrecognized, an age when the connection between moral and artistic forces has been lost, could think and judge in this way. For such an age Plato's demand is bound to read like a riddle.

The corrosion of forces enters its last phase when sickness, as in the works of Marcel Proust, crippling and at the same time shielding from all activity, becomes the key that opens up the world of artistic illusion. The artist is like Noah, shutting himself in the ark to escape the flood. He sits in the dark, while the dove comes and goes; and when the flood is abated and the dove departs, some sadness is mingled with the joy of the world reborn: 'Douce colombe de déluge! . . . Douceur de la suspension de vivre, de la vraie "Trève de Dieu" qui interrompt les travaux. . . .'[57] Proust found for this state a parable which could hardly be surpassed for horror. A young boy loves a girl older than himself, with a love entirely of the mind. He would stay at his window for hours to see her pass, wept if he did not see her, wept still more if he did.

Il passait de très rares, de très brefs instants auprès d'elle. Il cessa de dormir, de manger. Un jour, il se jeta de sa fenêtre. On crut d'abord que le désespoir de n'approcher jamais son amie l'avait décidé à mourir. On apprit qu'au contraire il venait de causer très longuement avec elle: elle avait été extrêmement gentille pour lui. . . . Après cette entrevue suprême où il avait, à sa fantaisie déjà habille, conduit son amie jusqu'à la haute perfection dont sa nature était susceptible, comparant avec désespoir cette perfection imparfaite à l'absolue perfection dont il vivait, dont il mourait, il se jeta par la fenêtre. Depuis, devenu idiot, il vécut fort longtemps. . . . —La vie est comme la petite amie. Nous la songeons, et nous l'aimons de la songer [sic]. Il ne faut pas essayer de la vivre: on se jette, comme le petit garçon, dans la stupidité, pas tout d'un coup, car tout, dans le vie, se dégrade par nuances insensibles.[58]

I do not want to read too much into this story, but it has a particular meaning when we reflect upon the evolution of art and society in recent decades. Today, having experienced most acutely within ourselves this disintegration of forces, we take it as a good omen when we see activities until recently entirely separate once more drawing closer together. In the course of its own development, science has been forced to discard some formerly cherished dogmas that questioned or even rejected the arts. Art, in its turn, has begun to abjure the hatred of intellectual culture that had temporarily plunged it into self-conscious primitivism. Yet this *rapprochement* may produce not only the conditions for new interaction, but also the danger of a new kind of sophistry, the danger that art and eloquence will, in mastering new material, toy with it, misuse and corrupt it. Plato has taught us to be suspicious of art—

[57]'Les regrets, rêveries couleur du temps', dédication 'A mon ami Willie Heath', *Les Plaisirs et les jours* (1896) (*Jean* *Santeuil* précédé de *Les Plaisirs et les jours*, Bibl. de la Pléiade, ed. P. Clarac and Y. Sandre, 1971, pp. 6 f.).
[58]'Les regrets', vi (ibid., pp. 111 f.).

not because it is bad in itself, but because it endangers man. It is the intention of his teaching that we should expose ourselves to this danger only within the limits determined by our insight into human nature. How to discover those limits and so arrive at a conception of humanity, this is the problem we have to wrestle with. But in so doing we must remain mindful of Plato's warning that we can be prepared for the divine madness only in so far as we keep the divine fear vigilant within us.

II · Warburg's Concept of *Kulturwissenschaft* and its Meaning for Aesthetics

MY task is to describe to this Congress on Aesthetics the problems of a library which defines its own method as that of *Kulturwissenschaft*.[1] I ought first, therefore, to explain the relationship between aesthetics and *Kulturwissenschaft* as it is understood in this library. With this purpose in mind I shall refer to the changes which the relationship between art history and the history of culture has undergone in recent decades, and explain, with reference to one or two episodes in the history of these changes, how the development of these studies has generated problems which the library seeks to cater for by providing both material and a framework of thought. In explaining this need I shall concentrate on three main points: Warburg's concept of imagery, his theory of symbols, and his psychological theory of expression by imitation and by the use of tools.[2]

The Concept of Imagery

If we consider the works of Alois Riegl and of Heinrich Wölfflin, which have exercised such a decisive influence in recent years, we see that, despite differences in detail, they are both informed by a polemical concern for the autonomy of art history, by a desire to free it from the history of civilization and thus to break with the tradition associated with the name of

This paper was delivered in Hamburg in October 1930 for the fourth Congress on Aesthetics, concerning 'Time and Space', at a special meeting held a year after Warburg's death in the library that he had founded. The lecture was then published in the proceedings of the society as 'Warburgs Begriff der Kulturwissenschaft und seine Bedeutung für die Ästhetik', in *Beilageheft zur Zeitschrift für Ästhetik und allgemeine Kunstwissenschaft*, XXV (1931), pp. 163-79, and is here reprinted in translation with additions to the notes.

[1] [Warburg called his library 'Kulturwissenschaftliche Bibliothek Warburg', and Wind's lecture was intended as an introduction to Warburg's theory of imagery. Wind is here attempting to put into systematic order the basic ideas he had learnt from Warburg in long conversations. On the meaning of 'Kulturwissenschaft' and the difficulty of rendering it in English, see Wind's introduction to the English edition of *A Bibliography on the Survival of the Classics*, I (1934), pp. v f. The background to Warburg's concern with *Kulturwissenschaft* is to be found in late nineteenth-century writings by Windelband, Rickert, and Dilthey on the relationship between history and the natural sciences, cf.

Wind's German introduction to the Bibliography, I (1934), pp. vii-xi, for his 'Kritik der Geistesgeschichte', not included in the English version. Warburg's particular contribution to historical method was to conceive of the humanities not only in their specificity and their totality, but primarily in their inter-relation. See below, pp. 106 ff.]

[2] [*Psychologie des mimischen und hantierenden Ausdrucks:* Warburg's elliptic use of 'hantierend' for 'functional' or 'artefactual' expression derives from Carlyle's definition of man as a 'Tool-using Animal (*Handthierendes Thier*)'. Cf. *Sartor Resartus*, I, v; also below, pp. 31 f. and 113.]

Jacob Burckhardt. I will try briefly to summarize the forces behind this struggle and their consequences for the methodology of the subject.

1. This separation of the scholarly methods of art history and those of cultural history was motivated by the artistic sensibility of an age which was convinced that it was of the essence of a pure consideration of a work of art to ignore the nature and meaning of its subject-matter and to confine oneself to 'pure vision'.

2. Within the history of art this tendency was given added impetus by the introduction of critical concepts which shifted the emphasis from the artistic object itself to the manner in which it was depicted, to a point where the two were fully separated. Thus Wölfflin, for example, makes use of the antithesis between subject-matter and form. Since he includes on the side of form only what he calls 'the visual layer of style',[3] everything else, which is not in this radical sense visible, belongs under the heading of matter—not only representational or pictorial motifs, ideas of beauty, types of expression, modulations of tone, but also the differences resulting from the distinct use of tools which cause gradations in the representation of reality and different artistic genres. It was as though Wölfflin had set himself to discover, in a mathematical manner, the most general characterization of a particular style that it is possible to conceive of. But just as a mathematical logician states in formal terms a propositional function, which only becomes a meaningful proposition when the variables are replaced by words of determinate meaning and names for particular relations, so Wölfflin defines the 'painterly' way of looking at things as a general stylistic function, which can be variously instantiated according to what needs to be expressed, leading now to the style of Bernini, now to the very different style of Terborch.[4] And this general formula, whose logical force undoubtedly lies in its ability to unite such contrasting phenomena under one head, so as to distinguish them as a whole from a differently structured formula, which in turn classifies as 'linear' such contrasting phenomena as Michelangelo and Holbein the Younger—this general formula is now suddenly reified as a perceptible entity with its own history. The logical tendency towards formalization, which lends to the theory of aesthetic form a degree of precision which it cannot justify in its own right, is thus combined with a tendency towards hypostasization which turns the formula, once it has been established, into the living subject of historical development.

3. The antithesis of form and matter thus finds its logical counterpart in the theory of an autonomous[5] development of art, which views the entire developmental process exclusively in terms of form, assuming the latter to be the constant factor at every stage of history, irrespective of differences both of technical production and of expression. This has both positive and negative consequences: it involves treating the various genres of art as parallel with each other—for, as far as the development of form is concerned, no one genre should

[3] [For Wölfflin's earliest definition of these 'optische Schichten', or visual layers of style, see the final chapter of *Die klassische Kunst* (1899), which anticipates the principles as defined in *Kunstgeschichtliche Grundbegriffe. Das Problem der Stilentwicklung in der neueren Kunst* (1915). See also Wind, 'Zur Systematik der künstlerischen Probleme', *Zeit-* *schrift für Ästhetik und allgemeine Kunstwissenschaft*, XVIII (1925), pp. 438 ff.; *Art and Anarchy* (1969), pp. 21 ff. and 126 ff.]

[4] *Kunstgeschichtliche Grundbegriffe*, p. 12.

[5] Cf. *A Bibliography on the Survival of the Classics*, I, pp. vi ff.

be any less important than another; it also involves levelling out the differences between them—for no one genre can tell us anything that is not already contained in the others. In this way we attain, not a history of art which traces the origin and fate of monuments as bearers of significant form, but, as in Riegl, a history of the autonomous formal impulse (*Kunstwollen*),[6] which isolates the element of form from that of meaning, but nevertheless presents change in form in terms of a dialectical development in time—an exact counterpart of Wölfflin's history of vision.[7]

4. Finally, it is not just the various genres within art that are treated as parallel with each other; art itself is treated as evolving in exact parallel to the other achievements within a culture. This, however, only means a further step on the path to formalization; for the same antithesis of form and content, which at its lowest level brought about the rift between the history of art and the history of culture, now serves at this higher level to re-establish the relationship between the two. But the subsequent reconciliation presents just as many problems as the original division; for the concept of form has now become, at the highest level, just as nebulous as that of content, which at the lowest level united the most heterogenous elements in itself. It has become identical with a general cultural impulse (*Kulturwollen*) which is neither artistic nor social, neither religious nor philosophical, but all of these in one.

There is no doubt that this urge towards generalization gave the art history confined within this scheme grandiose perspectives. Wölfflin brought this out graphically when he declared that one can as easily gain an impression of the specific form of the Gothic style from a pointed shoe as from a cathedral.[8] However, the more critics learnt in this way to see in a pointed shoe what they were accustomed to seeing in a cathedral, or to see in a cathedral what a shoe could perhaps have told them, the more they lost sight of the elementary fact

[6] [On the origins of Riegl's method and the term 'Kunstwollen' or, as rendered by Wind, 'autonomous formal impulse', see E. Heidrich, *Beiträge zur Geschichte und Methode der Kunstgeschichte*, XIX (1920), pp. 321–39; also Wind (1925), pp. 442 ff., and *Art and Anarchy*, pp. 128 ff., and 170 ff. On the difference between 'Kunstwollen' and 'Kunstwillen', see O. Pächt, 'Alois Riegl', *The Burlington Magazine*, CV (1963), pp. 188–93.]

[7] Of course, this conceptual scheme is quite different from Wölfflin's. There is no simple division of form and content, but a complex relationship of dynamic interaction between a conscious and autonomous 'formal impulse' and the 'coefficients of friction' of function, raw material, and technique. However, on closer inspection the dynamic element suddenly disappears from Riegl's method of procedure. For, in order to show that within a given period the most diverse forms of artistic phenomena are informed by the same autonomous 'formal impulse', Riegl can only resort to formalization. In the study of the history of ornament he explicitly bids us to abandon analysing the ornamental motif for its content and to concenetrate instead on the 'treatment it has received in terms of form and colour in plane and space'. And in the study of the history of pictorial art in the wider sense, he similarly demands that we disregard all considerations of subject-matter which place the picture in a cultural-historical context, and concentrate instead on the common formal problems which link the picture with all other forms of visual art. 'The iconographic content', he writes, 'is quite different from the artistic; the function of the former, which is to awaken particular ideas in the beholder, is an external one, similar to the function of architectural works or to that of the decorative arts, while the function of art is solely to present objects in outline and colour, in plane or space, in such a way that they arouse liberating delight in the beholder.' (A. Riegl, *Die spätrömische Kunstindustrie im Zusammenhange mit der Gesamtentwicklung der bildenden Künste bei den Mittelmeervölkern*, I, 1901, pp. 119 f.) In this antithesis of utilitarian and artistic functions only what is literally 'optical' is allocated to the artistic, while the utilitarian is held to include not only material requirements, but also the ideas that are awakened by the work of art and are supposed to play a part in any contemplation of it. With this we come full circle to Wölfflin's point of view.

[8] Wölfflin, 'Prolegomena zu einer Psychologie der Architektur', in *Kleine Schriften 1886–1933*, ed. J. Gantner (1946), pp. 44 f.; cf. *Art and Anarchy*, pp. 21 and 127.

that a shoe is something one slips on to go outside, whereas a cathedral is a place one goes into to pray. And who would deny that this, so to speak, pre-artistic functional differentiation constituting the essential difference between the two objects, arising from man's use of different tools for distinct purposes, is a factor which plays a decisive part in their artistic formation, giving rise to aesthetic differences in formal content in relation to the observer?

I mention this elementary fact not because I believe it would ever have been completely overlooked, but because by stressing it I can get to grips with the present problem. We must recognize that the refusal to adequately differentiate artistic genres, and the consequent disregard of the fact that art is made by tool-using man, are both derived from the conjunction of the formalist interpretation on the one hand and the 'parallelizing' historical view on the other. This fuses into an indissoluble triad the critical study of individual works of art, aesthetic theory, and the reconstruction of historical situations: any weakness in one of these enterprises is inevitably passed on to the others. We can therefore apply constructive criticism in three ways. First, by reflecting on the nature of history it can be shown that, if the various areas of culture are treated as parallel, we shall fail to take account of those forces which develop in the interaction between them, without which the dynamic march of history becomes unintelligible. Or, secondly, we can approach the problem from the standpoint of psychology and aesthetics, and show that the concept of 'pure vision' is an abstraction which has no counterpart in reality; for every act of seeing is conditioned by our circumstances, so that what might be postulated conceptually as the 'purely visual' can never be completely isolated from the context of the experience in which it occurs. But, thirdly, we can also approach the problem by taking a middle course, and instead of positing *in abstracto* that inter-relationships exist, search for them where they may be grasped historically—in individual objects. In studying this concrete object, as conditioned by the nature of the techniques used to make it, we can develop and test the validity of categories which can then be of use to aesthetics and historical understanding.

This third course is the one Warburg adopted. With the intention of determining the factors conditioning the formation of style more thoroughly than had hitherto been done, he took up Burckhardt's work and extended it in the very direction that Wölfflin, also in the interests of a deeper understanding of the formation of style, had deliberately eschewed. When Wölfflin called for the separation of the study of art and the study of culture, he was able, with a certain amount of justification, to cite the example of Burckhardt.[9] However, if in Burckhardt's *Cicerone* and *Kultur der Renaissance in Italien* there was a separation of the two disciplines, this was not based on principle, but dictated by the demands of the economy of the work. 'He did nothing more', Warburg writes, 'than first of all observe Renaissance man in his most highly developed type and Renaissance art in the form of its finest creations. As he did so he was quite untroubled by whether he would himself ever be able to achieve

[9] [On their relationship see *Jacob Burckhardt und Heinrich Wölfflin. Briefwechsel und andere Dokumente ihrer Begegnung 1882–1897*, ed. J. Gantner (1948); also Wölfflin's obituary notice of Burckhardt, *Repertorium für Kunstwissenschaft*, XX (1897), pp. 341 ff., reprinted in *Kleine Schriften*, pp. 186 ff.]

a comprehensive treatment of the whole civilization.'[10] In Warburg's view, it was the self-abnegation of the pioneer which caused Burckhardt, 'instead of tackling the problem of the history of Renaissance civilization in all its full and fascinating artistic unity, to divide it up into a number of outwardly disconnected parts, and then with perfect equanimity to study and describe each one separately.'[11] But later scholars were not free to imitate Burckhardt's detachment. Hence what for him was simply a practical problem of presentation became for Wölfflin and Warburg a theoretical problem. The concept of pure artistic vision, which Wölfflin developed in reacting to the ideas of Burckhardt, Warburg contrasts with the concept of culture as a whole, within which artistic vision fulfils a necessary function. However, to understand this function—so the argument continues—one should not dissociate it from its connection with the functions of other elements of that culture. One should rather ask the twofold question: what do these other cultural functions (religion and poetry, myth and science, society and the state) mean for the pictorial imagination; and what does the image mean for these other functions?

Characteristically, Wölfflin and Riegl, having explicitly declined to answer the first question, involuntarily overlooked the second. 'To relate everything solely to expression', Wölfflin writes, 'is falsely to presuppose that every state of mind must have had the same means of expression at its disposal.'[12] But what does 'every state of mind' really mean here? Is it that moods have remained the same, while only the means of expressing them have changed? Does the image only depict a state of mind? Does it not at the same time also stimulate it?

A very similar sort of observation can be found in Riegl. 'The visual arts', he says clearly, 'are not concerned with the What of appearance, but with the How. They look to poetry and religion to provide them with a readymade What.'[13] But what does 'provide readymade' mean here? Does the image have no effect on the poet's imagination, or play no part in the formation of religion?

It was one of Warburg's basic convictions that any attempt to detach the image from its relation to religion and poetry, to cult and drama, is like cutting off its lifeblood. Those who, like him, see the image as being indissolubly bound up with culture as a whole must, if they wish to make an image that is no longer directly intelligible communicate its meaning, go about it in a rather different way from those who subscribe to the notion of 'pure vision' in the abstract sense. It is not just a matter of training the eye to follow and enjoy the formal ramifications of an unfamiliar linear style, but of resurrecting the original conceptions implied in a particular mode of vision from the obscurity into which they have fallen. The method used for achieving this can only be an indirect one. By studying all kinds of documents that by methods of historical criticism can be connected with the image in question, one must prove by circumstantial evidence that a whole complex of ideas, which must be individually demonstrated, has contributed to the formation of the image. The

[10] *Bildniskunst und Florentinisches Bürgertum. Domenico Ghirlandajo in Santa Trinità: Die Bildnisse des Lorenzo de' Medici und seiner Angehörigen* (1902), Vorbemerkung, p. 5, reprinted in *Die Erneuerung der Heidnischen Antike. Kulturwissenschaftliche Beiträge zur Geschichte der Europäischen Renaissance*, ed. G. Bing in collaboration with F. Rougemont, *Gesammelte Schriften*, I (1932), p. 93.
[11] Idem.
[12] *Kunstgeschichtliche Grundbegriffe*, p. 13.
[13] *Die spätrömische Kunstindustrie*, I, p. 212 note.

scholar who thus brings to light such a complex of associations cannot assume the task of considering an image is simply a matter of contemplating it and of having an immediate empathic sense of it. He has to embark upon a process of recollection, guided by the conception he is trying to understand, through which he can contribute to keeping alive the experience of the past. Warburg was convinced that in his own work, when he was reflecting upon the images he analysed, he was fulfilling an analogous function to that of pictorial memory when, under the compulsive urge to expression, the mind spontaneously synthesizes images, namely the recollection, or more literally, the revival of pre-existing forms. The word ΜΝΗΜΟΣΥΝΗ, which Warburg had inscribed above the entrance to his research institute, is to be understood in this double sense: as a reminder to the scholar that in inter-preting the works of the past he is acting as trustee of a repository of human experience, but at the same time as a reminder that this experience is itself an object of research, that it requires us to use historical material to investigate the way in which 'social memory' functions.

When Warburg was studying the early Florentine Renaissance he came across just such concrete evidence of the operation of 'social memory'—in the revival of imagery from antiquity in the art of later ages. Thereafter, he never ceased to inquire into the significance of the influence of classical antiquity on the artistic culture of the early Renaissance. Because this problem always contained for him another more general one, namely what is involved in our encounter with pre-existing images transmitted by memory, and because his personal work was bound up with this more general one, the question of the continuing life of classical antiquity became by a kind of magical process his own. Each discovery regarding the object of his research was at the same time an act of self-discovery. Correspondingly, each shattering experience, which he overcame through self-reflection, became a means of enriching his historical insight. Only thus was he able, in analysing early Renaissance man, to penetrate through to that level at which the most violent contradictions are reconciled, and to develop a psychological theory concerned with the resolution of conflicts (*Ausgleichs-psychologie*), which assigns opposing psychological impulses to different psychological 'loci', and conceives of them as poles of a unifying oscillation—poles whose distance from each other is a measure of the extent of the oscillation. And only thus is it also possible to explain how the answer which he found in this theory of the polarity of psychological behaviour to his fundamental question concerning the nature of the response to the pre-existing forms of ancient art was developed into a general thesis: namely, that in the course of the history of images their pre-existing expressive values undergo a polarization which corresponds to the extent of the psychological oscillation of the creative power which refashions them. It is only by means of this theory of polarity that the role of an image within a culture as a whole is to be determined.

The Theory of the Polarity of the Symbol

Warburg acquired his conceptual framework by studying the psychological aesthetics of his day, and above all by coming to terms with the aesthetics of Friedrich Theodor Vischer.

Vischer's essay, 'Das Symbol',[14] which Warburg cited in his very first work, the dissertation on Botticelli,[15] he read again and again, thinking through for himself the principles that Vischer had developed in the essay, testing them on actual material, and building upon them in his own way. Vischer's work therefore offers the best approach to the study of Warburg's conceptual system as a whole.[16]

Vischer defines the symbol as a connection of image and meaning through a point of comparison. By 'image' he means some visible object, and by 'meaning' he means some concept, no matter what area of thought it may be drawn from. Thus, for example, a bundle of arrows is a symbol of unity, a star of fate, a ship of the Christian Church, a sword of power and division, a lion of courage or pride.

This definition, however, is only a provisional one, serving no more than to outline the problem of 'distinguishing the main types of connection between image and meaning'; and as will be seen, the concept of the image and the concept of the meaning both alter as the nature of the connection varies.

Vischer goes on to distinguish between three kinds of connection. The first, which belongs entirely to religious consciousness, he calls 'darkly confusing',[17] the type that Warburg later called the 'magical-linking'.[18] Image and meaning become one and the same thing. The bull, Vischer says, because of its strength and procreative powers, comes to symbolize the primitive life-force; but it is also confused with this force and consequently worshipped as divine. The snake, to take one of Warburg's examples, because of its shape and dangerous nature, comes to symbolize lightning; but during a snake-dance which is meant to bring on vital rainstorms it is grasped and put into the mouth.[19] The palpable substance of the object which symbolizes the power one wishes to appropriate is physically taken into the body through eating and drinking—symbols of assimilation. 'The pupa of the butterfly', Vischer writes, 'is a resurrection symbol, a symbol of immortality. As it happens, it is not worshipped as a religious symbol. But if it were, I am sure that in accordance with the principle of assimilation the custom would be to eat pupae, so as to get inside oneself the stuff of immortality.'[20] Vischer points out with special emphasis that the Christian doctrine of the

[14] In *Philosophische Aufsätze. Eduard Zeller zu seinem fünfzigjährigen Doctor-Jubiläum* (1887), pp. 153-93.

[15] *Sandro Botticellis 'Geburt der Venus' und 'Frühling'. Eine Untersuchung über die Vorstellungen von der Antike in der italienischen Frührenaissance* (1893), Vorbemerkung (*Gesammelte Schriften*, I, p. 5).

[16] [On the importance also of Robert Vischer, F. Th. Vischer's son, and the theory of empathy in Warburg's psychology of art, *Einfühlung als stilbildende Macht*, see now Wind's review of E. H. Gombrich's biography of Warburg (appended below, pp. 106 ff.), where he points to the significance of Robert Vischer's paper, *Über das optische Formgefühl* (1873). By 1887 F. Th. Vischer had incorporated and expanded his son's observations with proud acknowledgement in 'Das Symbol', which became a sort of breviary for Warburg. In the preface to the dissertation Warburg

gave Robert Vischer pride of place, putting the younger Vischer's work before that of his father. Later in a note Wind described Warburg's theory of polarity as 'F. Th. Vischer applied *historically*'.]

[17] F. Th. Vischer, op. cit., p. 160: 'die religiöse, dunkel verwechselnde'.

[18] Warburg, 'A Lecture on Serpent Ritual', 1923, trans. by W. F. Mainland, *Journal of the Warburg Institute*, II (1939), p. 285.

[19] Ibid., p. 287. Warburg's experiences among the Pueblo Indians in 1896 are described in this informal lecture which he gave many years later in unusual circumstances. It is the only complete paper by him that has been translated into English. See below, p. 111.

[20] [We have been unable to identify the source of the quotation on the butterfly and the resurrection.]

Eucharist, the distribution of bread and wine as symbols of the body and blood of Christ, conforms completely to this pattern.

It is precisely here, however, with the theological interpretation of the doctrine of the Eucharist, that the problem begins to bifurcate. The controversy over whether, at the moment of the distribution, the bread and wine actually are or merely symbolize the body and blood of Christ, in other words whether Christ's words, 'This is my body . . .', are to be understood figuratively or metaphorically—this controversy reflects a crisis, in which two conflicting interpretations of the nature of a symbol have arisen: the one, the magical-associative which joins the image and meaning together; the other, the logically-dissociative, which explicitly introduces the 'like' of comparison. For the first interpretation religious ritual is indispensable. It requires a priest, whose word has the necessary magic power to effect transubstantiation. It, therefore, gives a miraculous connotation to bread and wine, substances which in themselves, as Vischer points out, are quite neutral. The second interpretation restores the neutral status of these objects, for it does not tie the religious experience to the ritual. It holds bread and wine to be signs which can be intellectually comprehended, not powers which work mysteriously. The symbol, in the sense of an indissoluble unity of object and meaning, has turned into allegory, with both sides of the comparison conceived of as clearly distinct entities. The image has been transformed from a magical force in a ritual into a token of a theological concept.

Between these two extremes, however, lies a third type of connection, which Vischer calls a 'connection with reservation'. It occurs when the beholder does not really believe in the magical animation of the image, but is nevertheless compelled by it—for instance, when the poet speaks of the 'ominous' light of the setting sun. But even the unpoetic language of everyday life is constantly personifying inanimate objects in the same way: 'Grapes like to be warm', 'The nail doesn't want to come out of the plank', 'The packet won't go into my pocket'.[21] Were we to dissolve all such metaphors without exception, language would turn into a lifeless system of allegorical signs. Were we, on the other hand, to let the enlivening power of metaphor affect us so powerfully that we were no longer aware of its non-metaphorical meaning, we would fall victims to the magical way of thinking. The more the poet comes to believe in the heroes and gods whose images fill his mind, the nearer he approaches to the priest. However, he totally succumbs to the enchantment only when he either makes sacrifices, or indeed sacrifices himself, to the god who is the subject of his poetry.

We have, then, a whole spectrum of possibilities. At one extreme lies the pure concept, expressed by an arbitrary, lifeless, and unambiguously determinable sign which is connected with the extension of the concept only by convention. At the other extreme lies the ritual act, which, dominated by the power of the incarnate symbol, literally grasps the symbol, consuming it, or being consumed by it.

The critical point, however, lies in the middle of the spectrum, where the symbol is

[21] F. Th. Vischer, p. 167.

understood as a sign and yet remains a living image, where the psychological excitation, held in tension between the two poles, is neither so concentrated by the compelling power of the metaphor that it turns into action, nor so detached by the force of analytical thought that it fades into conceptual thinking. It is here that the image, in the sense of the artistic illusion, finds its place.

Artistic creation embodies this intermediate position by transforming physical materials into aesthetic representations. So, too, the enjoyment of art, through contemplation of the representation, recreates and experiences this suspension between concept and magical symbol. Both, according to Warburg, draw on the darkest energies of life, and remain dependent on them and threatened by them even where a harmonious equilibrium is the product of a confrontation, in which the whole man, with his religious urge for incarnation and his intellectual desire for enlightenment, with his impulse to personal engagement and his will to critical detachment, participates.

If we reflect on just how much these forces war with one another, we can well understand how Warburg, when working on his history of the survival of past images in the European mind, conceived of them as forming a chapter of the still unwritten book 'The Lack of Freedom of Superstitious Modern Man'.[22] And when he took as the connecting thread of his book, the mnemonic recovery of ancient imagery, it is clear that by 'ancient' he did not mean 'ancient' in the same sense as Winckelmann, as referring to a world of noble simplicity and serene grandeur, but rather in the same sense as Nietzsche and Burckhardt, as connoting a Janus-face of Olympian calm and daemonic terror. However, mention should also be made in this context of Lessing: for Lessing's refutation of the reasons Winckelmann gave for Laocoön's suffering in silence contains in embryo the whole problem that Warburg was investigating.[23] The notions of the 'transitory' and of the 'pregnant moment' contain an intimation of that crisis in which the tensions embodied in a work of art irrupt and threaten to destroy the artistic character of the work.

To describe the method of inquiry that Warburg practised and taught I can hardly do better than quote a passage from Schleiermacher's essay 'On the Extension of the Concept of Art with Reference to the Theory of Art':

Thus we will for the present confine ourselves to an old notion, restated, however, by some modern experts, that all art springs from inspiration, from the lively awakening of the innermost emotional and intellectual faculties, and to another equally old view, profoundly rooted in our habits of thought, namely that all art must bear witness to the process of its creation. The next step would then no doubt be to observe to what extent the work of art springs from inspiration in the same manner in the different arts. On account of the difficulty of the enterprise, however, it might be advisable to begin by investigating those arts in which the distance between both points—inspiration and the

[22] 'Von der Unfreiheit des abergläubigen modernen Menschen', see *Heidnisch-antike Weissagung in Wort und Bild zu Luthers Zeiten* (1920), pp. 4 ff. (*Gesammelte Schriften*, II, pp. 490 ff.).

[23] *Laokoon*, I, iii, also xvi (*Sämtliche Schriften*, ed. K. Lachmann and F. Muncker, IX, 1893, pp. 19 ff. and 95). Cf. Wind, *Vorträge der Bibliothek Warburg 1930-1931* (1932), p. 188; and now *Hume and the Heroic Portrait*, the companion volume.

finished work—can only be short and the process appears very simple. And we should be fortunate and should have succeeded in the attempt if, on the one hand, we were able to find, alongside the work of art, a related 'artless' phenomenon, so as to be able to show how the one differs from the other, and if, on the other hand, we were able to apply our findings to the other arts in which the distance is less short and the process less simple.... It is the essence of that 'artless' state that stimulus and expression are identical, and that, united by an unconscious bond, they originate and decline together absolutely simultaneously, or to express it even more precisely, they are both truly one and are only arbitrarily separated by the outside observer, whereas in every artistic creation, in accordance with its nature, this identity is abolished.... Another higher faculty has intervened and separated that which is otherwise directly connected; an element of reflection breaks in, as it were, to effect a separation, and on the one hand disrupts the violent force of the stimulus through the very fact of arrest, of pause, and at the same time during this moment of arrest takes control, as an organizing principle, of the emotion already aroused.[24]

But though on the whole Schleiermacher's words aptly characterize Warburg's position, there is one respect in which the two do seriously differ. Schleiermacher treats the act of reflection, the critical moment of arrest, as a kind of miracle—as if, in his own words, 'another higher faculty' had intervened, 'and separated that which is otherwise directly connected'. Warburg, however, sees no break between the condition which Schleiermacher defines as a complete unity of stimulus and expression, and the act of reflection, which he holds is the beginning of true art; for him there is a continuity between the two. This can be seen in detail in his theory of mimetic expression and of man's use of tools.

Reflection and Expression

It is possible to conceive of a state of affairs, such as one can in fact find among lower forms of life, in which every external excitatory stimulus immediately results in an organic movement running throughout the whole of the animal's body. It would be pointless to ask whether such a creature enjoys any kind of perception, for its body is completely and evenly permeated by the state of stimulation. Events pass through its organism, so to speak, and leave no trace. There can be no question of it having a memory, even in the broadest sense of the word.

Then we can conceive of a somewhat higher level, at which the state of stimulation becomes differentiated and the resulting movement does not affect the organism as a whole uniformly, but affects some parts and leaves other parts unaffected. Events now leave traces. Excitation begins to become differentiated into distinct types.

If we pursue this development further, we come to a stage where we can study the process of the formation of images *in statu nascendi* in the shape of the expressive gestures made by the body. We shall find that even in its most elementary form the phenomenon of expression is associated with a minimum of reflection. We need not have recourse to such speculations

[24] 'Ueber den Umfang des Begriffs der Kunst in Bezug auf die Theorie derselben', *Friedrich Schleiermacher's sämmtliche Werke*, ed. L. Jonas, III, 3 (1835), pp. 191 f.

as Schleiermacher's to conceive of the level at which excitation and physical movement become identical. We need only consider the way the human body functions. What we find is that the stimulus in question is converted into various different muscular movements and that each fulfils a particular function, strengthening its capacity to fulfil it every time it does so. It was in connection with such phenomena as the strengthening of muscles through their exercise that Hering spoke of the memory as a 'general function of organized matter'.[25] Frequent repetition of the same action leaves its traces.

However, on account of these traces, or, if you will, this 'memory function', human muscles serve a further purpose beyond their purely physical one. They serve the purpose of mimetic expression. Since Darwin there has been much controversy over the relation between these two functions.[26] We are concerned only with the fact that the same muscles often perform both functions, the physical and the expressive. When we want to express our disgust and accordingly make a face, we use the same muscles that are automatically activated when we are physically sick. Once again we find the phenomenon of metaphor, this time in the use of our own bodies. All expression through movement of muscles is metaphorical, and subject to the polarity of the symbol. The stronger and more intense the psychological excitation released in the expression, the nearer the symbolic movement comes to the physical one. (In cases of extreme psychological revulsion we are also physically sick.) The weaker and milder the excitation, the more restrained is the mimetic movement, the limit being when the momentary mimetic expression vanishes in the normal expression of the features.

However, the body is not the only vehicle of expression, even if it is, so to speak, the most obvious. Man is also, as Carlyle tells us in *Sartor Resartus*, 'a Tool-using Animal', creating implements with which to extend and supplement the functions of his body.[27] But with regard to the use of these tools we can make the same observation as with regard to the movement of the muscles. Their products become the bearers of expressive values over and above the fulfilment of the purpose for which they are made. Carlyle showed this in connection with clothes, which now lend their wearer dignity, now make him look ridiculous, but in any event both mark him out and cover him up, set him apart and yet do not give him away. The result is a language of social gestures, which supplements and extends mimetic language. Taking off one's hat becomes an expression of deference, carrying a sceptre a symbol of majesty, riding high in the saddle a triumphal gesture. And each one of these acts conforms to the polarity of the symbol. For every socially expressive gesture, depending on whether it is accelerated or retarded, or arrested at a critical point and turned in a quite different direction, can change from a gesture of association to one of withdrawal, from a

[25] E. Hering, *Über das Gedächtnis als Funktion der organisierten Materie*, a lecture delivered to the Akademie der Wissenschaften in Vienna (1870); translated into English by Samuel Butler and included in *Unconscious Memory* (1880), as supporting evidence in his controversy with Darwin.

[26] *The Expression of the Emotions in Men and Animals* (1872).

[27] On Warburg's lifelong interest in Carlyle's thought, see below, p. 113. [Boswell in conversation on 7 April 1778 refers to Franklin: 'I think Dr. Franklin's definition of *Man* a good one—"A tool-making animal".' JOHNSON. 'But many a man never made a tool; and suppose a man without arms, he could not make a tool.' (*Boswell's Life of Johnson*, ed. G. B. Hill and L. F. Powell, III, 1934, p. 245.)]

gesture of seizing and appropriating something to one of relinquishing it or letting it go free, from an act of persecution and conquest to one of hesitation and generous pardon.

Likewise the tool, too, points beyond itself to a stage at which man creates objects not only so that he can do things with them (as with a stick) or put them on (as he puts on clothes) and not only so that they can help him to extend the possibilities of mimetic expression of his own body, but also so that he can set them up apart from himself and contemplate them from a distance. For Schleiermacher it is at this stage that art begins: for only at this stage does the element of retardation in artistic expression appear in the form of conscious reflection. One need not dispute whether Schleiermacher's theory correctly circumscribes the domain of art. But one should point out that between the two stages of greatest detachment and closest connection—that is, between the level at which the stimulation of movement seems to have been almost entirely transformed in the act of contemplation, and the stage at which stimulation and expression become almost one and the same in the precipitated action—there lie two intermediate stages: that of the expressively charged muscular movement, whose two poles are the states of being mimetically tense and of being physiognomically relaxed, and that of the expressive use of an implement, which oscillates between the poles of the social urge to appropriate a thing and the social will to distance oneself from it.

Warburg showed how important just these two intermediate levels are for the theory of the formation and the recall of images, once again referring to the example of the continuing vitality of features of the ancient world. For time and again it was the expressive gestures of antiquity or, to use Warburg's words, the 'pathos formulae' of that civilization, which were taken up by later art and polarized in being redeployed.[28] But when they were rediscovered in works of art or handed down, these ancient emotive formulae always appeared in a form which was tangible: in the form of sculptured stone or painted paper—in any case as objects which stand in a technological relationship to tool-using man. The status which an epoch accords to the tangible embodiments of these emotive formulae—whether a classical work of art is an object of specialized archeological interest added to a collection, an *objet d'art* built into a garden wall to satisfy its owner's pride of possession, or reproduced in miniature, no more than a mere ornament for the mantelpiece—is crucial to the determination of the relationship of that epoch to classical antiquity. The degree of involvement men have in these objects can be measured in terms of the use they make of them, in the sense of the way they handle them. Nothing is more characteristic of the development of the early Renaissance than the first form in which it incorporated into its art the emotive formulae of classical antiquity (to whose stimulus it was so highly responsive)—that highly distancing mode of representation, grisaille.[29]

[28] See 'Dürer und die italienische Antike', in *Verhandlungen der achtundvierzigsten Versammlung deutscher Philologen und Schulmänner in Hamburg vom 3. bis 6. Oktober 1905* (1906), pp. 55–60 (*Gesammelte Schriften*, II, pp. 443 ff.).
[29] Cf. 'Francesco Sassettis letztwillige Verfügung', in *Kunstwissenschaftliche Beiträge August Schmarsow gewidmet* (1907), pp. 145 f. (*Gesammelte Schriften*, I, pp. 157 f.), now also Warburg's notes on grisaille in Gombrich, *Aby Warburg. An Intellectual Biography* (1970), pp. 246 f. and 296 f.

It follows that, even if we define the notion of aesthetics in the narrowest sense, as the theory of the conscious cultivation of taste and of the abstract perception of beauty, we cannot fully develop this theory without taking into account these more elementary forms of expression—mimetic expression and the extended form of expression achieved with tools. For these are, so to speak, the fertile soil lying at the roots of those more refined creations (just as verbal magic lies at the roots of metaphor), a basis out of which they must develop in order to acquire their distinguishing characteristics, but from which they cannot entirely detach themselves without wilting or dying.

Because this relationship of relative dependence and independence is a relationship of tension, the problem of the polarity of the psychic reaction has always been conceived of and analysed in the history of aesthetics, from Plato down to Lessing, Schiller, and Nietzsche, as the central problem. It is only by going back to this basic problem as Warburg does that we can also tackle the problem of periodicity in the development of art, a problem with which Riegl and Wölfflin wrestled in vain. But we can, with Warburg's help, turn their formal insights to good account. For we can invest them with a genuine significance by taking what is no more than an abstract antithesis as an actual indication of two poles of an oscillation which can be rendered intelligible in geographical-historical terms as a process of cultural interaction. When Wölfflin, to go back to our first example, defines a particular concept of the painterly as a single stylistic principle, comprising such heterogenous phenomena as Terborch and Bernini, this can only be taken to refer to a process of interaction between the North and the South in the age of the Baroque that has its concrete and geographical aspect. And the names of Bernini and Terborch would indicate the range of an intellectual movement of which the historical subject, conceived of as a social unity, would be the cultural community of seventeenth-century Europe.

I have tried to convey some idea of the nature of Warburg's method of inquiry; but my words must necessarily remain somewhat abstract and lifeless without concrete illustration. Indeed this lecture is intended as an introduction to the picture display which is set up here in the hall,[30] and also to the library itself which is expressly arranged to bring out the particular problems that were Warburg's concern.

You will there clearly see the great extent to which Warburg, in pursuing his theory of polarity, was obliged to forsake the traditional domains of art history and to enter into fields which even professional art historians have tended on the whole to fight shy of—the history of religious cults, the history of festivals, the history of the book and literary culture, the history of magic and astrology. However, it was just because he was interested in revealing tensions that these intermediate areas were of great importance to him. It is in the nature of festivals to lie between social life and art; astrology and magic lie half-way between religion and science. Warburg, intent on probing further, always chose to study those intermediate

[30][Warburg himself habitually arranged and rearranged on portable screens the photographs of material he was studying; and such photographic demonstrations remained for some years a characteristic feature of the Warburg Institute's public exhibitions.]

fields in precisely the historical periods he considered to be themselves periods of transition and conflict: for example, the early Florentine Renaissance, the Dutch Baroque, the orientalizing phases of late classical antiquity. Furthermore, within such periods he always tended to apply himself to the study of men who, whether through their profession or their fortune, occupy ambiguous positions: for example, merchants who are at the same time lovers of art, whose aesthetic tastes mingle with their business interests; astrologers who combine religious politics with science and create a 'double truth' of their own; and philosophers whose pictorial imagination is at odds with their desire for logical order. In dealing with the individual work of art, Warburg proceeded in a way which must have seemed somewhat paradoxical to the student of art with a formalist training; his practice of gathering together pictures in groups gave his work its peculiar stamp: he interested himself just as much in the artistically bad picture as in the good, and indeed often more so, for a reason which he himself explicitly acknowledged—because it had more to teach him. In his study of the iconographic meaning of the cycle of frescoes in the Palazzo Schifanoia—a pictorial enigma which he solved brilliantly[31]—he went first to the master who seemed to him to be the weakest. And why? Because the problem posed by the task with which the artist had to wrestle was easier to see in the flaws of the undistinguished work: the complicated structure of the major work made the problem much harder to pick out, because the artist resolved it with such a display of virtuosity.

The same applies to other branches of learning. Physicists were able to analyse the nature of light by studying its refraction through an inhomogenous medium. And modern psychology owes its greatest insights into the functioning of the mind to the study of those disorders in which individual functions, instead of harmonizing, are in conflict. To proceed only from great works of art, Warburg tells us, is to fail to see that the forgotten artefact is precisely the one most likely to yield the most valuable insights. If we go straight to the great masters, to Leonardo, Raphael, and Holbein, to works in which the most violent conflicts have been most perfectly resolved, and if we enjoy them aesthetically, that is, in a mood which is itself no more than a momentary harmonious resolution of opposing forces, we shall spend happy hours, but we shall not arrive at a conceptual recognition of the nature of art, which is, after all, the real business of aesthetics.

Warburg adopted the same kind of approach in assembling his remarkable library. Compared with other specialist libraries, it must appear peculiarly fragmentary, for it covers many more areas than a specialist library normally seeks to do. At the same time, its sections on particular fields will not be found to be as complete as one would normally expect of a specialist library. Its strength, in short, lies precisely in the areas that are marginal; and since these are the areas that play a crucial part in the progress of any discipline, the library may fairly claim that its own growth is entirely in keeping with that of the particular field of study it seeks to advance. The more work that is done in those 'marginal' areas classified by

[31] 'Italienische Kunst und internationale Astrologie im Palazzo Schifanoja zu Ferrara', in *L'Italia e l'arte straniera*, *Atti del X congresso internazionale di storia dell'arte*, Rome, 1912 (1922), pp. 179-93 (*Gesammelte Schriften*, II, pp. 459 ff., see especially p. 464).

the library, the more the corresponding sections in the library will automatically fill up. This means that it depends upon collaborative effort. That is why the library welcomes the opportunity this Congress offers us to learn something of the problems with which aestheticians are concerned: for, in Warburg's own words, it is 'a library eager not only to speak, but also to listen'—*eine Bibliothek, die nicht nur reden, sondern auch aufhorchen will.*

III · Donatello's *Judith*

A Symbol of Sanctimonia

THE name Holofernes is translated in medieval textbooks by the words *enervans vitulum saginatum* (he who weakens the fatted calf). In the allegories of the *Biblia Pauperum* and the *Speculum humanae salvationis*, Holofernes stands for the Devil, just like Goliath, Haman, or any other vicious fiend. By virtue of his name, however, he often signifies that particular power of the Devil by which Man was first tempted and seduced: Incontinence, or by her Latin name, Luxuria. Durandus in his *Rationale divinorum officiorum*, a book that was handed down in innumerable manuscript copies and was printed in forty-four editions in the fifteenth century alone,[1] gives a full account of the symbolic significance attributed to the victory of Judith over Holofernes:

The Church also directs us towards sanctimony, or to continence, by the example of Judith. For just as she slew Holofernes, which means *he who weakens the fatted calf*, so the Church directs that we should slay Holofernes, i.e. the devil, who weakens and slays the lascivious in the world, which is to be achieved through sanctimony by cutting off his head. For the head of the devil is luxury, because it is, as it were, first with this that he begins to tempt men, and for that reason the Lord says: *Let your loins be girded about* (Luke xii), that is, gird yourselves against the first vice, like that passage in Exodus at the eating of the lamb: *With your loins girded* (Exodus xii). But in another way pride is the beginning of all sin.[2]

In the last sentence of this text a second interpretation is added to the first. Holofernes signifies Luxuria, the primeval form of sin, but he can also signify Superbia because she is *alio modo initium omnis peccati*. Donatello was acquainted with this particular tradition; for

Journal of the Warburg Institute, I (1937), pp. 62 f.

[1] J. Sauer, *Symbolik des Kirchengebäudes* (1924), p. 32.

[2] Durandus, *Rationale divinorum officiorum*, VI, cxxviii, 1: 'Et monet nos Ecclesia ad sanctimoniam, sive ad continentiam, exemplo Judith. Sicut enim interfecit Holofernem, qui interpretatur *enervans vitulum saginatum*, sic monet Ecclesia, ut interficiamus Holofernem, idest diabolum, qui enervat, et interficit lascivos mundi, quod fiet per sanctimoniam abscindendo ei caput. Nam caput diaboli est luxuria, quia quasi primo de ea incipit homines tentare, et ideo Dominus dicit: *Sint lumbi vestri praecincti* (Luc. xii), hoc est praecingatis vos contra primum vitium, juxta illud Exodi in comestione agni: *Renes vestros accingetis* (Exod. xii). Alio tamen modo superbia est initium omnis peccati.'

precisely the same juxtaposition of the two vices appears in the distich which served originally as the inscription to his statue of Judith and Holofernes (Fig. 6):

REGNA CADUNT LUXU, SURGUNT VIRTUTIBUS URBES
CAESA VIDES HUMILI COLLA SUPERBA MANU[3]

Although these verses were quoted in a recent interpretation of the statue, only the second line was used as a key to its meaning.[4] Judith, we are told, represents Humilitas vanquishing Superbia in the form of Holofernes. Of Luxuria there is no mention. And yet, in studying the characterization of the two figures it becomes clear that a victory over Luxuria must have been foremost in the sculptor's mind, just as it was the first idea expressed by the theologian Durandus, and by the poet who wrote the distich. Holofernes lying half-naked on a soft cushion is the perfect embodiment of Luxuria; and Judith's long veils and heavy garments, that cover even her forehead and her arms down to the wrists, clearly emphasize her 'sanctimoniousness'. Also a minor detail can now be explained which hitherto seemed to have no relation to the main subject. On the pedestal are three reliefs with orgiastic bacchanalian scenes.[5] They illustrate the subjugated vice of Incontinence, the power of 'enervation' once invested in Holofernes: *Regna cadunt luxu.*

[3] The source of the inscription, first quoted by A. Ademollo, *Marietta de' Ricci*, ed. L. Passerini, I (1845), p. 758, no. 39, is now known to be a letter of condolence to Piero il Gottoso on Cosimo de' Medici's death, attributed to 'F. Francischus cognomento paduanus' in the *Zibaldone* of Bartolommeo della Fonte, Florence, Biblioteca Riccardiana, MS. 907, fol. 142ᵛ. Cf. E. H. Gombrich, 'The Social History of Art', *Meditations on a Hobby Horse* (1963), p. 170; also 'The Early Medici as Patrons of Art', *Norm and Form* (1966), p. 41.

[4] H. Kaufmann, *Donatello. Eine Einführung in sein Bilden und Denken* (1935), p. 170.

[5] Reproduced in H. Janson, *The Sculpture of Donatello*, I (1957), figs. 372–7b, and discussed fully in II, pp. 198 ff. U. Middeldorf in his excellent review of Dr Kaufmann's book, *The Art Bulletin*, XVIII (1936), pp. 570–85, rejects Dr Kaufmann's interpretation of the bacchanalian reliefs (p. 576), but does not stress their close correspondence to the allegorical meaning of the statue. [Recently Janson, 'La signification politique du David en bronze de Donatello', *Revue de l'art*, no. 39 (1978), pp. 33 ff., has suggested that the *Judith* was commissioned by the Commune of Siena in 1457 as a Sienese counterpart to Donatello's *David*, but that it never reached its destination, and was then acquired by the Medici who added the second inscription. However, the document quoted by Janson in support of his hypothesis, one originally published by V. Herzner ('Donatello in Siena', *Mitteilungen des Kunsthistorischen Institutes in Florenz*, XV (1971), pp. 161 ff.), refers to a 'mezza figura'.]

IV · The Subject of Botticelli's *Derelitta*

THE painting called *La Derelitta* (Fig. 7), ascribed first to Masaccio, then to Botticelli, then to that amiable fiction L'Amico di Sandro, and recently regarded as part of a series of cassone panels executed by the young Filippino Lippi after designs by Botticelli, is a source of discomfort not only to the connoisseur, but also to the student of iconography.[1] The subject is as enigmatic as the authorship. A young woman, shut out of a palace, sits 'derelict' on the steps before the gate and weeps. This is the sort of pathetic scene which appealed to nineteenth-century novelists by arousing reflections as to what had happened before and what would happen after.[2] In the mind of a fifteenth-century painter such a response would be, to say the least, an anachronism. At that time the themes of pictures were not meant to prompt flights of the imagination. They formed part of a precise set of ideas. An attempt to reconstruct the correct connotations of the picture called *La Derelitta* may help to dispel the false sentiment which the false title, most certainly of fairly recent invention, suggests.

A decisive step towards finding the clue to the picture was made by Horne and Gamba when they discovered that it belonged to a set of six panels representing the story of Esther, which originally formed the decoration of two marriage chests.[3] The two large panels, each being a cassone front, show *Esther presented to Ahasuerus* and *Mordecai embracing Esther before the king*. Of the four smaller panels which served as side pieces, three represent *Esther entering the king's palace*, *Esther leaving the king's palace*, and *the Triumph of Mordecai* (Fig. 8), while the fourth one is the so-called *Derelitta*.[4] Naturally Gamba tried to fit the picture into the cycle of the Esther story, but alas, 'la derelitta' was in his mind. He identified the

Journal of the Warburg and Courtauld Institutes, IV (1940), pp. 114-17.

[1] The various attributions are discussed by C. Gamba, 'Filippino Lippi e l'amico di Sandro', in *Miscellanea di storia dell'arte in onore di I. B. Supino* (1933), pp. 461 ff., and a comprehensive survey of the interpretations is given by J. Mesnil, *Botticelli* (1938), pp. 232 f.

[2] It actually did appeal to Zola, *Rome* (1896), p. 724.

[3] The argument has recently been summarized by Gamba, *Botticelli* (Paris, [1937]), pp. 133 f.

[4] These six panels, originally in the Torrigiani Collection, Florence, are now in the Musée Condé, Chantilly, the Vogüé Collection, Paris, the National Gallery of Canada, Ottawa, the Fondazione Horne, Florence, the National Gallery of Canada, and the Pallavicini Collection, Rome. There is some doubt whether the panels in the Vogüé Collection and

in the Fondazione Horne actually belong, as is generally assumed, to the same set as the others. When the Vogüé picture is compared with the Chantilly panel, and the picture in the Fondazione Horne with the corresponding panel in Ottawa, they seem too similar to form counterparts, and yet too different to belong together. All that may be inferred from the Horne and Vogüé pictures, *Esther leaving the king's palace* and *Mordecai embracing Esther before the king*, is that they formed part of a set of Esther pictures for cassoni and the missing pictures of the set may be filled in accordingly. With the exception of the *Derelitta*, they are all reproduced by A. Scharf, *Filippino Lippi* (1935), pls. 6-8, who differs from Horne and Gamba by refusing to admit the *Derelitta* into this context, pp. 15 ff., also (1950), p. 52.

figure with the despairing Vashti, the queen whom Ahasuerus deposed for disobedience and replaced by Esther.

The Book of Esther says little about this queen except that she lost the throne (i. 19). It does not say that she was locked out of the palace and sat weeping at the gate, dressed in a plain shift with one torn sleeve, or that any garments were thrown after her and remained lying on the steps. A fifteenth-century artist would be unlikely to invent all these touching incidents. He would rely upon what was said in his text or what was transmitted to him by a pictorial tradition; for otherwise his clients would recognize the subject of his picture as little as we do. The pictorial tradition is as silent as the text, regarding the despair of Queen Vashti after her removal from the palace.

In the Book of Esther, one—and only one—person is described as sitting on the palace steps. That is Mordecai. He is repeatedly described as 'sitting at the king's gate'.[5] In fact, it is because of his refusal to rise when Haman passes that the latter feels all his honours and glory are as nothing if he cannot destroy the Jews: 'Yet all this availeth me nothing, so long as I see Mordecai the Jew sitting at the king's gate' (v. 13). When Haman has at last induced the king to issue the decree for the annihilation of the Jews, Mordecai rends his garments, dresses himself in sackcloth and ashes, and wails. It is in this state that Esther's attendants see him 'even before the king's gate' (iv. 2, 6). Esther, on learning that he is dressed in sackcloth, sends out other garments for him, but he refuses to accept them (iv. 4).

I shall leave it for the reader to decide whether the garments lying on the steps in the picture are those which Esther sent out for Mordecai or those which he tore off when he dressed himself in sackcloth. In either case I feel certain, however startling the suggestion must appear at first, that the figure clothed in sackcloth and lamenting at the king's gate is Mordecai—the same Mordecai whom we see triumphant in the corresponding panel (Fig. 8). He has the same dark curly hair, and close examination shows that he even has the same dark beard.

This, I imagine, will dispose in advance of two objections which would otherwise necessarily arise: first, that the figure represented is clearly a woman, not a man, and secondly, even if it is a man, he is too young to be Mordecai.

What I would chiefly object to in the first statement is the word 'clearly'. In the style of Botticelli or even Filippino Lippi the distinction between feminine and masculine features is not so sharply drawn as to make a figure completely covered with sackcloth unambiguously male or female. The bulking of the cloth over the stomach which would make the figure, if it were a woman, look pregnant, is quite *de rigueur* even for men in Botticelli's paintings—for the ascetic John the Baptist no less than for the worldly Solomon.[6] As to the age of Mordecai, he was of the same generation as Esther herself. The Bible says explicitly that they were cousins: Esther is described as 'his uncle's daughter' (ii. 7, 15). The view that he was an older man was probably suggested by the fact that he adopted her 'for his own daughter'. But the Renaissance reading stressed the relation of cousinship with Esther and preferred to picture him as young: a humble but beautiful counterpart of the proud Haman

[5] Esther ii. 19, 21; iii. 3; v. 9, 13; vi. 10, 12. [6] See Gamba, op. cit., pls. 61 and 139.

whom he was to overthrow and replace. It is as such a youth that Michelangelo painted him in the Sistine Chapel, again sitting on the steps before the gate while Haman comes out to raise him to high honours in accordance with the king's commands.[7]

In the story of Esther as represented on the six panels of the two cassoni, the scene of Mordecai weeping at the palace gate occupies exactly the right place according to the historical sequence. It correctly precedes the scene in which Mordecai is received by Ahasuerus:

First Cassone	1. Esther entering the king's palace	2. Esther presented to Ahasuerus	3. Esther leaving the king's palace
Second Cassone	4. Mordecai weeping at the king's gate	5. Mordecai embracing Esther before the king	6. The Triumph of Mordecai

At the same time, the series of pictures as a whole was meant to convey a moral suitable to a young married couple—the glorification of humility. It would be appropriate if the panel showing Esther presented to Ahasuerus was the central panel of the cassone destined for the bride, while the panel showing Ahasuerus receiving Mordecai belonged to the cassone intended for the bridegroom. As a biblical figure, King Ahasuerus symbolized the king of heaven, Christ, whose marriage with the Church was foreshadowed in the marriage of Ahasuerus to Esther. Correspondingly, the calling of Mordecai by Ahasuerus to be dressed in the 'royal apparel' and the 'crown royal' (vi. 8) is the choice by the heavenly bridegroom of his earthly representative: 'Thus shall it be done to the man whom the king delighteth to honour' (vi. 9). In Catholic wedding ceremonies, the sacrament of marriage actually was—and still is—celebrated as an 'imitation' of the union of Christ, the bridegroom, with the Church, his bride; and it was fitting to recall this idea in the decoration of the two marriage chests. Thus the central panel of each cassone reminded the young couple of the sanctity of marriage, in which the bride should be glorified by the bridegroom as the Church was glorified by Christ, while the bridegroom should be honoured by the bride as the chosen representative of the godhead. The side panels translated this lesson into simpler language. The bride, prefigured by Esther coming from the king's palace as his queen, must see herself also as a humble maiden like Esther when she sought the king's favour at Mordecai's bidding. The bridegroom, honoured like Mordecai in his glorious procession, must remember that he is also a penitent pleader like Mordecai who owes his salvation to the intercession of the queen. And since the marriage chests were to contain the garments of the bride and bridegroom, the pictures have a certain reference to the 'philosophy of clothes'. As the panels of the two processions show Esther and Mordecai in their festival garments, so their two companion pieces show them in the garments of humility: Esther dressed as a suppliant maiden, conscious of her unworthiness; Mordecai covered with sackcloth and rending his heart as he has rent his garments.

[7] [R. Lightbown, *Botticelli*, II (1978), pp. 208 ff., sees Mordecai as a middle-aged man and refers to the Vulgate, where Esther is described as 'his brother's daughter'.]

V · The Revival of Origen

Ah! monsieur, il est bien dur de ne pouvoir damner
à son plaisir tous les hérétiques de ce monde. —Voltaire

'IN the Middle Ages it was a subject of dispute whether Origen might possibly escape damnation.' This curious pronouncement by Dean Inge in a recent lecture on Origen before the British Academy[1] indicates the extent to which a great Renaissance controversy has been forgotten. The memory of it was still alive in the seventeenth century when the abbé Huet included in his *Origeniana* a reference to Pico della Mirandola: 'Origen could not have wished for a more noble or a more learned defender. Among the *Nongentae conclusiones* which [Pico] proposed to the whole world for debate, the following thesis was outstanding: *It is more reasonable to believe that Origen is saved than to believe that he is damned.*'[2]

Pico's *Nongentae conclusiones*, published in 1486, was one of the first books to be placed on the Index.[3] An inquisitional committee appointed by Innocent VIII had found in it thirteen objectionable theses, among them the defence of Origen. When Pico published an *Apologia* (1487) in which, instead of revising these opinions, he developed them with considerable force, he was indicted for heresy and temporarily arrested.[4] Six years later the indictment was revoked by Alexander VI. But although Pico himself survived his release for only a short while, the knowledge of his vindication gradually showed its effect upon humanist and theological learning. In promoting a wide acceptance of Pico's view a decisive role belongs to the edition of Origen which Aldus published in 1503, an astute enterprise that has been little noticed: 'Si nous abordons les temps modernes,' we read in a book crowned by the French Academy,[5] 'la Renaissance est trop païenne, la Réforme trop augustinienne pour laisser beaucoup de place aux imaginations philosophiques d'Origène, dont le XVIᵉ siècle ne pensa même pas à imprimer les écrits.' And yet, the Aldine edition was dedicated to Fra Egidio da Viterbo, who was the most prominent Augustinian preacher of his time, a

Studies in Art and Literature for Belle da Costa Greene, ed. D. Miner (1954), pp. 412-24 (with additions to the notes from Wind's papers).

[1] W. R. Inge, *Origen*, in *Proceedings of the British Academy*, XXXII (1946), p. 123.

[2] P. D. Huet, *Origenis in Sacras Scripturas commentaria quaecunque graece reperiri potuerunt ... cui idem praefixit Origeniana*, I (1668), bk. II, ch. iv, 'Fortuna doctrinae Origenianae', p. 230 (*Patr. graec.* XVII, col. 1178).

[3] H. Reusch, *Der Index der verbotenen Bücher*, I (1883), p. 59.

[4] L. Dorez and L. Thuasne, *Pic de la Mirandole en France, 1485-1488* (1897).

[5] M. J. Denis, *De la philosophie d'Origène* (1884), pp. 585 f.

defender of pagan elegance in religious diction, and the friend and inspirer of Sannazaro. A study of the circumstances surrounding this forgotten book is perhaps not out of place in homage to the custodian of a great Aldine collection.

The Aldine Origen and the Apologia of Pico

Aldus gave his edition two prefaces. One, written and signed by himself, contained the dedication to Fra Egidio. It was composed with prudence, as might be expected. The second preface, unsigned, was a eulogy of Origen written with fervour and a remarkable lack of restraint. In it Origen's wisdom was compared to that of Solomon and the reader was invited to 'drink from this highest fountain the waters of salutary wisdom'. That this panegyric was not written by Aldus is proved by the luxuriant style, by the compliments the author addressed to Aldus, and by his inability to suppress his own name completely: he revealed in a rather laboured manner that his name was the same as St. Jerome's (perhaps Jerome Aleander?).

Introduced by two prefaces so completely different in tone, the edition proved to be a shrewd *plaidoyer*. Merlin, Erasmus, and Génébrard were all persuaded by this example to produce editions of Origen more complete and more ambitious, with the result that a supposedly uncongenial and suspected author, 'dont le XVIᵉ siècle ne pensa même pas à imprimer les écrits', was printed in the sixteenth century eleven times and in ever-increasing bulk.[6] In France, Symphorien Champier adopted for one of his philosophical vade-mecums the title of Origen's *Peri archon*, the book which contained his 'mistaken views' about the pre-existence of the soul and universal redemption;[7] and the pious Jean Vitrier, Erasmus' friend, was teased by Erasmus because 'he took delight in the writings of a heretic'—for 'in sacred letters he admired no one's genius more than Origen's'.[8] But in writing to Colet in 1504 Erasmus himself expressed the same veneration: 'for he reveals some of the well-springs, as it were, and demonstrates some of the basic principles of the science of theology.'[9] And in the preface to the New Testament (1516) he declared him superior to all other commentators on the Bible: 'Origenem qui sic est primus ut nemo cum illo conferri possit.'[10]

Aldus, however, was more cautious. Instead of inviting his readers, as Champier did, to study a book condemned by the Fifth Ecumenical Council (553), a book, moreover, that had

[6] This count does not include editions of single works such as the fragments of a commentary on Matthew edited by Erasmus in 1527, or the extensive commentary on John edited by A. Ferrarius in 1551. A fairly complete list of the collective editions is in E. R. Redepenning, *Origenes*, II (1846), pp. 472 ff., of which the list in the Ante-Nicene Library, XXIII (1872), p. xxxvii, is an extract. For a Venetian edition of 1512 not listed in Redepenning, see C. W. E. Leigh, *Catalogue of the Christie Collection*, University of Manchester Publications, XC (1915), p. 319. On the Aldine edition of 1503, cf. A. A. Renouard, *Annales de l'imprimerie des Alde* (1834), p. 44.

[7] *Periarchon* (1533). See also Champier's *Symphonia Platonis cum Aristotele*, I (1516), fol. xvᵛ: 'De materia prima et eius nomine ex libro quarto Peri archon Origenis Adamantii'; fol. xviiʳ: 'De materia ex diversis libris Origenis' ('in libris Peri archon . . .').

[8] Letter to Jodocus Jonas, 13 June 1521, *Opus epistolarum Des. Erasmi Roterodami*, ed. P. S. Allen, H. M. Allen, and H. W. Garrod, IV (1906–58), no. 1211, p. 508 (hereafter referred to as Allen). Cf. A. Renaudet, *Préréforme et humanisme à Paris* (2nd edn., 1953), pp. 426 f.

[9] *c.* December 1504 (Allen, I, no. 181, p. 405); trans. by R. A. B. Mynors and D. F. S. Thomson, *Collected Works of Erasmus*, II (1975), no. 181, p. 87. Cf. F. Seebohm, *The Oxford Reformers* (1869), p. 169.

[10] Fol. B bb 4ᵛ; cf. Renaudet, p. 678 note 1.

The Eloquence of Symbols

transformed St. Jerome from a disciple of Origen into a relentless opponent,[11] he confined the edition to a group of homilies on the Old Testament, sermons preserved in a Latin translation which was said to have been made by St. Jerome himself.[12] This point was also stressed in the table of contents: *Origenis homiliae ... divo Hieronymo interprete*.

If the title of the book thus looked innocuous, the time for its publication was also well chosen. Ten years had elapsed since Alexander VI—in this instance distinguished from his predecessor by a strain of benevolence and enlightenment—had issued the famous brief, dated 18 June 1493, which absolved Pico della Mirandola from the charge of heresy. Among the theses condemned under Innocent VIII and now readmitted[13] were at least two that bore on the Origenist controversy. Pico held 'that a mortal sin of finite duration is not deserving of eternal but only of temporary punishment'.[14] This proposition would seem to condone, if not support, Origen's belief in universal redemption. The more fantastic parts of Origen's angelology Pico was prepared not to defend, but to excuse. Even if mistaken, Origen's belief that the souls of men were descended from angels could hardly deserve those eternal flames of which he had presumed to deny the existence.[15]

In Origen's system the angelic choir was divided into three groups when Lucifer revolted. Some angels favoured Lucifer and thus became devils, others remained angels because they sided with God; but there was a third group who could not make up their minds. These were made into men 'so that under the spur of passion (*passionibus incitantibus*) they might make their choice between good and evil'. The definition of man as an undecided angel temporarily exiled into a body, his creation conceived of as a fall from grace to which he is destined to return, these were doctrinal points easier to reconcile with Plato's views on pre-existence than with the Biblical account of the Creation. Pico was attracted to these ideas because they allowed for the self-transformation of man, which he expounded in *De hominis dignitate*. Although his doctrine is not identical with Origen's in any detail, they have in common the assumption that man's place in the universe is not fixed, that he is able to move freely, up and down, between the angelic and the animal spheres, belonging to both and bound to neither. When this doctrine was quoted fifty years later in Pagnini's *Isagoge*, the publisher took the precaution of placing these warning notes in the margin: 'Cave hoc

[11] Jerome, *Contra Rufinum*, I, 14 (*Patr. lat.* XXIII, col. 408; see also col. 427); *Epistolae*, lxxxiv (*Patr. lat.* XXII, cols. 743 ff.). On some of the 'hardiesses d'Origène' and their effect on French humanists, see L. Febvre, *Le Problème de l'incroyance au XVIᵉ siècle: La Religion de Rabelais* (rev. edn., 1962), pp. 174 ff., also 'Origène et Des Périers', *Bibliothèque d'Humanisme et Renaissance*, II (1942), pp. 7–131, particularly pp. 76 ff.

[12] 'Nos autem', Aldus wrote in the preface, 'optimis quibusque illius legendis: et quae barbatus Hieronymus approbavit: quales sunt hae sanequam utiles admirandaeque homiliae, admodum certe proficiemus.'

[13] Pastor (*The History of the Popes*, V, 1898, p. 345) rejects attempts 'to represent the pronouncement of Alexander VI as contradicting that of Innocent VIII' and states that 'there is no mention in the brief, as has been asserted by some

writers, of the theses condemned by Innocent VIII'. The actual evidence is to the contrary. The brief of Alexander VI refers to the *Conclusiones* twice by name and a third time by implication. It also refers repeatedly to the *Apologia*, which is concerned solely with a defence and reassertion of the theses condemned by Innocent.

[14] *Conclusiones in theologia ... secundum opinionem propriam a communi modo dicendi theologorum satis diversam*, no. 20: 'quod peccato mortali finiti temporis non debetur poena infinita secundum tempus, sed finita tantum' (*Opera omnia*, Basle, 1557, p. 94.).

[15] Ibid., no. 29: 'Rationabilius est credere Origenem esse salvum, quam credere ipsum esse damnatum.' Cf. Gibbon, *The History of the Decline and Fall of the Roman Empire*, IV (1788), xxxxvii.

dogma, quia haereticum est quod beati a beatitudine cadere possint.... Argumentum non valet, quia sunt et accidentia inseparabilia.'[16] In this rigidly orthodox view, the species and their attributes were clearly defined and separated by God, and there was no place for those cosmic mysteries of transmutation which Pico had studied and admired in Origen.

The *Disputatio de Origenis salute* formed the kernel of Pico's *Apologia*. Although he had thirteen separate theses to defend against his accusers, his argument in favour of Origen made up more than one-fifth of the entire discourse, of which it occupied the centre. He argued that, in so far as Origen had proposed heterodox opinions (which he conceded to be the case only with regard to the pre-existence of the soul), they concerned matters on which there was no ascertainable evidence from revelation and no decision by the Church in Origen's day;[17] that on these debatable subjects he had written neither dogmatically nor assertively but merely in an inquiring spirit;[18] that even if he had written on them in a positive vein, his error would not constitute a mortal sin;[19] and that, supposing he had committed a mortal sin, this would not, in the absence of pertinacity, entail eternal damnation.[20] He conceded that several Councils and Popes had condemned some of Origen's views and also his person, but he insisted that, unless one badly misread the Decretals,[21] the condemnation of his person referred to Origen only as a doctor, not as a man: 'for it does not pertain to the Church to damn or save the souls of men, because this belongs only to Him who is the judge of the living and the dead'[22]—a statement that would seem to take little account of the powers transferred by Christ to the keys of St. Peter.

Pico added, however, that in so far as the Church does issue damnations of men, these have the same degree of authority as canonizations, belief in which, according to St. Thomas Aquinas, is recommended to the faithful 'in piety but not of necessity'; for 'whether the soul of this or that person is in hell or in paradise has no bearing at all on the substance of the faith'.[23] 'From this proposition I infer', wrote Pico, 'that even if the Church had determined

[16] Sante Pagnini, *Isagoge ad mysticos sacrae scripturae sensus* (1536), pp. 448 f.

[17] *Opera*, pp. 210 f.: 'Origenes non omnia tenebatur suo tempore explicite de anima credere, quae nos nunc tenemur, quia nec in scriptura habebantur manifesta, nec per Ecclesiam, ut postea fuit, tunc fuerat determinatum.... Nam ipse Augustinus dubius erat in opinione de anima, ut patet ex eius epistola ad Hieronymum.... Nec credas solum in iuventute de hac re dubitasse Augustinum, quia in primo Retractationum, qui fuit de ultimis, de hac quaestione dubitat.... Ex quo patet evidenter, propter erroneam opinionem de anima praedictam, haereticum nullo modo posse dici Origenem.' This argument must have been widely used by Renaissance defenders of Origen; for it already occurs some twenty years earlier (1466) in Leonardo Dati's commentary on Palmieri's *Città di vita*. The relevant passage is published by G. Boffito, 'L'eresia di Matteo Palmieri "cittadin fiorentino"', *Giornale storico della letteratura italiana*, XXXVII (1901), p. 36 note 2.

[18] *Opera*, p. 212: 'Nam et post disputationem de anima inquit: *Haec iuxta nostram sententiam non sint dogmata, sed quaesita tantum atque proiecta*....' (italics mine); ibid., p. 217: 'ut ipse dicit, suam ignorantiam non ignorabat.'

[19] Ibid., p. 214: 'nam quantumcunque magnus sit error, modo sit solum error in intellectu, et in voluntate nulla sit malicia, non videtur quod taliter errans peccet mortaliter.'

[20] Ibid., p. 223: 'pertinacem non fuisse eum ... quia concilia in quibus damnatae fuerunt illae opiniones, fuerunt multo post mortem Origenis.' While Pico conceded that 'eternal damnation' would be a valid concept if applied to a sinner of continuous pertinacity, he claimed that it would require a particular revelation for any living man, or even the Church, to know whether the pertinacity in a given case was continuous.

[21] Pico referred in particular to the *Decretum Gelasianum* (ibid., p. 222, italics mine): 'Origenis nonnulla opuscula, quae vir beatus Hieronymus non repudiat, legenda suscipimus. Reliqua autem omnia *cum authore suo* dicimus esse renuenda.' Cf. A. Thiel, *Epistolae romanorum pontificum* (1868), p. 461.

[22] *Opera*, p. 222: 'ad Ecclesiam non pertinet damnare animas hominum aut salvare, quia ad illum attinet solummodo, qui iudex est vivorum et mortuorum.'

[23] Ibid., p. 224: 'Utrum autem anima huius vel illius sit in inferno, vel in paradiso, nihil attinet ad substantiam fidei.'

that Origen is damned, we should not be bound by the necessity of the Catholic faith to concede it.'[24] And he added defiantly that belief in general—even in the basic mysteries of the Christian faith—is not determined by the will; from which it follows that any attempt to compel belief is an extension of the will beyond its province (*actus tyrannicus voluntatis*).

Of the ensuing storms and vexations there is but a mild echo in Aldus' preface. He confined himself to reflecting with sorrow on the contrariety of opinions held about Origen:

Greatly do I grieve at the fate of this most learned man, that he was, and still is, considered at the same time the best and the worst writer of all. For you know what is universally said of Origen: *Ubi bene, nemo melius; ubi male, nemo peius.* But I need not write on this subject, for it has been dealt with in a treatise by Giovanni Pico della Mirandola, a man of admirable genius and marvellous erudition, who discussed this question with copious learning in his *Apologia*.

Feeling that the position was still precarious, Aldus placed his edition under Augustinian protection: 'ut virum illum ... protegeres et tuereris', he wrote in the dedication to Egidio da Viterbo.

An Augustinian Defence of Origen

Egidio's own statement of how he judged the opinions of Origen is preserved in the unpublished *Historia XX saeculorum*.[25] In it he confessed himself impressed by the virtues and superior insights occasionally displayed by those whom the Church has condemned:

When we study the writings of the ancient heretics, would it not seem that nothing could be more saintly, more chaste, more sacred than they, except for the one or two points on which they differed from other right believers? For to speak alone of Origen, whom Jerome and the Church condemn, what could be chaster, what purer, what more exalted in the rejection of human frailty, what more inspiring, more forceful, and more felicitous in desiring, observing, and revealing things divine? So that Jerome said he was unique after the Apostles and deserved, and should receive, a place before all other mortals.[26]

The contrariety of judgements about Origen to which Aldus had pointed in his preface—*ubi bene, nemo melius; ubi male, nemo peius*—was here discovered in the person of Jerome himself.

[24] Ibid.: 'Ex hac propositione infero, ad propositum meae conclusionis, quod etiam si Ecclesia determinasset Origenem esse damnatum, adhuc de necessitate fidei catholicae non tenemur assentire quod ita sit.'

[25] On the manuscripts see L. G. Pélissier, 'Manuscrits de Gilles de Viterbe à la Bibliothèque Angélique', *Revue des bibliothèques*, II (1892), pp. 228-40; more recently, with excellent notes, E. Massa, 'Egidio da Viterbo e la metodologia del sapere nel Cinquecento', in *Pensée humaniste et tradition chrétienne aux XVᵉ et XVIᵉ siècles*, ed. H. Bédarida (1950), pp. 185-239. Pélissier's dissertation, *De opere historico Aegidii Cardinalis Viterbiensis* (1896), and the more recent biography by G. Signorelli, *Il Cardinale Egidio da Viterbo* (1929), are of limited use. [But see now the basic studies by F. X. Martin of Egidio as humanist and Augustinian reformer in Luther's time, 'The Problem of Giles of Viterbo: A historiographical Survey', *Augustiniana*, IX (1959), pp. 357-79 and X (1960), pp. 43-60; and his comprehensive bibliographical list, 'The Writings of Giles of Viterbo', ibid., XXIX (1979), pp. 141-93. See also the important biography by J. W. O'Malley, *Giles of Viterbo on Church and Reform* (1968), with notes about the manuscripts and recent literature on the subject. Many references to Egidio are found in Wind's later work, especially *Pagan Mysteries in the Renaissance* (2nd edn., 1968); 'Maccabean Histories in the Sistine Ceiling', *Italian Renaissance Studies*, ed. E. F. Jacob (1960), pp. 324 ff.; and 'Michelangelo's Prophets and Sibyls', *Proceedings of the British Academy*, LI (1965), pp. 82 ff.]

[26] Rome, Biblioteca Angelica, MS. lat. 502, fol. 185ᵛ. See now Martin's list, op. cit., no. 18.

Jerome had condemned Origen, and the Church had followed Jerome (*Hieronymus, et Ecclesia damnat*). Yet Jerome had also declared that Origen was 'the first after the Apostles, and to be placed above all other mortals'.[27] If the wisdom of the Church spoke through Jerome, it appeared that some of its outcasts—heretics and schismatics—possessed unexpected virtues and knowledge, 'except for the one or two points on which they differed from other right believers'. It also appeared that the pagans and Jews, with whose mistaken opinions so many of Origen's profoundest thoughts were associated, had possessed a dark and secret foreknowledge of the Christian verities. 'The thing itself (*res ipsa*)', wrote St. Augustine, 'which is now called the Christian religion, was with the ancients, and it was with the human race from its beginning, until Christ appeared in the flesh: from then on the true religion, which already was there, began to be called the Christian.'[28] Egidio, who on this point adopted St. Augustine's view, has left an expression of the nostalgia with which he sought for the shadow of Christianity among the ancients, in an elegy composed on the theme of *luminis umbra*:

> Hinc quicquid Graii, quicquid scripsere Latini
> Ridere et nugas dicere iure potes.
> Illi etenim procul hec aut sunt exempla secuti
> Hiisque aliqua illuxit luminis umbra viris,
> Aut mersi plane in tenebras et lucis egentes
> Errarunt tota nocte premente via.[29]

By exploring these borderline cases between truth and error, Egidio hoped to discover a secret harmony between the pagan, Jewish, and Christian mysteries. *Huc omnis nocte dieque labor*. For this purpose he 'made Latin translations of Porphyry's Mysteries and Proclus' Theology; and truly,' says a contemporary witness, 'his genius is as great as his erudition in exploring the arcana of the ancients'.[30] For Cardinal Giulio de' Medici he wrote a graceful, lucid little tract, preserved in manuscript, on the Cabalistic secrets inherent in the Hebrew alphabet, which he introduced by the statement that sacred writings may be divided into pagan, Jewish, and Christian: 'Sane divinae res quae legi possunt, secantur in partes tres; quaedam gentes, quaedam prophetae veteres, quaedam novae legis scriptores prodidere.'[31] In much the same spirit he composed his huge commentary *In librum primum Sententiarum ad mentem Platonis*, in which, while taking his text from Peter Lombard, he traced the 'vestiges of the Trinity' through Plato's dialogues and through a large series of pagan fables,

[27] Cf. Jerome, *Liber de nominibus hebraicis* (*Patr. lat.* XXIII, col. 772): '... Origenem, quem post Apostolos Ecclesiarum magistrum, nemo nisi imperitus negabit.' Also *Translatio homiliarum Origenis in Jeremiam et Ezechielem* (*Patr. lat.* XXV, cols. 583 f.).

[28] *Retractationes*, I, xiii, 3 (*Patr. lat.* XXXII, col. 603).

[29] Paris, Bibliothèque Nationale, MS. lat. 527¹, fol. 1ʳ: 'Hence you can rightfully laugh at whatever the Greeks and Latins wrote, and call it trifles. For they either followed these examples from afar and some shadow of light shone upon them, or, completely immersed in darkness and

lacking light, they went astray the whole way, with night pressing down on them.' On the *Traductio et expositio librorum Cabalae et Talmudis*, see Martin, nos. 28 and 29.

[30] Celio Calcagnini, *Opera aliquot* (1544), p. 101 [who confuses Porphyry with Iamblichus as the author of *De Mysteriis*, cf. R. Klibansky, *Plato's Parmenides* (1981), pp. viii f.].

[31] Biblioteca Apostolica Vaticana, MS. Vat. lat. 5808, fol. 2. See *Scechina e Libellus de litteris hebraicis*, ed. F. Secret, I (1959), pp. 23-55; also Wind (1968), p. 20.

producing a remarkable fusion of St. Augustine's *De Trinitate* and Proclus' *In theologiam Platonis*.[32]

It was only appropriate that his admirers addressed him after Ficino's death as *Platonicorum maximum*.[33] In his preface Aldus also alluded to Egidio's Platonism, asking him to accept the edition of Origen (the most radical Platonist among the Greek Fathers) as a token of the Greek edition of Plato he was then preparing. But while Aldus carefully confined his edition to the unexceptionable homilies that St. Jerome had endorsed, Egidio himself took so strong an interest in the *Peri archon* that he had a special copy of it made in Florence, to which were added excerpts referring to 'Pamphilius the Martyr who wrote in defence of the books of Origen'.[34] At the end of the manuscript Egidio recorded the occasion on which he had procured it: 'Frater Aegidius Viterbiensis rescribi Florentiae iussit MDXII cum contra scisma a Julio secundo pontifice maximo missus est quatuor privatis cardinalibus qui ab eo ad Gallorum regem desciverant.'[35] Engaged in an attempt to heal a contemporary schism, Egidio's thoughts had turned to that ancient and most regrettable dispute by which Origen was cut off from the body of the Church.

Early Origenists in Florence and Rome

To what extent Fra Egidio entertained the hope of eventually overcoming this ancient schism it is difficult to say. Plans in that direction had been laid in the fifteenth century by Matteo Palmieri and Leonardo Dati, who did not dare, however, to test the issue themselves. They treated their opinion as a secret doctrine, divulging it only to a few, but willed that it should be published after their death. Their legacy consisted of Palmieri's poem *Città di vita*, to which Dati had written a commentary.[36] More certain about pre-existence than St. Augustine, who had left the question undecided, they claimed for Origen's view the positive support of two passages in the Bible: Revelation xii. 4, and Deuteronomy xxxii. 8, the latter in St. Gregory's version; and to these passages they added a quotation from St. Augustine himself, 'ubi aperte dicit non minus de hominibus salvari quam corruerint de angelis, et de pluribus non asserit scire.'[37] It is clear that these arguments are more rigid than those of the *Apologia*. Pico conceded that Origen's opinions on the pre-existence of the soul, while not

[32] MS. Ang. lat. 636; MS. Vat. lat. 6325; also Naples, Biblioteca Nazionale, MSS. VIII F. 8 and XIV H. 71; Hamburg, Staatsbibliothek, Ms. Phil. 308 (Martin, no. 17). An excerpt in Massa, *I fondamenti metafisici della 'dignitas hominis' e testi inediti di Egidio da Viterbo* (1954), pp. 54–110. Recently H. Pfeiffer published Seripando's headings in BN XIV H. 71, with a concordance of sections in the first four MSS., and a few extracts from Vat. lat. 6325, in his study *Zur Ikonographie von Raffaels Disputa. Egidio da Viterbo und die christlich-platonische Konzeption der Stanza della Segnatura* (1975), pp. 241–52. On the Renaissance search for pagan vestiges of the Trinity, see Wind (1968), pp. 241 ff.

[33] Dedication by Paolo da Genazzano of his edition of Gregorio da Rimini (Venice, 1503).

[34] MS. Ang. lat. 1244, translations of Origen etc., made for Egidio in 1512 (O'Malley, op. cit., p. 195).

[35] This refers to the 'schismatic cardinals' (d'Albret, Briçonnet, de Carvajal, de Prie), who had joined the Council of Pisa.

[36] Palmieri's poem, published by M. Rooke, *Libro del poema chiamato* Città di vita *composto da Matteo Palmieri florentino*, Smith College Studies in Modern Languages, VIII (1926/7) and IX (1927/8), was composed between 1455 and 1464. Palmieri died in 1475. Extensive extracts from Dati's commentary in Boffito (see above, note 17), pp. 1–69. In the following, all quotations from Palmieri and Dati are from these two publications.

[37] Boffito, p. 36.

heretical in the light of their time, had no Biblical evidence to support them. Leonardo Dati was convinced, on the contrary, although himself a priest and a skilled theologian, that Palmieri was right in claiming that the authority of the Bible and two Church Fathers concurred with Origen's view about the descent of the souls from one-third of the angelic choir.[38]

It might well be asked why such serious efforts were made to have this piece of arithmetic accepted. But on it hinged the chance of seeing Origen readmitted as a Christian doctor— Origen who had been anathematized by the Church because he believed, like Plato, in the pre-existence of the soul. To a clear-minded Christian Platonist, a character admittedly rare and not undangerous, it might well seem intolerable that Origen was condemned on a point so crucial to the Platonic doctrine. And anti-Platonists did not disguise their satisfaction. In the opinion of Paolo Cortese, who introduced the graces of Cicero into Peter Lombard, Origen would have been 'by far the most pious of Christians, had he not torn his mantle and sandals among the Platonic thornbushes'.[39] Both sides found their views of Origen sustained by the picture drawn of him by Porphyry and quoted in Eusebius: 'While his manner of life was Christian ... in his opinions ... he played the Greek.... For he was always consorting with Plato, and was conversant with the writings of ... the distinguished men among the Pythagoreans ... from whom he learnt the figurative interpretation, as employed in the Greek mysteries, and applied it to the Jewish writings.'[40] This character of an Alexandrian Father reconciling Plato and Moses by employing the figurative method of the Greek mysteries could have been invented for Marsilio Ficino.[41] Nor did Ficino spare his encomiums; he called him *Platonicum nobilissimum*.[42] In 1474, shortly after he had become a priest, Ficino listed Origen's virtues in *De Christiana religione*,[43] praising his doctrine without any indication that it might contain some questionable points. In another chapter of the same book he quoted from the *Peri archon*, again without reservations.[44] That he approved of Palmieri's *Città di vita* is shown by a letter in which he addressed him as *poeta theologicus*.[45] Apparently a revival of Origen was well under way before Pico's spectacular support of it precipitated a crisis.

Other traces of this early revival are not difficult to find. In 1475, a first and rather

[38] In Palmieri's verses, I, x, 18-21 (Rooke, p. 47), this reads as follows:

> El vangelista ad chi fu rivelato
> da l angel sancto el celestial secreto
> in pasmo ad lui dal vero idio mandato,
> Vide caduti per divin decreto
> col pessimo dracon la terça parte
> di quelle stelle ch eran nel ciel lieto;
> Truovasi scripto nelle sacre carte
> huomini tanti su nel ciel sarranno
> quanti angeli salvo lo primo marte;
> Agostino tanti quei si salveranno
> essere scrive quanti son caduti
> & di piu parla come que nol sanno.

Dati's commentary on the passage (Boffito, p. 37) says: 'Facit nunc auctor ex ante dictis collectionem suam dicens quod si terna pars angelorum cecidit cum dracone ut scribit evangel. iohannes, et tot homines credimus ascensuros in coelum quot ibi angeli remansere ut dicit Gregorius, et qui ascendunt in coelum tot erunt quot angeli fuerunt qui corruerunt ut Augustinus scribit, sequitur quod tot erunt qui ascendent in coelum quot fuerunt qui ceciderunt, et tot sunt qui remanserunt in coelo; tertia igitur pars in coelo remansit, tertia cecidit, et tertia in coelum ascendet, et haec sunt quibus auctor persuadere intendit suam opinionem non esse christianae religioni prophanam.'

[39] Paolo Cortese, *In Sententias* (1503), II, v.

[40] Eusebius, *Historiae ecclesiasticae*, VI, xix (*Patr. graec.* xx, col. 567).

[41] *Epistolarum liber*, viii, 'Concordia Mosis et Platonis', *Opera*, I (Basle, 1561), p. 866.

[42] *De voluptate* (ibid., p. 994).

[43] xxxv, 'De authoritate doctrinae Christianae' (ibid., p. 72).

[44] vii (ibid., p. 8): 'Origenes quoque in quarto Periarchon libro inquit....'

[45] Dated 10 April 1474, see below, note 65.

fragmentary edition of the homilies was appended to the sermons of St. Gregory;[46] and six years later the first printing of *Contra Celsum* was dedicated to Sixtus IV and to the Doge of Venice.[47] Remarkable reflections of Origen appear here and there in the visual arts, occasionally on some of the greatest monuments. Ghiberti's reliefs on the Porta del Paradiso (Fig. 9), and also Uccello's frescoes in the Chiostro Verde in Santa Maria Novella (Fig. 11), represent the Ark of Noah in the shape of a pyramid, contrary to the opinion of Hugh of St. Victor, who refutes at length this mathematico-mystical invention of Origen's.[48] In the Sistine Chapel, Botticelli represented the Temptation of Christ and the Healing of the Leper (Fig. 10) as parts of one great Biblical panorama which is centred on the Hospital of Santo Spirito, a foundation sponsored by Sixtus IV. A personal homage to the Pope was certainly intended by this topographical allusion,[49] yet this does not explain how the Healing of the Leper is related to the Temptation of Christ, or either of them to Santo Spirito. In a homily by Origen these three themes are fused into one.[50] And it is again to Origen that we must turn for an explanation why, in the same chapel, the Resurrection of Christ is foreshadowed by the Assumption of Moses—a subject of which there is no trace in the Old Testament, and only the faintest trace in the New (Jude 9). Sixtus IV, whose learning in secret Biblical lore was extolled in Pico's *Apologia*, apparently knew that a lost apocryphal book entitled *The Assumption of Moses* was repeatedly quoted by Origen.[51] With the Pope himself so deeply engaged in these studies, and with his chosen librarian Bartolomaeus Platina introducing the praise of Origen into the *Lives of the Popes*,[52] it is certain that Sixtus IV did not regard the shadow of Origen with any of those fears and apprehensions which were to predominate under Innocent VIII.[53]

The posthumous debate on Matteo Palmieri seems to confirm these observations. From the available documents[54] it appears that the agitation against him did not start until eight

[46] Hain, *Repertorium bibliographicum*, no. 7947. For an early selection of Origen's sermons, see also the *Homiliarius* of Pseudo-Alcuin, Hain, nos. 8789-93.

[47] Hain, no. 12078.

[48] Origen, *In Genesim homiliae*, ii (*Patr. graec.* XII, cols. 161 f.); Hugh of St. Victor, *De arca Noe morali*, I, iii, 'De forma et quantitate arcae secundum litteram' (*Patr. lat.* CLXXVI, cols. 626 ff.). As Uccello's fresco, the *Sacrifice of Noah*, which gives a full view of the Ark, is damaged, it is reproduced here after the engraving in Seroux d'Agincourt. I notice with pleasure that D. C. Allen, *The Legend of Noah* (1949), pp. 168 f., whose book reached me after the present article was completed, has come independently to the same conclusion, namely that Uccello and Ghiberti represented the ark of Origen. In this connection it is worth noting that both Palmieri and Dati studied Greek with Ambrogio Traversari, whom R. Krautheimer (*Lorenzo Ghiberti*, 1956, pp. 171 ff.) suggested as the author of the programme for Ghiberti's reliefs on the Porta del Paradiso, and one of whose 'proudest achievements' was the discovery of unknown homilies by Origen in the very years when the bronze doors were being designed (pp. 179 f.). [Recently Francis Ames-Lewis, 'A Portrait of Leon Battista Alberti', *The Burlington Magazine*, XCVI (1974), pp. 103 f., argued

that the prominent figure in the foreground of Uccello's *The Flood* in the Chiostro Verde cycle was a portrait of Alberti, a suggestion which receives some confirmation from the part played by Alberti in the revival of Greek thought, as described in C. Eisler, 'A Portrait of L. B. Alberti', ibid., CXVI (1974), p. 530.]

[49] E. Steinmann, *Die Sixtinische Kapelle*, I (1901), pp. 244-53.

[50] *In Lucam homiliae*, xxix (*Patr. graec.* XIII, cols. 1874 ff.).

[51] e.g. *Peri archon*, III, ii, 1 (ibid. XI, cols. 303 ff.); *In librum Josue admonitio*, i (ibid. XV, cols. 927 ff.).

[52] Cf. the Lives of Callistus I, Pontianus, and Caius in *Vitae Pontificum* (1481).

[53] [Origenism was a distinct characteristic of Rovere theology. Wind showed that later, under Julius II, traces of Origen's figurative theology are to be found in the frescoes of the Sistine Ceiling, both in the programme as a whole and in the details, for example in Michelangelo's rendering of the Ten Commandments on the bronze tablets, where he followed Origen's division of the scenes ('Maccabean Histories', op. cit., pp. 323 ff.).]

[54] An excellent collection is published by Boffito, except for a digression on p. 51.

years after his death. At his funeral in 1475, his book was publicly displayed and praised, and some time after that event read with approval by Fra Domenico da Corella,[55] whose theological authority was unquestioned. However, in 1483, the first edition of the *Supplementum chronicorum* by Filippo da Bergamo, published in Venice, contained the statement that Matteo Palmieri 'having written a book full of errors about the angels, was condemned as a heretic and burned before the city as audience'.[56] This falsehood was repeated in the editions of 1485, 1486, 1490, and 1492, and assiduously copied by other authors.[57] But by the time the chronicle reached the year 1502 the editors discovered their error, because this edition (published in Venice in 1505) adopts instead a long passage from Rinuccini's funeral oration in which the *Città di vita* was called *pergrandis liber*.[58] Although the old rumours did not subside at once, they were gradually replaced by paler versions. Some of these changed the burning of Palmieri into exhumation and reburial in unconsecrated ground;[59] others confined the burning to Palmieri's book,[60] although the official copy of it, first displayed at his funeral, can still be seen in the Biblioteca Laurenziana. Still others maintained that a veil had been draped over the 'heretical picture' in Palmieri's chapel in San Pier Maggiore.

This picture, now attributed to Botticini, is in the National Gallery, London. Since much has been written about its heretical character, it should be remembered (1) that Vasari dismisses the accusation as malicious gossip (Life of Botticelli); (2) that Borghini in *Il Riposo* (1584) ignores it altogether; (3) that in 1657 Stefano Rosselli remembered 'from hearsay' (*dicono*) that the picture had been considered heretical in the past, and was kept 'veiled for a long time' (*molto tempo coperta*), although in the writer's own time it was certainly unveiled and appeared to him *bellissima*; (4) that a veil would hardly be sufficient to remove the malignancy of a heretical picture from a consecrated chapel; (5) that so far no documentary evidence has been produced that either the picture or the chapel was ever placed under an interdict; (6) that in 1769 Bottari still saw the picture in its original place, from which it was not removed until 1785 when the church fell into disrepair and had to be demolished.[61]

As a matter of fact, echoes of the posthumous attacks on Palmieri were remarkably slight in Florence. A passage in the *Morgante* (1482) suggests that Palmieri's orthodoxy had been called into question, but while professing not to know what the right decision might be (*non so*), Pulci referred to the author affectionately as *il mio Palmier*.[62] Vespasiano da Bisticci, who admitted Palmieri's 'error', at the same time asserted 'che certo si vede che la malizia non fu in lui'.[63] L'Altissimo even referred to his theological verses as 'ingiustamente *d'alcun*

[55] Rooke, I, p. xiii.

[56] Boffito, p. 44.

[57] Trithemius, *Liber de scriptoribus ecclesiasticis* (1494), fol. 112ᵛ, and others listed by Boffito, pp. 44 f.

[58] Cf. F. Fossi, *Monumenta ad Alamanni Rinuccini vitam contexendam* (1791), pp. 122-6, funeral oration for Palmieri.

[59] In G. B. Gelli's *I capricci del bottaio* (1548), vi, p. 119, this action is attributed to the vaguest of ecclesiastical authorities—'chi reggeva all'hora la Chiesa Fiorentina'.

[60] Paolo Giovio, *Le iscrittioni poste sotto le vere imagini de gli huomini famosi* (1552), p. 220.

[61] Cf. M. Davies, *National Gallery Catalogues. The Earlier Italian Schools* (2nd edn., rev., 1961), pp. 122-7, the best discussion of the literature on the painting.

[62] *Morgante maggiore* (1482), xxiv, 109. The only perfect copy of the first complete edition containing twenty-eight cantos is in the British Library.

[63] *Vite di uomini illustri del secolo XV*, ed. A. Mai and A. Bartoli (1859), pp. 500 f.; see now *Le vite*, ed. A. Greco, I (1970), pp. 563 ff.

dannati',[64] which would seem to rule out an official verdict. Whereas Pico was indicted for heresy, no action appears to have been taken by the Inquisition to desecrate the memory of either Palmieri or Dati, both of whom had died before Pico's trial began. As for Ficino, he found it quite safe in 1494, one year after the brief of Alexander VI, to include in the printing of his *Epistolae* the letter in which he had addressed Palmieri as *poeta theologicus*.[65]

From these facts it appears that the critical period of agitation was almost entirely confined within a decade (1483–93). It ended naturally with the issue of the papal brief that sanctioned Pico's *Apologia*. In judging Pico's role in these developments we must remember that the year 1486, when he published his theses, is merely a *terminus ante quem* of their conception. In a letter to Ermolao Barbaro of 1485 in which he defended the style of the medieval doctors, he wrote that these studies had been occupying him for six years: *iam enim sexennium apud illos versor*.[66] And as Pico was not in the habit of being secretive about the ideas uppermost in his mind, his preparation for a public defence of Origen may have done much to invite a re-examination of Palmieri.[67]

Whether the impetuous Pico had inadvertently alarmed some of his elders and provoked their indignation, or whether he had deliberately chosen, as a matter of strategy, to force a secret foe into an open conflict, it is certain that he became the pivot of the battle. Until he proposed publicly to debate the thesis 'that it is more reasonable to believe that Origen is saved than to believe that he is damned', the revival of Origen was, as it were, without focus. Rigid Origenists like Palmieri and Dati had withheld their opinions from the public. And in the Platonic Academy the adoption of Origen merely added one more exotic figure to an assembly that already included Hermes Trismegistos and Zoroaster. Ficino's admirable powers of assimilation were never impeded by a gift for analysis.[68] If, as has been suggested, Pico's dialectic was largely employed in reducing to a very few leading ideas the vast collection of intellectual matter that Ficino had put forth diffusedly,[69] this would sufficiently explain why it was Pico who revolutionized the spirits. As Bergson and de Broglie have said, 'l'acte d'organisation a quelque chose d'explosif.'

[64] *Strambotti e sonetti dell'Altissimo*, ed. R. Renier (1886), p. xxvi (quoted by Boffito, p. 32). Italics mine.

[65] As a result of a careless misprint, the word 'poeta' is missing in the 1576 Basle edition of Ficino's *Opera*. The *editio princeps* of his *Epistolae* (Venice, 1495), fol. 18ᵛ, has the correct reading 'Matheo palmerio *poetae theologico*' (italics mine), the same as the manuscript in Florence, Biblioteca Laurenziana, Plut. 89. sup. Cod. II, fol. 11. Ficino's preface is dated 15 December 1494. See above, note 45.

[66] *Opera*, p. 352.

[67] In book xxi of the *Commentarii urbani* (1506) by Raffaello Maffei of Volterra, the important (because unfriendly) account of his meeting with Pico is followed by a biographical note on Palmieri.

[68] *Theologia Platonica*, v, xiii is a fair example of Ficino's manner: 'Quamquam Plotinus et Proclus aliique nonnulli Platonicorum animam fieri arbitrantur ab angelo, tamen Dionysium Areopagitam, *Origenem* et Aurelium Augustinum Platonicos excellentissimos sequor libentius, qui animam putant a Deo unico procreari' (*Opera*, I, p. 147, italics mine). That Ficino himself occasionally knew better is shown in the very next chapter (v, xiv), where he classifies Origen with Plotinus as 'existimantes animas humanas esse mentes delapsas ... posseque omnes iterum ad superiora converti'. But he preferred to brush this view aside: 'sed haec ipsi viderint ...' (pp. 151 f.). Pico may have had these ambiguities in mind when he wrote angrily in the *Commento*, I, iv: 'Però mi maraviglio di Marsilio che tenga secondo Platone l'anima nostra essere immediatamente da Dio produtta; il che non meno alla setta di Proclo che a quella di Porfirio repugna' (ed. E. Garin, 1942, p. 466).

[69] P. O. Kristeller, *The Philosophy of Marsilio Ficino* (1943), pp. 6 f.

The Aldine Origen and the Critique of Erasmus

To place an edition of Origen under Augustinian protection was a procedure that could not appeal to Erasmus. His unequal estimation of these two Fathers is contained in a remark to John Eck: 'One single page of Origen teaches me more of Christian philosophy than ten of Augustine.'[70] But by the time he prepared his own edition of Origen for Froben (1536),[71] it was possible for him to throw off the safeguards which Aldus had found indispensable. As the admired editor of Jerome, Erasmus declared it to be a disgrace that the inept Latin translation through which so much of Origen's thought had been both preserved and disfigured should be ascribed by 'audacious booksellers' to so great a stylist as Jerome.[72] The reflection on Aldus is unmistakable and, regardless of its philological merits, unjust, Erasmus being then full of spite and resentment against his former Italian friends. Among them Aleander had become his severest critic.

And yet, when full allowance is made for Erasmus' irritation, there does remain the shadow of a doubt whether the presentation of Origen under the cover of Jerome was not a *captatio benevolentiae*. True, the edition was confined to works that Aldus knew Jerome had approved, and that was all he said of Jerome in his preface. But in the 'Foreword to the Reader' following the preface, which we suspect might have been written by Aleander,[73] the acceptance of Origen by Jerome was stretched far beyond both what Aldus had intimated and what the facts would justify: 'Felicem te Adamanti: qui tali frueris et interprete simul et praecone meritorum.' Perhaps the extreme caution of Aldus' introduction was designed to counteract the exuberance of his youthful editor who wrote in a capricious and nervous style,[74] full of intricate jokes and cryptic allusions, and interspersed with lyrical fantasies reminiscent of Petrarch. As Alexander the Great standing at the tomb of Achilles had envied his fame because it was sung by Homer, so Origen appears enviable to Aleander (if it was he who wrote this piece) because Jerome had been his bard.[75] Most remarkable is the grand peroration on which this *praefatiuncula* ends:

[70] Letter to John Eck, 15 May 1518 (Allen, III, no. 844, p. 337). See now two recent essays on Erasmus' personal attitude to Origen: A. Godin, 'De Vitrier à Origène'. Recherches sur la patristique érasmienne', *Colloquium Erasmianum*, Actes du colloque international réuni à Mons du 26 au 29 octobre 1967 à l'occasion du cinquième centenaire de la naissance d'Erasme (1968), pp. 47–57, and 'Erasme et le modèle origénien de la prédication', *Colloquia Erasmiana Turonensia*, ed. J.-C. Margolin (1972), pp. 807–20.

[71] First plans for this edition date back to 1523. Cf. Renaudet, *Etudes érasmiennes 1521–1529* (1939), pp. 35 and 38.

[72] Fol. β iᵛ: '... pro invidioso nomine Rufini, suppositum est gratiosum nomen Hieronymi.'

[73] As early as 1499 Aleander had engaged in a public debate *De natura angelica* (E. Jovy, *François Tissard et Jérôme Aléandre*, I, 1899, p. 139). His youthful proficiency in Hebrew, Greek, and Latin was praised by Aldus in his dedication to the edition of Homer (1504). When their collaboration began is uncertain, but Aleander's first visit to Venice occurred in 1493 (J. Paquier, *Jérôme Aléandre*, 1900, pp. 12 ff.). In 1521, in his oration at the Diet of Worms, Aleander protested against a comparison of Luther with Origen (ibid., pp. 200 f.). Unfortunately, some of the decisive years are missing in H. Omont, 'Journal autobiographique du cardinal Jérôme Aléandre (1480–1530)', in *Notices et extraits des manuscrits de la Bibliothèque Nationale et autres bibliothèques*, XXXV, i (1896), pp. 1–116. A succinct characterization of Aleander's temper, *vehemens et eruditus*, in Pierio Valeriano's poem 'Ad sodales Patavii philosophantes' (*Hexametri, odae et epigrammata*, 1550, fol. 126ᵛ), is quoted by Paquier, p. 25 note 4.

[74] In transcribing Eusebius, VI, viii, he anticipated Gibbon's remark about the self-mutilation of Origen: 'As it was his general practice to allegorize Scripture, it seems unfortunate that, in this instance only, he should have adopted the literal sense.'

[75] One can hardly blame Erasmus for resenting a bard who had turned good Greek into bad Latin.

Whoever thou art, faithful soul, who desirest to be built together for the heavenly Jerusalem that rises with living stones: enter these sacred grounds ... where there is the well of living waters flowing from the heights of Lebanon, irrigating all the surface of the earth and issuing into life eternal.... Let me speak with daring: for many things have I read, yet nothing, in my opinion, was I ever granted to see which was so noble, so mysterious (*tam arcanum*), so profound, so perfect (*tam absolutum*), so suited to every age, condition and degree. But I had better be silent about this than say little; for if I had a hundred tongues for praise, I would not yet be able to touch the lowest hem of his garment. For if you will come close and unfold and see for yourself,—you, too, will say with the Queen of Sheba: True is what I heard in my own country about these sayings and about this wisdom great in the extreme; and I did not believe those who told me of it until I came myself and saw with my own eyes, and found that the better part of it had not been reported to me: for greater is this wisdom than the renown of it, which I heard. Truly, to have come here is sufficient. And for us too it is time to sound the retreat. Let Origen himself, setting out from the shore, offer the sails to the winds and lead us seaward (*Adamantius ipse litore solvens det vela ventis et ducat in altum*).

The image of the wind, the sail, and the high sea was borrowed from Jerome who had applied it to Origen's τόμοι, for the purpose of distinguishing their exaltation from the sober didactic style of the homilies.[76] This loose adaptation of a phrase in Jerome might deserve the censure of Erasmus: 'Hanc ipsam sententiam ... ex Hieronymi scriptis sublectam insulsa garrulitate dilatavit.' But the profusion of words has a Biblical ring and reveals a stylist of considerable cunning. And as is not uncommon among men of wit, he may have succumbed to the contagion he intended to spread.

That this performance was occasioned by 'enervate Origen' is a measure of the excitement with which he was studied. But to stir up this excitement in the name of Jerome was more than a paradox, it was a mystification. In the array of questions from Jerome with which this discourse is shrewdly adorned, one would not expect to find the derogatory remarks that Jerome used to discredit some of Origen's writings; but one seeks in vain for what was perhaps Jerome's most generous reflection on Origen: 'Let us not imitate his failings, whose virtues we cannot equal.'[77]

The sequence of events examined here is perhaps not without interest for the psychology of a great historical revival. A long period of fermentation during which interest in Origen was strong, but dispersed, was followed by a crisis of considerable violence (1486), and this was attended by attempts at suppression. These attempts having failed, there ensued a period of quiet (1493–1503), after which Origen emerged as a classic.

If it was Pico who produced the crisis that released Origen from the cave of shadows, it was left for Aldus to inaugurate the classical period of Origenist studies. Erasmus, Huet, Montfaucon, Delarue: in looking back at this succession of Origen's editors one is perhaps too easily inclined to project some of their circumspect assurance into an earlier and more

[76] Prologue to the *Translatio homiliarum Origenis in Jeremiam et Ezechielem* (*Patr. lat.* xxv, cols. 585 f.).

[77] *Epistolae*, lxxxiv (*Patr. lat.* xxII, col. 750).

anxious age.[78] In the *Dictionnaire de théologie catholique*, the otherwise excellent article, *Origénisme*,[79] ends shortly after the Fifth Ecumenical Council with the year 556: 'A partir de ce moment, Origène n'intéresse plus que les historiens et sa doctrine ne donne plus d'occasion de controverses.'

And yet, controversial views within the Church have continued to this day to draw strength from a study of Origen, as can be seen, for example, in two recent books: Jean Daniélou's *Origène*, and Henri de Lubac's *Histoire et esprit*. As Charles Bigg observed in his classic lectures on *The Christian Platonists of Alexandria*: 'Origen's name has been a kind of touchstone. There has been no truly great man in the Church who did not love him a little.'

[78] Although Merlin's edition of 1512 was presented to Louis XII by his father-confessor (copy in the Bibliothèque Nationale), Merlin was forced in 1522 to defend his preface, *Apologia pro Origene*, by an *Apologia apologiae* (cf. Huet, *Origeniana*, bk. II, ch. iv, pp. 230 f.; *Patr. graec.* XVII, cols. 1179 f.).

[79] XI (1931), col. 1588.

VI · Platonic Justice designed by Raphael

IN the fresco crowning the wall of the Stanza della Segnatura which is meant to exemplify Jurisprudence[1]—in accordance with that universal plan in which Philosophy is exemplified by the *School of Athens*, Poetry by the *Parnassus*, and Theology by the *Disputa*—Raphael painted the three virtues of Fortitude, Prudence, and Temperance (Fig. 41), which in the classical canon of the cardinal virtues ought to have Justice for their companion; but Justice herself does not appear.[2] Some explain this paradox by saying that Justice appeared already on the ceiling and could not therefore be repeated on the wall. Others declare that Prudence, Fortitude, and Temperance are virtues 'necessary for the just'. But neither of these arguments, though satisfactory to those who suggest them, can be ascribed to the author of Raphael's programme. The mind (or minds) that invented the *School of Athens* should not be credited with such dullness as to place Justice first on the ceiling and, failing to think of something appropriate for the wall below, simply fill it with the other three virtues.

There is a riddle in this arrangement, and its key is to be found in Plato. In the first books of the *Republic* Socrates goes in search of Justice. He encounters the other virtues—Prudence, Fortitude, Temperance—but Justice will not appear. The explanation given is that Justice is not a particular virtue juxtaposed to Prudence, Fortitude, and Temperance, but the fundamental power of the soul that assigns to each of them its particular function.[3]

This is one of the tenets in Plato's philosophy which was not contradicted but accepted by Aristotle.[4] In the encyclopaedic plan of the Stanza della Segnatura the 'Concordia Platonis et Aristotelis' plays a decisive role. It seems natural, therefore, that in choosing a theme to demonstrate the nature of Justice, the author of the programme should have selected a passage that aptly supports this concordance.

But there is an even wider concordance at which the author of the Stanza aimed. He not only resolved contrasts within ancient philosophy but also reconciled ancient learning with

Journal of the Warburg Institute, I (1937), pp. 69 f.

[1] Throughout his lectures and unpublished papers on Raphael as well as in the article on the Four Elements in the Stanza della Segnatura (*Journal of the Warburg Institute*, II (1938), pp. 75-9), Wind referred to this wall as representing Jurisprudence, following the generally accepted interpretation of the four walls as the Four Faculties. The first sentence has been amended to make his meaning clear.

[2] [A recent discovery (cf. M. Putscher, *Raphaels Sixtinische Madonna*, 1955, pp. 83 and 225; also J. White and J. Shearman, 'Raphael's Tapestries and Their Cartoons, II', *The Art Bulletin*, XL (1958), p. 306) shows that there was an earlier project for a Last Judgement on the Giustizia wall of the Stanza, recorded in a drawing made in Raphael's studio (Louvre no. 3866, reproduced in Putscher, fig. 44). For further discussion of the drawing, see Shearman, 'Raphael's Unexecuted Projects for the Stanze', *Walter Friedlaender zum 90. Geburtstag* (1965), pp. 164 f.]

[3] *Respublica*, IV, 432B ff.

[4] *Ethica Nicomachea*, V, i, 1129a ff.

Christian dogma, human knowledge with divine wisdom. The fresco of Jurisprudence, placed as it is between the *School of Athens* and the *Disputa*, asserts and resolves in its lower section the contrast between secular and sacred Justice. On the side of the *School of Athens* the emperor accepts the Pandectae: on the side of the *Disputa* the Pope blesses the Decretalia. Should the fundamental idea of concordance between the heavenly and the earthly rule have remained unexpressed in the principal part of the fresco where Justice appears as the harmony of the virtues?

The three virtues are assisted by *putti*, who have been taken as purely ornamental figures. The *putto* on the right, next to Temperance, lifts his arm and points upwards. This is the traditional gesture of Hope. The two *putti* in the centre, next to Prudence, hold a mirror and a flame. The flame is an attribute of Faith, in accordance with St. Augustine: 'Illuminatio est Fides.'[5] The mirror, a normal attribute of Prudence, is also related to Faith: 'Videmus nunc per speculum in aenigmate.'[6] On the left, one of the children seems to be engaged in plundering the branches of the tree which Fortitude is holding (Fig. 40); and a tree offering its fruits to children was used as an emblem of Charity, as can be seen in a design by Holbein (Fig. 42) who, by emphasizing the destructiveness of the children rather than the charitableness of the tree, turned the image into a jest. The serious moral, as usual, can be read in Ripa's *Iconologia*.[7]

Thus Platonic Justice, the union of the cardinal virtues, is made concordant with the virtues of Christian grace: Faith, Hope, and Charity. In studying this group as a whole it might seem hazardous to seek a deeper meaning in the particular pairing of the virtues: Prudence assisted by Faith, Temperance directed by Hope, Fortitude mated with Charity. But at least in the case of Fortitude a definite point was intended—a personal compliment to the Pope. The tree of Charity which is held by Fortitude is an oak tree, the family emblem of the Della Rovere. Belligerence, the outstanding characteristic of Julius II, is united to the greatest of Christian virtues.

[5] C. Ripa, *Iconologia*, s.v. *Fede Cattolica*.

[6] I Corinthians xiii. 12.

[7] S.v. *Carità*. For further examples of charity in emblematic literature, and a discussion of children plundering trees, see Wind, *Giorgione's* Tempesta. *With Comments on Giorgione's Poetic Allegories* (1969), especially pp. 21 f. note 14, also note 11. Wind argues that the theme of Giorgione's enigmatic painting is 'a pastoral allegory in which *Fortezza* and *Carità* are dramatically placed in a setting of *Fortuna*', pp. 1–4. See also 'Charity. The Case History of a Pattern', *Journal of the Warburg Institute*, 1 (1938), pp. 322–30.

VII · An Allegorical Portrait by Grünewald
Albrecht von Brandenburg as St. Erasmus

THE painting in Munich by Grünewald of a meeting between St. Erasmus and St. Maurice (Fig. 18) has been the subject of many learned discussions,[1] but so far no one has been able to say exactly what the scene represents. Both saints are clearly characterized by their attributes. On the left St. Erasmus, Bishop of Antioch, holds the symbol of his martyrdom, the windlass by which his intestines were drawn from his body. On the right is St. Maurice, the Moorish knight, unmistakably African in appearance, accompanied by members of the Theban legion who followed him into martyrdom. Although the identity of the two saints is not in doubt, there is no event in their legends that corresponds with this encounter.[2]

The picture was ordered for the city of Halle by the archbishop, Albrecht von Brandenburg, who is portrayed as St. Erasmus.[3] That Albrecht should be seen in conversation with St. Maurice can be explained by a local circumstance: St. Maurice is the patron saint of the city. The principal church in Halle (Moritzkirche), the chief monasteries (Kloster zum Neuen Werck and Moritzkloster), and the castle overlooking the town (Moritzburg) were all dedicated to him. But St. Erasmus, in whose image the archbishop appears, has no similar

Journal of the Warburg Institute, 1 (1937), pp. 142-62 (with additions to the notes).

[1] The early literature concerning the theme of the picture is discussed in two classical works, H. A. Schmid, *Die Gemälde und Zeichnungen von Matthias Grünewald* (1911) and W. K. Zülch, *Der historische Grünewald. Mathis Gothardt-Neithardt* (1938). Further studies include R. Hünicken, 'Grünewald in Halle', *Zeitschrift für Kunstgeschichte*, v (1936), pp. 219 ff.; W. Fraenger, *Matthias Grünewald in seinen Werken. Ein physiognomischer Versuch* (1936); L. Grote, *Die Erasmus-Mauritius-Tafel* (rev. edn., 1957); A. Weixlgärtner, *Grünewald* (1962), with a bibliography by O. Kurz [and now U. Steinmann, 'Der Bilderschmuck der Stiftskirche zu Halle. Cranachs Passionszyklus und Grünewalds Erasmus-Mauritius-Tafel', *Staatliche Museen zu Berlin. Forschungen und Berichte*, XI (1968), pp. 69-104]. See also the bibliography in A. Burchard, *Matthias Grünewald* (1936); and the valuable references in K. Schottenloher, *Bibliographie zur deutschen Geschichte im Zeitalter der Glaubensspaltung 1517-1585* (1933-).

[2] Some writers claim to know a legend according to which St. Maurice was converted to Christianity by St. Erasmus

and declare this to be Grünewald's theme, for example O. Hagen, *Matthias Grünewald* (1919), p. 164; see now 4th edn. (1923), p. 188. But as this is chiefly quoted by those who try to explain the picture, it was probably invented for this very purpose and handed down uncritically. I am supported in this view by Father Paul Grosjean SJ of the Société des Bollandistes, and by Mr Francis Wormald, to whom I am greatly indebted for his constant help and advice in liturgical matters.

[3] [Albrecht was a serious patron of learning and had attracted to his court such humanists as Heinrich Stromer, Ulrich von Hutten, and Wolfgang Capito. In September 1517 he wrote to Erasmus to congratulate him on his edition of the New Testament, and Erasmus subsequently dedicated to him the *Ratio verae theologiae*; cf. *Opus epistolarum Des. Erasmi Roterodami* (Allen), III, nos. 661 and 745.] On the portraits see W. A. Luz, 'Der Kopf des Kardinals Albrecht von Brandenburg bei Dürer, Cranach, und Grünewald', *Repertorium für Kunstwissenschaft*, XLV (1925), pp. 41-77.

connection with Halle. He must be Albrecht's own patron saint to whom he seems to have felt a particularly strong allegiance,[4] for this is not the only instance of his being portrayed in this character (Fig. 19). Indeed, the evidence for Albrecht's cult of St. Erasmus is so striking and, for the solution of our problem, so instructive, that it will be necessary to relate it in greater detail.

The Cult of St. Erasmus in Halle and the Date of Grünewald's Painting

On Easter Monday 1516, two years after his accession to the archbishopric, Albrecht von Brandenburg introduced the cult of his saint to Halle. He arranged for the remains of the body of St. Erasmus to be transferred from Magdeburg, and to be deposited with great pomp in the chapel dedicated to St. Mary Magdalene in the castle of St. Maurice.[5] He seems to have looked upon this event as the beginning of a new era in the local worship of Halle, for in the following year (1517) we find him writing a letter which expresses great concern for a special procession in honour of St. Erasmus.[6] The same letter gives the order to negotiate *at any price* for the skull of the saint, then in the possession of the monks of Olivia. This transaction was evidently crowned with success, for the woodcuts of the *Heiltumsbuch* of 1520, an illustrated guide to the indulgences offered in Halle, show both relics—the skull as well as the body of the saint—as possessions of the church of St. Maurice and St. Mary Magdalene.[7]

The church bearing the name of these two saints was no longer the chapel in the castle of St. Maurice where the relics were first deposited, but a more stately substitute, a building of vast proportions, now the cathedral of Halle, which originally belonged to the Dominican Order but was acquired by Albrecht (with the special consent of Leo X) because it suited his ambitious ecclesiastical projects.[8] His predecessor, Ernst von Sachsen, had planned to establish a Collegiate Church (Kollegiatstift) and to place it under the protection of St. Mary Magdalene. This plan was eagerly taken up by Albrecht, who intended to carry it out on a grand scale and to connect it with the veneration of his favourite saint. The new establishment was to be named after St. Erasmus,[9] and an elaborate constitution was drafted which provided among other items that the provost and other superiors should receive the rank of prelates. The members, selected from the monastery of St. Maurice and released

[4] [But cf. now Steinmann, op. cit., pp. 92 ff.]

[5] *Cresses Annalen*, fols. 72b and 76b, quoted by P. Redlich, *Cardinal Albrecht von Brandenburg und das neue Stift zu Halle, 1520-1541* (1900), pp. 273 f.

[6] Magdeburg Archiv, *Erzstift Magdeburg*, II, 788, fol. 1, quoted by Redlich, pp. 274 f.

[7] There are two accounts of the *Hallesche Heiltum*: the so-called *Heiltumsbuch*, printed in 1520 and illustrated with woodcuts, and an illuminated manuscript, the *Liber ostensionis reliquiarum* (Aschaffenburg, Hofbibliothek Ms. 14), written a few years later; a selection of the woodcuts without text in R. Muther, *Das Hallesche Heiligthumsbuch vom Jahre 1520* (1889); a facsimile edition of the manuscript by P. M. Halm and R. Berliner, *Das Hallesche Heiltum* (1931). The

best study of both works is still Gabriel von Térey, *Cardinal Albrecht von Brandenburg und das Halle'sche Heiligthums-buch von 1520* (1892).

[8] The relevant documents were collected by J. C. von Dreyhaupt in the first volume of his monumental work, *Pagus nelitici et nudzici, oder ausführliche diplomatisch-historische Beschreibung . . . des Saal-Creyses, und aller dar-innen befindlichen Städte, Schlösser, Aemter, Rittergütter*, etc. (Halle, 1755). Additional documents in Redlich, op. cit., Beilagen; see also Gustav Fr. von Hertzberg, *Geschichte der Stadt Halle*, II (1891).

[9] Cf. A. Wolters, *Der Abgott zu Halle 1521-42* (1877), p. 31, who I think was the first to notice the role played by St. Erasmus. See also below, p. 67.

from their vows, were to become secular canons (*collegiata ecclesia saecularis*). A new residence was assigned to them near the church of the Dominicans, who were induced to exchange their abode for that of the Mauritians. This exchange of houses took place, again with great pomp, on 15 July 1520.[10]

The *Heiltumsbuch* printed in that year describes and illustrates the great treasure of the newly decorated church: its enormous collection of relics, '8,133 particles of saints' and '42 complete bodies'. St. Maurice and St. Erasmus figure prominently among them; they introduce the saints who follow immediately after the Apostles of Christ. The frontispiece (Fig. 17) commemorates the new foundation; the model of the Collegiate Church is held by the two archbishops who planned its establishment, Albrecht on the left, and his predecessor, Ernst von Sachsen, on the right.[11] Both are represented with their coat of arms, while the college's escutcheon is between them, directly under the church.[12] The three patron saints are assembled in the sky above: St. Maurice as the local saint in the middle, on the left St. Mary Magdalene who had been chosen by Albrecht's predecessor, and on the right St. Erasmus, the saint whom the archbishop had recently introduced.[13]

It is generally taken for granted that Grünewald's picture was ordered and painted for this Collegiate Church founded in 1520.[14] An inventory dated 1525 lists it as one of the altarpieces and so it was inferred that the picture must have been painted between 1520 and 1525. Most scholars incline to date it near 1525, for Albrecht was born in 1490, and they declare that a man who looks so stout ought to be at least thirty-five years old.[15]

However, the picture contains a symbol which renders these somewhat personal conjectures superfluous. The embroidered apparel of the archbishop's alb shows the emblems of Albrecht's three sees, the archbishoprics of Mainz and Magdeburg and the bishopric of Halberstadt; but there is no indication that the bearer is a cardinal. This curious omission has been the subject of some very ingenious speculation.[16] The actual facts permit, to my

[10] The principal sources for studying this event are the abusive reports of the Protestants who describe, with epithets hardly fit for print, the great 'pomp und gebreng eyner procession vorlauffener abtrüniger monche' (Redlich, Beilage 4, pp. 10* f.). A remarkable document representing the Catholic side is published by Dreyhaupt, p. 783.

[11] One of Albrecht's gracious habits, expressive of his reverence for tradition, was that he liked to associate himself, when he appeared as founder or donor, with the man who had preceded him and whose work he continued. This may explain the anomaly of the escutcheon of Dietrich von Erbach being added to his own coat of arms on Grünewald's *Lamentation* in Aschaffenburg. The fact that in the present woodcut he had himself represented in conjunction with a man already dead is an important precedent.

[12] It has the Brandenburg eagle in the centre, and its fields are filled symmetrically with St. Mary Magdalene's jars and with little salt heaps which refer to the salt mines of Halle, the main source of income of the new establishment.

[13] Although these three saints were considered the patron saints of the church, there is no reference to St. Erasmus, either in the actual name of the church, which is called after

St. Maurice and St. Mary Magdalene, or in the papal bull which codified its foundation. On the other hand, he is named in the document by which the new college became established (Dreyhaupt, p. 766; Redlich, pp. 14 ff., and especially p. 16 note 2). This implies that his cult in the church had a special reference to the college.

[14] Practically all writers report this as an established fact. H. A. Schmid, certainly the most painstaking of Grünewald students, says (p. 242): 'Es ist soviel wie sicher.'

[15] Redlich, p. 182; Hagen, p. 242. The exception is again Schmid (p. 250), who finds that the archbishop looks younger than in Dürer's engraving of 1519. Others scholars do not seem to have considered that Dürer's and Cranach's engravings of 1519, 1520, and 1523, which explicitly give his age as 29, 30, and 33, represent him as at least twice as old as he 'ought to be' according to their standards.

[16] Hagen (p. 242) chose to believe that the emblem referred to the time when the embroidery was made, but not to the time of the picture. Schmid (p. 245) imagined that the cardinal's insignia had been painted separately on the original frame and had been lost with it. The most ingenious argument, though equally misleading, is that of H. Feurstein, *Matthias Grünewald* (1930), pp. 67 f., who

mind, only one possible inference. Since the cardinal's insignia do not appear, the picture must have been painted at a time when Albrecht was not yet cardinal.[17] He became cardinal in 1518. This date must, therefore, be accepted as the *terminus ante quem* of the picture.[18]

The *terminus post quem* is easily settled. The traditional argument that the picture cannot have been painted before 1520, because that is the date of the foundation of the Collegiate Church, has no validity whatsoever. It fails to give sufficient weight to a signal event which took place four years before the church was founded and which stands in direct relation to the painting. In 1516, as already mentioned, the relics of St. Erasmus were acquired by Albrecht and with a great procession were introduced into the chapel of the castle of St. Maurice. I suggest that this event not only supplies the *terminus post quem*, but also explains the theme of the picture. Albrecht appears in the character of the saint whose relics he secured for the church in Halle, and St. Maurice is painted in the attitude of the host who greets and receives the newcomer—and the newcomer is, at the same time, Albrecht himself who was instrumental in bringing about this meeting.[19]

I think one can even identify the canon who accompanies Albrecht and whose face is seen in the background between the two saints. He is probably Johannes Pals, the provost of the Kloster zum Neuen Werck in Halle, an Austin Canon of St. Maurice who in contemporary documents is called the archbishop's chief counsellor (*Erzbischoff Albrechts fürnehmster Rat*).[20] He had been charged by Albrecht's predecessor with the first, already very difficult, negotiations for the establishment of the college,[21] and he took a central part in the transactions commemorated in the picture; for when the relics and treasures for the new college first arrived in Halle they were entrusted to him and his monastery before they were transferred in procession to the castle of St. Maurice. There is also every reason to believe that Albrecht intended to make him the provost of the new college, for its constitution says explicitly that its provost will be archdeacon of Halle,[22] and Johannes Pals was already holding that office. He must have died just before the college was established, probably in

declares that the emblem does not represent the personal coat of arms of Albrecht von Brandenburg, but only that of his sees. If it had been a personal coat of arms, Albrecht, we are told, would have added the Brandenburg eagle and the cardinal's hat, but in a heraldic representation of his functions as bishop these personal symbols had no place. Yet this argument would be valid only if the sees had really been an administrative unit by constitution. Actually they were united only *in the person of Albrecht*. The very fact that they are combined in one piece of embroidery makes it a personal emblem, so that Albrecht could very well have added the cardinal's hat. The alb and mitre were made by Grünewald's friend Hans Plock, cf. W. Stengel, 'Der neue Grünewald-Fund', *Zeitschrift für Kunstwissenschaft*, VI (1952), p. 73. See below, note 18.

[17] [But cf. now Steinmann, op. cit., p. 97.]

[18] In correspondence with Dr A. Weixlgärtner, Wind referred to one occasion when Albrecht considered the cardinal's hat so important that he had it painted in above

his coat of arms on the *Martyrdom of St. Erasmus* (Fig. 20) several years after the picture's completion. For a recent discussion of the heraldry in Albrecht's pictures, see Weixlgärtner, *Grünewald*, p. 86; cf. also the objections raised by Steinmann, pp. 97 ff.

[19] [Despite St. Maurice's welcoming gesture, Steinmann, p. 98, argues conversely that St. Erasmus was receiving St. Maurice.]

[20] Dreyhaupt, p. 704: 'stund wegen seines frommen Wandels und klugen Raths bey denen Ertzbischöffen Ernesto und Alberto in grossem Ansehen; daher ihn eine zu der Zeit gehaltene gerichtliche Registratur *Alberti vornehmsten Rath* nennt.' By virtue of his position as provost of the monastery Zum Neuen Werck, he was archdeacon of Halle (ibid., p. 701, Redlich, p. 51).

[21] Dreyhaupt, p. 846. It was again he who, in January 1516, accompanied Albrecht to a ceremony in the City Hall as the leader of his *fürnehmste Räte* (ibid., p. 190).

[22] Ibid., p. 850.

1519, for in that year his successor was confirmed in the monastery Zum Neuen Werck, and his own name does not appear in any later document.[23]

Although other names have been suggested for the canon in Grünewald's painting,[24] there is none in whom so many qualifications are united. In particular, there is no one else Albrecht could have considered as a personal link between himself and his predecessor whom he liked to honour as the originator of the plan.[25] Further evidence in favour of Johannes Pals may be derived from the canon's dress. The fringes of fur are apparently the last vestige of the old *ferraturae* or *Grauwerck*[26] remaining after the reform introduced in the Kloster zum Neuen Werck by Buschius.[27]

There is only one point which at first sight might still appear unsatisfactory. The chapel in the castle of St. Maurice, in which the Erasmus relics were deposited, was dedicated to

[23] Johannes Pals has been the subject of considerable confusion among historians. Dreyhaupt (p. 704) falsely identified him with his namesake, the Rector of the University of Trier, who wrote *Coelifodina*, a treatise on indulgences, and who died in Mühlhausen in 1511. This date is given by Dreyhaupt as that of the death of Johannes Pals of Halle. Yet Dreyhaupt's own collection of documents contains a deed dated 1517 (ibid., p. 732) which is signed by Johannes Pals and to which his personal seal is attached. T. Kolde, *Die deutsche Augustiner-Congregation* (1879), pp. 174 ff., tried to correct the error, but in doing so introduced a new one. He quoted a document published by J. B. Mencke, *Scriptores rerum Germanicarum*, II (1728), col. 1519, which said that in 1524 Johannes Pals, provost of the monastery Zum Neuen Werck, absconded with some of the monastery's treasures and became a Lutheran. Also discussed by J. K. Seidemann, *Erläuterungen zur Reformationsgeschichte durch bisher unbekannte Urkunden* (1844), p. 3. Now it can be shown that by 1524 Johannes Pals was no longer provost, but had been succeeded by Nicolaus Demuth, who in fact did become a Lutheran and absconded in 1523 (Dreyhaupt, p. 704). So it is evident that in this particular source Johannes Pals was confused with his successor. It is regrettable that this error was continued in the *Allgemeine Deutsche Biographie* (s.v. *Johann von Paltz*).

The following summary may help to dispel the confusion: (1) Johannes Pals was provost of the monastery Zum Neuen Werck, archdeacon of Halle, and the chief counsellor to both Ernst von Sachsen and Albrecht von Brandenburg. (2) He probably died in 1519, when he was succeeded by Nicolaus Demuth as provost of the monastery Zum Neuen Werck. (3) Unlike the latter, he did not become a Protestant nor did he abscond with the monastery's treasure.

The effect on the monastery of Nicolaus Demuth's defection was disastrous. In 1530 there were only three canons left. Albrecht then confiscated the monastery's goods, transferred them to the new collegiate establishment, and razed the buildings to the ground. The demolition aroused the anger of the reactionary opposition within the Catholic party. The accusations against which Johannes Crotus tried to defend Albrecht in his *Apologia* (see following note) are still reflected in Dreyhaupt's remarks (p. 705): 'Indeß ist zu bewundern, daß sich eben zur Zeit der angegangenen Reformation ein eyfrig catholischer Erzbischoff

finden müssen, der die vornehmsten Clöster, sammt verschiedenen Kirchen und Capellen zu Halle, selbst zerstöhret.'

[24] For example Johannes Ryder (Hünicken, op. cit., p. 221), who became provost of the new college. But this suggestion was sensible only as long as it was thought that the picture was painted after 1520. In 1517 Johannes Ryder was a subordinate figure; and even in 1520, after the death of Johannes Pals, his promotion can only be interpreted as an expression of Albrecht's embarrassment. On the other hand, the original provost of the Moritzkloster, to which Johannes Ryder belonged as a senior, refused to accept the new office and resigned (Dreyhaupt, p. 746). All these developments show how closely the fate of the new establishment was dependent upon the person of Johannes Pals and how strongly it was affected by his death. The only figure of prominence to join the college later was Johannes Crotus, the principal author of the *Dunkelmännerbriefe* (*Epistolae obscurorum virorum*). He became disgusted with the vulgarities of the Protestant campaign, renounced his allegiance to Luther, and returned to Albrecht. It was he who wrote the *Apologia qua respondetur temeritati calumniatorum non verentium confictis criminibus in populare odium protrahere Albertum*, etc. (1531).

[25] See above, note 11.

[26] Cf. Dreyhaupt, p. 701, where he discusses the 'Stand und Habit der Chorherren Ordinis S. Augustini' with special reference to the monks of the 'Convent des Closters zum Neuen Werck'.

[27] See Buschius' own account in *De reformatione monasteriorum*, reprinted by Leibniz in *Scriptorum Brunsuicensia illustrantium*, II (1710), p. 501. Chapter xiv, *De reformatione monasterii ad novum opus prope Hallis*, is the relevant one, and worth reading. The following is an example of its gross, though possibly unintentional, humour: 'Dixit autem mihi Marcgravius Brandenburgensis: Domine Pater, vos vultis Dominos istos reformare. Quis scit, an pater vester S. Augustinus habitum vestrum portaverit, an istorum Dominorum? ... Ego autem dixi, omnes reformati terrae huius in isto incedunt habitu, et non in habitu ipsorum. Respondit: Pater meus juxta *Nurenbergam* instituit monasterium huius ordinis in habitu ipsorum: sed Praepositus quandoque dormit cum mulieribus, et non est diu, quando hoc facere coepit. Et ego: Ergo non sunt reformati, ut praedixi, et ita quievit.'

St. Mary Magdalene. She ought somehow to appear in the picture; and, in a subordinate form, she actually does. Her figure is seen on the collar (the apparel of the amice) worn by Albrecht-Erasmus.

If it be accepted that these are the circumstances that make the picture intelligible, it follows that its date can be fixed within the span of one year. It must have been painted after Easter Monday 1516, when the relics of St. Erasmus were deposited in the castle of St. Maurice, and before August 1518, after which date the cardinal's insignia ought to appear on Albrecht's portrait. The year 1517, with several months' margin on either side, is, therefore, the date of the painting.[28] The supposition still universally held that it is one of Grünewald's latest works must be abandoned.[29]

This early date—an unwelcome one for those who, in accepting the painting as a *Spätwerk*, were too ready to trace the line of Grünewald's development—is supported by further evidence which tends to confirm the view that the panel was transferred to the new church but not originally painted for it.

1. According to the inventory of 1525, the new church had fifteen altars with painted altarpieces along the main nave, representing the successive stages of Christ's Passion (Diagram I).[30] Among these altarpieces Grünewald's panel is an anomaly. It is the only one that does not represent a scene from Christ's Passion, and efforts were made to counteract

(cont. p. 66)

[28] St. Maurice's armour with 'high neck-guards and sparse fluting' has been classified by Mr J. G. Mann ('Notes on the Armour of the Maximilian Period and the Italian Wars', *Archeologia*, LXXIX (1929), p. 233 note 3) among the 'earlier type of Maximilian armour'. He has kindly informed me that the early date of 1517 fits particularly well with his observations [cf. Steinmann, pp. 98 ff.].

[29] [Steinmann, pp. 97 ff., with reference to the armour of St. Maurice and the life-size statue of St. Maurice in silver armour that stood near the high altar in the Collegiate Church (*Liber ostensionis*, fol. 227ᵛ; Halm and Berliner, no. 174b, pl. 97), connects Grünewald's painting with Charles V's entry into Aachen in 1520, and dates it to 1520-2. See below, note 53.]

[30] The inventory of 1525, reprinted by Redlich (Beilage 17, pp. 42*-55*), gives the name of each altar and the theme represented in the altarpiece. Our list (Diagram II) omits the altars placed against the rood-loft (A, B, C in Diagram I) as there is no problem connected with them and they are irrelevant to our question. In our numbering we follow the inventory which begins 'im Aufgang auf Seiten des Probstes', that is, in the north-east corner, and continues from east to west along the north aisle. [See Steinmann, p. 72 note 21, who, like Redlich, pp. 30 and 133 f., puts the Probstseite on the south side.] After having mentioned eight altars, the writer of the inventory has reached the north-west corner. In moving across to the opposite side, he refers to the *Chörleintür* which is in the south-west. From here he proceeds eastward along the south aisle and, after having described seven altars, he reaches the south-east corner,

that is, the corner just opposite the one from which he started. This order is so clearly indicated in the description that it seems surprising it should have been misunderstood by both Redlich (pp. 172 ff.) and Schmid (pp. 238, 242 f. and 290). The confusion was evidently caused by the expressions 'auf Seiten des Probstes' and 'auf Seiten des Dechanten'. Redlich himself was apparently hesitant about his orientation. On p. 174 he locates the *Allerheiligenkapelle* 'im östlichen Teil des nördlichen Seitenschiffs', on p. 263 'im östlichen Teil des südlichen Seitenschiffs'. The second is correct.

As will be seen (Diagram I and below, note 47) there is some relation between the altars placed in corresponding bays. The altar of St. John the Baptist is opposite that of St. John the Evangelist, the altar of the Trinity opposite that of the Three Magi. The three patron saints have received the most distinguished places—the altars nearest to the east. St. Maurice's altar (north-east corner) is opposite that of St. Mary Magdalene (south-east corner), and that of St. Erasmus follows after that of St. Maurice. In the extreme west, this grouping of the three saints is repeated in the statues of the pillars, not indicated in the diagram. The two staircases in the north-east and south-east corners are also omitted. They are probably of a later date, as they do not appear in the description of 1525, which explicitly mentions the one in the south-west corner. That one staircase is of the seventeenth century is generally admitted, cf. G. Schönermark, *Beschreibende Darstellung d. ält. Bau- u. Kunstdenkm. d. Stadt Halle Prov. Sachsen*, N.F. I (1886), p. 230.

64

The Eloquence of Symbols

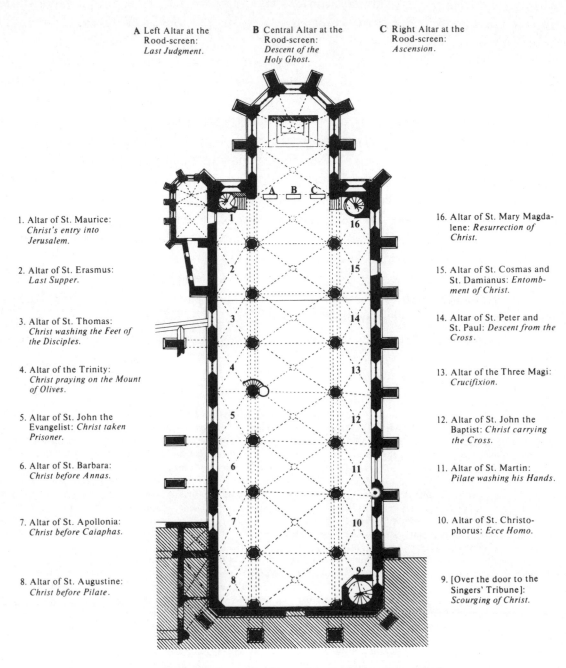

A Left Altar at the Rood-screen: *Last Judgment.*

B Central Altar at the Rood-screen: *Descent of the Holy Ghost.*

C Right Altar at the Rood-screen: *Ascension.*

1. Altar of St. Maurice: *Christ's entry into Jerusalem.*

2. Altar of St. Erasmus: *Last Supper.*

3. Altar of St. Thomas: *Christ washing the Feet of the Disciples.*

4. Altar of the Trinity: *Christ praying on the Mount of Olives.*

5. Altar of St. John the Evangelist: *Christ taken Prisoner.*

6. Altar of St. Barbara: *Christ before Annas.*

7. Altar of St. Apollonia: *Christ before Caiaphas.*

8. Altar of St. Augustine: *Christ before Pilate.*

16. Altar of St. Mary Magdalene: *Resurrection of Christ.*

15. Altar of St. Cosmas and St. Damianus: *Entombment of Christ.*

14. Altar of St. Peter and St. Paul: *Descent from the Cross.*

13. Altar of the Three Magi: *Crucifixion.*

12. Altar of St. John the Baptist: *Christ carrying the Cross.*

11. Altar of St. Martin: *Pilate washing his Hands.*

10. Altar of St. Christophorus: *Ecce Homo.*

9. [Over the door to the Singers' Tribune]: *Scourging of Christ.*

I. The Original Arrangement of the Altars of the Collegiate Church, Halle.

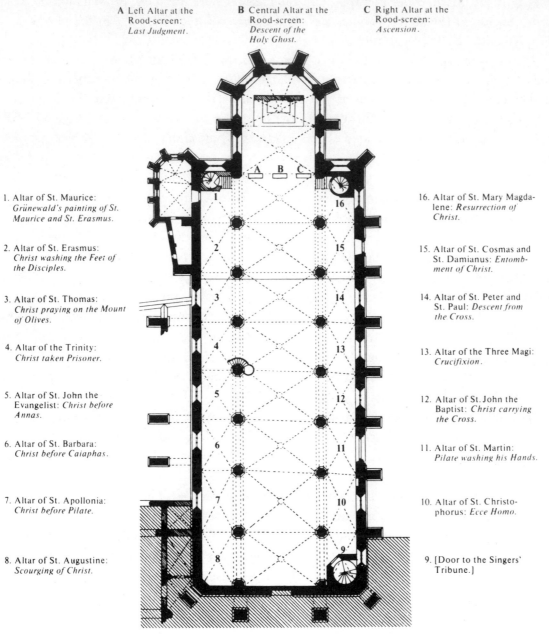

A Left Altar at the Rood-screen: *Last Judgment.*

B Central Altar at the Rood-screen: *Descent of the Holy Ghost.*

C Right Altar at the Rood-screen: *Ascension.*

1. Altar of St. Maurice: *Grünewald's painting of St. Maurice and St. Erasmus.*

2. Altar of St. Erasmus: *Christ washing the Feet of the Disciples.*

3. Altar of St. Thomas: *Christ praying on the Mount of Olives.*

4. Altar of the Trinity: *Christ taken Prisoner.*

5. Altar of St. John the Evangelist: *Christ before Annas.*

6. Altar of St. Barbara: *Christ before Caiaphas.*

7. Altar of St. Apollonia: *Christ before Pilate.*

8. Altar of St. Augustine: *Scourging of Christ.*

16. Altar of St. Mary Magdalene: *Resurrection of Christ.*

15. Altar of St. Cosmas and St. Damianus: *Entombment of Christ.*

14. Altar of St. Peter and St. Paul: *Descent from the Cross.*

13. Altar of the Three Magi: *Crucifixion.*

12. Altar of St. John the Baptist: *Christ carrying the Cross.*

11. Altar of St. Martin: *Pilate washing his Hands.*

10. Altar of St. Christophorus: *Ecce Homo.*

9. [Door to the Singers' Tribune.]

II. The Arrangement of the Altars according to the Inventory of 1525.

its isolation. Two pictures, *Christ's Entry into Jerusalem* and the *Last Supper*,[31] were hung next to it. Although other pictures from the Passion were hung on the walls to *continue* the series begun on the altars, Grünewald's is the only painted altarpiece in the nave that was supplemented by two such pictures.

It might be argued that this substitution of the picture of St. Maurice and St. Erasmus for an episode from Christ's Passion is sufficiently explained by the fact that the altar was dedicated to St. Maurice, one of the patron saints of the church. But this argument is invalidated by the fact that the altars of the two other patron saints, St. Mary Magdalene and St. Erasmus, are not treated in this manner. Their altars carry the obligatory picture from the life of Christ, in strict accordance with the sequence as a whole, and the pictures of the saints are relegated to the wings.

2. Two wings with pictures of saints were added to Grünewald's panel, thus enlarging it to a regular triptych, in exact correspondence with the other altars. Art historians have been puzzled by the fact that these additions were carried out by another hand.[32] Some suspected that they were added for a special occasion, but no such occasion could be named. I suggest that they were added at the time when the picture was transferred to the new church, and that they represent the adjustments necessary to fit in with the other altarpieces.

3. The church possessed a large number of isolated paintings that were hung on the walls and pillars. One of them bears the date 1516, which is a clear indication that it was painted before the foundation of the church and was transferred to it from another place. It is significant that the picture represents the martyrdom of St. Erasmus (Fig. 20), for this shows that the cult of St. Erasmus in Halle began in 1516 with the transference of his relics to the castle of St. Maurice, and was reflected in pictures painted in the very same year. The relics were introduced into the chapel on Easter Monday, and the picture must have been painted shortly after—a parallel to what we have assumed to be the case of Grünewald's panel.[33]

4. A final proof can be derived from artistic evidence. The woodcut edition of the *Heiltumsbuch* printed in 1520—the year which, according to the traditional view, is the *terminus post quem* for dating the picture—already shows the influence of Grünewald's painting. The figure of St. Victor (Fig. 30), one of the followers of St. Maurice, is clearly copied after Grünewald's figure of St. Maurice himself (Fig. 27). Not only is the general attitude the same, but even the hand that holds the sword is similar. This fleshy and sensuous, almost shapeless hand, which in the painting touches the sword with strangely

[31] The description in the inventory, according to Redlich (Beilage 17, p. 52*), reads as follows:

'Eyne kunstliche gemahlte taffel mitt sanct Moritz und S. Erasmo etc.

.

Darneben an der mawren: eyne taffel gemalt, wye Christus am palmentage ist eyngeritten.
Noch eyn ander taffel mit dem abentessen.'

[32] M. J. Friedländer and J. Rosenberg, *Die Gemälde von Lucas Cranach* (1932), no. 360, p. 97.

[33] The picture is described in the inventory of 1525 as *uff welsche art aussbereitt und verfast*. Is it possible that we have here a foreign style of conscious mannerism? This would throw new light on the character of the so-called *Pseudo-grünewald* and incidentally on Cranach's *style précieux*.

contorted fingers, is so characteristic of Grünewald's style and feeling that it is something of a shock to find it imitated in the flabby form of the hand in the woodcut.[34]

St. Erasmus as a Humanist Saint

The years 1516 to 1518, which would encompass the date of Grünewald's painting on the evidence presented here, were the most decisive in the development of the German Protestant movement. It was in 1517 that Luther placarded his ninety-five theses on the church door in Wittenberg. One must picture this general state of unrest in order to comprehend the steps taken by Albrecht. The introduction of a new saint at this particular moment must have been understood as an omen by believers; and the omen assumed a poignant significance through the fact that the name of the saint was Erasmus.

As long ago as 1877 Wolters proved in a remarkable study that Luther's expression 'Der Abgott zu Halle' was directed against the relic worship of Albrecht von Brandenburg.[35] In describing the *Hallesche Heiltum* Wolters somewhat tentatively presented a hypothesis that has not received sufficient attention. He suggested that Albrecht's cult of St. Erasmus, which is without precedent in the tradition of Halle, may have been due to his admiration for Erasmus of Rotterdam. A fact can be cited in support of this thesis that seems to have escaped Wolters's notice. In 1517, the very year when Albrecht was in the midst of fostering the veneration of St. Erasmus, he extended to Erasmus of Rotterdam an invitation to come to Germany.[36] The eulogies contained in this letter far exceed the typical humanist flatteries which one would expect. Albrecht began by rejoicing that he was born to see the time when Erasmus vindicated the German people (*communem Germaniam*) with regard to the accusation of barbarism. He praised Erasmus as the inspired man who, through his editions and emendations, gave back to divine theology her ancient purity and splendour.[37] When he came to the point of pressing his invitation, his language grew quite ecstatic: 'Et o foelicem illum (si quis nobis illucescet) diem, quo in tuam faciem hos oculos defigemus, quo ad suavissimum tuum eloquium has aures arrigemus, quo abs tuo penitus ore pendebimus!' Livy the historian and Christ the Saviour are invoked almost in the same breath to give force to these exclamations: 'Nihil enim inter nos et illos Titi Livii admiratores interesse censebimus. Quod faxit Christus Servator ut quem absentes ex libris admiramur, eius coram alloquio frui liceat.' At the end Albrecht suggested that Erasmus should write the Lives of

[34] In order to uphold the traditional dating, Hagen (p. 242) assumes that Grünewald copied the woodcut, which he mistakenly calls St. Maurice. It is curious and of some interest in our context that the reliquary of St. Victor which this woodcut is meant to reproduce, fol. P ii^v, is listed as a head reliquary, not a full figure, in the *Liber ostensionis*, fol. 259^v, the manuscript version of the *Heiltumsbuch* (cf. the concordance in Térey, op. cit., p. 72; also Halm and Berliner, pp. 70 f.). Another example of Grünewald's influence is the representation in the same printed book of the head reliquary of St. Maurice, the first figure of the Sechste

Gang, fol. L vi^v. Again the woodcut differs from the manuscript version, fol. 228^v, in just those formal traits in which it agrees with Grünewald. The life-size 'silver' St. Maurice, fol. 227^v, is not illustrated in the book.

[35] See above, note 9.

[36] Letter to Erasmus, 13 September 1517 (Allen, III, no. 661, pp. 84 f.).

[37] '. . . tu divinam theologiam, ab illa antiqua ac germana in novam quandam et impuram aliquot iam seculis deformatam, suo splendori reddis ac priscum in nitorem restituis.'

the Saints in *elegantiori et quali tu polles stilo*—in other words, *humanist* lives of the very saints whose relics he had collected in '8,133 particles' and '42 complete bodies'.

Erasmus was far too cautious to accept the invitation. He replied with elegant modesty: 'gratulor iis qui vere sunt id quod me credis esse'.[38] The fact, however, that the invitation was issued is indicative of the archbishop's plans. The presence in Halle of Erasmus himself would have completed and perfected that series of transactions which began when he acquired the saint's relics. Their abode was to be the Collegiate Church, so that the veneration of St. Erasmus would have been combined with humanist studies after Erasmus' model.

There is in this arrangement a curious crossing of medievalism and modernity altogether characteristic of Albrecht's method. He established his college by dissolving a monastery: the monks of St. Maurice were transformed into secular canons. This was distinctly an act of enlightenment, but this very act became the occasion for introducing a relic worship whose gigantic proportions aroused the fury of Luther.[39]

Narrowly rational minds might be inclined to explain away the devotional side of this transaction by attributing it to hypocrisy and a desire for exploitation. But these minds, I fear, are more primitive than those which they try to interpret. To imagine Albrecht as a cynical abbé is, to say the least, anachronistic. Before the Protestant 'conscience' had been fully developed, every churchman thought it meet and proper that objects of devotion should supply the substance for artistic embellishment and intellectual study, which in their turn were to serve the church that nourished and maintained them. To combine Catholic orthodoxy with a taste for humanism was the great endeavour of the age; and Albrecht expressed his allegiance to this aspiration by introducing the worship of a humanist saint.

From the point of view of Catholic ritual, it was no doubt an innovation to venerate St. Erasmus for the sake of humanism. Each saint, in the hierarchy of Heaven, has a particular power to intercede. In view of the awkward martyrdom he had suffered, St. Erasmus intercedes chiefly for men and women suffering pain that even remotely resembles his torture: victims of intestinal disorders, women in labour, travellers by sea, etc.[40] That the saint assigned to these very specialized functions should suddenly become a saint for humanists is due to a novel way of approaching him, the humanist approach *par excellence*. It was Albrecht's admiration for Erasmus the man that prompted him to place himself under the protection of Erasmus the saint. This personal allusion in an act of devotion may seem to resemble a frivolous pun, and there is no reason to deny that a verbal element is involved. But a name and a word mean far more to a religious mind than to a purely rational one. St. Jerome had written an onomasticon in which he translated the Hebrew names into Latin, so that readers of the sacred stories could better understand their moral significance.

[38] Letter to Albrecht, 22 December [1517] (Allen, III, no. 745, pp. 176 f.).

[39] [It was the elevation of Albrecht to the see of Mainz in 1514 that had occasioned the granting of the special indulgence that brought Tetzel on the scene, and prompted Luther's attack in the ninety-five theses.]

[40] As one of the fourteen *Nothelfer*, St. Erasmus had particular power in times of epidemics. These traditional functions he also retained in Halle (cf. Albrecht's letter of 26 May 1517, Redlich, Beilage 2, p. 8*).

When he came upon a name which signified nothing (for example, that of Joel's father) he changed it by a daring conjecture: a meaningless name would have been a contradiction in terms. A man like Albrecht, who lived in this tradition, could not consider it a mere accident that the man whom he so much admired should have the name of Erasmus. In searching for the cause of the man's enviable virtues, he turned to the saint whose name he bore.

This verbal way of thinking, so deeply rooted in the medieval tradition, had a particular appeal for humanists. It was part of their profession to play with words, and both their flattery and their wit relied on a shrewd understanding of puns. The Medici, because of the resemblance of their name to *mendici*, were said to be invariably kind to beggars, Michelangelo was addressed as *Angel Divino*, Alberto Pio could not help being 'pious', and Erasmus wrote his *Moria* for Morus. This delight in discerning verbal allusions and elaborating them with more or less ingenuity ranges from the slightest and most superficial jokes to the profoundest expressions of love, faith, and devotion. 'What's in a name?. . . a rose by any other name would smell as sweet.' The touch of hopeless protestation that lies in these words could be felt only by one who knew to the core the secret power of verbal allusion.

It is in this spirit of a 'faith in names' that Albrecht must have chosen St. Erasmus for his saint. In this verbal aspect of his devotion, there is an element of 'invention', not to say of wit—what pleased the humanist could not offend the bishop.

As a humanist bishop, he appears in Grünewald's painting enacting the part of a humanist saint. Again, a cynic might find it strange that a prelate should have himself portrayed as a saint. But for an orthodox Catholic of the sixteenth century this was a privileged method of approaching the saint and securing his aid and blessing. By appearing in the character of St. Erasmus, Albrecht not only confessed himself to be an Erasmian by faith, but also probably even hoped, by the magic use of that symbol, to acquire some of the truly Erasmian virtues ($\dot{\epsilon}\rho\dot{\alpha}\sigma\mu\iota\sigma\varsigma = amabilis$).[41]

When Albrecht became cardinal in 1518, he was faced with a delicate problem of etiquette. St. Erasmus, in whose image he liked to be pictured, had been a bishop but never a cardinal. Was it fitting to have oneself portrayed in a robe symbolic of a greater dignity than that of the saint whom one imitated? Albrecht's logic was irreproachable. When he changed the garment he changed the saint: St. Jerome took the place of St. Erasmus (Figs. 21–2). It would be a foolish misunderstanding to interpret this step as a breach of allegiance or as a sign that little meaning was attributed to these 'masquerades'. Albrecht did not abandon any of his humanist convictions, he only asserted them on another level of the hierarchy. St. Jerome was a cardinal and at the same time a man of a truly Erasmian temper. To assume his character was to combine the cardinal's robe with an attitude of study and retirement.

[41] Albrecht played on this meaning when he addressed Erasmus in the superlative: 'amabilissime Erasme'. [On the influence of Erasmus on the programme of Albrecht's statuary for the Cathedral in Halle, see now E. Kähler, 'Der Sinngehalt der Pfeilerfiguren und Kanzelplastiken im Dom zu Halle', *Wissenschaftliche Zeitschrift der Ernst-Moritz-Arndt-Universität, Greifswald. Gesellschafts- und Sprachwissenschaftliche Reihe*, v (1955/6), pp. 234 ff., who found, on the statue of St. Paul, a Greek inscription that is taken from Erasmus' text of the New Testament. Cf. also Steinmann's (pp. 71 f. and pp. 92 ff.) discussion of Kähler's discovery, and his argument that Albrecht's cult of Bishop Erasmus is an old Hohenzollern tradition rather than a novel symptom of his admiration for Erasmus of Rotterdam. Neither explanation necessarily excludes the other.]

This was what Albrecht desired, and even here a personal homage to Erasmus may have been intended. For Erasmus himself had praised St. Jerome as the humanist wit among the Church Fathers, as the saint who, in the serenity of his faith, wrote a classical Latin of immaculate beauty. When Albrecht invited Erasmus to come to Halle, he referred explicitly to his edition of St. Jerome by which the saint had been resurrected *quasi* from death. 'What could have been more painful than to hold in one's hands that mutilated "Jerome", disfigured beyond recognition? But through you he has been returned to the light and called back, as it were, from death into life. *Macte virtute, decus Germaniae, amabilissime Erasme; sic itur ad astra.*'[42]

The Ritual Place of Grünewald's Painting

The Renaissance delight in punning is so well known to literary and social historians that it would be remarkable if it had no place whatsoever in the history of Renaissance art. To my knowledge, no study of the subject as yet exists.[43] For this reason, the suggestion I am about to make, that the 'spirit of allusion' has entered into the very composition of Grünewald's picture, might be mistaken for an isolated instance. It could be shown, however, that the habit of introducing pictorial allusions, which imply a meaning without disclosing it directly, was fully developed under Julius II, that Raphael's and Michelangelo's works abound in these ambiguities, and that the fashion reached its climax under Leo X, who in more ways than one must be regarded as Albrecht's guide, if not his model.

Grünewald has arranged his figures in a characteristic pattern. A knight, dressed in silver armour and coming from the right, meets a priest who, dressed in long, heavy garments, approaches from the left. This is the traditional way of representing a scene which, in the mystical interpretation of the scriptures, had assumed the highest symbolic significance: the meeting of Abraham and Melchisedek (Fig. 25). In this meeting, Melchisedek the priest is said to have brought bread and wine to the knight. Therefore the scene foreshadows the Last Supper. It is a prefiguration of the mass.[44] Its power over the Christian imagination has been constant: one finds it in monumental sculptures of the Middle Ages as well as in pictures by Grünewald's own contemporaries. In the woodcuts of the *Biblia Pauperum* Melchisedek even wears a bishop's mitre (Fig. 26).

There is no doubt that Grünewald modelled his picture after this prototype. The only doubt that can arise is whether he intended it to be understood as an allusion or whether it

[42] Allen, III, no. 661, p. 85. An enquiry into the role of Jerome as a humanist saint would be worthwhile. Long before Albrecht, humanists had themselves portrayed in his image (see Antonello da Messina's *St. Jerome* in the National Gallery, London). Perhaps even some of Erasmus' own portraits ought to be interpreted in this way. This would give additional meaning to the contemporary expression 'Erasmus im Gehäus'.

[43] I do not mean the study of emblems and devices which abound in puns; for these puns are not strictly pictorial. An *impresa*, being a contracted legend, requires expansion by words so as to be understood; and as the meaning is intended to be hidden and secret, it is no wonder that the pun is often very far-fetched. Generally, the words must be pronounced for the pun to be noticeable. One could not guess, for instance, why the picture of a sphere should be an image of hope unless one pronounced the word *sfera*, the sound of which distantly resembles *spero*. See A. Warburg, 'Delle "Imprese Amorose" nelle più antiche incisioni fiorentine', *Gesammelte Schriften*, I (1932), pp. 85 and 337.

[44] K. Künstle, *Ikonographie der christlichen Kunst*, I (1928), p. 283.

is just another case of a supposedly neutral *Typenübertragung*. Happily there is a criterion which takes us beyond the realm of speculation. Though we do not know the original setting in which the panel was seen in its first abode, we do know the altar on which it was placed after it had been transferred to the new Collegiate Church. We have observed that the altarpieces along the nave of the church, with the exception of Grünewald's panel, represented the successive stages of Christ's Passion (Diagram II). The sequence of these scenes indicates clearly that the altar on which Grünewald's panel was placed is exactly the one which *ought to have had* the Last Supper. We also saw that a picture of the Last Supper was actually juxtaposed to it,[45] so that the effect was to suggest a typology best known through the *Biblia Pauperum* (Fig. 26).[46]

It is, of course, possible to dismiss this as evidence by declaring it accidental that the altar on which the panel was placed just happened to call for a representation of the Last Supper. This seems very forced to me. The simpler view is to admit that there was some planning in this arrangement, that the picture, because it contained this allusion from the first, was therefore assigned this particular place.[47]

But what motive could Albrecht and Grünewald have had for incorporating into a picture already packed with meaning the additional allusion to Melchisedek?

To celebrate mass is the highest office of the priest. In a picture which ostentatiously displays the ecclesiastical dignities held by Albrecht, he would want this office to be indicated. A simple way would be to have him wear the chasuble—the special vestment in which a priest celebrates mass. Albrecht is actually wearing it. But he does not seem to have considered this simple device adequate. The office of celebrating mass was for all time foreshadowed in the archetype of Melchisedek the priest. Every priest who officiates at mass *repeats*, as it were, the act of Melchisedek. His name is invoked in the Canon of the Mass, and the crescent-shaped support of the host in the monstrance was even called 'Melchisedek'

[45] See above, note 31.

[46] The significance of the *Entry into Jerusalem* mentioned in the inventory together with the *Last Supper* will be explained later (see below, note 52).

[47] That there was a purpose in the arrangement can be inferred from the original order. When Albrecht had Grünewald's painting removed from the church in 1540, he wrote that *Christ's Entry into Jerusalem*, which was hanging on the north wall, should be put *back* on the altar of St. Maurice: 'Item die zwei grosse tafelnn uff beyde altaria in den abseyttenn, als sanctj Mauritij und der ander Marie Magdalene, soll man auch in meyn haus setzenn. Und soll uff sanct Moritz altar die tafell vonn der wandt mit dem palmtag widder gesatzt unnd uff sanct Magdalenen alttar die tafel mit der figur des heyligenn geists' (Redlich, Beilage 40, pp. 188*-9*).

The word 'widder' ('again'), in conjunction with the evidence contained in the inventory of 1525, gives the key to the original arrangement of the series (cf. Diagram I) which proves to be clear and simple, as there are nineteen pictures available and exactly nineteen places for them in the church. When Grünewald's painting was introduced and placed on the altar of St. Maurice, *Christ's Entry into*

Jerusalem had to be removed from this altar; it was placed next to it on the wall. Now the curious and interesting point is that the picture of the Last Supper, which was the next in order, was also removed from its altar and placed next to the altar of St. Maurice (cf. above, note 31). Exactly why was this done?

The effect was decidedly awkward. The pictures which followed had to be moved up one place. The *Scourging of Christ*, originally hanging near the *Chörleintür* in the south-west corner, came thus to be placed on the altar of St. Augustine in the north-west corner; and the vacant place near the *Chörleintür* was filled with pictures which, like those hanging on the pillars, are not part of the series.

It was probably at the time of this general rearrangement that the rood-screen was moved to the front so as to enlarge the choir (as suggested by Schmid). Three new altarpieces were then made for the rood-screen, and the three paintings originally placed there (the *Ascension*, the *Descent of the Holy Ghost*, and the *Last Judgement*) were removed to the south aisle. [Cf. Steinmann's objections (p. 87) to the reorganization of the altarpieces as demonstrated here in Diagrams I and II.]

in Germany.[48] By the very fact that Albrecht was a priest, he was 'another Melchisedek'. To allude to that age-old power of priesthood vested in him was not inappropriate in this particular picture, since St. Erasmus himself had been a priest. He, too, was 'another Melchisedek'.[49]

In working out this allusion, Grünewald seems to have taken care not to destroy the fabric of the main story by overstressing the point of the secondary one. It would have been possible, for instance, to make the allusion to Melchisedek blatantly clear by having him carry bread and wine; but this would bring to the foreground a potent symbol that could unduly interfere with the meeting between St. Erasmus and St. Maurice (not to speak of the fact that on this level of the story St. Maurice is the host and not St. Erasmus). The art of handling such allusions is to make them understood without rendering them offensive, and the instinctive regard for both these requirements is expressed to perfection in Grünewald's formula. He has chosen the general type of composition which is associated with the 'meeting of Abraham and Melchisedek'. Within this general frame he has represented the Archbishop in a garment which he would wear only when celebrating mass, and accompanied by an attendant who, as is suggested here, was the archdeacon.[50] The reception of St. Erasmus by St. Maurice remains the principal theme; but also, in the meeting of these two saints, there is an overtone of the highest mystery that the Church confers upon the priest.

The intellectual efforts we are obliged to make in order to reconstruct the setting in which Albrecht lived must not be projected into Albrecht himself or into any of his contemporaries who saw the picture, least of all into the artist who designed it. To judge the psychological plausibility of our thesis, we must imagine one of these contemporaries who lived in Halle, who was accustomed to participate in local worship, was sufficiently versed in Scripture to recognize a parallelism when he saw it, and perhaps enough of a humanist to enjoy tracing and understanding an allusion. If such a man saw Grünewald's picture, he would first of all recognize the two saints: St. Maurice, the patron saint of Halle, and St. Erasmus, the new saint whom Archbishop Albrecht had introduced and in whose character—very suitable to a humanist—he had been portrayed. No doubt he would relate the meeting of the two saints to the joining of their relics in the very church in which he saw the picture.[51] He would

[48] Künstle, loc. cit. Mr Wormald has pointed out to me that, when the choir was enlarged, the Blessed Sacrament was probably moved from the High Altar to the east end of the north aisle, which in many other churches of the Middle Ages is the place where the Blessed Sacrament was reserved. The altar of St. Maurice thus became the altar of the Blessed Sacrament; and to emphasize this liturgical function the picture of the Last Supper was moved near to it, and thus the allusion to Melchisedek, contained in Grünewald's painting, received a liturgical substantiation. It is very likely, in Mr Wormald's view, that this corresponds to the original function of the picture in its first abode, where it may also have been placed on an altar of the Sacrament.

[49] Albrecht's preoccupation with Old Testament typology is evident in the 'error' of his first letter to Erasmus (Allen, III, no. 661, p. 85): 'Quid enim desyderari magis etate nostra potuit quam ut emendatiora essent Veteris Instrumenti exemplaria?' The compliment was quite misplaced as Erasmus had edited the New, but not the Old Testament; cf. J. Huizinga, *Erasmus* (1924), p. 178.

[50] Grünewald seems to have placed in the attendant's left hand an object which refers to the general cult of the relic or to the particular mass celebrated in its honour—an implement which in the fresh condition of the picture was probably more easily identified than it is today. As the canon's hand holding the object is exactly in the centre of the painting, Grünewald must have thought it important that it should be noticed, though here again he took pains to keep it subdued in tone, so as not to disturb the principal accents of the scene. [Steinmann, p. 103, following H. H. Naumann, sees the object held by the canon as a finger-relic.]

[51] Like the picture, the relics themselves were transferred to the Collegiate Church (cf. Redlich, pp. 20 ff. and 228 f.).

notice that Albrecht was dressed to celebrate mass and would find it fitting that he should be accompanied by an attendant whom he knew to be the archdeacon. He would feel that he had seen this scene of the meeting between priest and knight infinitely often before, namely, every time the story of Abraham and Melchisedek was presented to him as a prefiguration of the Last Supper; and having been struck by this idea he would notice with satisfaction that the panel was placed on an altar actually referring to the Last Supper and that a picture of the Last Supper was juxtaposed to it.[52]

If this ideal spectator were gifted with a sense for colour and form, he would probably enjoy the fact that the great richness of meaning with which this picture is packed has a visual counterpart in its crowded appearance, in the density with which these jewelled materials fill and transfigure the available space. Although Grünewald seems almost haunted by a *horror vacui*, he has enlivened the picture by a telling contrast: the vividness of the background figures, which are handled with an impressionist's brush-stroke, intensifies the stilted, mummified appearance of the two principal actors in the foreground. Although they seem to act out a living scene, they have the look of relics.

Indeed, most of the details of the equipment can be referred to actual reliquaries and other implements of ritual. The jewelled wreath on the Moor's head resembles closely the one which decorated the head reliquary of St. Maurice (Fig. 31).[53] The bishop's crozier with the figure of the Virgin corresponds very closely to the one described in the inventory of the possessions left by Albrecht after his death;[54] and the scenes on the mitre contain allusions both to a mitre on a head reliquary of St. Erasmus and to one that belonged to Albrecht.[55]

[52] There is little doubt that *Christ's Entry into Jerusalem*, mentioned in the inventory together with the *Last Supper*, was meant to be seen in relation to Grünewald's panel. While the *Last Supper* referred to the liturgical meaning of Grünewald's picture, the *Entry into Jerusalem* may have referred to its commemorative function. The event commemorated by Grünewald, the Entry of St. Erasmus into the diocese of Halle, was probably interpreted as being one 'type' with *Christ's Entry into Jerusalem*. There is ample evidence of this mode of thinking in the local records of Halle. When the Dominican monks exchanged their abode with that of the Mauritians (see above, pp. 59 f.), the event took place on the feast day of the *Divisio Apostolorum*. The monks were meant to 'repeat' what the Apostles had done before them. In the same way *Christ's Entry into Jerusalem*, by being placed next to Grünewald's panel, may suggest that St. Erasmus 'repeats' the Entry of Christ into the Holy City. [Recently Steinmann, pp. 98 ff., has proposed another typology, the Reception of David as Conqueror.]

[53] [From the time when Louis Réau first made the romantic suggestion that the idea of painting the meeting of St. Erasmus and St. Maurice came to Grünewald when he saw Albrecht standing before the life-size silver reliquary of St. Maurice (*Liber ostensionis*, fol. 227ᵛ), scholars have continued to accept this anecdote without questioning its source (cf. for example, Steinmann, pp. 98 ff.). They have also assumed that Grünewald's painting postdated the reli-

quary, which was first recorded in Halle in 1521. In a letter to Dr Weixlgärtner, dated 22 December 1950, Wind discussed the problem and expressed regret that he had not referred to it in his article, although, having proved, he thought conclusively, that Grünewald's panel was painted in 1517, he had not considered it strictly relevant. He suggested that the design for the reliquary could be attributed to Grünewald, since he had on other occasions supplied drawings for craftsmen such as the silk embroiderer, Hans Plock, who had made Albrecht's alb and mitre (cf. above, note 16), and Plock's goldsmith brothers. Weixlgärtner (op. cit., p. 89) also maintained that it was not necessary for Grünewald to have seen the reliquary before painting the picture.]

[54] This is Redlich's observation (p. 181), and Schmid's criticism (p. 250 note 1) has corrected but not disproved it.

[55] The scene on the mitre has been described by Hagen (p. 242) as an Annunciation; and an Annunciation was actually to be seen on the head reliquary of St. Erasmus (Fig. 24). On closer inspection it seems strange that the figure that is said to represent the approaching angel is provided with heavy armour and a spear, while the figure receiving the message holds four peculiar round objects which look like stones (Fig. 23). The alternative is to suppose that the figures are the saints who appeared on Albrecht's mitre when he was the local bishop, cf. the mitre on the statue of his predecessor, reproduced in *Journal of*

The display of all these objects was not meant merely to arouse disinterested pleasure. They were intended to convey a sense of the immense accumulation of treasures which, as we shall see, was part of Albrecht's ecclesiastical policy.[56]

Rarely has there been a more complete harmony between the intentions of the patron who ordered the picture and those of the artist who painted it. A curious interpenetration of the old and the new was characteristic of Albrecht's outlook, and the same is true of Grünewald's artistic impulse. It expresses itself clearly in the figure of the Moor (Fig. 27). Grünewald must have known the woodcut by Cranach of St. George (Fig. 28), which was modelled after a figure by Dürer (Fig. 29). If one accepts Dürer as a standard of modernity and arranges the three pictures in order of date, putting Dürer's first and Grünewald's last, they represent a retrogressive series. Dürer's figure shows clearly the classical *contraposto*, then considered modern. Cranach retains it, but adds a setting of elaborate romantic confusion. Grünewald gives it up altogether and returns to a medieval pose. We have reason to suspect that this medievalism was not unconscious. A statue formerly in Halle on the outside of the church of St. Maurice (Fig. 32) represented the saint with the face of a negro and in the awkward attitude of medieval grace. While bending towards the right, he lifts his right arm and steps forward with his right foot: the very opposite of classic equilibrium. It is by using this position literally that Grünewald differs from both Cranach and Dürer.[57]

This attachment to medieval form is united with a hypertrophic sensitivity in his rendering of the surface of things. The white kid gloves, the piece of bare black skin at the wrists, the silver armour, all these are handled and juxtaposed with a gusto for exploring the visible world that reaches its climax in the extreme pleasure he must have experienced in modelling this black face. The 'technique' of the picture is one with the 'story': a unique blending of medievalism with a striking sense of modernity. It was the tragedy of Albrecht's career that the same pattern that was of triumphant grandeur in art proved to be a failure in politics.

The Religious Policy of Albrecht von Brandenburg

Albrecht's political acts were in exact correspondence with his character. As an orthodox Catholic and a professed humanist he could not but favour a policy of conciliation. At the

the *Warburg Institute*, I (1937), pl. 19c. If this is so, how are we to explain the position of the two figures, which really is—I think Hagen is right here—very strongly reminiscent of an Annunciation?

As no explanation has yet been offered, I suggest that we have here on a small scale the same use of metaphor, the same interpenetration of types, which pervades the picture as a whole. As Albrecht von Brandenburg enacts the role of St. Erasmus, the saints that would normally appear on his mitre enact the scene which would normally appear on the mitre of St. Erasmus' reliquary. It cannot be repeated often enough that we are here dealing with a kind of humanist devotion which seeks metaphor with a sort of mystical delight.

[56] As if he had foreseen the danger, and possibly to safeguard himself against the Fuggers, who had financed his policy, Albrecht made a special contract with the chapter according to which these treasures were not to be sold unless the church was in extreme need (Dreyhaupt, p. 879; Redlich, p. 230).

[57] The resemblance to the statue is the more remarkable as this particular piece had a far less prominent place in Halle than Konrad von Einbeck's over-life-size *Moritz*, who had the westernized traits of a sturdy Christian soldier, not the exotic charm of a black-faced knight.

Diet of Augsburg he appeared as the foremost spokesman for a peaceful settlement with the dissenters. The fact that he became cardinal at the age of twenty-eight shows how great were the hopes men placed in his powers. But his fame was as short-lived as that of Leo X, with whom he had many traits in common. His sumptuous patronage of art and learning, his ambition to glorify the Church through the accumulation of treasures, his pious belief in the efficacy of relics, all these combined to deprive him of the strength to quell the growing religious revolt. When it began, it found him mild and pliant.[58] When it had grown beyond control, he tried to suppress it by brute force,[59] but in vain. Twenty-one years after he had so positively expressed his faith in the virtue of Catholic ritual by exhibiting that vast collection of costly relics which now were to prove of no avail, he had to admit himself defeated. In 1541 he was forced to dissolve the College of St. Erasmus and relinquish the church to which it was joined, the church he had remodelled and furnished with all the splendour due to a *domus Dei*. What was left of his treasures he transferred to Aschaffenburg, thus abandoning his favourite residence of Halle in which—as a true Renaissance cardinal—he had already built his tomb.

In his person had been united the great vested interests of the Catholic Church, the house of Brandenburg, and the firm of the Fuggers in Augsburg. That he aimed at concentrating in himself the power of controlling the three principal German bishoprics was an unheard-of ambition and can be explained only as part of Brandenburg policy.[60] He required, to carry out his plan, a special permission from the Pope, which he received.[61] Leo X would never have granted this permission had he not been advised that the colossal financial burden could be met by a loan from the house of Fugger.[62] The Fuggers, in their turn, would never have granted this loan had they not been entitled, again with the Pope's explicit permission, to one-half of the returns of the great 'indulgence' which Albrecht was to establish in his bishoprics and which became the chief butt of Luther's attacks.

One is apt, in thinking of the fatal outcome of this enterprise, to forget its propitious beginnings. The Pope, the Fuggers, and Albrecht himself were united in one common front which aimed at concentration of power. That such a union not only existed by intent, but that it actually succeeded in its initial stages, makes the ultimate failure the more remarkable. What, then, were the errors of calculation which Albrecht and his supporters committed? One may say—and this is the easiest answer—that all the participants in this action, Leo X, the Fuggers, and Albrecht himself, underestimated the degree of religious unrest and the moral seriousness of the Protestant temper. But the question, I think, ought to be put and

[58] Letter to Luther, 'am Tage Thomae Apostoli, Anno 1521': 'Denn ich von mir selbst nichts vermag, und bekenne mich, daß ich bin nötig der Gnaden Gottes, wie ich denn ein armer sündiger Mensch bin, der sündigen und irren kann, und täglich sündiget und irret, leugne ich nicht; ich weiß wohl daß ohne die Gnade Gottes nichts Guts an mir ist, und sowohl ein unnützer stinkender Kot bin, als irgend ein ander, wo nicht mehr.

Das habe ich auf Euer Schreiben gnädiger Wohlmeinung nicht wollen bergen, denn Euch Gnad und Guts umb

Christus willen zu erzeigen, bin ich williger denn willig.' (*D. Martin Luthers Werke*, Kritische Gesamtausgabe, *Briefwechsel*, ed. O. Clemen, II, 1931, no. 448, pp. 420 f.)

[59] For details of the edicts of expulsion or imprisonment and the gruesome case of Hans Schenitz, see Redlich, pp. 321 ff., and especially p. 324.

[60] Huizinga, op. cit., pp. 178 ff.

[61] Dreyhaupt, pp. 188 f.

[62] Redlich, pp. 325 ff.

answered more concretely: what exactly was done with this power when it became concentrated in Albrecht's person?

He used it to reinforce, by traditional means, the authority of the Church over its adherents. He refined and expanded to the utmost those paraphernalia of ritual and guidance which in the past had never failed to produce their effect. The splendour of the Church was to impress the believers, the intelligence of its priests was to persuade and instruct them. Grünewald's painting is the greatest monument that he was able to erect to this hopeless endeavour.

And it was, indeed, hopeless: for he very soon found himself in a truly Erasmian dilemma. The reformers scoffed at his display of relics, while the monks detested him because of his enlightened measures. His ambition to unite traditionalism and reform involved him in the most complicated transactions with persons who resented his interference. Any other man would have built a new church for the newly established College; Albrecht insisted upon remodelling an old one. For this purpose he had to acquire the church from an order of monks who were unwilling to release it and whom he had to force by a papal decree. The new men who took over the church and established the college were themselves not really new. They were recruited from another monastery and could not take over their function without being released from their vow, again by a special papal decree. The great power which Albrecht wielded with constant papal reinforcement was thus focused on settling local disputes by decrees which he himself might regard as minor adjustments, but which, being backed by the highest ecclesiastical authority, could serve a militant and recalcitrant temper as a welcome signal to revolt.

To do justice to the vanquished party is among the most difficult tasks of the historian. In the case of Albrecht, the difficulty is increased by the ambiguous outlines of his character. It would be a hazardous enterprise, in any man, to distinguish between the virtue of clemency and the vice of indulgence. But one need only look at Albrecht's face to realize that—as with the face of Leo X—the graces and failings of his person were inextricably mixed. One quality he certainly did not possess, and that proved to be the one which was indispensable: vigilance. It is a curious irony that he should have been deficient in that power which was the outstanding trait of his idol, Erasmus.

VIII · AENIGMA TERMINI

The Emblem of Erasmus of Rotterdam

IN 1509, while travelling in Italy, Erasmus received from his pupil, Alexander Stewart, the gift of an ancient gem which an Italian antiquary identified as a figure of Terminus. Erasmus had it copied on his seal, adding the name TERMINVS and the legend CEDO NVLLI—'I yield to none' (Fig. 16). From that time the figure of Terminus, the bust of a youth with flying hair, appeared on Erasmus' medals and portraits. When he visited Froben in Basle, his host placed a large representation of Terminus over the chimney-piece. Pirckheimer sent him a cup on which the emblem was engraved and Bonifacius Amerbach, the executor of his will, had the figure carved on Erasmus' tombstone.

We know from Erasmus' correspondence that his enemies took the choice of this emblem as a sign of his 'intolerable arrogance'. In 1528 he was forced to write an 'Epistola apologetica de termini sui inscriptione CONCEDO NVLLI',[1] in which he protested that the offensive words were not at all meant to be spoken by himself, but by Death, 'the Terminus that yields to none'. He explained how, by the chance gift of his pupil, the pagan god had come to him: *Obvenit, non adscitus est.* Being told by an *Italus quidam, rerum antiquarum curiosus,* that the figure on the stone was Terminus, he interpreted it as an omen of his approaching death: 'Itaque ex profano Deo feci mihi symbolum, adhortans ad vitae correctionem: Mors enim vere Terminus est, qui nulli cedere novit.'

It must be remembered that these words, which did not satisfy his enemies,[2] were written almost twenty years after the event. They may represent the true opinion of Erasmus in 1528, but it would be rash to infer, as is generally done, that this was also his opinion in 1509 when he began using the sign on his seal. He was then on his visit to Italy, where he moved among a well-known circle of humanists. In 1508 he stayed with Aldus Manutius in Venice,[3]

Journal of the Warburg Institute, I (1937), pp. 66–9 (with additions to the notes).

[1] Letter to Alfonso de Valdés, 1 August 1528, in *Desiderii Erasmi opera omnia*, ed. J. Clericus (Jean Leclerc), X (Leiden, 1703–6), cols. 1757 ff.; also *Opus epistolarum Des. Erasmi Roterodami* (Allen), VII, no. 2018, pp. 430 ff.

[2] 'De *Termino* quum fuerit stolidissima cavillatio, tamen non accipit excusationem meam', Letter to Pero Mexia, 30 March, 1530 (*Opera*, III/2, col. 1283; Allen, VIII, no. 2300,

p. 408). The reaction of Erasmus' other correspondents is discussed by E. Panofsky, 'Erasmus and the Visual Arts', *Journal of the Warburg and Courtauld Institutes*, XXXII (1969), pp. 200–27.

[3] D. J. Geanakoplos, *Greek Scholars in Venice* (1962), pp. 256 ff.

supervising the printing of his *Adagia* and conversing with the scholars of the Academy that used to assemble around Aldus. The chief patron of this circle—in fact, the Maecenas who financed the Aldine Press—was Alberto Pio, Prince of Carpi, the nephew of Pico della Mirandola. On his uncle's advice the young prince had received his classical training from Aldus, and there ensued a lifelong friendship between pupil and teacher. Alberto Pio conferred his own name upon Aldus, who thereafter called himself Aldus *Pius* Manutius. Aldus dedicated his books to Alberto, and when he died it was found that in his will he had expressed the wish to be buried at Carpi.

In this circle of humanists the figure of Terminus had been the subject of learned conversations. For it was discovered that 'Terminus' was the answer to an old riddle quoted in Gellius' *Noctes Atticae*.[4] Gyraldus expounded it at length in a book of *Aenigmata* written for the young Giovanni Tommaso Pico della Mirandola and dated 'Carpi, 1507'. Under the heading 'Aenigma Termini', he gives the following exposition:

> *Once less, or twice less—I am not quite sure—*
> *or is it both of these, long ago, I have heard it said,*
> *refused to yield to King Jupiter himself.*

This is a riddle in iambic senarii which Gellius has left unexpounded in Book xii so that he might whet the guessing skills of his readers. But to spare you that toil we offer the following solution to the riddle. It refers to the God Terminus, whom the Romans worshipped with the utmost reverence: it is to this God that they performed religious rites on the seventeenth of February, rites described by the poet Ovid in the second book of his *Fasti*. His verses are:

> *O Terminus, whether thou art a stone or a stump dug*
> *up in the fields thou hast thy name from ancient times . . .*

and so on. This God Terminus refused to yield to Jupiter when the Capitol was being dedicated. The same poet tells us this in the following verses:

> *Why, when the Capitol was being built anew, the whole*
> *family of Gods yielded to Jupiter and gave up his place:*
> *Terminus, the ancients tell, was found within the shrine*
> *and stood his ground, and shares the sanctuary with the*
> *mighty Jupiter.*

The same tradition appears in Dionysius of Halicarnassus, but he records that the Goddess Youth was found with them, and others Mars too.

So whoever was the author of the riddle (not Varro, as a certain otherwise learned individual wrongly inferred from Gellius) is expressing doubt whether it was once less, or twice less, or both of these, i.e. thrice less [ter minus] (for the sum of both of these, viz. once and twice, is thrice). So it

[4] XII, vi.

was not once less, not twice less, but thrice less [Terminus] who refused to yield to Jupiter, King of the Gods. Angelo Politian, whose early death we constantly feel so great a loss, was the first, as far as I know, to unravel the perplexing obscurities of this riddle.[5]

From this text two points can be clearly inferred: (1) that Terminus was a topic of lively discussion at the time Erasmus adopted the symbol and in the very circle he then frequented; (2) that no one in this circle would have understood Erasmus' emblem in the sense he gave to it twenty years later.

In quoting Ovid, Gellius, Dionysius of Halicarnassus, and of modern authors, Politian, the text gives the full story of Terminus, the god who refused to yield to Jove when he turned all the other gods out of the Capitol. That explains the motto CEDO NVLLI. But there is no allusion in this text to Death as a connotation of Terminus, and this is the more remarkable as the mention in it of Politian's premature death would seem bound to elicit the idea from so searching a humanist as Gyraldus. We may take this as a proof that, when the words CEDO NVLLI and the figure of Terminus were engraved on Erasmus' seal, his own friends of 1509 must have understood him to say exactly what he was accused of saying by his enemies of 1528. It was an emblem of defiance. But in 1509 when the suspicion of the Church had not yet been aroused by the havoc of the Reformation, no fault would be found with a man who chose this pagan god for his symbol. To show that he remained a loyal Christian he needed only to do as Gyraldus had done and refer to the text of the *Fasti*.

[5] Gyraldus, *Aenigmata*, in *Opera*, II (1696), cols. 627 f.:

> *Semel minus, bis an minus, non sat scio,*
> *Ad horum utrumque, quondam, ut audii dicier,*
> *Iovi ipsi Regi noluit concedere.*

Aenigma est ex Senario Iambico, quod in 12. inenarratum reliquit Gellius, ut legentium coniecturas acueret: at nos ut laborem tibi hunc adimamus, aenigma sic absolvimus. Terminus Deus significatur, quem summa religione Romani colebant, eique Deo nono Kal. Martias rem divinam faciebant, quam pluribus versibus in secundo *Fastorum* poeta Ovidius exsequitur. Ita enim canit:

> *Termine, sive lapis, sive es defossus in agro*
> *Stipes, ab antiquis tu quoque nomen habes*

et reliqua quae subdidit. Qui Terminus Deus Iovi noluit concedere, dum Capitolium exauguraretur: quod idem poeta ita canit:

> *Quid, nova cum fierent Capitolia, nempe Deorum*
> *Cuncta Iovi cessit turba, locumque dedit:*
> *Terminus, ut veteres memorant, inventus in aede*
> *Restitit, et magno cum Iove templa tenet.*

Idem Halicarnasseus Dionysius prodidit, cum iis tamen una Iuventam Deam fuisse tradit, alii et Martem. Dubitat ergo, quisquis fuit aenigmatis auctor (neque enim Varro est, ut vir quidam alioqui doctus male ex Gellio putavit) semel minus, an bis minus fuerit, an utrumque eorum, id est terminus (ex utroque enim, hoc est, semel et bis, ter

resultat). Non igitur semel minus, non bis minus, sed terminus fuit, qui Iovi Deorum Regi noluit concedere. Angelus Politianus, cuius immaturo obitu multum semper amisimus, primus (quod sciam) scrupeas aenigmatis huius ambages explicavit.

Gyraldus evidently refers to Politian (*Miscellanea*, I, xxxvi), who gives both the riddle and its solution. In his preface Politian explicitly mentions Gellius as his chief Latin model and gives a slightly different reading from Gyraldus of the first two lines:

> *Semel minus ne, an bis minus sit non sat scio,*
> *An utrumque horum, ut quondam audivi dicier.*

For a modern editor's view of these lines, see P. K. Marshall (1968), p. 371. Evidence of how closely Erasmus connected the book containing the original Terminus riddle with the one that first proposed its solution is found in the preface to his notes on the New Testament: 'Let no one take up this work as he takes up Gellius' *Noctes Atticae* or Poliziano's *Miscellanies*' (cf. J. Huizinga, *Erasmus*, 1924, p. 141). For Erasmus' sketch of Terminus in the margin of his Tacuinius edition of Gellius (Venice, 1509), see J. Białostocki, 'Rembrandt's "Terminus"', *Wallraf-Richartz-Jahrbuch*, XXVIII (1966), pp. 49 ff. note 23. In the eighteenth century James Harris, *Philological Inquiries*, II, x, dismissed Gellius' account of the Latin enigma as 'a strange thing, far below the Greeks, and debased with all the quibble of a barbarous age' (*Works*, 1841, p. 444).

RICKS COLLEGE
DAVID O. McKAY LRC
REXBURG, IDAHO 83440

There Ovid, after saying that Terminus did not yield to Jove, adds that he must forever refuse to yield to men lest he seem to place men higher than God:

<p style="text-align:center">ne videare hominem praeposuisse Iovi.[6]</p>

This is a thoroughly Christian idea, and I submit that it may have been in Erasmus' mind when in 1509 he placed the words CEDO NVLLI on the figure of Terminus.[7]

Between this early version and the late one that Erasmus gives in his Apology, there is an intermediate phase represented on the reverse of the medal by Quentin Massys (Figs. 14–15), which bears the date 1519.[8] Here the figure of Terminus with the motto CONCEDO NVLLI is placed in the centre, and round the edge of the medal are added the words: MORS VLTIMA LINEA RERVM[9] (Death is the ultimate boundary of things) and ΟΡΑ ΤΕΛΟΣ ΜΑΚΡΟΥ ΒΙΟΥ (Keep the end of a long life in view).[10] I call this an intermediate version because it remains open to doubt whether, by introducing Death as a connotation of Terminus, Erasmus already ceases to be the speaker of the words CONCEDO NVLLI. There is a definite argument against it. The classical story of Terminus would lose its point if Death were the only speaker. There would remain just the verbal significance of CONCEDO NVLLI and the abstract notion of the boundary god. On the other hand, these two allusions to death would enrich the classical story and enhance its meaning if the original plot was left intact and Terminus continued to be the model of one who refuses to yield to external forces. In this case the peripheral inscriptions would merge with the one in the centre and produce the following moral: 'He who looks upon Death as the boundary of Life and keeps the ultimate end of Life in view may well take Terminus as his emblem, for he refuses to place his temporal welfare higher than his eternal.'

The air of youthful defiance in the figure of Terminus seems to fit this idea of refusal but would be difficult to reconcile with the simple notion of death. Was Death ever seen represented as a youth with flying hair?[11]

Not unless Death meant Eternity. Erasmus, by introducing Death in this context, must actually have had Eternity in mind. This can be inferred from his own description of

[6] *Fasti*, II, 676. To say 'Jove' for 'God' was so common in the Renaissance that even Sante Pagnini's hatred of classical allusions did not prevent the name 'Jove' from appearing in his epitaph, cf. D. de Colonia, *Histoire littéraire de la ville de Lyon, avec une bibliothèque des auteurs lyonnois, sacrez et profanes*, II (1730), pp. 599 f., who quotes Joannes Vulteius Remensis, *Epigrammatum libri quattuor* (Lyons, 1537), p. 258.

[7] As it was Politian who first solved the Terminus riddle, the legend must have been known to the artists of the Medici circle. Therefore, it is possible that the story of Terminus also explains the subject of a drawing by Michelangelo at Windsor, supposedly made for Cavalieri. Reproduced in A. E. Popham and J. Wilde, *The Drawings of the XV and XVI Centuries in the Collection of His Majesty the King at Windsor Castle* (1949), no. 424, pl. 20.

[8] See now J.B. Trapp and H. Schulte Herbrüggen, *Sir Thomas More 1477/8–1535* (1977), no. 87.

[9] Horace, *Epistulae*, I, xvi, 79 (Panofsky, op. cit., p. 215).

[10] In his Apology of 1528, Erasmus always refers to this version as if it were the original one, which it clearly is not. Even the double verse 'Concédo núlli Términús' (*iambicus dimeter acatalectus*) and 'Términús concédo núlli' (*dimeter trochaicus acatalectus*), which plays so large a part in the argument, cannot be read into the first version, which has 'cedo' and not 'concedo'.

[11] Some such questions must have been asked by the correspondent against whom Erasmus inveighs in his letter to Valdés: 'Poteras, inquient, insculpere defuncti cranium' (*Opera*, X, col. 1759; Allen, VII, p. 432). That Terminus, 'the gift of the ill-fated Alexander Stewart', may have always had the connotation of death for Erasmus has been recently argued by J. K. McConica, 'The Riddle of "Terminus"', *Erasmus in English*, II (1971), pp. 2 ff., who illustrates both the original gem and the seal in the Historisches Museum, Basle. Archaeologists now consider that the ancient gem represents Dionysus rather than Terminus.

Terminus: *Vident illic sculptam imaginem, inferne saxum, superne iuvenem capillis volitanti-bus.*[12] He divides the figure into two separate sections. The block of stone with the inscription is one thing. The head of the youth with flying hair is another. Terminus was meant to be a stone, the boundary stone at the end of the field or, in Erasmus' interpretation, at the end of life. That explains the lower half of the figure. The upper half can be explained from Livy[13] (whom Erasmus quotes extensively in his Apology) and Dionysius of Halicarnassus[14] (who is mentioned by Gyraldus). Both these authors report that when Terminus refused to yield to Jove he was joined by the god or goddess of youth, *Iuventus* or *Iuventas*. Long flying hair was an attribute of youth—not of the youth which yields to age, but of the youth which will not yield, that is, eternal youth:

> Solis aeterna est Baccho Phoeboque iuventas,
> nam decet intonsus crinis utrumque deum.[15]

The figure of Terminus-Iuventas—youth placed on the rock of death—may thus be taken to signify *Aeternitas*. And this actually corresponds—and Erasmus knew it well[16]—to the original meaning placed by the Romans upon the Terminus legend. They rejoiced at it because they took it as an omen of the eternity of the Empire.[17]

To the Christian mind eternity begins when time is ended. Death is the gateway to eternity. Hence Erasmus could justly claim in retrospect that Terminus stood for Death. Death, however, as seen in the Terminus image of the medal, was not a gruesome spectre, a threat of destruction to the living, but on the contrary the vital force that gives them strength and direction—a daemon in the Socratic sense of the word. Therefore—and here the circle closes again—the words CONCEDO NVLLI as spoken by Death would also be spoken by him who lives in the hope of eternity. Death in the sense of a new life was not only his goal, but also his model.

By 1528, when Erasmus was writing his Apology, such an interpretation of the motto CONCEDO NVLLI would have come dangerously near to Luther's *Hier stehe ich, ich kann nicht anders*. It would never have been acceptable to Erasmus. What later critics have said to his discredit, he himself said in his own praise, that he was yielding to all rather than to none: *citius concedens omnibus quam nulli*. He considered it a Socratic virtue, and in practising it he shrewdly joined malice to irony. Every party accused him of compromising with the other. In ceding to all he really ceded to none. When he was charged with arrogance in his choice of emblem he complained that his opponents not only accused him of that vice, but imputed to him the stupidity of confessing to it publicly in a symbol. This jest ought perhaps also to

[12] Col. 1757; p. 431
[13] I, 55 and V, 54.
[14] *Antiquitates romanae*, III, 69.
[15] These lines from an elegy by Tibullus (I, iv, 37-8) were quoted by Ficino, *Opera* (1561), p. 828, and by Gyraldus, 'De Baccho', *Historia deorum gentilium* (*Opera*, I, col. 270).
[16] He refers specifically to it in his Apology of 1528 (col. 1758; p. 431).

[17] This notion of *Aeternitas* influenced the learned Dinet, *Cinq livres des hiéroglyphiques* (1614), p. 29, when he told the story of Terminus in a corrupt form, mistakenly substituting Cronos for Jove: 'Les Romains rendoient les honneurs divins à une grosse pierre qui estoit au Capitole, qu'ils appelloient *Terminus*: qu'ils disoient estre celle que Saturne n'avait peu devorer.'

be a warning against taking his words of apology at their face value. When he said that he meant the words CONCEDO NVLLI to be spoken by Death he may have told only part of the story. If our interpretation of the Massys medal is correct, both figures—Death and the man who takes Terminus for his emblem—are correlated speakers and express fundamentally the same idea. But in times of distress when minds grow incensed with bigotry and accusations are made of arrogance and conceit, the man might be wiser to remain silent and let Death alone speak.

By observing this silence, Erasmus gave up part of his emblem and, with it, part of his old allegiances. He had felt in sympathy with the religious reformers, but was shocked by the violence of Luther's apostasy. He had rejoiced in the revival of classical studies, but felt now forsaken by the Italian humanists, many of whom had abandoned the cause of *bonae literae*. They accused him of having laid the eggs that had been hatched by Luther. Those who had been most prominent in the Aldine circle had become his avowed enemies. Alberto Pio himself prepared an open attack.

Erasmus seems to have responded to the changed situation by erasing from the explanation of his emblem any trace of his indebtedness to his former friends and present enemies. It is curious to observe—and it cannot be an accident—that in telling the story of Terminus in his Apology he omits without exception every one of the sources which Gyraldus had cited and which he used to cite himself: Ovid, Gellius, and Dionysius of Halicarnassus. He seems intent upon stressing his 'independence'. Of classical authors he quotes only the one whom Gyraldus had omitted—Livy. He adds two Christian authors, St. Augustine and St. Ambrose. Of his contemporaries he mentions neither Politian nor, of course, Gyraldus.[18] And the chief inspirer of his emblem, the man who had first identified the stone as Terminus, has become an anonymous figure, *Italus quidam, antiquarum rerum curiosus*.[19]

[18] Throughout the sixteenth century the figure of Terminus is frequently illustrated in emblem books, cf. the tailpiece in Horapollo's *Emblemata* (Paris, 1551) and Claude Mignault's commentary on Alciati's *Emblemata* (1602), pp. 721-4. A brief discussion of the Terminus legend in L. Pignoria's annotations to Cartari, *Imagini de gli dei delli antichi* (1615), p. 318, does not mention Politian at all.

[19] [On the interpretation of a very different image of Erasmus, Holbein's portrait at Longford Castle, see J. Anderson, 'Erasmus and the Siren', *Erasmus in English*, xi (1981-2), pp. 8 ff., an article which was inspired by scattered notes and references among Wind's papers.]

IX · The Christian Democritus

IF one were asked to decide a priori which is the more Christian attitude to the world: that of Democritus who is said to have laughed at its folly, or that of Heraclitus who, according to the same apocryphal tale,[1] is supposed to have cried when he saw its misery, there is little doubt that the pity of Heraclitus would earn him the title of a Christian philosopher. Yet the verdict of history has been the reverse. In the contest of Mockery and Mirth versus Pity and Sorrow, the laughing philosopher has remained the winner, even within the Christian tradition. That a sceptic like Montaigne should have taken this view is only to be expected,[2] but Montaigne, in preferring Democritus to Heraclitus, did not merely voice an opinion of his own, nor did he mean to state a paradox.[3] He accepted, and developed, in terms of a sceptic's experience, a decision that had been anticipated by the Christian Platonists of the Renaissance. Cristoforo Landino in his *Camaldulensian Conversations* had even identified Democritus' conception of Euthymie with the Christian ideal of Peace: 'Qua propter credo idem ab hoc philosopho Euthimian appellari, quod nostri in sacris litteris pacem appellant: in qua summum bonum Hebraeus poeta collocat.'[4]

This figure of the Christian Democritus was, naturally, dear to Erasmus. In the introduction to the *Praise of Folly*, he confesses that he himself would like to play the laughing Democritus, *Democritum quendam agere*. There is a little metal-cut initial, designed by Holbein or one of his followers, which was prefixed to the first chapter in Erasmus' edition of the theological works of St. Ambrose, the *Hexaemeron*, published in Basle in 1527 (Fig. 33). Although the engraver has by mistake interchanged the names of the two philosophers, it is clear that Democritus is the winner in the dispute. Triumphantly he presents his arguments and confounds his gloomy opponent.

In the moralizations of Pierre de Besse, one of the most prominent preachers at the time of Marie de' Medici and Louis XIII, and an exponent of the French *humanisme dévot*,[5] the

Journal of the Warburg Institute, I (1937), pp. 180–2.

[1] Juvenal, *Saturae*, x, 28–53.

[2] *Essais*, I, 50.

[3] His argument is very straightforward: 'La plainte et la commiseration sont meslées à quelque estimation de la chose qu'on plaint; les choses dequoy on se moque, on les estime sans pris. Je ne pense point qu'il y ait tant de malheur en nous comme il y a de vanité, ny tant de malice comme de sotise.' (*Œuvres complètes*, Bibl. de la Pléiade, 1962, p. 291.)

[4] *Disputationes Camaldulenses* (1475), ii, 'De summo bono' (Paris, 1511, fol xixᵛ). Many more classical sources

and Italian antecedents for the subject of Democritus and Heraclitus are to be found in Wind's later discussion of the two philosophers, who were represented in paintings that once decorated Ficino's study, and the library of the Platonic Academy in Florence, cf. *Pagan Mysteries in the Renaissance* (1968), pp. 48 f.

[5] For the use of the term, see Henri Bremond, *Histoire littéraire du sentiment religieux en France*, I (1924), p. 309. On Pierre de Besse, see É. Fage, *Variétés limousines* (1891), pp. 239 ff.

christianizing tendency becomes quite explicit. He wrote a textbook on penitence entitled *L'Heraclite chrestien* (1612). But a few years later he supplemented it by another volume, *Le Democrite chrestien* (1615), in the preface of which he expresses the same preference that we observed in Landino, Erasmus, and Montaigne: 'J'ay bien estimé les larmes de ce dolent, mais je fais encore plus d'estat des mocqueries de ce folastre.' One of the poems prefixed to this edition gives special emphasis to this development:

> Cecy m'a nourry d'esperance
> Qu'un grand Oracle de ce temps
> Apres l'hyver de repentance
> Donneroit de ioye un printemps:
> Apres un Chrestien Heraclite
> Qui nous faist pleurer nos malheurs.
> Qu'il bailleroit un Democrite,
> Changeant en ioyes nos douleurs.

In Germany the connection of the laughing philosopher with a mystical type of Christian devotion has its most startling example in that adventurous character Johann Conrad Dippel, theologian, alchemist, and physician, who at the time of his conversion to the 'Pietism' of Spener and Arnold (1697) began writing under the pseudonym *Christianus Democritus*.[6]

The Christian mocker's strange way of asserting himself where he is least expected has left traces in pictorial art. There are, to be sure, quite a number of representations in which painters do not take sides in the controversy, but merely juxtapose the laughing and the crying sages.[7] In true genre-like style they depict these extremes of mirth and dejection as equally farcical and foolish. Yet the most famous representation, by Rubens (Figs. 38–9), plainly shows a preference for Democritus by giving him the philosopher's globe which Heraclitus lacks. Being a professed Stoic of the school of Lipsius, Rubens naturally followed Seneca, who had decided in favour of Democritus: 'Humanius est deridere vitam quam deplorare.'[8] At first sight one might think that Terbrugghen's paintings in Amsterdam (Figs. 35–6) are of a neutral genre-like type. They show a bald-headed, beggarly-looking, moaning old man next to a drunken young reveller 'in the truly Dutch manner'. But these two figures are provided with two different spheres: Heraclitus' globe is that of the earth, while Democritus rejoices over the sphere of heaven.[9] In cases where the painter does not depict that joy with quite the gusto and suavity of Terbrugghen, the Christian allusion may

[6] See J. C. G. Ackermann, *Das Leben J. C. Dippels* (1781); W. Bender, *Johann Konrad Dippel, der Freigeist aus dem Pietismus. Ein Beitrag zur Entstehungsgeschichte der Aufklärung* (1882). On an earlier German humanist who emulated the example of Democritus and Heraclitus, see now J. Lebeau, ' "Le rire de Démocrite" et la philosophie de l'histoire de Sebastien Franck', *Bibliothèque d'Humanisme et Renaissance*, XXXIII (1971), pp. 241 ff.

[7] The relevant material has been collected by Werner Weisbach, 'Der sogenannte Geograph von Velasquez und die Darstellungen des Demokrit und Heraklit', *Jahrbuch der Preußischen Kunstsammlungen*, XLIX (1928), pp. 141–58.

[8] Seneca, *De tranquillitate animi*, XV, 2; *De ira*, II, X, 5. See now S. Alpers, *The Decoration of the Torre de la Parada* (1971), p. 134 note 288.

[9] On Terbrugghen's unusual interpretation of the *Weeping Heraclitus*, as represented in a painting now in the Cleveland Museum of Art, see A. T. Lurie's recent article in *The Burlington Magazine*, CXXI (1979), pp. 279–87.

even extend to the glass of wine held by Democritus, as in Jan van Bylert's picture in Utrecht (Fig. 34). But by far the most daringly explicit conceit of a painter—and for that reason the most paradoxical—is to shape Democritus in the image of Christ. This was done by Cornelis Cornelisz (Fig. 37). The composition is curiously reminiscent of representations of the Ecce Homo;[10] and to make the allusion unmistakable, Democritus holds an orb surmounted by the cross, the symbol of majesty that belongs to Christ.

An allusion which involves contradiction is always more poignant than a plain analogy. In choosing as his theme *Democritus Christianus*, Cornelis only did what many before him had done. But in composing his picture he availed himself to the full of the most provocative device which the theme permitted: the paradox that the laughing philosopher, not the crying one, should be made to resemble the Man of Sorrows.

[10] Cf. Dürer's *Man of Sorrows* in the mezzotint copy by Caspar Dooms, reproduced in *Klassiker der Kunst, Dürer* (1928), p. 74; also E. Panofsky, *Albrecht Dürer*, II (1943), nos. 20, 21, and 635.

X · Platonic Tyranny and the Renaissance Fortuna

On Ficino's Reading of *Laws*, IV, 709A-712A

ALTHOUGH political realism is not generally associated with the legacy of Plato, a certain practical boldness, of the kind that Machiavelli was to perfect, is present in Plato's theory of chance (τύχη) and skill (τέχνη). While little noticed by modern readers of Plato, the theory was carefully studied in fifteenth-century Florence, as is shown in a famous letter on Fortuna addressed to Giovanni Rucellai by Ficino.[1] In it the philosopher set forth the unexpected theory, which must have pleased the seasoned merchant-prince and politician, that human foresight can conspire with chance, their obvious disparity notwithstanding. Since chance and foresight, he argued, have their source in God, who mysteriously provides for their final agreement, the prudent man should take the divine hint and not conceive of chance solely as a hostile thing. To oppose the whims of fortune may be noble and to evade them may be wise; but by far the best and most prudent course is to conspire with fortune through skill. When Ficino added that this advice conformed 'alla segreta et divina mente di Platone nostro', he did not indulge, as has been claimed, in empty declamation.[2] He had in mind a particular passage in the fourth book of the *Laws*, 709A-712A, where Plato introduces the same three powers—chance, God, and human skill:

Anyone who sees all this [the vicissitudes of weather, pestilence, war, and poverty] naturally rushes to the conclusion . . . that in human affairs chance (τύχη) is almost everything. And this may be said of the risks of the sailor and the pilot and the physician and the general, and may seem to be well said; and yet there is another thing which may be said with equal truth of all of them . . . that God (θεός) governs all things and that chance and occasion (τύχη καὶ καιρός) work with him in the government of human affairs. There is, however, a third and tamer view, that skill (τέχνη) should

First published in *De artibus opuscula XL. Essays in honor of Erwin Panofsky*, ed. M. Meiss, I (1961), pp. 491-6 and revised by Wind in the present form for *Adelphiana 1971*, pp. 23-36 (with some further additions to the notes from Wind's papers).

[1] *Supplementum Ficinianum*, ed. P. O. Kristeller, II (1937), pp. 169 ff.; A. Warburg, *Gesammelte Schriften*, I (1932), pp. 147 f. note 2; A. Perosa, who re-edited the letter in *Giovanni Rucellai ed il suo zibaldone*, I (1960), pp. 114 ff., was able to date it between 1460 and 1462 (p. 176).

[2] A. Doren refers to the letter as written 'im *angeblichen*

Anschluß an Plato' ('Fortuna im Mittelalter und in der Renaissance', *Vorträge der Bibliothek Warburg 1922-1923*, I. Teil (1924), p. 121 note 99; italics mine). Kristeller, *The Philosophy of Marsilio Ficino* (1943), p. 298, does not discuss the source.

also be of the party; for I should say that on the occasion of a storm (καιρῷ χειμῶνος) there might be a great advantage in having the pilot's skill.[3]

Ficino's commentary on this passage[4] should be read side by side with his letter to Rucellai. Both argue the same moral: that man should conspire with Fortuna instead of evading or resisting her. And since the word *fortuna* was used in his day as a synonym of *tempestas* to signify storm,[5] Ficino seized on Plato's image of the storm and the pilot, and expanded it in his commentary with considerable zest: '[When God] moves the sea by a storm and the storm rocks the ship, God also moves the ship through the mind of the pilot, that is, by the exercise of the pilot's skill, which continuously depends on God. When therefore the ship is directed by skill to a certain harbour, and is also driven there by the storm, then skill is in perfect agreement with chance (*tunc ars simul cum fortuna consentit*).' It was surely with this argument in mind that Rucellai chose the nautical Fortuna for his emblem, seen on the armorial crest in the inner court of his palace (Fig. 59).[6] While characterized by her flying forelock as the volatile goddess of Chance, she acts firmly as the ship's mast, holding up the sail to the favourable wind which she herself represents as *fortuna*. The skill of the pilot and the driving force of the gale appear united in her person, which is both mobile and stable (*manens moveor*)—an auspicious emblem of *steady fortune*, vividly illustrating Ficino's thesis that chance and skill are in concord, *tunc ars cum fortuna consentit*.[7]

Given Rucellai's trust in a fortune favourable to his skill, it is certain that he also knew

[3] *Leges*, IV, 709B-C. Jowett's translation, selected and slightly adapted.

[4] 'In dialogum quartum de Legibus', *Opera* (1561), p. 1497.

[5] Late Latin and Italian usage; cf. the dictionaries of Ducange and of the Accademia della Crusca. For a list of texts, see Wind, *Giorgione's* Tempesta (1969), pp. 20 f. notes 7-9.

[6] Warburg, I, p. 146, fig. 38. In listing some parallels for Rucellai's Fortuna, Warburg included among them a figure of Fortuna carrying her sail while crossing the sea on a dolphin, from a Florentine engraving of a Petrarchan *Triumph of Chastity* (A. M. Hind, *Early Italian Engraving*, 1938, no. A. I. 19, pl. 19). The posture of Rucellai's Fortuna may have been originally inspired by a *Venus marina* or Galatea, who would carry her sail thus while floating over the waters on a dolphin. Galatea appears on Florentine medals in exactly the same posture (G. F. Hill, *A Corpus of Italian Medals*, 1930, nos. 981, 1027, 1070), but unfortunately even when these Renaissance images of Galatea are accompanied by the inscription PRIVS▼MORI▼QUAM TVRPARI▼, they have been misnamed 'Fortuna', although it makes no sense in the given context.

[7] On the humorous adaptation of Rucellai's device to a popular *impresa amorosa*, see Warburg, I, p. 150, fig. 36; also Hind, no. A. I. 6, pl. 6. The coarse print belongs to the same class of folk art (*imagerie populaire*) as the so-called Otto prints, in which personal emblems, partly of Medici origin,

were vulgarized and put to common use (cf. ibid., pls. 134-41). Whenever a private emblem becomes public and popular, it loses its personal connotations, a point well illustrated by the popular print in which Rucellai's device of Fortuna is made to designate an unspecified *impresa amorosa*. The ship, formerly occupied by Rucellai's Fortuna, is now navigated by a young couple, assisted by favourable winds and a jubilant Cupid in the sky—clearly a *Fortuna amoris*. Whether it is right to identify the happy pair with the young Bernardo Rucellai and his bride Nannina de' Medici is doubtful. The tone of the inscription speaks against it: J[O]MJ · LAS[CI]O · PORTARE · ALLA · FORTVNA · SPERANDO/ALFIN · DAVER · BVONA · VENTVRA, a motto suitable for one of those gallant adventures for which *imprese amorose* were made, but hardly applicable to a solid marriage bond uniting the Rucellai and Medici families. Attempts to identify portraits in any of these popular engravings have been impressively unsuccessful. For example, in one of the Otto prints a youth wears a sleeve embroidered with a *diamante in paenis*, an emblem favoured by Lorenzo de' Medici (Warburg, I, p. 81, fig. 20; Hind, no. A. IV. 11, pl. 140), yet the youth cannot possibly be Lorenzo himself since the shield in the engraving is left empty so that any gallant might send it to his mistress with the appropriate crests inserted. A familiar event of courtly art is submerged as a part of folk culture, encouraged no doubt by Lorenzo's policy of eliciting popular support by pageantry.

the spectacular conclusion, in Plato's *Laws*, of the passage quoted to him by Ficino. Since, according to Plato, skill requires a proper chance for its exercise, and God determines whether that chance is provided or not, the craftman is advised 'to pray rightly' for favourable conditions as a pilot might pray for favourable winds. What, then, would be the 'right prayer' for the skilled legislator, the man intent on transforming an imperfect state into an ideal republic? What favours should he ask of Fortune that he may apply his skill effectively? Plato's answer is so disconcerting that it must be quoted here at some length:

Give me a state which is governed by a tyrant, and let the tyrant be young and have a good memory; let him be quick at learning, and of courageous and noble nature; . . . for there neither is nor ever will be a better or speedier way of establishing a polity than by a tyranny.

By what possible arguments, Stranger, can any man persuade himself of such a monstrous doctrine? . . . You would assume, as you say, a tyrant who was young . . . ?

Yes; and you must add fortunate; and his good fortune must be that he is the contemporary of a great legislator, and that some happy chance brings them together. When this has been accomplished, God has done all that he ever does for a state which he desires to be eminently prosperous. . . . But I suppose you have never seen a city which is under a tyranny?

No, and I cannot say that I have any great desire to see one.

And yet, where there is tyranny, you might certainly see that of which I am now speaking. . . . You might see how, without trouble and in no very long period of time, the tyrant, if he wishes, can change the manner of a state . . . he himself indicating by his example the lines of conduct, praising and rewarding some actions and reproving others, and degrading those who disobey. . . . Let no one, my friends, persuade us that there is any quicker and easier way in which states change their laws. . . . The real difficulty is of another sort . . . but when once it is surmounted, ten thousand or rather all blessings follow.

Of what are you speaking?

The difficulty is to find the divine love of temperate and just institutions existing in any powerful forms of government. . . . And this may be said of power in general: When the supreme power in man is combined with the greatest wisdom and temperance, then the best laws and the best constitutions come into being; but in no other way. And let what I have been saying be regarded as a kind of sacred legend or oracle, and let this be our proof that, in one point of view, there may be a difficulty for a city to have good laws, but that there is another point of view in which nothing can be easier or sooner effected, granting our supposition.[8]

This oracle was clearly heard in Florence at the 'Orti Oricellari', a Platonic gathering of poets, philosophers, and politicians over which Giovanni Rucellai's son Bernardo—himself a devoted friend (*amicus suavis*) of Ficino, whose translation of Plato he helped to publish[9]— presided in the late Quattrocento;[10] whereas towards 1520, when Cosimo Rucellai had

[8] *Leges*, IV, 709E–712A.

[9] See Ficino's letters to Bernardo in *Opera*, pp. 661, 665 f., 836, 859, 906. For the correct date of the last letter, 4 January 1489 (*not* 1499), compare Ficino's *Epistolae* (Venice, 1495), fol. 164ᵛ.

[10] The garden in the Via della Scala was acquired by Bernardo Rucellai in 1482; see L. Passerini, *Genealogia e storia della famiglia Rucellai* (1861), p. 128; also 'Degli Orti Oricellari', *Curiosità storico-artistiche Fiorentine* (1866), pp. 57–87; Felix Gilbert, 'Bernardo Rucellai and the Orti Oricellari. A Study on the Origin of Modern Political Thought', *Journal of the Warburg and Courtauld Institutes*, XII (1949), pp. 101–31. To suppose that the use of the garden as an academe, as described in Pietro Crinito's poem

become the guiding spirit, some of the meetings were marked by the prominence of Machiavelli.[11] Although the philosophical debates ranged widely, politics was a recurring theme; and given a setting in which Machiavelli was received among the heirs of Giovanni Rucellai, it looks very much as if Plato's prayer for a suitable tyrant had foreshadowed the terrible reality of Machiavelli's *Prince*.

That inference is supported by Machiavelli's *Discourses on Livy*, which had grown out of the debates of the Orti Oricellari.[12] In the chapters on 'good' and 'bad' despotism,[13] in which he demonstrates how the regeneration of a state 'must be the work of one man only',[14] Machiavelli's conclusion reads like a new version of Plato's prayer:

E veramente, cercando un principe la gloria del mondo, doverrebbe desiderare di possedere una città corrotta, non per guastarla in tutto come Cesare, ma per riordinarla come Romolo. E veramente i cieli non possono dare agli uomini maggiore occasione di gloria, né gli uomini la possono maggiore desiderare.[15]

Particularly striking is the perverse wish for a *città corrotta* on which the saviour-prince might exercise his skill. As 'raw material' for governmental art, a decadent society that had reached an advanced stage of disintegration seemed to promise Machiavelli some of the same advantages as he had dreamt of finding in a primitive tribe, consisting of *uomini grossi* or *montanari, dove non è alcuna civiltà*, a supposedly shapeless human stuff on which he thought that it would be easy to impress a newly conceived constitution (*potendo imprimere in loro facilmente qualunque nuova forma*), 'as a sculptor can more easily draw a beautiful statue out of a rough piece of marble (*marmo rozzo*) than from one badly blocked out by others (*male abbozzato da altrui*).'[16] This unmistakable allusion to Michelangelo's *David* is precious because, apart from Baraballo's mock-triumph in the Stanza della Segnatura, from which Machiavelli drew the idea for a comic monument,[17] he never paid much attention to works of art.[18]

Ad Faustum de sylva Oricellaria, could not have started until after 1498 because in that year Bernardo's tax declaration refers to the yield of vegetables and fruit as only sufficient for family use, is to misconceive the nature of the grove, which was never commensurate with Bernardo's kitchen garden (except possibly for tax purposes) and cannot be assumed to have replaced it. According to C. Angeleri, in his edition of Crinito's *De honesta disciplina* (1955), p. 15 note 34, the ascendancy of the Orti Oricellari as a meeting place of philosophers, poets, and politicians began about 1492, after the death of Lorenzo de' Medici, and it was interrupted temporarily in 1506, when Bernardo Rucellai went into voluntary exile for some years.

[11] D. Cantimori, 'Rhetoric and Politics in Italian Humanism', *Journal of the Warburg Institute*, I (1937), pp. 83–102; see also P. Villari, *The Life and Times of Machiavelli*, II (1898), vii.

[12] See the dedication to Zanobi Buondelmonti and Cosimo Rucellai.

[13] *Discorsi sopra la prima deca di Tito Livio*, I, ix and x; also xvii and xviii.

[14] Ibid., I, ix.

[15] Ibid., I, x. See now Machiavelli, *Tutte le opere*, ed. M. Martelli (1971), also *The Chief Works and Others*, trans. by Allen Gilbert, 3 vols. (1965).

[16] Ibid., I, xi.

[17] The delightful *intarsia* of the *poeta Baraballo* in his abortive procession on the Pope's elephant, almost certainly an invention by Raphael who also designed the elephant's memorial tablet (reproduced in a drawing by Francisco d'Ollanda, El Escorial, Biblioteca, MS. 28-1-20, fol. 31ᵛ), should be compared with Machiavelli's verses in *L'asino d'oro*, vi, 'il grande abate di Gaeta'.

[18] In the *Istorie fiorentine*, for example, the account of the reign of Lorenzo de' Medici, whose patronage of art is acknowledged only in a passing sentence, does not digress into naming any painters or sculptors or any of their works. Nor is the Introduction to the first book of the *Discorsi* very flattering to those who surround themselves at great expense with fragments of ancient statuary, and have them imitated 'a coloro che di quella arte si dilettono', without thinking of an imitation of ancient statesmanship.

In *The Prince* the chapter on Fortuna begins, as if Machiavelli had taken Plato as his model, with a recitation of reasons for the common view 'che le cose del mondo sieno . . . governate dalla fortuna e da Dio';[19] but when he pleads, like Plato, for the admission of human skill, Machiavelli draws his illustrations not from the art of piloting a ship through a sudden storm, but from the building of dams and canals in anticipation of a flood. Akin in spirit to Leonardo da Vinci, he prefers engineering to navigation. The final chapter, following that on Fortuna, is the famous Exhortation in which the calamitous conditions in Italy are declared propitious for the advent of a new Prince, a magnificent despot who, *con la sua fortuna e virtù*, would impose redemption through well-contrived tyranny.[20]

It would not be incompatible with Ficino's complaisant character, nor with the role he assigned to himself as a new Plato, if it was he who first infused the merchant tyranny of Florence with this particular Platonic poison—*la segreta et divina mente di Platone nostro*. Plato had certainly set an example for that most oblique exercise of Renaissance ingenuity, the philosopher's 'Advice to a Prince'. In his commentary on *Laws*, IV, 709E, Ficino did not fail to observe that the idea of associating a philosophical sage with a youthful tyrant corresponded to a grand episode in Plato's life, his attempt to redirect the policy of Syracuse under Dionysius the Younger: 'Animadverte vero ubi Plato de occasione disputat quam vir magnus novas conditurus leges exoptet, ad id magnopere opportunam, sub illius tyranni nomine iuniorem Dionysium significare, seipsum vero sub appellatione legiferi.'[21]

Plato's Syracusan expeditions have been held to reflect not only on his political judgement but also on his philosophical integrity: for how can his readiness to assist the young tyrant of Syracuse be reconciled with his denunciation of tyranny, in the *Republic*, as the last and lowest stage of corruption to which a republic is doomed to descend if it falls away from its original perfection?[22] To grasp the full meaning of that law of decline, it is essential to consider a relevant myth expounded at some length in Plato's *Statesman*.[23] Here Plato says that 'when God lets go' and the universe is left to revolve by itself, without divine superintendence, then 'by an inherent necessity' the world reverses its motion and runs backwards until it reaches a raw state, whereupon God takes hold again and turns it in the right direction. Now if the body politic, as a small world 'imitating and following the condition of the universe', is subject to the same law of retrogression and reversal, then the worst and most retrograde form of government, tyranny, must offer the most favourable conditions for producing the best: for it represents the crucial stage at which 'God takes hold'. Aristotle drew that conclusion in his *Politics* when he summarized Plato's discussion of tyranny as the last and worst form of government: 'According to him', he said, 'it should revert to the first and best, and then there would be a complete cycle.'[24] That this was Plato's opinion is made plain by his statement in the *Laws*, with which his actions in

[19] *Il Principe*, xxv.

[20] Ibid., xxvi. In *Discorsi*, I, xi, Machiavelli had a more acid way of defining that problem: 'for where the fear of God is wanting, there the country will come to ruin unless it be sustained by the fear of the prince, which may supply the want of religion.'

[21] *Opera*, p. 1497.

[22] *Respublica*, IX, 546-76.

[23] *Politicus*, 269-73.

[24] Aristotle, *Politica*, V, xii, 1316a.

Syracuse conform. The concentration of all power in an intelligent young tyrant, however undesirable in itself, gives the skilled legislator a unique chance for which he should address 'the right kind of prayer to Fortune'. The paradox could hardly be bolder. The skilled pilot, as well, might pray for a violent storm, knowing that it could wreck the ship, yet seizing on it as a unique opportunity to reach safe harbour swiftly. 'When the ruling force is concentrated and very strong, as in a tyranny, the change is likely to be easiest and most rapid.'[25]

The devious way in which Plato conveyed his opinion that tyranny should be used for creating the perfect state, hinting at it twice before saying it plainly, is characteristic of his approach to an important lesson which he would not wish to impart without some ceremony. In the *Republic*, as Aristotle observed, the transition from the worst to the best government is silently implied; in the *Statesman* it is suggested by a myth; in the *Laws* it is explicitly stated ἐκ τυραννίδος ἀρίστην γενέσθαι πόλιν —the best government is produced from a tyranny.[26] Ficino would be right in ascribing this heresy *alla segreta et divina mente di Platone nostro*. The political history of Plato's Academy shows how bravely the precept was put into practice. Speusippus and Xenocrates, who went with Plato to Syracuse, shared also in his Macedonian sympathies, which they continued to affirm when they presided over the Academy after his death; and Phocion, Plato's most influential pupil in politics, became, as Demosthenes' enemy, the foremost statesman of the Macedonian party.[27] Ficino could hardly reproach himself for having diligently served the Medici: he carried on the Platonic tradition.[28]

It has often been asked how so many Italian despots, *condottieri*, and merchant adventurers could have professed an ardent belief in Plato, given the low opinion he had expressed in the *Republic* of a form of government to which they were committed. Had Plato written only about the ideal republic and its decline, without discussing whether there was any real chance for its renovation, the spell he exercised over Renaissance despots would indeed be hard to understand. However, as they knew of Plato's prayer to Fortuna (no doubt recited to them by fawning humanists), they took some pride in adopting the dream of a philosophically guided tyranny. Did any of them follow Plato so far as to consider their despotism provisional? Plato's own views on that point are unambiguous. He classed tyranny as inferior to democracy, but found it, nevertheless, more useful, because democracy was bound to

[25] *Leges*, IV, 711A.

[26] Ibid., 710D-E.

[27] J. Bernays, *Phokion und seine neueren Beurtheiler: Ein Beitrag zur Geschichte der griechischen Philosophie und Politik* (1881), pp. 35 ff.: 'Die makedonischen Könige und die Philosophen', a detailed account of the relations of the Academy to the Macedonian court, preceded by reflections on Plato's estimate of 'die blutigen Schöngeister auf dem sicilischen Thron, Vater und Sohn Dionysios'. See also H. Berve, *Dion* (1956), p. 34 note 2; and on other tyrannies administered by members of the Academy, ibid., p. 138.

[28] Against the belief that Ficino 'died an admirer of Savonarola' (F. Gilbert, op. cit., p. 121), see *Apologia Marsilii Ficini pro multis Florentinis ab antichristo Hieronymo Ferrariense hypocritarum summo deceptis . . .*, in *Supplementum Ficinianum*, II, no. xxx, pp. 76 ff. This document was produced for the Cardinals' College in 1498 and contains the verifiable statement that Ficino had held that negative view for three years. His earlier view is revealed in a letter to Cavalcanti on tribulations and prophecy (*Opera*, pp. 961 ff.), dated 12 December 1494, the day on which Savonarola in one of his famous sermons on Haggai had outlined a new constitution for Florence. Written under·the direct impact of this sermon, Ficino's letter urges Cavalcanti and the whole of Florence to follow Savonarola's advice (*salutaribus tanti viri consiliis obsequi*), but even before the end of the year, as the *Epistolae* show, he withdrew in irritation to the country *propter hospitum domesticorum turbam, publicos tumultus*, etc. (*Opera*, p. 964.)

deteriorate into tyranny, whereas tyranny could dictate the ideal state: the worst constitution would engender the best. Such are the desperate hopes of Utopians; and who would deny that a Utopian strain runs through the political convulsions of Renaissance Italy? Sigismondo Malatesta, Lodovico il Moro, Cesare Borgia, Machiavelli, Lorenzo de' Medici himself, were all possessed by messianic illusions that both guided and thwarted their political cunning. The ground for such fantasies was only too well prepared by what Plato had written in vindication of tyranny, as the meeting point of chance and skill according to the plan of an inscrutable deity.

Perhaps it was Plato's Socratic style that enabled him to give his boldest thoughts the semblance of commonplaces. Nothing could be more banal than to propose that the forces of chance should be harnessed by skill; yet from this platitude he drew political rules for conspiring with power, rules that might deceptively flatter the opportunist, but must leave the moralist pensive before the abyss. As if to disclaim reliability for these precepts, Plato stressed that Fortuna cannot be forced. Any attempt to do so would be a sign of *hubris*, an insult to the inscrutable wisdom of the God who in the end adjusts our chances to our skill. Hence the skilful pilot, who knows 'the right kind of prayer', will never relinquish his sense of the ominous. His patience in waiting for the right kind of storm is as important as his ability to ride it.

The lesson was well understood by Renaissance politicians. As Machiavelli put it, supreme political skill is shown not so much in active plotting as in a judicious suspension of wasteful plots. The most effective strategy of any Renaissance despot was to display terrifying powers without using them.[29] From that splendid economy of intimidation Shakespeare drew an image for the despotism of love:

> They that have power to hurt and will do none,
> That do not do the thing they most do show,
> Who, moving others, are themselves as stone,
> Unmoved, cold, and to temptation slow;
> They rightly do inherit heaven's graces,
> And husband nature's riches from expense;
> They are the lords and owners of their faces,
> Others but stewards of their excellence.[30]

And yet, the graces of the adorable tyrant may perish through his acts:

> For sweetest things turn sourest by their deeds;
> Lilies that fester smell far worse than weeds.

'If this was Shakespeare's only surviving work,' writes William Empson, 'it would still be clear, supposing one knew about the other Elizabethans, that it involves somehow their feelings about the Machiavellian, the wicked plotter who is exciting and civilized and in some way right about life.'[31] If we replace in this memorable sentence 'the wicked plotter'

[29] *Il Principe*, viii: 'crudeltà male usate o bene usate.' [31] *Some Versions of Pastoral* (1935), p. 90.
[30] *Sonnets*, xciv.

by 'the wicked Platonist', the description fits the philosophers of the Rucellai circle, who ended by listening to Machiavelli. 'Io credo', wrote Machiavelli himself to Guicciardini, 'che questo sarebbe il vero modo ad andare in Paradiso, inparare la via dello Inferno per fuggirla.'[32]

[32] Carpi, 17 May 1521 (*Opere*, p. 1203, no. 261).

XI · Traditional Religion and Modern Art
Rouault and Matisse

I T has been suggested that ours is an age of religious revival, but perhaps we should rather call it an age of conversions. The two are not identical. Conversions, however central to those who experience them, are peripheral events in a religious community, but revivals when they do occur produce a communal enthusiasm that transfigures even the secular expressions of life. Men's actions are heightened by the fresh awareness of a mysterious power that appears to animate and transcend them; and there results a joyous sense of renovation such as Europe experienced in the twelfth and thirteenth centuries and again in the fifteenth and sixteenth. But I do not think we live in such a period now. In so far as there is a new religious awareness it is produced less by enthusiasm than by fear. It does not seem to engender generosity or fortitude but rather nurtures a secret terror, a self-centred anguish and anxiety. Distrust of intellectual exercise, and of the risks involved in the use of reason, invites new attempts, as Kleist said so well in his essay on the puppet theatre, to 'slip backwards into Paradise'.[1]

Yet I have not called this lecture 'Contemporary Art and Religious Conversions', for I should like to raise a more central issue: 'Traditional Religion and Contemporary Art'. How does the conservative institution of the Roman Catholic Church, committed for centuries to a set of traditional doctrines, react to modernism in art? My remarks stem principally from the works of two artists who are not converts. Georges Rouault was born a Roman Catholic and remained a devout member of the Church throughout his life. Henri Matisse was never a believer, nor has he become one. In recent years, however, he has enjoyed the friendship of the Dominican nuns at Vence and, with a gracious gesture that deserves to be remembered, he has applied his art to assist them in a form of devotion which he cannot personally share.

If Matisse, the most tolerant and disengaged of religious artists, and Rouault, the most intolerant and obsessed, should express, as I hope to show, a parallel attitude towards

A lecture delivered in April 1953 at the Museum of Modern Art, New York, on the occasion of a Rouault exhibition; subsequently published, without notes, in *Art News*, 52, no. 3 (May 1953), pp. 18-22, 60-3.

[1] 'Über das Marionettentheater' (1810), conclusion: '. . . müßten wir wieder von dem Baum der Erkenntnis essen, um in den Stand der Unschuld zurückzufallen?' (*Werke und Briefe*, ed. S. Streller, III, 1978, p. 480.)

Christian devotion, it is perhaps worth enquiring how the official Church has judged that attitude. The question is of importance because Rouault and Matisse, in their religious works, may possibly escape the indictment of Hegel, who foresaw, some hundred and thirty years ago, the dilemma of a modern religious art. Religion, he foretold, would no longer occupy the centre of life. Science and the State would take over the functions which religion once had. He did not doubt artists would nevertheless continue to paint religious pictures; and if they did, it would be desirable that they paint them well. Yet 'no matter how nobly and perfectly portrayed God the Father, Christ, and Mary seem to be, it is no use; we no longer bend our knees before them.'[2]

Manet's *Dead Christ mourned by Angels*, in the Metropolitan Museum of Art, is a perfect illustration of Hegel's thesis: a religious picture, supremely well painted, but one that does not make us bend our knees. In fact, it was not intended to do so. The painting was conceived as an exhibition piece and shown first in the Salon of 1864, together with another Spanish picture by Manet, a bull-fight with a dead toreador in the foreground.[3]

Thus juxtaposed, these two Spanish subjects, one sacred the other secular, were to show the range of Manet's art. He intended to compete with the Old Masters. But despite the orthodox Biblical inscription (John xx. 5-12)—which may have been suggested to Manet by his friend Hurel, an enlightened abbé who later wrote a two-volume work on the classical style of French pulpit oratory—Manet's own diction is free from devotional exhortation. The coolness of his painting invites admiration and there are technical achievements in it of exceptional skill—for example, the wax-like nuance of white by which he makes the corpse stand out against the whiteness of the adjoining cloth; but the enjoyment of the play of *valeurs* requires an attitude of aesthetic detachment, the very contrary of ritual participation.[4] We need only to compare this superbly contrived religious still-life with a modest panel by Mantegna, in Copenhagen, to see how the same subject, the *Dead Christ mourned by Angels*, is treated as a devotional theme. Placed on a tomb that is also an altar, Christ offers himself and displays his wounds with a bitter-sweet expression, smiling and pained. This is the sacramental offering of the body. Christ appears as a living corpse because his immolation is the source of life for those who believe in him.

The modern spectator is easily embarrassed when he finds himself addressed in this direct way and invited to participate in a ritual. An emotional timidity, perhaps one of the symptoms of religious decline and therefore relevant to Hegel's prophecy, is noticeable even in a painter like Paul Gauguin, who yet hankers after religious experience. Vicariously enjoying the devotional exercises of a group more primitive than himself, he acquired a relish for the rituals he observed in the South Sea Islands. Even before settling in his exotic paradise he had found among the peasants of Brittany a formula of picturesque evasion by which he could both enter a religious experience and stay out of it. The *Christ jaune*, in the Albright Art Gallery, Buffalo, is not the painter's god. He is a peasant god adored by a

[2] *Vorlesungen über die Aesthetik*, see above, p. 16 and note 45.
[3] 'Épisode d'un combat de taureaux', from which the toreador was cut out and called 'L'homme mort'. This is now in the National Gallery of Art, Washington, DC.
[4] Cf. Wind, *Art and Anarchy* (1969), pp. 13 and 199 ff.

group of peasant women. Dressed in Breton costumes, they kneel before their Christ in a
Breton landscape and thereby serve as emotional *repoussoirs* by distancing the pious action
from the spectator. Reduced to the role of an observer, he participates vicariously in a
devotional experience that the artist no longer cares, or perhaps dares, to induce directly.

In a sophisticated form the same dilemma recurs in Henry Moore's *Madonna and Child*,
a statue designed for worship in an Anglican church distinguished for its enlightened
patronage of the contemporary arts, St. Matthew's Church, Northampton. The rustic
features of the woman, the gazing expression of the child, seem to be addressed to a different
kind of sensibility from that which would respond to the sweep of the skirt, or to the forceful
modelling of the feet and knees. The upper part of the sculpture is self-conscious and fussy.
It appeals to a more conventional Nazarene taste, even in such details as the Virgin's collar
or the folds of her sleeve. Moore had attempted to overcome the frigidity which he feared
an abstract style might inspire in a church, but in trying to produce a devotional image took
refuge in rusticity. The contradiction in style reveals a psychological dilemma, an uncertainty
as to the state of mind to be aroused in the beholder. The result is a tactful compromise; but
will it bring us to our knees? Perhaps Matisse was both wiser and shrewder in delineating
the *Virgin and Child* for the Chapelle du Rosaire at Vence, where he relied on an eloquent
and consistent abstraction for the expression of devotional sentiments.

The reduction of a sacred face to a mere outline, but so well defined that posture and
expression, even the direction of the glance, are suggested with unmistakable clarity, is an
economic device that Matisse employed to the greatest effect in the *Ave* and the *St. Dominic*
for the chapel at Vence. Rouault's meditations on the sacred face are, on the contrary,
distinguished by their concreteness. He painted innumerable variations of the Veil of St.
Veronica (Fig. 45). Some of these images look like Coptic weaving, others like Byzantine
icons, still others like exotic portrayals of a man from Galilee, and the expression changes
from pain, pity, and grief to serenity. In painting so many moods of the Divine Face,
Rouault engaged in a devotional exercise very similar to those practised by mystics in the
fifteenth century, for example, by Nicolaus Cusanus when he wrote in *De visione Dei*, vi:

If the lion were to ascribe thee a face, he would imagine the face of a lion, the ox would imagine that
of an ox, the eagle, of an eagle. Oh Lord, how marvellous is thy face, which youths cannot conceive
of but as youthful, men but as manly, and the aged as aged! ... Oh marvellous face, whose beauty all
those who see it are insufficient to admire! The face of faces is veiled in all faces and seen in a riddle.
Unveiled it is not found until one has entered, beyond all visions, into a state of secret and hidden
silence, in which nothing is left of knowing or imagining a face. For so long as this obscurity is not
reached, this cloud, this darkness—that is, the ignorance into which he who seeks thy face enters
when he transcends all knowledge and understanding—so long can thy face be encountered only
veiled. This darkness itself, however, reveals that it is here, in the transcending of all veils, that the
face is present. ... And the more densely the darkness is felt, the truer and closer is the approach, by
virtue of this darkness, to the invisible light.[5]

⁵ 'De visione faciali', *Opera*, I (1514), fols. CI f. For the Renaissance context of this passage, see Wind, *Pagan Mysteries in the Renaissance* (1968), pp. 220 f.

In a painting of *Christ and the Evangelists* (Fig. 46),[6] Rouault attempted to associate the faces of the four disciples as contrasting in temperament and character with the central face of Christ himself, which is supposed to contain them all and hence resembles none. In accordance with a tradition drawn from the vision of Ezekiel, each of the evangelists was associated with an animal symbol: Mark, whose symbol is the lion, looks choleric and violent; John, the eagle, looks like a smiling bird; Luke, the ox, looks patient and peaceful; Matthew, the man, looks melancholy. As these four characters merge, two on either side with their leader in the middle, putting their heads together as in a conspiracy, the strange vacancy of Christ's face stands out like a mirror, or like a pure crystal whose light is broken up into its component colours. Meanwhile, in the background on the left, a bearded figure is sketched in, a marginal Apostle, to suggest the infinite succession of these four.

The Absolute, reflected in its particulars and transcending them, has rarely been symbolized so convincingly. And yet this is a private picture. It would be inconceivable on an altar. In reflecting on this supreme achievement of Rouault's religious imagination we may well wonder whether a true devotional art can be public any longer, or whether public art can remain devotional. The two attitudes seem to have become divorced in modern life. *Christ and the Evangelists* can have only been intended for an individual owner, or a small group, to meditate upon.

In the same way Matisse's chapel at Vence was designed for semi-private devotion. On the altar is a simple crucifix reduced to the shape of a sacred rod (Fig. 56). The figure seems inanimate except for the slight inclination in the featureless head. But when it is seen against the *Stations of the Cross* (Fig. 54), this abstract, hieratic image is like the perfect cipher of a mystery, an eloquent summary of the tragic drama to which the wall design alludes in scrawls. The calligraphy of these *Stations of the Cross* produces a studied effect of primitivism. They recall the *sgraffiti* of Early Christian grottoes, scratched on the walls by pious hands, which expressed these agonies as in a stammer. Matisse has studied each scene in great detail before reducing it to a sacred scratch. These rude designs, thrown on to the white glazed tiles in rapid black strokes, impress themselves on the memory with the intensity of ideograms. The numbers below the scenes prescribe the sequence of readings, and thus heighten the sense of a mnemonic exercise in which the beholder recites each event that the cipher unfailingly brings to his mind through a trembling outline. The stained-glass windows figuring the Tree of Life throw their clear light on these fleeting scenes, which also contrast with the firm contours of the other images—the *Ave* and the *St. Dominic*. On the altar, the Crucifix—in the highest abstraction—combines the halting mood of the primitive script with the simplicity of the ultimate promise.

Rouault's friend, André Suarès, when describing the religious diction of Paul Verlaine, remembered it as a mixture of prayer and invective: 'Son accent, un peu lourd et lent, avait aussi un agrément ambigu: il tenait de l'oraison et de l'invective.'[7] The poet of *Sagesse*, whose face Rouault recalled in a lithograph and in a posthumous painting, now in the Phillips

[6] [Rouault's title for the painting was simply 'Christ', and it is open to interpretation who his companions are.]

[7] Essay on Verlaine in *Sur la vie*, II (1925), p. 76.

Memorial Gallery, Washington, was compared by his friends 'to a crucified faun or a tartaric Socrates'.[8] Verlaine saw no contradiction between the mystical and the sensual sides of his character: 'Le ton est le même dans les deux cas ... l'HOMME mystique et sensuel reste l'homme intellectual toujours.'[9] With the exception of Rouault and Matisse, religious art in recent years has rarely appeared to be intellectually secure. Sometimes the ideal balance between prayer and invective has been evaded by the cold splendours of formal design, like Fernand Léger's mosaic for the Alpine church of Notre-Dame-de-Toute-Grâce at Assy, whose façade is also meretriciously rustic. Sometimes the obvious inability to pray has been compensated by a relentless surrender to pure invective. Perhaps the most obvious example of this aggressive tendency is the *Crucifixion of Christ* by Graham Sutherland (Fig. 48), acquired in 1946 for St. Matthew's Church, Northampton, and placed facing Moore's *Madonna* across the transept. In this combination of coldness and horror Sutherland avowedly produced a restatement of what many modern artists have regarded as a *non plus ultra* of sacred agony, Grünewald's *Crucifixion* for the Isenheim Altarpiece (Fig. 47). Picasso, for example, in a series of drawings reduced this superhuman crucifix to a relic of bones, a mammoth-like prehistoric idol commemorating a barbaric enormity (Fig. 49).[10] Compared to Picasso's defiant extravaganza Sutherland's *Crucifixion* is literal-minded, but no less extreme in its spirit of accusation which seems to exclude Grünewald's compassion and ecstasy. Although the painting was made for a church, one cannot imagine that redemption could come from so monstrous a sacrifice. Sutherland painted the picture at the end of the war in 1946, an outcry against senseless agony. Not unlike Jose Orozco's fresco, *Christ with the Axe*,[11] or Karl Schmidt-Rottluff's woodcut *Kristus* of 1918, it is in the style of a ferocious poster and contains no prayer.

And yet, by showing this supernaturally large Christ nailed to the Cross in an agony that is superhuman, the blood streaming from the wounds in his hands, in his feet, and in his side, Sutherland came closer than Rouault and Matisse ever did to the spirit of the encyclical *Mediator Dei*, which was issued by Pope Pius XII in 1947: 'It is absolutely necessary', says the document, 'that all men should individually come into vital contact with the Sacrifice of the Cross and should thus share in the merits derived from it. It can be said, in a way, that Christ built on Calvary a purifying and salutary reservoir which He filled with the blood he poured forth; but if men do not immerse themselves in its waves and do not there cleanse themselves of the stains of their sins, they cannot be purified or saved.'[12] It was only logical

[8] Ibid., p. 75: 'tantôt à un faune crucifié, tantôt à un Socrate tartare'.

[9] *Les Poètes maudits*, vi, 'Pauvre Lélian'; see above, p. 16 and note 45.

[10] The other drawings after Grünewald are reproduced in C. Zervos, *Pablo Picasso*, Cahiers d'art, VIII (1957), nos. 49–56. See now also nos. 515–19 in the catalogue of the Paris exhibition, *Picasso. Œuvres reçues en paiement des droits de succession* (1979).

[11] A fresco from the cycle *The Modern Migration of the Spirit*, in the Baker Library, Dartmouth College, New Hampshire.

[12] Acta Pii Pp. XII, 2 Decembris 1947, see *Acta Apostolicae Sedis*, XXXIX (1947), p. 551: '... opus est prorsus ut singillatim homines vitali modo Crucis Sacrificium attingant, ideoque quae ex eo eduntur merita iisdem impertiantur. Dici quodammodo potest in Calvaria Christum piacularem salutaremque instruxisse piscinam, quam suo replevit effuso cruore: at si homines eius non se mergunt in undas, atque inibi suas iniquitatum maculas non detergunt, purificati ac salvi fieri profecto nequeunt.' The English translation quoted here is a literal rendering of the Latin text issued in seven instalments by the National Catholic Welfare Conference, Washington, DC, 23 December 1947–9 February 1948.

that the same encyclical warned the modern artist that 'he wanders from the right path ...
who commands that images of our Divine Redeemer on the Cross be so made that His body
does not show the bitter wounds He suffered'.[13] It is the more important and the more
remarkable that the devout Rouault never did 'dwell in the wounds of Christ'. Whenever he
represented Christ on the Cross he avoided showing the sacramental wounds, the pierced
hands, the pierced feet, and the pierced side of the body, and he often omitted the hands
and feet altogether. There seems to be no exception to this rule. Rouault never represents
Christ with the stigmata. Not even in his aquatint of the Lamentation over the body of
Christ (Fig. 44), one of the magnificent portfolio plates for the *Miserere* album[14] which
illustrates human suffering, is there any indication that the body of Christ has been crucified,
even though the text beneath reads: *Au pressoir, le raisin fut foulé*. To impress the sacramental
meaning of the same scene on the beholder, Mantegna, in his *Lamentation* (Fig. 43), had
used an aggressive foreshortening to increase the sense of agony by distorting the body. The
wounds on the hands and feet are displayed in a singularly emphatic and shocking way,
because their position appears in reverse to how they would have appeared when Christ was
on the cross, the stigmata on the hands being shown from above, and those on the feet from
below. Compared to Mantegna's ruthless evocation of the sacrifice Rouault's devotional
apostrophe is purely humane. The close juxtaposition of the three suffering heads arouses
a profound religious compassion. Almost as if in protest against Mantegna the body of
Christ is not distorted but laid out straight like a classical Meleager. Only Mary's sorrowful
face looks out at the spectator.

The agonized Christ appears throughout Rouault's work as a human figure, a humble
model of all the earthly suffering that will continue for as long as the world: "*Jésus sera en
agonie jusqu'à la fin du monde ...*" (Pascal), attests the inscription beneath the crucified Christ
in the *Miserere* (Fig. 53). The devotion which these images arouse is closer to moral
meditation on human cruelty and divine meekness than to participation in a sacrament. It
is not accidental that the pose assumed by Christ in one of the prints in the *Miserere* (Fig.
52) is almost literally repeated by a Job-like sinner in another (Fig. 50), a condemned man
whose callous attorney utters 'hollow phrases ... below a forgotten Crucifix' (Fig. 51).

To suggest that the *Christ on the Cross*, as seen by Rouault, has anything in common with
the rod-like crucifix of Matisse (Fig. 56) may seem like a wilful paradox; Matisse's image is
as abstract and remote, as Rouault's is passionate and expressive. Yet the two have a negative
trait in common. Both artists recoil from representing the blood sacrifice as it appears in
Sutherland's imitation of Grünewald, upon which the Catholic Church insists even today. In
their religious imagery both Rouault and Matisse are unsacramental—one might almost

[13] Op. cit., p. 545 f.: '... is ex recto aberret itinere, qui priscam altari velit mensae formam restituere; ... qui divini Redemptoris in Crucem acti effigies ita conformari iubeat, ut corpus eius acerrimos non referat, quos passus est, cruciatus. ...'

[14] Rouault's first drawings for the *Miserere* plates were made in 1914, their final printing took place in 1927, but twenty-one more years elapsed before their publication in 1948. See Rouault's preface to the *Miserere* in the small facsimile edition issued in 1952 by the Museum of Modern Art, New York, with an introduction by Monroe Wheeler.

say antisacramental. They produce devotional images without the ritual connotation which the encyclical *Mediator Dei* prescribes.

Issued in 1947, the encyclical also warns against a liturgical restitution which we find adopted very beautifully in Vence in 1951: the altar is shaped in the ancient form of a table, which stresses the communion rather than the sacrifice (Fig. 55). Yet the encyclical affirms that 'they err greatly who ... sophistically assert that there is a question here not only of a sacrifice, but of a sacrifice and a banquet of brotherly unity, and make the general communion the climax of the whole celebration'.[15] The immolation of the lamb is to remain the central phase of the mass; and the altar, suggestive of a tomb, is to retain all the tragic connotations of a painful offering which is necessary to atone for the crimes of the world by a bloodshed even more criminal. The liturgical criticism of the table-shaped altar is, therefore, consistently combined in the encyclical with a warning against understating the sanguineous aspects of redemption: 'He wanders from the right path who wishes to restore to the altar the ancient form of a table, ... who commands that images of our Divine Redeemer on the Cross be so made that His body does not show the bitter wounds that He suffered.'[16] Reflecting on these 'subtle and harmful errors', the encyclical condemns them as 'false mysticism and poisonous quietism', as 'dangerous humanism and excessive archeologism'.[17] It would seem that Rouault and Matisse, and the Dominican nuns at Vence, were guilty of several or all of these heterodoxies, which attest to the continued vitality of Gallican independence within the Roman Church.

Thus Rouault, the devout Catholic, and Matisse, the tolerant pagan with a great sympathy for those who believe, have both produced a devotional art which rejects the horrors of Grünewald, although Matisse himself paid homage to this very great master by copying the Virgin's hands, folded in prayer, from the Isenheim *Annunciation*. This exquisite drawing, inscribed *d'après Grünewald*,[18] is an eloquent protest against the imitation of Grünewald only as a master of martyrdom, and shows this ancient painter to be an unexpected model for a more worldly reverence.

Despite his gloom, Rouault, too, holds out hope for an earthly renovation. For in the *Miserere* one of the nocturnal landscapes is inscribed *Chantez Matines, le jour renaît*, and in other evangelical landscapes a huge luminary, the moon or sun, hangs over the tangible ghosts below who revisit familiar places or stand like statues in abandoned shrines. These apostolic pilgrims wander over an earth that is humanized and ploughed, or as if modelled in clay. Isolated towers suggest desolation and the houses are those of a derelict suburb. Yet within these autumnal panoramas human figures are so firmly and clearly placed that they

[15] Op. cit., p. 563: 'Ex veritatis igitur itinere ii aberrant, qui sacris operari nolint, nisi si christiana plebs ad divinam mensam accedat; ac magis etiam ii aberrant, qui, ut contendant necessarium omnino esse Christi fideles una cum sacerdote Eucharistica pasci dape, captiose asseverent heic agi non de Sacrificio solummodo, sed de Sacrificio ac caena fraternae communitatis, atque sacram Synaxim ponant, communiter actam, quasi totius celebrationis culmen.'

[16] See above, note 14.

[17] Op. cit., p. 593: '... hoc est ne irrepant in greges vestros subtiles illi perniciosique errores, qui falsus *mysticismus* ac noxius *quietismus* audiunt—qui quidem errores iam a Nobis, ut nostis, reprobati sunt—itemque ne animos seducat periculosus quidam *humanismus*, neve fallax doctrina inducatur ipsam perturbans catholicae fidei notionem, neve denique nimium restituendae in liturgicis rebus antiquitatis studium.'

[18] *H Matisse / D. Grunwald 49*. Charcoal drawing. Vence, Chapelle du Rosaire.

recall the Biblical landscapes of Poussin. These images confirm the evangelical nature of Rouault's religious art and its concern with the germane and primitive forms of Christianity to the exclusion of the dogmatic. Like Charles Péguy in his litanies and pilgrimage songs, Rouault celebrates the terrestrial Christ:

> Heureux ceux qui sont morts pour des cités charnelles.
> Car elles sont le corps de la cité de Dieu.
> Heureux ceux qui sont morts pour leur âtre et leur feu. . . .
> Dans l'étreinte d'honneur et le terrestre aveu.[19]

[19] 'Eve', *Cahiers de la quinzaine*, XV, 4 (1913), p. 274.

XII · Yeats and Raphael

The Dead Child on a Dolphin

IN a letter to Sturge Moore, Yeats asked a question that has been regarded as more mysterious than it really is: 'Do you know Raphael's statue of the Dolphin carrying one of the Holy Innocents to Heaven?'[1] Contrary to what has been claimed, the statue exists, and in two versions, of which one (Fig. 58) belongs to the Hermitage, Leningrad, while the other was for a long time in Ireland and is now at Ickworth.[2]

The statue in the Hermitage was acquired by Catherine II as a Raphael. It is probably identical with a sculpture formerly in the Ludovisi Collection, Rome, listed in an inventory of 12 January 1633 as 'un puttino morto sopra un delfino ferito di grandezza del naturale'.[3] The first to claim the design for Raphael, and the execution for his pupil Lorenzetto, was the restorer and dealer Bartolomeo Cavaceppi, who reproduced the statue in a good engraving (Fig. 57).[4] Passavant was probably right in supposing[5] that it was Cavaceppi himself who sold the marble to Jacques Laure Le Tonnelier de Breteuil, Maltese Ambassador to the Holy See, from whose collection it passed, via Lyde Browne at Wimbledon, to the Empress of Russia. Before the statue left Rome a cast was taken from it for Anton Raffael Mengs, whose heirs sold it to the Dresden Gallery.[6] Somewhat later a marble replica was acquired by the 4th Earl of Bristol, Bishop of Derry, for his collection at Downhill, Co. Derry.[7] This was first described in *The Penny Magazine*, with an illustration engraved by 'Mr Jackson'.[8] By that time the sculpture in the Hermitage had passed from memory and the Irish version was claimed as an original. It came into the possession of Sir Henry Hervey Bruce, who lent it to the Manchester Exhibition of 1857,[9] where it aroused much comment and considerable doubt, partly on the grounds of quality,[10] but also for documentary reasons: neither the measurements nor the state of preservation agreed with the cast in Dresden.[11] The question was, however, definitely settled in 1872, when a member of the

The Times Literary Supplement, 25 October 1963, p. 874.

[1] [8 October 1930.] *W. B. Yeats and T. Sturge Moore. Their Correspondence* (1953), p. 165.

[2] See below, notes 7 and 22.

[3] Quoted by A. Springer, *Raffael und Michelangelo*, II (1883), p. 366.

[4] *Raccolta d'antiche statue*, I (1768), pl. 44.

[5] *Rafael von Urbino*, I (1839), pp. 250 f.

[6] Ibid., II, p. 439.

[7] In a letter to *The Times Literary Supplement*, 21 Nov-ember 1963, Mr James Tudor-Craig noted that the Irish version is now at Ickworth House, Suffolk.

[8] X (1841), pp. 277 f.

[9] *Catalogue of the Art Treasures of the United Kingdom. Collected at Manchester in 1857* (2nd edn., n.d.), p. 135, no. 91: 'Raffaelle, Boy and Dolphin'.

[10] W. Bürger, *Trésors d'art exposés à Manchester* (1857), p. 446.

[11] J. D. Passavant, op. cit., III (1858), p. 321.

Academy of St. Petersburg drew attention to the statue in the Hermitage and traced its provenance to the Breteuil collection.[12] In spite of occasional scepticism not unjustly aroused by the indefatigable Cavaceppi's handiwork, and also by later repairs made by the Russian restorer Kouznetzow, the statue in the Hermitage has been generally accepted as a work of the sixteenth century, ascribed either to Lorenzetto or to Pietro d'Ancona, both known to have worked from designs by Raphael.[13]

In the literature on Yeats the straightforward question he addressed to Sturge Moore, 'Do you know Raphael's statue of the Dolphin carrying one of the Holy Innocents to Heaven?', has caused a fair amount of confusion. According to Giorgio Melchiori, 'it is understandable that Moore did not answer this question, for though there are plenty of classical and Renaissance groups of statuary representing children riding on dolphins to be found in galleries, no art historian attributed any of them to the Italian painter.'[14] F. A. C. Wilson refers to the sculpture as 'a statue which I have not been able to identify' and concludes that 'the unexplained and apparently inconsequential reference to Raphael is clearly *pour épater*'.[15] How vividly Yeats remembered the statue, presumably in the Irish version, although he seems also to have studied a cast in the Victoria and Albert Museum,[16] is shown in 'News for the Delphic Oracle':

> Straddling each a dolphin's back
> And steadied by a fin,
> Those Innocents re-live their death,
> Their wounds open again.
> The ecstatic waters laugh because
> Their cries are sweet and strange,
> Through their ancestral patterns dance,
> And the brute dolphins plunge
> Until, in some cliff-sheltered bay
> Where wades the choir of love
> Proffering its sacred laurel crowns,
> They pitch their burdens off.

With his unfailing instinct for Renaissance imagery, Yeats interpreted the statue exactly as Raphael's contemporaries treated that kind of subject—as an example of the 'bitter-sweet union of Love and Death' to which Marsilio Ficino, *De amore*, II, viii, applied the Sapphic word γλυκύπικρον. On the mutual love between children and dolphins, and some tragic

[12] M. de Guédéonow, 'L'enfant mort porté par un dauphin, groupe en marbre, attribué à Raphael', *Bulletin de l'Académie impériale des Sciences de St-Pétersbourg*, XVIII (1873), cols. 82-90, read at the session of 22 August 1872.
[13] Cf. J. A. Crowe and G. B. Cavalcaselle, *Raphael*, II (1885), pp. 343 f.; Eugène Müntz, *Raphaël* (1886), pp. 596 ff., with illustration; A. Venturi, *Storia dell'arte italiana*, x, i (1935), p. 315 note. The catalogue of the Prince Consort's

Raphael Collection in the Royal Library at Windsor Castle (1876), p. 307, lists a photograph of the statue in the Hermitage, and also one of the plaster-cast in Dresden.
[14] *The Whole Mystery of Art: Pattern into Poetry in the Work of W. B. Yeats* (1960), p. 213.
[15] *W. B. Yeats and Tradition* (1958), pp. 220 f.
[16] Cf. R. Ellmann, *The Identity of Yeats* (1954), p. 284.

accidents that spoiled their games, the stories related by Pliny,[17] or Aelian,[18] and also by Gellius,[19] were eagerly collected in the Renaissance. The incident represented in the sculpture—the dead child carried to shore by the dolphin—was retold, for example, by Niccolò Perotti[20] and also by Ripa.[21] It would not have been unlike Raphael to design the image as a sort of aquatic Ganymede.[22]

[17] *Naturalis historia*, IX, viii, 20 ff.

[18] *De natura animalium*, VI, 15.

[19] *Noctes Atticae*, VI, viii: 'An incredible story about a dolphin that loved a boy.' On the dolphin in classical mythology, see C. M. Bowra, 'Arion and the Dolphin', *Museum Helveticum*, XX (1963), pp. 121 f.

[20] *Cornucopiae* (1513), cols. 565 f.

[21] *Iconologia*, s.v. *Animo piacevole, trattabile et amorevole*.

[22] [Following the publication of this article, further dead children on dolphins, for the most part either by Nollekens or attributed to him, were noted. Variants are at Althorp, Northampton; at Burghley House, Stamford (cf. M. Whinney's letter in *The Times Literary Supplement*, 7 November 1963, which also mentions Garrick's version); at Broadlands, near Romsey (see S. Howard, 'Boy on a Dolphin: Nollekens and Cavaceppi', *The Art Bulletin*, XLVI (1964), pp. 177-89, who argues, in a study of neo-classic taste in eighteenth-century Rome, that Cavaceppi himself created the statue); in the collection of Mrs Julian Peck, Rathbeale Hall, Swords, Co. Dublin, a variant said to have come from Castletown, Co. Kildare; and a small nineteenth-century replica in 'Parian china' is in the possession of Brian Hill, Esq., London. Nollekens probably made his copies after the original in Cavaceppi's collection, when he was in Rome (cf. Howard, loc. cit.).]

Appendix

On a recent Biography of Warburg

THE cultural significance of pagan revivals, as sources both of light and of superstition, may roughly be said to have been the theme of Aby Warburg's bold researches. A seemingly threadbare academic subject, the so-called 'survival of the classics', was here freshly attacked from such unexpected angles, and with such a wealth of new documentary evidence on the underlying social, moral, and religious forces, that it could justly be said by a famous German art historian, availing himself of a phrase of Dürer's, that Warburg had opened up 'a new kingdom' to the study of art.[1]

Today that kingdom is associated less with Warburg's own writings, which are virtually unknown in England, than with the great library which he built up in preparing them, and which is now the property of the University of London. A biography of the man could well have helped to redress the balance, on the assumption that it would introduce the reader to the large number and wide range of Warburg's factual discoveries and to his new method of compact demonstration, in which divergent disciplines are fused together as instruments for solving a particular historical problem. However, as the author of *Aby Warburg* explains at some length in the introduction, this book was conceived under an ill-omened star. The work was forced on E. H. Gombrich by circumstances beyond his control, and it is clear from the depressing tone of much of the writing that he found himself faced with an uncongenial task. It might well be asked whether it would not have been better to leave a book on such a difficult subject unwritten rather than to write it against the grain. But Professor Gombrich has made his choice, and one must discard one's sympathy, and say what has gone wrong.

Some of the weaknesses of the book are foreshadowed in its plan. It sets out to be three things at once and, consequently, never does full justice to any of them: first, a presentation of some of Warburg's unpublished notes and drafts in what purports to be a usable edition; second, a biographical history, to serve as a 'scaffolding' for the notes in place of regular annotation; and third, a conspectus of Warburg's research and of his growth as a scholar. That these three aims, although supposedly dovetailed, constantly get in each other's way may account, at least in part, for the dragging pace of the book. The claim that in this sluggish progress one of the most alert of historical explorers 'speaks in his own words' is absurd. The fragments quoted from unpublished notes, drafts, diaries, and letters, and indiscriminately mixed with pieces torn from finished works as if they were fragments, are drowned in a slow-moving mass of circumlocution which determines the tone and tempo of the book.

A review of E. H. Gombrich's *Aby Warburg. An Intellectual Biography* (1970), in *The Times Literary Supplement*, 25 June 1971, pp. 735-6. Notes and references have been added from Wind's papers.

[1] E. Panofsky, 'Professor A. Warburg†', obituary notice in *Hamburger Fremdenblatt*, 28 October 1929.

The following is a fair example of Professor Gombrich's attitude towards Warburg: 'He was like a man lost in a maze and the reader who attempts the next chapter should perhaps be warned that he, too, will have to enter the maze.' Strange to say, this inauspicious invitation refers to the years 1904-7, one of Warburg's great productive periods, in which he published the exquisitely fresh *Imprese amorose* (1905), the now classic discourse on Dürer's *Death of Orpheus* (1906), and the masterly treatise *Francesco Sassetti* (1907), perhaps his finest essay on Renaissance psychology. To Professor Gombrich the process of discovery underlying these works, which are exemplary in their union of new archival evidence with psychological demonstration, spells confusion, agony, and frustration: 'It might seem an impertinence to attempt to trace Warburg's wanderings through the maze, but it is possible at least to indicate why he found it so agonizingly hard to map it out.' This is the author's way of building up what he considers to be his subject's persona.

It is from his reading of the unpublished papers that Professor Gombrich has abstracted this tortured figure. However, 'the inside view', as he hopefully calls it, is not necessarily the most authentic. Rummaging in fragments, drafts, and other unfinished business easily gives a compiler, unless he is on his guard against that error, a disproportionate sense of tentative gropings, particularly if, as in the case of Warburg, too many preparatory scribbles have survived.

No doubt, there was some obsessional quirk in Warburg's over-extravagant habit of preserving all his superseded drafts and notes, thus swelling his personal files to a gargantuan size, with comic side-effects that did not escape him. And yet this living tomb of superannuated memoranda was as indispensable to the exercise of his genius as, say, the smell of rotting apples was to Schiller's inspiration—not to speak of the inexhaustible battery of pills assembled and labelled by Stravinsky. As mechanical props in the operation of the spirit, such personal rituals, however odd, certainly merit the historian's attention; but when they protrude too far into the foreground of his narrative they are likely to falsify the picture. This is what has happened in the present book. The economy and elegance of Warburg's finished work, which mark it as that of a master-craftsman, are not seen here as an integral part of his personal character. The incisive style of the man is lost in the pullulating swarm of ephemeral notations, from which he emerges, like a spectre, in the now fashionable guise of a tormented mollusc: shapeless, flustered, and jejune, incessantly preoccupied with his inner conflicts and driven in vain to aggrandize them by some unconquerable itch for the Absolute.

Considering what Warburg thought of people who had 'a noisy inner life',[2] the fact that he himself is here portrayed in that fatiguing character, without any respite from its vulgarity, suggests some obtuseness in the author's outlook. After referring, as a matter of hearsay, to Warburg's reputation for 'epigrammatic wit', Professor Gombrich proceeds to disregard 'this more volatile side of Warburg's personality' because 'in the nature of things' it 'has left few traces in his notes'. But the distinction is much too facile, and the notes themselves do not bear it out, since they inevitably include examples of the aphoristic felicity which also illumines Warburg's published writings. To begin an 'intellectual biography' of this particular scholar by ruling the Comic Muse out of court is to lose sight of an important phase of his historical imagination. Unfailingly responsive to human incongruities, which he would re-enact in his own person with a disconcerting degree of verisimilitude, Warburg used his wit as an ideal instrument for refining and deepening his historical discernment.

[2] *ein geräuschvolles Innenleben.*

Despite a strong strain of melancholy in his temperament which rendered him susceptible, from early years, to fits of dejection and nervous apprehension, Warburg was not a splenetic introvert but very much a citizen of the world, in which, knowing himself favoured by intellectual and economic wealth, he played his part with expansive zest and with a glorious sense of humour, not to forget a substantial dose of personal conceit which always marked his bearing. Admired in his youth as 'a ravishing dancer', he became notorious, while he was studying at Bonn, as one of the most ebullient among the revelling students who took part in the carnival at Cologne. His animal vitality (which illness never quite managed to subdue) was at the root of his marvellously exact comprehension of folk festivals, whether in Renaissance Florence or among the Pueblo Indians. Even his pursuit of far-fetched allegories had an ingredient of festive participation. A phrase that he enjoyed using in speech and writing, 'das bewegte Leben', defines what Pope would have called his ruling passion.

Given Warburg's pleasure in miming, and the important role it played in his conception of art, it is understandable that he seized with delight on the theory of *Einfühlung* (empathy), introduced into psychology and aesthetics by Robert Vischer, who had coined the term in his revolutionary little treatise *Über das optische Formgefühl* (1873),[3] directed against 'die Herbartische Schule'. Warburg referred to this book in the preface to his first work, the dissertation on Botticelli,[4] listing it as the principal source for the study of *Einfühlung*, which he said had some bearing on his own method. In describing Botticelli's peculiar trick of animating his firmly-set figures with the help of flamboyant accessories, such as fluttering draperies and flying hair, reminiscent of ancient Bacchantes, Warburg thought he could show in what devious ways empathy became a force in the formation of style. In later years, when he studied the link between Olympian and demonic deities in the transmission of pagan imagery, he noticed a similar bifurcation to that which he had first traced in Botticelli's art: an 'idealistic' firmness of outline offset by a 'manneristic' agitation in the accessories.

It is a measure of Professor Gombrich's imperfect rapport with some of Warburg's chief sources of inspiration that he has taken no account at all of Vischer's work or of the reference to it in Warburg's dissertation. *Einfühlung* is a term regularly used by Warburg, and the word 'empathy' occurs quite often in Professor Gombrich's book. But he gives no indication that this term, so important in Warburg's thought, was a new coinage of the 1870s. A closer study of Warburg's method, with an exact analysis of his debt to Vischer and of the constructive ideas that grew out of it, might have led Professor Gombrich to revise his opinion, pronounced several times with an air of finality which would have been ill-judged even if the evidence had been less faulty, that Warburg's psychological concepts make no allowance for the creative imagination and are therefore of little use for an understanding of artistic traditions. He repeatedly asserts that Warburg based his conception of the human mind on an outmoded mechanistic psychology that only 'talked in terms of sense impressions and the association of ideas'—the very doctrine against which Vischer had written *Über das optische Formgefühl*.[5]

One phase of Warburg's psychological thinking embarrasses Professor Gombrich particularly: like Vischer, Warburg believed that the physiology of the brain would one day offer the means of giving a scientifically exact account of the workings of empathy and its ramifications. Professor

[3] Reprinted in *Drei Schriften zum ästhetischen Form-problem* (1927), pp. 1–44.

[4] See above, p. 27 notes 15 f.

[5] The lively debates on the nature of *Einfühlung* arising from Robert Vischer's spirited treatise still survive in Croce's diatribe *L'estetica della 'Einfühlung' e Roberto Vischer* (1934). On Vischer's aesthetic psychology in relation to Wölfflin, Berenson, and Geoffrey Scott, see Wind, *Art and Anarchy* (1969), pp. 150 f., also 128.

Gombrich has looked with some despair on the 'increasing' number of notes devoted by Warburg to these reflections. Unfortunately none is quoted. It is to be hoped that this interesting phase of Warburg's thought will eventually be studied by a historian who has mastered the physiological psychology of that period. The interest is more than antiquarian: for in Warburg's concern with empathy and its operation lies the key to his later and more famous researches into magic and demonology, which led, for example, to his epochal discovery of oriental star-demons in the frescoes of the Palazzo Schifanoia in Ferrara, or of traces of pagan augury in Luther's anti-papal policy of advertising animal monstrosities as authentic portents, illustrated in broadsheets. Indeed, some perhaps over-refined distinctions introduced by Vischer into the study of empathy—'Einfühlung, Anfühlung, Zufühlung'[6]—recur in one of Warburg's earliest attempts to distinguish between various kinds of magical appropriation ('Einverleibung, Anverleibung, Zuverleibung').[7]

On Warburg's skill in revising his drafts and refining his formulations, often with the help of astringent exercises in permutation, by which he liked to test the range and density of his terms, Professor Gombrich's opinion is unfavourable: 'The result was often paralysis.' It is open to doubt whether the term 'blockage', also used by Professor Gombrich, is much too coarse to designate the uneven rhythm that Warburg noticed in the progress of his work. In a delightful autobiographical note on his *Trüffelschweindienste* (services as a pig for rooting out truffles) Warburg observed that, so far as his conscious awareness was concerned, his general ideas on historical psychology and his discoveries about particular historical situations had resisted the disclosure of their 'intimate connexion' until he was forty.[8] To a reader of the important works that Warburg had published between 1902 and 1906, this would suggest that at the age of forty (1906), when he began composing *Francesco Sassetti*, Warburg suddenly felt a new freedom and clarity in his application of principles that had governed his previous writings in a more instinctive way. But despite the truffles, Professor Gombrich insists that this note, which has a good deal of self-parody in it, must be accepted as positive proof that Warburg had suffered in the years before 1906 from a protracted and very severe 'blockage' of his mental faculties of co-ordination. Given the humorous tone of the note, and considering the publications of 1902-6 (beginning with *Bildniskunst und Florentinisches Bürgertum*, immediately followed in the same year, 1902, by *Flandrische Kunst und Florentinische Frührenaissance*, both packed with new heraldic and iconographic discoveries of the widest psychological import), the inference seems a little hasty; but it adds to the splenetic gloom that Professor Gombrich has spread over his canvas.

In the biographical narrative, the impression that Warburg must have suffered from intense intellectual isolation is strengthened by an important source for his intellectual history being left untapped—his scholarly friendships. Time and again a name flits across these pages—'his friend Mesnil', 'his friend Jolles', 'his Florentine friend Giovanni Poggi', 'his friend, the Hamburg art historian Pauli'—but beyond the bare fact that Mesnil was 'a Belgian art historian' or Jolles 'a Dutch author-philosopher', no attempt is made anywhere to characterize these men or to give even the slightest idea of their scholarly preoccupations or personal idiosyncrasies—particularly attractive in the benign anarchist Mesnil, author of Baedeker's Italian volumes, who worked concentratedly, as did Warburg, on Botticelli and on artistic exchanges between Flanders and Italy.

Even Jolles, who appears as Warburg's co-author in a *jeu d'esprit* (whose title, *Ninfa fiorentina*,

[6] R. Vischer, op. cit., p. 26.

[7] Warburg in a note written at Santa Fé in 1896, quoted by Gombrich, p. 91.

[8] Warburg's Diary, 8 April 1907, quoted by Gombrich, p. 140.

derives almost certainly from Boccaccio's *Ninfa fiesolana*), remains a mere shadow in this book; not to speak of the famous Poggi, to whom Warburg paid the odd compliment that while he himself was working through the dark tunnel of the Medicean *vita amorosa*, he heard 'friend Poggi knocking at the other end'. As for Pauli, it is a memorable fact, here unremembered, that the intimate friendship that united him and Warburg could hardly have been foretold from a scathing review of Warburg's dissertation, in which Pauli declared it absurd that this novice should apply to Botticelli a mass of learning that was much larger and weightier than Botticelli's own.[9] This brilliantly written critique, in which a well-worn paradox was stated for the first time, is not listed in the bibliography of 'Writings about Warburg' which Professor Gombrich has appended to his book. For no apparent reason this bibliography begins only with the year 1917 and so omits all that was written about, against, and in favour of Warburg at the time when his major discoveries first appeared in print.[10]

Considering that Warburg never assumed that he could understand a historical character unless he had meticulously related him to his intellectual surroundings, it seems extraordinary that he himself should have been made the subject of a monograph which ignores that fundamental principle in dealing with his mature years. It may indeed be doubted whether a biography which omits such an important part of a scholar's life as his intellectual friendships can itself be called 'an intellectual biography' at all. No reference is made, for example, either in the text or in the bibliography, to the long and eloquent tribute to Warburg, composed in the name of the community of learning that had found its centre in Warburg's library and person, which Ernst Cassirer prefixed as a sort of collective dedication to his book *Individuum und Kosmos in der Philosophie der Renaissance* (1926).

By the time the biography reaches that final period in Hamburg (after 1924), when Warburg became deeply involved in the affairs of the new university, even names become scarce and tend to disappear in a shadowy phrase—'the *entourage*'—rather ill-suited for a group of scholars except perhaps in a satirical sense, which is not intended here. Warburg's frequent confabulations with Cassirer, marked by a vivid contrast of personalities—Cassirer being always impeccably Olympian in the face of Warburg's demonic intensity—are not even mentioned by Professor Gombrich, although Cassirer was among the first scholars to visit Warburg during his convalescence from a long mental illness. In memory of a clarifying exchange of ideas that they had at that time about Kepler, Warburg ordered the reading-room in his new library to be built in the shape of an ellipse.

Some five years later, reflecting on his association with Warburg and on the impression he had received at their first meeting, Cassirer wrote: 'In the first conversation that I had with Warburg, he remarked that the demons, whose sway in the history of mankind he had tried to explore, had taken their revenge by seizing him.'[11] Professor Gombrich, who has looked at the diaries that Warburg kept during his illness, has reached a different conclusion: 'Written in pencil in states of obvious excitement and anxiety, they are both hard to decipher and uninformative to the non-psychiatrist. They hardly sustain the legend which has grown up that the patient's main preoccupations at that time were connected with his past researches into demonology and superstition.' It is not quite clear how a script which Professor Gombrich found hard to decipher and uninformative enabled him to dispose of an existing account as legendary. In any case, 'the legend' did not 'grow up' at random but was apparently started by Warburg himself. It could of course be argued that this may well have

[9] G. Pauli, 'Antike Einflüsse in der italienischen Früh-renaissance', a review of A. Warburg, *Sandro Botticellis 'Geburt der Venus' und 'Frühling'* (1893), in *Kunstchronik*, N.F. 5 (1894), pp. 14-177.

[10] See below, note 13.
[11] From Cassirer's address at Warburg's funeral, in *Aby M. Warburg zum Gedächtnis* (privately printed, Darmstadt, 1929).

been Warburg's way of looking back on his illness after he had recovered from it, and that during the illness itself he would have had other and perhaps less elevated preoccupations; but two facts speak against taking Warburg's retrospective judgement too lightly. It is generally agreed, and Professor Gombrich admits, that Warburg's astounding insight into the nature of his obsessions contributed to his cure; and it is known that the crucial test he proposed to his doctor, by which he hoped to show that he had freed himself of the terrors that beset him, was that he would manage to give a coherent lecture on 'Pueblo Serpent Rituals'—and he delivered it to the patients of the hospital. By a strange irony, it is the only work of his that has appeared in English (translated by W. F. Mainland).[12] He, of course, never published it himself.

In an essay 'Vom Nutzen und Nachteil der Historie für das Leben', Nietzsche remarked that an apt cultivation of forgetfulness is indispensable to mental health. It is certain that Warburg was never mentally healthy in that respect. Although he knew the dangers of excessive empathy and of all-too-passionate recollection, he exercised these powers without thrift. Having entered deeply, as a witness of contemporary political history, into the spirit of a whole cluster of quite calamitous decisions that left the comity of nations in a shambles, this good European went out of his mind in 1918, and it took him six years to recover. During his illness Warburg wrote more or less constantly. In the hands of an experienced physician these papers ought to be an extremely valuable source for studying the progress and recovery of an exceptionally gifted psychotic. Professor Gombrich decided to leave those six years untouched, on the ground that he was not competent to deal with them. Warburg would not have favoured that decision: for he held, and always vigorously insisted, that whenever a scholar runs up against a problem which he has not the professional competence to handle, he must call in the help of an expert and make the work a joint investigation. It is fair to say that if those six years had been studied as they deserve to be, the darkness which has spread over the whole of Professor Gombrich's presentation would have been concentrated in the right place.

Understandably, Professor Gombrich was unable to close his eyes and mind completely to some of those papers that he did not feel qualified to interpret. In a casual way he has even made some use of them. Thus his account of Warburg's childhood rests in part on notes written by Warburg during his illness: that is, written some fifty years after the events on which they reflect, and under decidedly abnormal circumstances. As they stand, they impart to the chapter entitled 'Prelude' a psychopathic ingredient that somehow sets the tone of the book. Professor Gombrich says, in the introduction, that 'the precarious balance of Warburg's mental health' has enabled 'the biographer often to discern the reasons for his personal involvements more clearly than would be the case with more extrovert scholars'. To judge from this remark, and indeed from the book itself, the biographer's terms of reference have not been kept free from medical connotations, and this makes it all the more regrettable that this province was not surrendered to more competent hands.

A few words must be said about the workmanship of *Aby Warburg*. The bibliographies are careless, even with regard to Warburg's own writings (*Gesammelte Schriften*, for example, is listed without its title, *Die Erneuerung der heidnischen Antike*, and without the names of the editors: G. Bing assisted by F. Rougemont). Works published in periodicals are given without pagination, so that it is impossible to distinguish between major studies and short notes. The bibliography of writings about Warburg, besides omitting everything written before 1917, is also incomplete after that date. If a selective bibliography was intended here, a good deal could have been left out to make room for Boll-Bezold's *Sternglaube und Sterndeutung*, Ernst Robert Curtius's *European Litera-*

[12] See above, p. 27 notes 18 f.

ture and the Latin Middle Ages, Mesnil's *Botticelli*, or Pauli's reminiscences, to mention only a few works.[13] The extracts from Warburg's unpublished papers are printed without annotations. Thus, when Warburg reflects on 'contemporary artists such as Philipp, Niels, Veth', these obscure names are left unexplained. Where it is said that Warburg's brothers bought 'two paintings by Consul Weber', it is more likely that they brought them *from* Consul Weber, who was a well-known collector in Hamburg. In one of the fragments from the *Ninfa fiorentina*, Warburg quotes a poetic phrase by Jean Paul ('auf einen Stamm geimpfet blühen'); but no reference is here given to the text (*Vorschule der Ästhetik*, II, ix, 50) or to the important role it played in Warburg's later reflections on the nature of metaphor. The index not only fails to list this early quotation under the name of Jean Paul, but is altogether an uneven instrument, apparently omitting names on which the editorial work has been deficient. The illustrations at the end of the book are coarsely arranged. A plate on which a portrait of Warburg is juxtaposed to Max Liebermann's painting of old-age pensioners in Amsterdam is unintentionally hilarious. Captions are often incomplete and occasionally incorrect: 'Death of Alcestis' is inscribed under an image actually representing 'The Death of Meleager'.

Professor Gombrich is content to cite Edmund Wilson, *To the Finland Station*, as his sole source for a ranting letter by Michelet, from which he quotes, inaccurately and lengthily, on the ground that it 'might have been written by Warburg'. Fortunately it was not. An old and so far unverified supposition that Warburg's famous adage, 'Der liebe Gott steckt im Detail', might be a translation from Flaubert is repeated here without any reference to an authentic sentence in Flaubert, whose writings are not inaccessible.[14] Furthermore, while Professor Gombrich never misses an opportunity to inveigh against the notion of *Zeitgeist*, he continues to use the concept in the guise of 'period flavour'. Thus the aura of Isadora Duncan is supposed to be discernible in Warburg's *Ninfa fiorentina*, an analogy so completely off-key that it is not surprising to learn from a footnote that Warburg found Isadora Duncan ludicrous; but this fact has not induced Professor Gombrich to question the pertinence of his construction. Indeed, the author's certainties appear at times excessive. The truculent Karl Lamprecht, for example, whose historical courses Warburg attended for three terms in Bonn, is confidently declared to be the 'one man who may be called Warburg's real teacher'; but unlike Usener and Justi, whose lectures Warburg had likewise heard in Bonn, Lamprecht is not mentioned in any of Warburg's publications. Can this fact be left out of the reckoning?

Misjudgements of scale occur quite regularly when analysis of personal motivations is attempted. Sentences like 'he wanted to prove to himself, to his family, and to his in-laws that he had something to offer' belong, on the evidence of their vocabulary alone, to a mentality and a milieu that are smaller than Warburg's; not to speak of the touch of humour in the Lilliputian statement that Warburg 'never failed to attend congresses to counteract his isolation in the academic world'—a sentence that has the undeniable quality of 'period flavour'. Warburg was in fact extremely proud of exercising the

[13] [A comprehensive bibliography has now been published by Dieter Wuttke in his edition of *Aby Warburg. Ausgewählte Schriften und Würdigungen* (1979), pp. 521–81, which lists Warburg's complete writings, critical opinion of his work from the dissertation of 1893 onwards, and other material in the archives of the Warburg Institute, London, and elsewhere.]

[14] [Wuttke, pp. 614-25, traces the confused history of Warburg's phrase, from Cassirer's mention of it as Warburg's own (see above, note 11) to its reappearance in print in Ernst Robert Curtius's classic work *Europäische Literatur und Lateinisches Mittelalter* (1948). But as Wuttke notes, so apt a formulation, and one that has slipped into common parlance, sent later scholars looking for sources; the unsuccessful attribution to Flaubert is one of several examples. In Wind's view, Warburg's adage was a tough precept of historical demonstration: all his major papers from 1902 onwards were composed on the principle that his general psychological insights must appear in and through the historical particular, *universalia in re*, and this accounts for the density of Warburg's writings. The *contiguum* (as he called it) is at least as important as the *continuum*.]

'adventurous prerogatives of the independent private scholar'. To suggest, as Professor Gombrich does twice without producing any evidence, that a momentary dissatisfaction with the Kunsthistorisches Institut in Florence, on whose board Warburg worked most energetically, would have 'increased his eagerness to demonstrate through a rival institution how he saw matters' is not only out of character but objectively absurd, since Warburg never conceived of his own library and that of the Florentine institute as comparable, let alone as 'rival undertakings'.

Another unfounded speculation, which turns historical order upside down, is that Warburg's style was 'probably influenced' by Carlyle's *Sartor Resartus*, a book Warburg cherished because its 'Philosophy of Clothes' contained some penetrating remarks on the nature of symbols: for example, that in a good symbol, as in a good costume, concealment and revelation are combined. As for style, Warburg's language, with its sharp twists and cumulative periods, belongs to a familiar tradition of German prose which Carlyle parodied in *Sartor Resartus*, drawing on his intimate knowledge of Jean Paul, 'that vast World-Mahlstrom of Humour, with it heaven-kissing coruscations, which is now, alas, all congealed in the frost of death'.[15] As a parody this sort of language has its merits, but it is hardly a source of Warburg's style. He was never tempted to imitate, even as a spoof, Carlyle's brusque Germanic mannerisms. They are, indeed, notably absent from a cunningly phrased draft for a mock dedication, in which Warburg meant, with proper irony, to express his sense of affinity with the absurd professor of the philosophy of clothes: 'Dem Andenken Thomas Carlyles in Ehrfurcht ein Weihgeschenk von Teufelsdröckh dem Jüngeren.' Professor Gombrich, in discussing Warburg's affection for *Sartor Resartus*, has made no use of this priceless piece, perhaps because it belongs to the 'more volatile side of Warburg's personality'.

There is a danger that, despite its shortcomings, the book will be used and quoted as a surrogate for Warburg's own publications, which are still unavailable in English. A translation of those incomparable papers, lucid, solid, and concise, which Warburg himself committed to print, would have formed, if not a lighter, most certainly a shorter volume than the book under review. It appears, however, that among Warburg's followers it has become a tradition to regard his literary formulations as a sort of arcanum, as an exceedingly fine but too highly concentrated elixir of learning which should not be served to British consumers without an ample admixture of barley water. Though the chances of an English translation may now seem diminished by the sheer bulk of Professor Gombrich's inadequate treatment, the set-back is not likely to be permanent. Since an authorized Italian translation has been published,[16] the justified desire to read Warburg undiluted in English cannot be ignored in perpetuity.

[15] *Sartor Resartus*, I, iv. [16] *La rinascita del paganismo antico*, ed. G. Bing and trans. by E. Cantimori (1966).

The Published Writings of Edgar Wind

Works reprinted here or in the forthcoming companion volume *Hume and the Heroic Portrait* are marked with an asterisk (*).

1924

1. *Aesthetischer und kunstwissenschaftlicher Gegenstand. Ein Beitrag zur Methodologie der Kunstgeschichte.* Auszug aus der Inaugural-Dissertation. Universität Hamburg, 1922. 10 pp.

1925

2. 'Zur Systematik der künstlerischen Probleme.' *Zeitschrift für Ästhetik und allgemeine Kunstwissenschaft*, XVIII, 438-86 [from the Inaugural Dissertation].

3. 'Theory of Art versus Aesthetics.' *The Philosophical Review*, XXXIV, 350-9.

4. 'Contemporary German Philosophy.' *The Journal of Philosophy*, XXII, 477-93, 516-30.

5. Review of Hermann Count Keyserling, *The Travel Diary of a Philosopher*, trans. by J. H. Reece. New York, 1925. *The Nation*, CXXI, 19 August, 213-14.

1927

6. 'Experiment and Metaphysics.' In *Proceedings of the Sixth International Congress of Philosophy*, Harvard University, 1926. Ed. E. S. Brightman. New York, Longmans. Pp. 217-24.

7. Review of Alfred C. Elsbach, *Kant und Einstein*. Berlin, 1924. *The Journal of Philosophy*, XXIV, 64-71.

1931

8. * 'Warburgs Begriff der Kulturwissenschaft und seine Bedeutung für die Ästhetik.' In *Vierter Kongress für Ästhetik und allgemeine Kunstwissenschaft*, Beilageheft zur *Zeitschrift für Ästhetik und allgemeine Kunstwissenschaft*, XXV, 163-79. [Reprinted in *Aby M. Warburg. Ausgewählte Schriften und Würdigungen*. Hrsg. v. D. Wuttke. Baden-Baden, Valentin Koerner, 1979; 2nd edn., 1980. Pp. 401-17. Also in *Bildende Kunst als Zeichensystem*. Band I. *Ikonographie und Ikonologie: Theorien—Entwicklung—Probleme*. Hrsg. v. E. Kaemmerling. Köln, DuMont Buchverlag, 1979. Pp. 165-84.]

1932

9. * 'Θεῖος Φόβος. Untersuchungen über die Platonische Kunstphilosophie.' *Zeitschrift für Ästhetik und allgemeine Kunstwissenschaft*, XXVI, 349-73 [inaugural lecture as Privatdozent in the University of Hamburg, 1930].

10. * 'Humanitätsidee und heroisiertes Porträt in der englischen Kultur des 18. Jahrhunderts.' In *England und die Antike*, Vorträge der Bibliothek Warburg 1930-1931. Leipzig/Berlin, Teubner. Pp. 156-229, pls. XIII-XXX. [Kraus Reprint 1968.]

11. 'Mathematik und Sinnesempfindung. Materialen zu einer Whitehead-Kritik.' *Logos, Internationale Zeitschrift für Philosophie der Kultur*, XXI, 239-80.

1934

12. *Das Experiment und die Metaphysik. Zur Auflösung der kosmologischen Antinomien.* Tübingen, J. C. B. Mohr. xii + 120 pp. [Habilitationsschrift in der Philosophischen Fakultät, Universität Hamburg, 1929].

13. *Kulturwissenschaftliche Bibliographie zum Nachleben der Antike*. Erster Band. *Die Erscheinungen des Jahres 1931*. In Gemeinschaft mit Fachgenossen bearbeitet von Hans Meier, Richard Newald, Edgar Wind. Einleitung von Edgar Wind [pp. v-xvii]. Hrsg. v. d. Bibliothek Warburg. Leipzig/Berlin, Teubner. xvii + 333 pp. [for Wind's reviews of books in the bibliography, see nos. 88, 127, 133, 145, 146, 155, 282, 292, 404, 428, 429, 430, 440, 464, 823, 982, 992, 993, 996, 1000, 1045, 1055, 1060, 1063, 1066, 1067, 1068, 1072, 1093, 1119, 1123, 1125, 1160, 1161, 1162, 1163, 1164, 1169, 1171, 1201, 1202]. [Kraus Reprint 1968, with English title of no. 14.]

14. *A Bibliography on the Survival of the Classics*. First Volume. *The Publications of 1931*. The text of the German edition with an English introduction by Edgar Wind [pp. v-xii]. Ed. The Warburg Institute. London, Cassel & Co. xii + 333 pp.

15. 'Can the Antinomies be restated?' *Psyche*, XIV, 177-8.

1935

16. 'The Warburg Institute Classification Scheme.' *The Library Association Record*, II, 193-5.

17. Review of M. D. George, *Catalogue of Political and Personal Satires preserved in the Department of Prints and Drawings in the British Museum*, V (1771-1783). London, 1935. *The Burlington Magazine*, LXVII, 179.

1936

18. 'Some Points of Contact between History and Natural Science.' In *Philosophy and History. Essays presented to Ernst Cassirer*. Ed. R. Klibansky and H. J. Paton. Oxford, The Clarendon Press. Pp. 255-64. [Reprinted New York, Harper Torchbooks, 1963; Gloucester, Mass., Peter Smith, 1975.]

1937

19. *Journal of the Warburg Institute*, I-II (1937-9). Ed. Edgar Wind and Rudolf Wittkower. [Kraus Reprint 1965.]

20. * 'Donatello's *Judith*. A Symbol of Sanctimonia.' Ibid., I, 62-3.

21. * 'AENIGMA TERMINI [the Emblem of Erasmus of Rotterdam].' Ibid., 66–9.

22. * 'Platonic Justice designed by Raphael.' Ibid., 69–70.

23. * 'The Mænad under the Cross: 1. Comments on an Observation by Reynolds.' Ibid., 70–1.

24. 'An Emendation of Pope by Lessing.' Ibid., 78–9.

25. 'Studies in Allegorical Portraiture, I: 1. In Defence of Composite Portraits. Ibid., 138–42.

 * 2. Albrecht von Brandenburg as St. Erasmus [by Grünewald].' Ibid., 142–62.

26. * 'The Christian Democritus.' Ibid., 180–2.

27. 'The Saint as Monster.' Ibid., 183.

28. 'Verrio's "Terribilità".' Ibid., 184–5.

29. Review of Kaiser Wilhelm II, *Studien zur Gorgo*. Berlin, 1936. *The Burlington Magazine*, LXXI, 55 [signed 'N. B.'].

1938

30. Friedrich Gundolf, *Anfänge deutscher Geschichtschreibung*. Hrsg. v. Elizabeth Gundolf und Edgar Wind. Amsterdam, Elsevier. 176 pp.

31. *A Bibliography of the Survival of the Classics*. Second Volume. *The Publications of 1932–1933*. Ed. The Warburg Institute. London, The Warburg Institute. xv + 382 pp. [for Wind's reviews see nos. 1136 and 1161]. [Kraus Reprint 1968.]

32. 'The Criminal-God.' *Journal of the Warburg Institute*, I, 243–5.

33. 'The Crucifixion of Haman [by Michelangelo].' Ibid., 245–8.

34. 'Two Notes on the Cult of Ruins.' Ibid., 259–60.

35. 'Homo Platonis.' Ibid., 261.

36. 'Charity. The Case History of a Pattern.' Ibid., 322–30.

37. 'A Mediaeval Formula in Kant.' Ibid., II, 64.

38. 'The Four Elements in Raphael's Stanza della Segnatura.' Ibid., 75–9.

39. * 'The Revolution of History Painting.' Ibid., 116–27. [Reprinted in *Readings in Art History*. Ed. H. Spencer. 2 vols. New York, Scribners, 1976. II, pp. 233–52. Also in *Rococo to Romanticism: Art and Architecture*. New York, The Garland Library of the History of Art, 1976. Pp. 187–200, and separately.]

40. * '"Borrowed Attitudes" in Reynolds and Hogarth.' Ibid., 182–5.

41. * 'Shaftesbury as a Patron of Art. With a Letter by Closterman and two Designs by Guidi.' Ibid., 185–8.

1939

42. 'An Eighteenth-Century Improvisation in a Leonardo Drawing.' *Old Master Drawings*, XIII, no. 52, 49–50.

43. '*Hercules* and *Orpheus*. Two Mock-heroic Designs by Dürer.' *Journal of the Warburg Institute*, II, 206–18.

44. 'Giordano Bruno between Tragedy and Comedy.' Ibid., 262.

45. 'Dürer's *Männerbad*. A Dionysian Mystery.' Ibid., 269–71.

46. *Journal of the Warburg and Courtauld Institutes*, III–V (1939–42). Ed. Edgar Wind, Rudolf Wittkower, T. S. R. Boase, and Anthony Blunt. [Kraus Reprint 1965.]

47. * 'Julian the Apostate at Hampton Court.' Ibid., III, 127–37. [Reprinted in *England and the Mediterranean Tradition*. Ed. the Warburg and Courtauld Institutes. London, Oxford University Press, 1945. Pp. 131–8.]

48. 'A Self-Portrait of [El] Greco.' Ibid., 141–2.

49. 'The Monarch's Crown of Thorns: 2. Heine on Louis Philippe.' Ibid., 160–1.

1940

50. * 'The Subject of Botticelli's *Derelitta*.' Ibid., IV, 114–17.

 'Das Thema von Botticellis *Derelitta*.' Übersetzt von Kurt Wölfel. *Akzente*, XXIX, 1982, 173–8.

1941

51. * 'The Sources of David's *Horaces*.' Ibid., 124–38.

1943

52. * 'The Lion Filled with Lilies. A Reminiscence of Leonardo in Hogarth.' Ibid., VI, 222–3.

53. 'Reynolds and Pope on Composite Beauty.' Ibid., 223.

54. 'A Lost Article on David by Reynolds.' Ibid., 223–4.

55. 'Harlequin between Tragedy and Comedy.' Ibid., 224–5.

56. * '"Milking the Bull and the He-Goat".' Ibid., 225 [reprinted in a revised version with the title 'Johnson and Demonax'].

1945

[47. 'Julian the Apostate at Hampton Court', reprinted London.]

1946

57. 'Jean-Paul Sartre: a French Heidegger.' *Polemic*, V, 54–7.

1947

58. * 'Penny, West, and the *Death of Wolfe*.' *Journal of the Warburg and Courtauld Institutes*, X, 159–62.

59. 'The Hogarth-Constable-Turner Exhibition [at the Metropolitan Museum of Art, New York].' *Art News*, XLV, no. 13 (March), 14–17, 62–4.

60. 'Sante Pagnini and Michelangelo. A Study of the Succession of Savonarola.' In *Mélanges Henri Focillon, Gazette des Beaux-Arts*, VI Series, XXVI (1944, pub. 1947), 211–46.

1948

61. *Bellini's Feast of the Gods. A Study in Venetian Humanism*. Cambridge, Mass., Harvard University Press, also London, Oxford University Press. 81 pp., 74 illus.

62. 'The Critical Nature of a Work of Art.' In *Music and Criticism*. A Symposium. Ed.

R. F. French. Cambridge, Mass., Harvard University Press. Pp. 53–72. [Reprinted in *Form and Idea*. Ed. M. W. Bloomfield and E. W. Robbins. New York, Macmillan, 1953. Pp. 263–76.]

1949

63. 'Mantegna's *Parnassus*. A Reply to Some Recent Reflections.' *The Art Bulletin*, XXXI, 224–31.

64. * 'A Source for Reynolds's Parody of *The School of Athens*.' *Harvard Library Bulletin*, III, 294–7.

1950

65. 'The Ark of Noah. A Study in the Symbolism of Michelangelo.' *Measure*, I, 411–21.

66. 'The Eloquence of Symbols.' *The Burlington Magazine*, XCII, 349–50.

 'Die Beredsamkeit der Symbole.' Übersetzt von Kurt Wölfel. *Akzente*, XXIX, 1982, 168–72.

67. 'A Note on Bacchus and Ariadne.' Letter to the Editor. Ibid., 82–5.

1951

68. 'Typology in the Sistine Ceiling. A Critical Statement.' *The Art Bulletin*, XXXIII, 41–7.

69. Letter to the Editor [on *Bellini's Feast of the Gods*]. Ibid., 70.

1952

70. Three Talks on Leonardo da Vinci for the British Broadcasting Corporation, London:

 I. 'Mathematics and Sensibility.' *The Listener*, XLVII, 1 May, 705–6.

 II. '*The Last Supper*.' Ibid., 8 May, 747–8.

 III. 'Leonardo as a Physiognomist.' Ibid., 15 May, 787–8.

1953

[62. 'The Critical Nature of a Work of Art', reprinted New York.]

71. * 'Traditional Religion and Modern Art [Rouault and Matisse].' *Art News*, LII, no. 3 (May), 18–22, 60–3.

72. 'Un art de caprice, de recherches, un art marginal.' In *Problèmes de l'art contemporain. Supplément de la Revue 'Preuves'*, Nr. 29, 16–17.

1954

73. * 'The Revival of Origen.' In *Studies in Art and Literature for Belle da Costa Greene*. Ed. Dorothy Miner. Princeton, NJ, Princeton University Press. Pp. 412–24.

1956

74. Review of Herbert Read, *Icon and Idea*. London, 1955. *The Times Literary Supplement*, 11 May, 277–8.

1957

75. * 'Blake and Reynolds.' *The Listener*, LVIII, 28 November, 879–80.

1958

76. *Pagan Mysteries in the Renaissance*. London, Faber & Faber, also New Haven, Conn., Yale University Press. 230 pp., 77 illus.

 Enlarged and revised edn. Harmondsworth, Middx., Penguin Books, 1967. xiv + 345 pp., 102 illus.

 New and enlarged edn. London, Faber & Faber, 1968, also New York, Barnes & Noble. [Reprinted New York, The Norton Library of Art and Architecture, 1968.]

 The 1968 edn. revised and reprinted, Oxford University Press (Oxford Paperback), 1980.

 > *Misteri pagani nel Rinascimento*. Traduzione di Piero Bertolucci. Milano, Adelphi, 1971. xvi + 465 pp., 102 illus.

 > *Los misterios paganos del Renacimiento*. Traducción de Javier Fernández de Castro y Julio Bayón. Barcelona, Barral Editores, 1972. 366 pp., 102 illus.

 > *Heidnische Mysterien in der Renaissance*. Übersetzt von Christa Münstermann unter Mitarbeit von Bernhard Buschendorf und Gisela Heinrichs [based on the 1968 edn., revised in 1980, with further additions to the notes]. Mit einem Nachwort von Bernhard Buschendorf. Frankfurt am Main, Suhrkamp, 1981. 484 pp., 102 illus.

77. 'Microcosm and Memory.' Letter to the Editor. *The Times Literary Supplement*, 30 May, 297.

1959

78. Review of Ellis Waterhouse, *Gainsborough*. London, 1958. *The Times Literary Supplement*, 20 March, 153–4.

1960

79. 'Maccabean Histories in the Sistine Ceiling.' In *Italian Renaissance Studies. A Tribute to the late Cecilia M. Ady*. Ed. E. F. Jacob. London, Faber & Faber. Pp. 312–27. [Reprinted 1966.]

80. *Art and Anarchy*. The Reith Lectures 1960. The British Broadcasting Corporation, London.

 I. 'Our Present Discontents.' *The Listener*, LXIV, 17 November, 881–4.

II. 'Aesthetic Participation.' Ibid., 24 November, 929–32.

III. 'Critique of Connoisseurship.' Ibid., 1 December, 973–6.

 'Technique du coup d'œil' [trans. by Jean-François Revel]. *L'Œil*, Nr. 95,
 novembre 1962, 32–9, 96.

 'Krytyka znawstwa.' [In] *Pojęcia, problemy, metody współczesnej nauki o
 sztuce*. Redagował i tłumaczyl Jan Białostocki. Warszawa, 1976. Pp.
 170–92.

IV. 'The Fear of Knowledge.' *The Listener*, 8 December, 1039–41. [Reprinted in
 The Saturday Evening Post, 235, 10 February 1962, 52–6.]

 V. 'The Mechanization of Art.' Ibid., 15 December, 1095–8. [Reprinted in
 Harper's Magazine, 228, February 1964, 65–72. Also in *Readings in Art History*.
 Ed. H. Spencer. New York, Scribners, 1969. Pp. 377–91.]

VI. 'Art and the Will.' Ibid., 22 December, 1137–40. [Reprinted in *Harper's
 Magazine*, 229, March 1964, 98–108.]

Art and Anarchy. The Reith Lectures 1960 revised and enlarged. London, Faber
& Faber, 1963, also New York, Alfred Knopf, 1964. xii + 194 pp., 16 illus.

 Geijutsu to Kyōki. [Trans. by] Shūji Takashina. Tokyo, Iwanami Shoten, 1965.
 vii + 255 pp., 16 illus.

 Arte y anarquía. Versión española de Salustiano Masó. Madrid, Taurus
 Ediciones, 1967. 175 pp., 16 illus.

 Arte e anarchia. Traduzione di Rodolfo Wilcock. Milano, Adelphi, 1968. 258
 pp., 16 illus.

Art and Anarchy. The Reith Lectures 1960 revised and enlarged, including Addenda
1968. New York, Random House, 1969. xii + 213 pp., 16 illus.

 Arte e anarchia. Traduzione di Rodolfo Wilcock e [the Addenda only] Dario
 Turchini. Milano, Arnoldo Mondadori, 1972. 228 pp., 16 illus. [Reprinted
 1977.]

 Kunst en anarchie. De Reith Lectures van 1960, herzien en uitgebreid. Vertaald
 door N. H. Fuchs-van Maaren. Met een inleidung van J. A. Emmens.
 Amsterdam, Meulenhoff, 1973. 186 pp., 16 illus.

 Artă și anarhie. Conferințele Reith 1960. Revizuite și lărgite—incluzînd
 Addenda 1968. Traducere de Cristina Anastasiu-Condiescu. Prefață de Ion
 Pascadi. București, Editura Meridiane, 1979. 192 pp., 35 illus.

Kunst und Anarchie. Die Reith Lectures 1960. Durchgesehene Ausgabe mit den
Zusätzen von 1968 und späteren Ergänzungen. Übersetzung von Gottfried Boehm.
Frankfurt am Main, Suhrkamp, 1979. 220 pp., 16 illus.

1961

81. * 'Platonic Tyranny and the Renaissance Fortuna. On Ficino's Reading of *Laws*, IV,
 709A–712A.' In *De artibus opuscula XL. Essays in honor of Erwin Panofsky*. Ed.
 Millard Meiss. 2 vols. New York, New York University Press. I, pp. 491–6.

 'Tirannia platonica e Fortuna rinascimentale' [a revised version]. Traduzione
 di Piero Bertolucci. [In] *Adelphiana 1971*. Milano, Adelphi.· Pp. 23–36.

1962

[80. 'Critique of Connoisseurship', French trans., Paris. 'The Fear of Knowledge',
 reprinted Philadelphia.]

82. 'Une copie de la gravure de Claude Mellan pour l'Horace de 1642 utilisée comme
 frontispice pour un Juvénal.' *Gazette des Beaux-Arts*, LX, 316.

83. 'Modern Sacred Art.' Letter to the Editor. *The Times Literary Supplement*, 25 May,
 373.

1963

[18. 'Some Points of Contact between History and Natural Science', reprinted New York.]

[80. *Art and Anarchy*, revised and enlarged edn., London.]

84. * '[Yeats and] Raphael. The Dead Child on a Dolphin.' *The Times Literary Supple-
 ment*, 25 October, 874.

1964

[80. *Art and Anarchy*, revised and enlarged edn., New York. 'The Mechanization of Art'
 and 'Art and the Will', reprinted New York.]

85. 'Art and Anarchy.' Letters to the Editor. *The Times Literary Supplement*, 2 and 9
 April, 277 and 296 [included in a revised form in the Addenda to the 1969 edn. of *Art
 and Anarchy*, see no. 80].

1965

[80. *Art and Anarchy*, Japanese trans., Tokyo.]

86. *Michelangelo's Prophets and Sibyls*. Aspects of Art Lecture 1960. In *Proceedings of
 the British Academy*, LI, 1965 [1966] and separately. London, Oxford University
 Press. Pp. 47–84, with 48 pls.

87. 'PORUS CONSILII FILIUS: Notes on the Orphic "Counsels of Night".' In *L'opera e
 il pensiero di Giovanni Pico della Mirandola nella storia dell'umanesimo*. Atti del
 Convegno Internazionale, Mirandola, 15–18 settembre 1963. A cura dell'Istituto
 Nazionale di Studi sul Rinascimento, Firenze. II, pp. 197–203 [reprinted as Appen-
 dix 9 in *Pagan Mysteries in the Renaissance*, 1967, see no. 76].

1966

[79. 'Maccabean Histories in the Sistine Ceiling', reprinted London.]

1967

[76. *Pagan Mysteries in the Renaissance*, enlarged and revised edn., Harmondsworth, Middx.]

[80. *Art and Anarchy*, Spanish trans., Madrid.]

1968

[76. *Pagan Mysteries in the Renaissance*, new and enlarged edn., London and New York.]

[80. *Art and Anarchy*, Italian trans., Milan.]

88. Review of J. Byam Shaw, *Paintings by Old Masters at Christ Church, Oxford*. London, 1967. *J. B. S. Selected Writings*. [London] 1968. *The Times Literary Supplement*, 29 August, 912.

89. Review of Ellis Waterhouse, *The James A. de Rothschild Collection at Waddesdon Manor. Paintings*. Fribourg, 1967. *The Times Literary Supplement*, 31 October, 1216.

1969

[80. *Art and Anarchy*, revised and enlarged edn.—including Addenda 1968, New York. 'The Mechanization of Art', reprinted New York.]

90. *Giorgione's* Tempesta. *With Comments on Giorgione's Poetic Allegories*. Oxford, The Clarendon Press. xii + 51 pp., 57 illus.

1970

91. Review of John Sparrow, *Visible Words. A Study of Inscriptions in and as Books and Works of Art*. Cambridge, 1969. *The Times Literary Supplement*, 26 March, 337-8.

1971

[76. *Pagan Mysteries in the Renaissance*, Italian trans., Milan.]

[81. 'Platonic Tyranny and the Renaissance Fortuna', Italian trans., Milan.]

92. K. B. McFarlane, *Hans Memling*. Ed. Edgar Wind with the assistance of G. L. Harriss. Oxford, The Clarendon Press. xvi + 74 pp., 153 illus.

93. *Review of E. H. Gombrich, *Aby Warburg. An Intellectual Biography*. London, 1970. *The Times Literary Supplement*, 25 June, 735-6.

1972

[76. *Pagan Mysteries in the Renaissance*, Spanish trans., Barcelona.]

[80. *Art and Anarchy*, Italian trans. of the 1969 edn., Milan.]

1973

[80. *Art and Anarchy*, Dutch trans. of the 1969 edn., Amsterdam.]

1975

[18. 'Some Points of Contact between History and Natural Science', reprinted Gloucester, Mass.]

1976

[39. 'The Revolution of History Painting', reprinted New York.]

[80. 'The Critique of Connoisseurship', Polish trans., Warsaw.]

1977

[80. *Art and Anarchy*, Italian trans. of the 1969 edn., reprinted Milan.]

1979

[8. 'Warburgs Begriff der Kulturwissenschaft', reprinted Baden-Baden, and Cologne.]

[80. *Art and Anarchy*, new edn. in German, Frankfurt am Main; also Romanian trans. of the 1969 edn., Bucharest.]

1980

[76. *Pagan Mysteries in the Renaissance*, the 1968 edn. revised and reprinted Oxford.]

1981

[76. *Pagan Mysteries in the Renaissance*, German trans. of the 1980 edn., with additions, Frankfurt am Main.]

1982

[50. 'The Subject of Botticelli's *Derelitta*', German trans., Munich.]

[66. 'The Eloquence of Symbols', German trans., Munich.]

Index

Abraham, 70, 72–3, Figs. 25, 26
Abū Ma 'shar, xv
Achilles, 53
Ackermann, J.C.G., 84 n.
Ademollo, A., 38 n.
Aelian, *De natura animalium*, 105
Aeternitas, xxix, 81, Fig. 3
Agincourt, Seroux d', 50 n., Fig. 11
Ahasuerus, King, 39–41
Ajax, 14
Alberti, Leon Battista, 50 n.
Albret, Amanieu d', Cardinal, 48 n.
Alciati, Andrea, *Emblemata*, xxix, 82 n., Fig. 4
Alcibiades, 7
Aleander, Jerome, 43, 53; *De natura angelica*, 53 n.
Alexander the Great, 53
Alexander VI, Pope, 42, 44, 52
Allen, D.C., 50 n.
Allen, H.M., 43 n.
Allen, P.S., 43 n., 53 n., 58 n., 67–8 nn., 70 n., 72 n., 77 n., 80 n.
Alpers, S., 84 n.
Althorp (Northampton): Nollekens, *Dead Child on a Dolphin*, 105 n.
Ambrose, St., 82, 83, Fig. 33
Amerbach, Bonifacius, 77
Ames-Lewis, F., 50 n.
Amico di Sandro, l', 39
Amor, xxv
Amsterdam, Rijksmuseum: Hendrick Terbrugghen, *Democritus* and *Heraclitus*, 84, Figs. 35–6
Anderson, J., 82 n.
Angeleri, C., 89 n.
Antonello da Messina, *St. Jerome*, 70 n.
Antonio (in Goethe's *Tasso*), *see* Montecatino
Antony, St., xiii
Apelles, xxv
Apollo, xx, 5, 81
Aristotle, xviii, xx; *Ethica Nicomachea*, 56; *Politica*, 90–1
Arnold, Gottfried, 84
Aschaffenburg, Hofbibliothek: Ms. 14 (*Liber ostensionis reliquiarum* or Hallescher Heiltumcodex), 59, 63 n., 67 n., 73, Figs. 24, 31
Aschaffenburg, Staatsgemäldegalerie: Cranach

School, *Albrecht von Brandenburg as St. Erasmus*, 59, Fig. 19; Cranach School, *Martyrdom of St. Erasmus*, 61 n., 66, Fig. 20; Grünewald, *Lamentation*, 60 n.
Assy (Haute Savoie), Notre-Dame-de Toute-Grâce, Léger's mosaic, 99
Auden, W.H., xxv
Augustine, St., 45 n., 48, 52 n., 53, 57, 62 nn., 82; *De Trinitate*, 48; *Epistolae ad Hieronymum*, 45 n.; *Retractationes*, 45 n., 47
Averoldo, Altobello, medal of Tommaso Campeggi, xxix, Fig. 3

Bacchus, 81, *see also* Dionysus
Bamberger, F., 9 n.
Baraballo, Julius II's jester, 89
Barbaro, Ermolao, 52
Bartoli, A., 51 n.
Bartolommeo della Fonte, *Il Zibaldone* (Florence, Biblioteca Riccardiana, MS. 907), 38 n.
Basle, Historisches Museum: Erasmus' gem and seal, 80 n.
Baudelaire, 16–17, *Les Fleurs du mal*, 17
Beattie, James, xviii
Beazley, Sir John, xv
Bédarida, H., 46 n.
Beechey, H.W., xxx n.
Bell, Clive, xxxii, xxxiv, xxxvi
Bellini, Giovanni, *Feast of the Gods*, xxii
Bembo, Pietro, xxii
Bender, W., 84 n.
Berenson, Bernard, xv, xxxii, 108 n.
Bergson, Henri, 52
Berlin, Sir Isaiah, xix
Berlin (West), Staatliche Museen Preußischer Kulturbesitz, Gemäldegalerie: Lucas Cranach, *Cardinal Albrecht von Brandenburg as St. Jerome*, 69, Fig. 22
Berliner, R., 59 n., 63 n., 67 n.
Bernays, J., 91 n.
Bernini, 22, 33
Berve, H., 91 n.
Besse, Pierre de, *Le Democrite chrestien* and *L'Heraclite chrestien*, 83–4
Bezold, C., 111

Kolde, T., 62 n.
Konrad von Einbeck, *St. Maurice*, 74 n.
Kouznetzow, Russian restorer, 104
Krautheimer, R., 50 n.
Kristeller, P.O., 52 n., 86 n.
Künstle, K., 70 n., 72 n.
Kurz, O., 58 n.

Lachmann, K., 29 n.
Lacoste, H. de Bouillane de, 18 n.
Lamprecht, K., 112
Landino, Cristoforo, 83-4; *Disputationes Camaldu-lenses*, 83
latenter vivendum, xxxv
Lebeau, J., 84 n.
Le Dantec, Y.-G., 17 n.
Lee of Fareham, Viscount Arthur Hamilton, xix, xxi
Léger, mosaic for Notre-Dame-de-Toute-Grâce, Assy (Haute Savoie), 99
Leibniz, 62 n.
Leigh, C.W.E., 43 n.
Leland, John, *Genethliacon*, 57, Fig. 42
Leningrad, Hermitage: Raphael, *Dead Child on a Dolphin*, 103-105, Fig. 58
Leo X, Pope, 59, 70, 75-6
Leonardo da Vinci, xxi, xxvi, xxx, 34, 90; *Academia Leonardi Vinci*, xxvi; *Last Supper*, xxvi; his note-books (Paris, Bibliothèque de l'Institut de France, MS. A; Windsor Castle, Royal Library, Quaderni d'Anatomia, IV), xxvi
Lessing, xviii, 9-10, 15, 33; *Laokoon*, 29
Liber ostensionis reliquiarum, *see* Hallescher Heiltum-codex
Liebermann, Max, 112
Lightbown, R., 41 n.
Lippi, Filippino, attributed to, panels from a cas-sone: *Esther presented to Ahasuerus*, *Esther leaving the king's palace*, *Mordecai embracing Esther before the king*, *Triumph of Mordecai*, 39-41, Fig. 8
Lipsius, Justus, 84
Livingstone, Sir Richard, xix
Livy, 67, 81, 82
London, British Library: seal of Erasmus, 77, Fig. 16
London, British Museum: Altobello Averoldo, medal of Tommaso Campeggi, xxix, Fig. 3
London, National Gallery: Antonello da Messina, *St. Jerome*, 70 n.; Francesco Botticini, *Assumption of the Virgin*, 51
London, Victoria and Albert Museum: Quentin Massys, medal of Erasmus, 80-2, Figs. 14-15
Longford Castle (Wilts.): Holbein, *Portrait of Erasmus*, 82 n.
Lorenzetto (Lorenzo di Ludovico di Guglielmo Lotti), 103-4

Lothian, Lord, xxi
Louis XII, King of France, 55 n.
Louis XIII, King of France, 83
Lubac, Henri de, SJ, 55
Lucifer, 44
Luke, St., 98
Lurie, A.T., 84 n.
Luther, 46 n., 53 n., 62 n., 67-8, 75 n., 81-2, 109
Luxuria, 37-8
Luz, W.A., 58 n.

Machiavelli, 86, 89-90, 92, 93; *L'asino d'oro*, 89 n.; *Discorsi sopra la prima deca di Tito Livio*, 89, 90 n.; *Istorie fiorentine*, 89 n.; *Lettere*, 93 n.; *Il Principe*, 89-90, 92 n.
McCarthy, Senator Joseph, xxv
McConica, J., CSB, 80 n.
MacCurdy, E., xxvi n.
McFarlane, K.B., xxx
McKeon, R., xvi
Madrid, Museo del Prado: Rubens, *Democritus* and *Heraclitus*, 84, Figs. 38-9
Maffei, Raffaello, 52 n.
Magi, the Three, 63 n.
Mai, A., 51 n.
Mainland, W.F., 27 n., 111
Malatesta, Sigismondo, 92
Malermi, Niccolò, his edition of the Bible, xxx-xxxi
Mallarmé, Stéphane, xxx, 18 n.
Manchester Exhibition of 1857, 103
Manet, *Dead Christ mourned by Angels*, xxxi, 96; *L'homme mort* (fragment of *Épisode d'un combat de taureaux*), 96
Mann, J. G., 63 n.
Mantegna, *Dead Christ mourned by Angels*, xxxi, 96; *Lamentation*, 100, Fig. 43; *Parnassus*, xxii
Manutius, Aldus, 78, 82; Erasmus' *Adagia*, 78; edi-tion of Origen, 42-4, 46, 48, 53-4; Greek edition of Plato, 48
Margolin, J.-C., 53 n.
Mark, St., 98
Marshall, P.K., 79 n.
Martelli, M., 89 n.
Martin, F. X., OSB, 46 n., 47 n., 48 n.
Mary Magdalene, St., 59-60, 63, 66, 71 n.
Mary, the Virgin, 51, 73, 96, 97, 98, 99, 101, Fig. 54
Masaccio, 39
Massa, E., 46 n., 48 n.
Massys, Quentin, medal of Erasmus, 80-1, 82, Figs. 14-15
Matisse, Henri, xxvii, 95-102; his works for the Chapelle du Rosaire des Dominicaines, Vence: *Ave*, 97, 98, Fig. 54; *Crucifix*, 98, 100, Fig. 56; *St. Dominic*, 97, 98, Fig. 55; *Stations of the Cross*, 98,

Plates

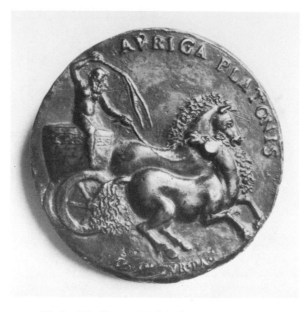

1. Giulio della Torre: Medal of Francesco di Giulio
della Torre (reverse), AVRIGA PLATONIS. Turin, Museo
Civico d'Arte Antica

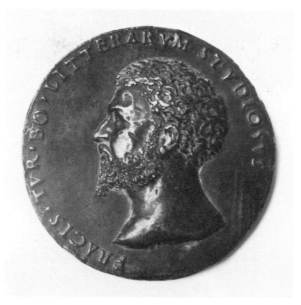

2. Giulio della Torre: Medal of Francesco di Giulio della
Torre (obverse), FRACIS · TVR · BO[NARVM] · LITTERARVM
STVDIOSVS. Turin, Museo Civico d'Arte Antica

3. Medal of Tommaso Campeggi (reverse),
AETERNITAS ▾ MDXXV ▾. London, British Museum

4. 'Ex literarum studiis immortalitatem acquiri', engraving
from Andrea Alciati's *Emblematum libellus*, 1542

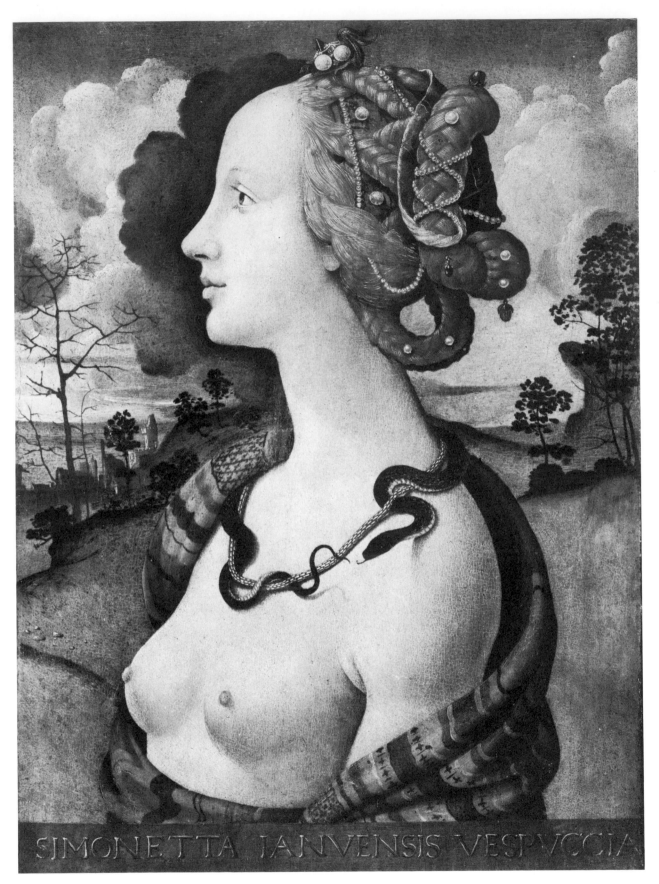

SIMONETTA IANVENSIS VESPVCCIA

5. Piero di Cosimo: *Simonetta Vespucci*. Chantilly, Musée Condé

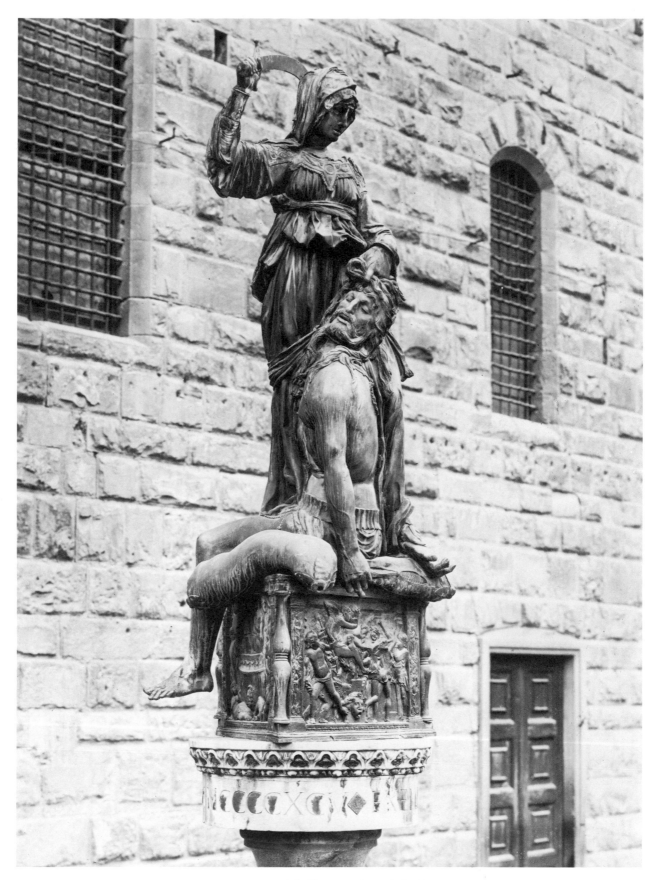

6. Donatello: *Judith*. Florence, Piazza della Signoria

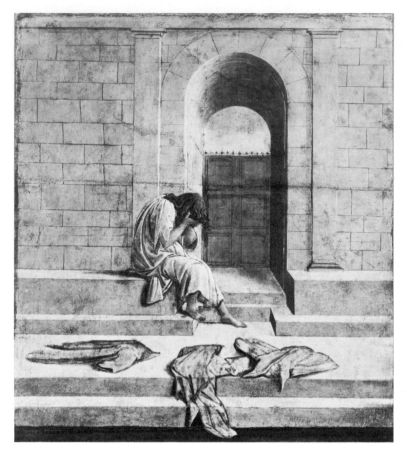

7. Botticelli: *Mordecai weeping at the King's gate.*
Rome, Pallavicini Collection

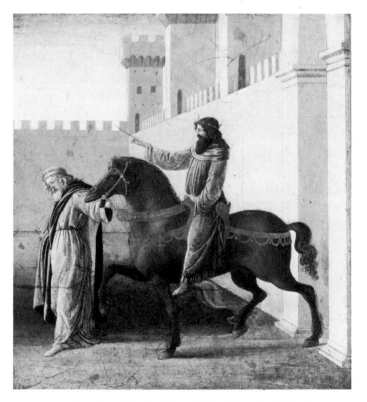

8. Attributed to Filippino Lippi: *The Triumph of Mordecai.*
Ottawa, The National Gallery of Canada

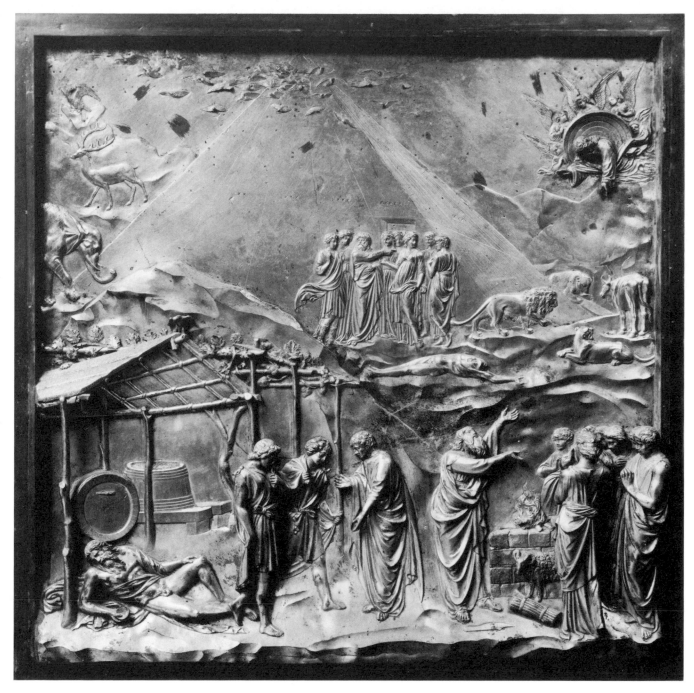

9. Ghiberti: *The Story of Noah*, from the Porta del Paradiso. Florence, Battistero

10. Botticelli: *The Healing of the Leper*. Palazzo Vaticano, Cappella Sistina

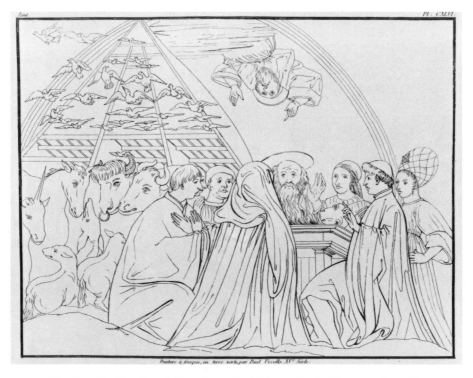

11. Uccello: *The Sacrifice of Noah*, from the Chiostro Verde. Florence, Santa Maria Novella. Engraving from Seroux d'Agincourt's *Histoire de l'art par les monumens*, 1823. London, British Library

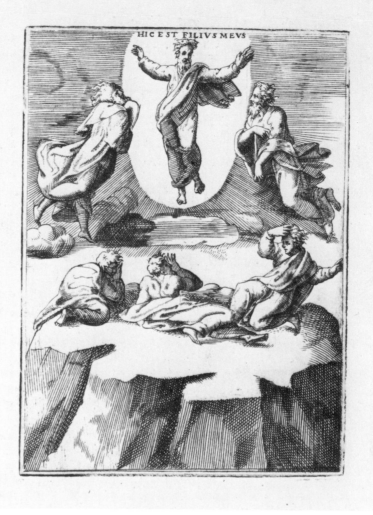

12. Giulio Bonasone: Engraving after Raphael's *Transfiguration*, from
Achille Bocchi's *Symbolicae quaestiones*, 1555. London, British Library

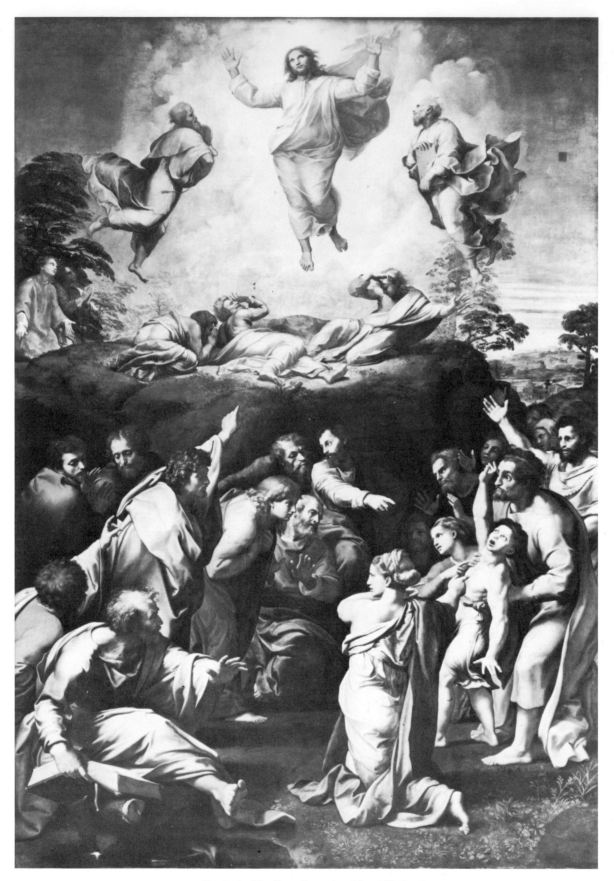

13. Raphael: *The Transfiguration*. Musei Vaticani

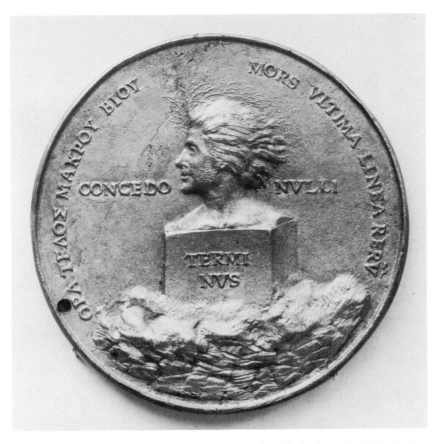

14. Quentin Massys: Medal of Erasmus (reverse), with the bust of TERMINVS
and the motto CONCEDO NVLLI, inscribed ΟΡΑ ΤΕΛΟΣ ΜΑΚΡΟΥ ΒΙΟΥ
MORS VLTIMA LINEA RERVM. London, Victoria and Albert Museum.

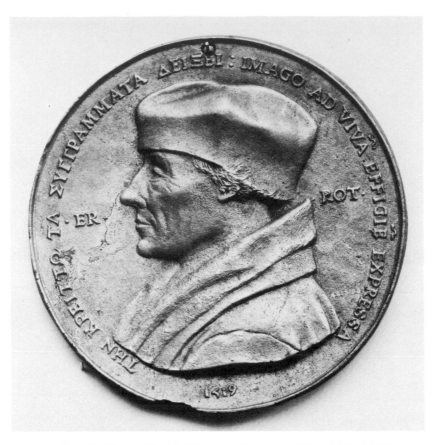

15. Quentin Massys: Medal of Erasmus (obverse), · ER · · ROT · / ΤΗΝ
ΚΡΕΙΤΤΩ ΤΑ ΣΥΓΓΡΑΜΜΑΤΑ ΔΕΙΞΕΙ: IMAGO AD VIVAM EFFIGIEM
EXPRESSA / 1519 [?]. London, Victoria and Albert Museum

16. The Seal of Erasmus, with the bust of
TERMINVS, inscribed CEDO NVLLI. After a
cast (enlarged). London, British Library

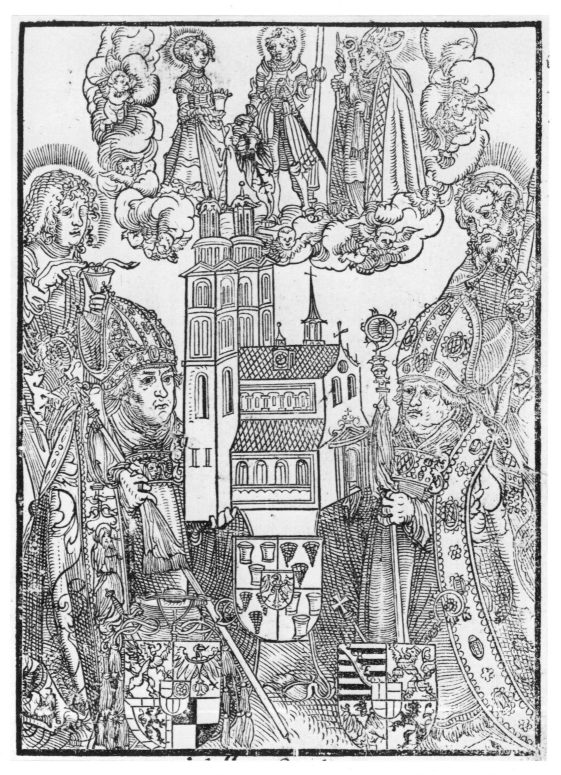

17. Albrecht von Brandenburg and Ernst von Sachsen with a model of the Kollegiatstift, Halle. Frontispiece to *Das Hallesche Heiltumsbuch*, 1520. Woodcut (enlarged). London, British Library

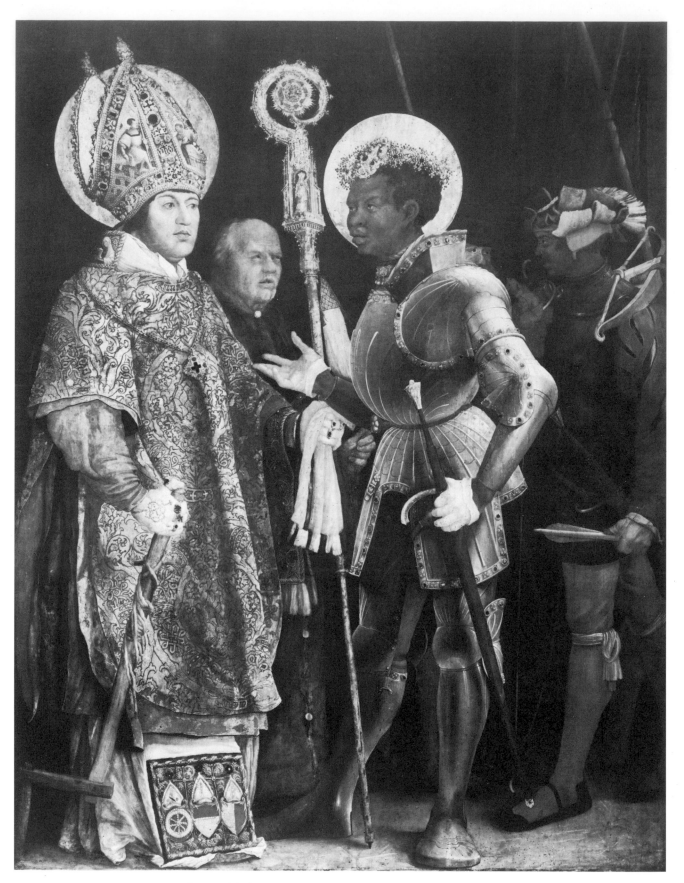

18. Grünewald: *St. Erasmus and St. Maurice*. Munich, Alte Pinakothek

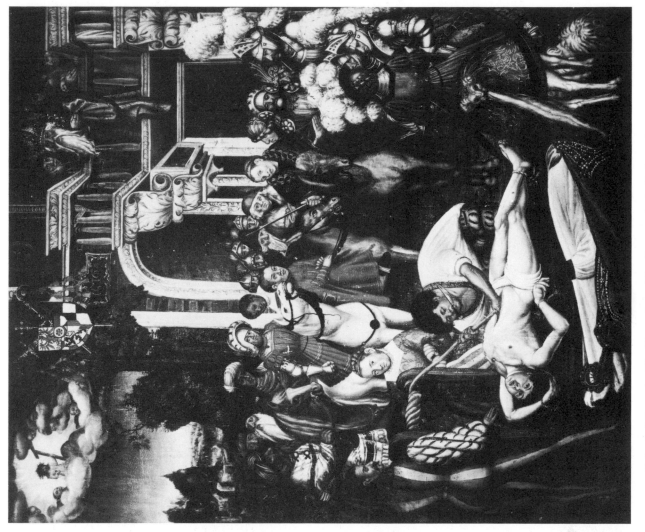

20. School of Cranach: *The Martyrdom of St. Erasmus*. Aschaffenburg, Staatsgemäldegalerie

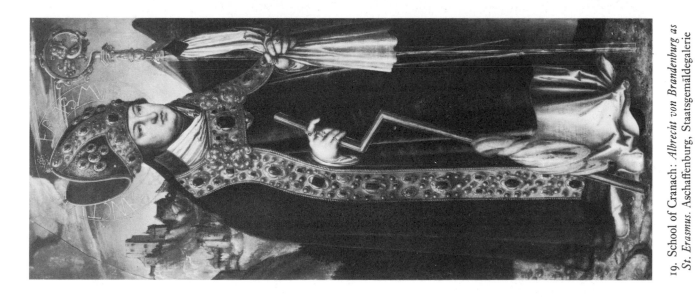

19. School of Cranach: *Albrecht von Brandenburg as St. Erasmus*. Aschaffenburg, Staatsgemäldegalerie

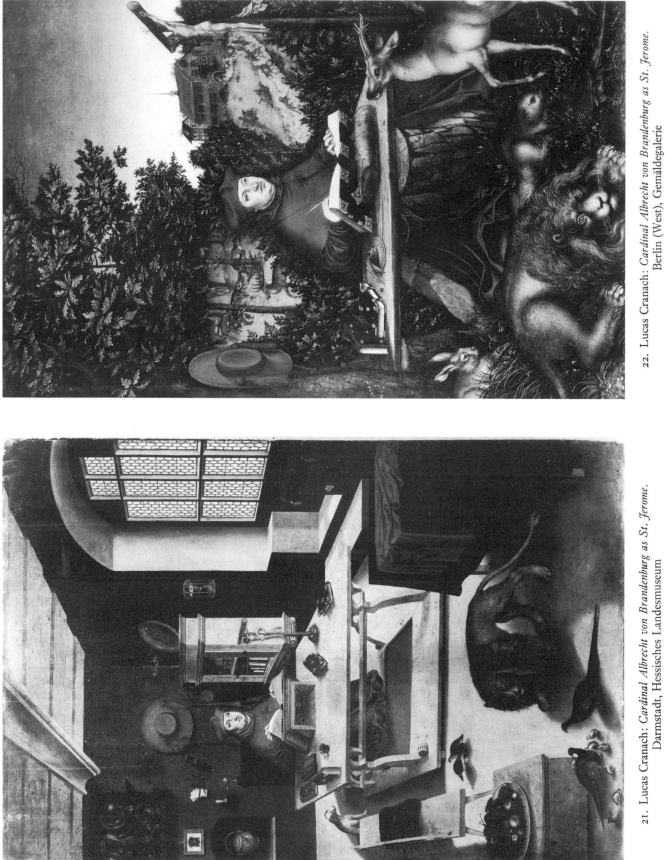

21. Lucas Cranach: *Cardinal Albrecht von Brandenburg as St. Jerome.* Darmstadt, Hessisches Landesmuseum

22. Lucas Cranach: *Cardinal Albrecht von Brandenburg as St. Jerome.* Berlin (West), Gemäldegalerie

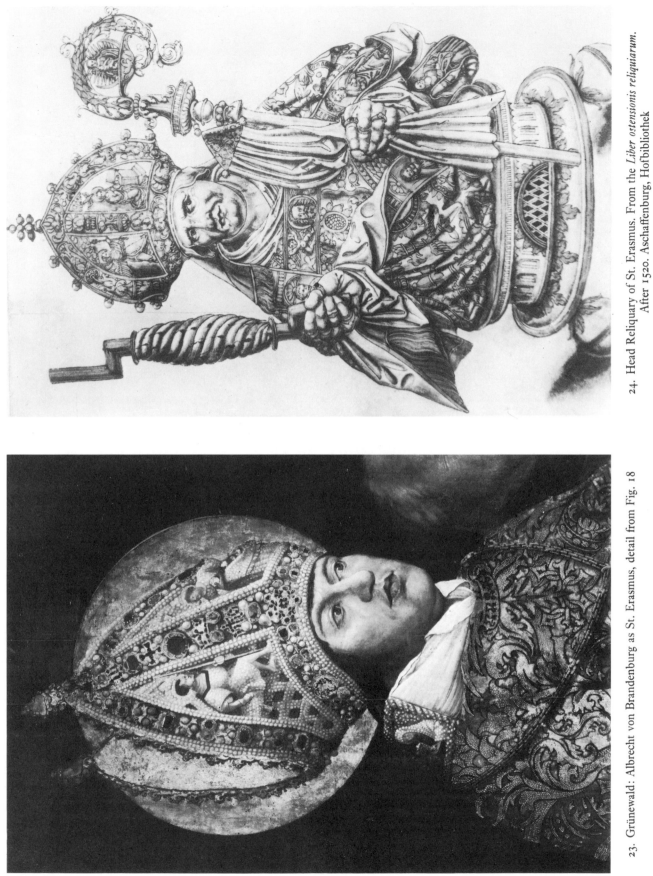

23. Grünewald: Albrecht von Brandenburg as St. Erasmus, detail from Fig. 18

24. Head Reliquary of St. Erasmus. From the *Liber ostensionis reliquiarum*. After 1520. Aschaffenburg, Hofbibliothek

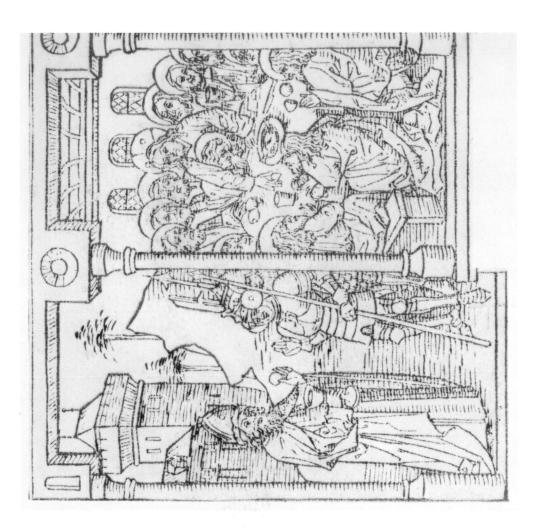

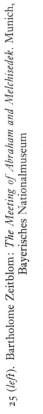

25 (left). Bartholome Zeitblom: *The Meeting of Abraham and Melchisedek*. Munich, Bayerisches Nationalmuseum

26 (above). *Abraham and Melchisedek: The Last Supper*. Woodcut from the *Biblia Pauperum*, c. 1470. London, British Museum

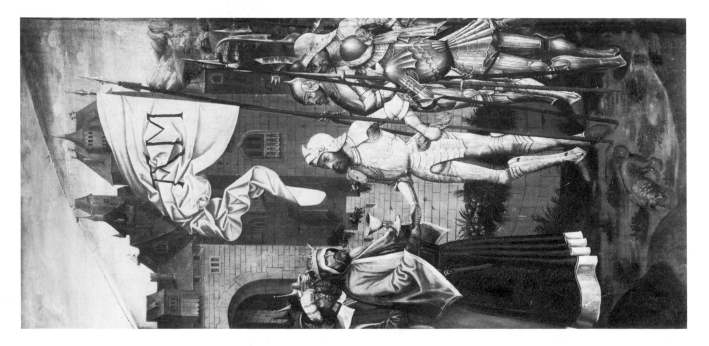

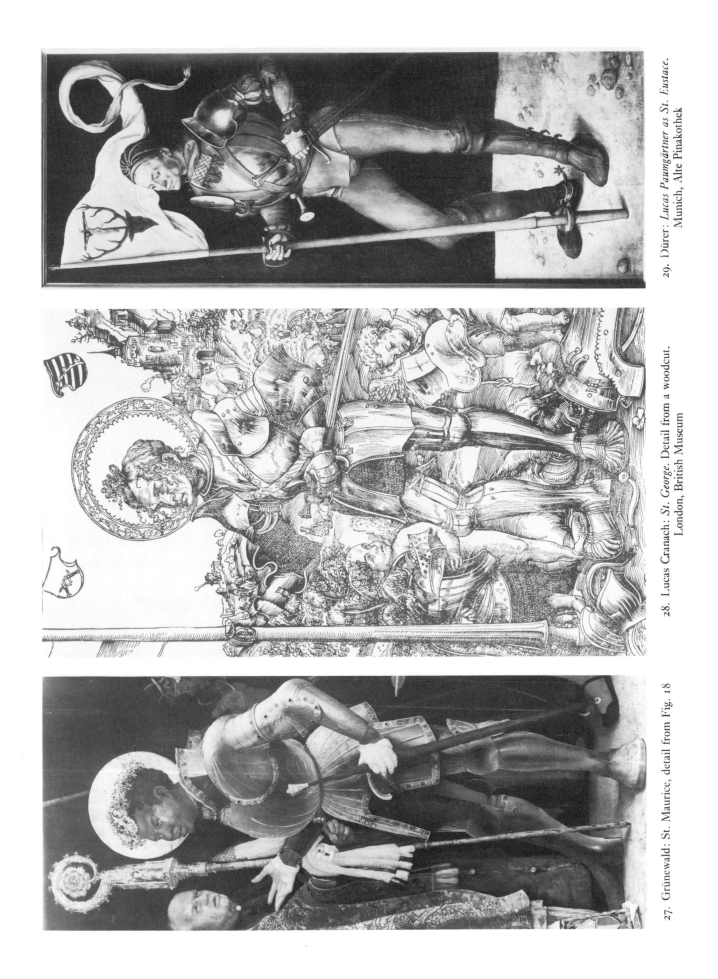

29. Dürer: *Lucas Paumgärtner as St. Eustace.*
Munich, Alte Pinakothek

28. Lucas Cranach: *St. George.* Detail from a woodcut.
London, British Museum

27. Grünewald: St. Maurice, detail from Fig. 18

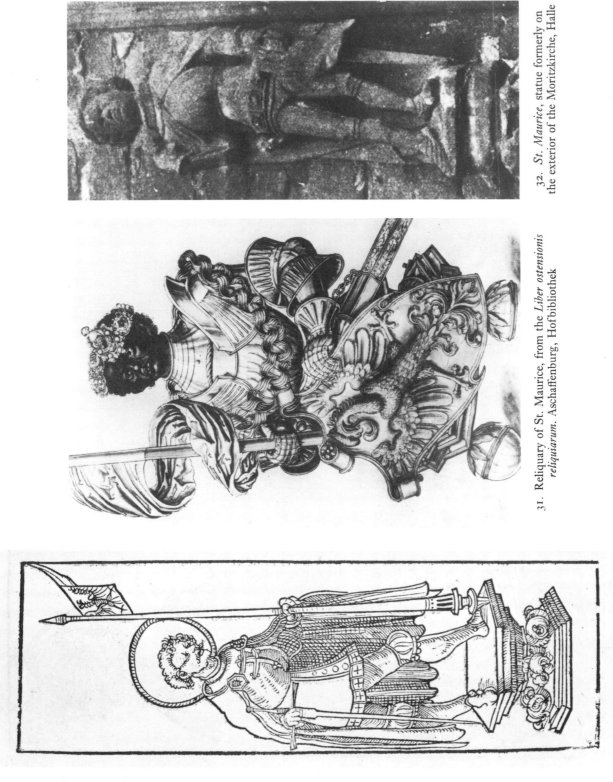

32. *St. Maurice*, statue formerly on the exterior of the Moritzkirche, Halle

31. Reliquary of St. Maurice, from the *Liber ostensionis reliquiarum*. Aschaffenburg, Hofbibliothek

30. Reliquary of St. Victor, woodcut from *Das Hallesche Heiltumsbuch*, 1520. London, British Library

33. School of Holbein: *Democritus and Heraclitus*. Woodcut initial (enlarged), from Erasmus' edition of St. Ambrose, 1527. London, British Library

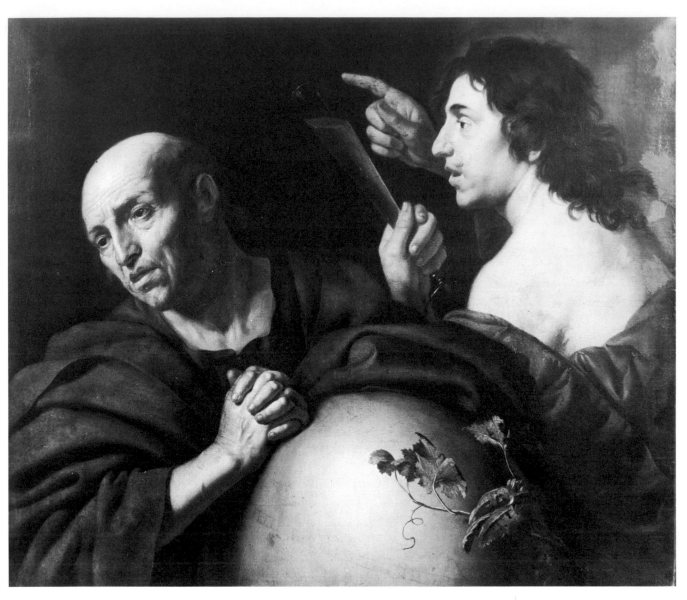

34. Jan van Bylert: *Democritus and Heraclitus*. Utrecht, Centraal Museum

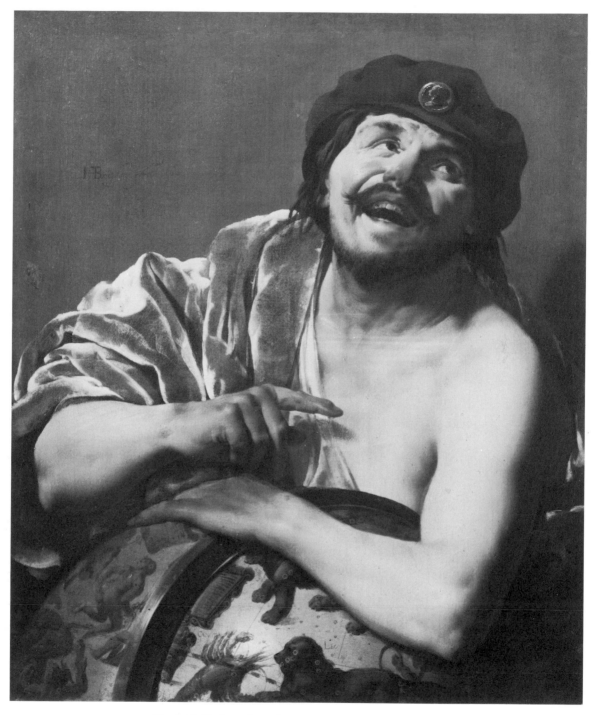

35. Hendrick Terbrugghen: *Democritus*. Amsterdam, Rijksmuseum

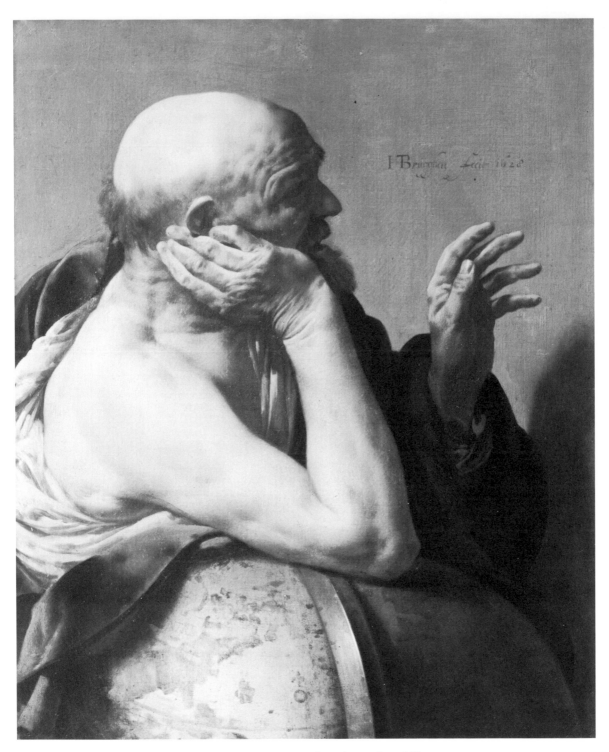

36. Hendrick Terbrugghen: *Heraclitus*. Amsterdam, Rijksmuseum

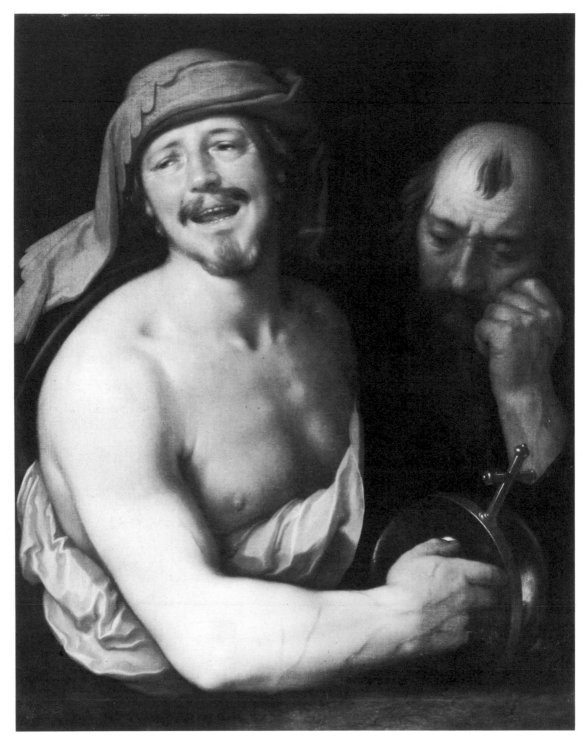

37. Cornelis Cornelisz: *Democritus and Heraclitus*. Braunschweig, Herzog Anton Ulrich-Museum

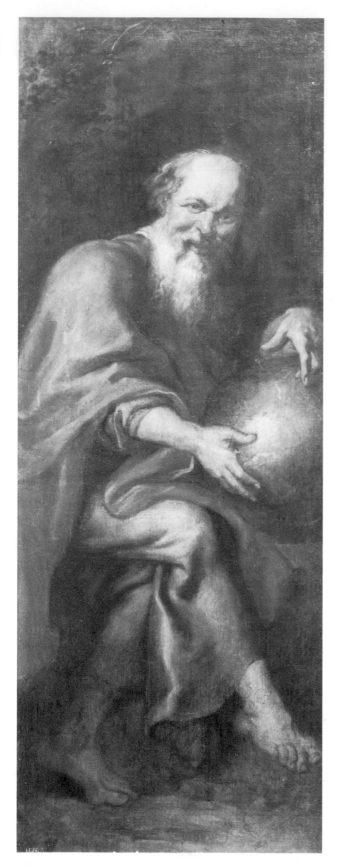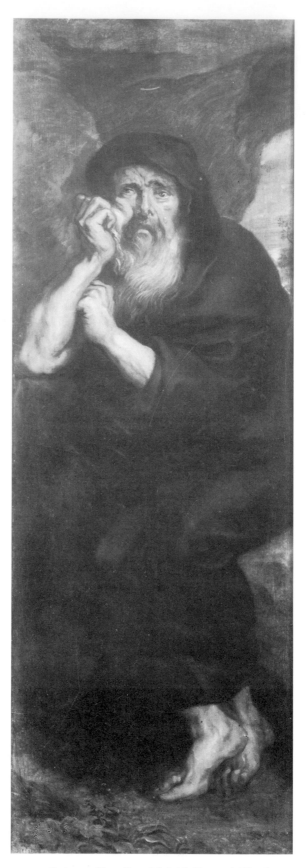

38. Rubens: *Democritus*. Madrid, Museo del Prado 39. Rubens: *Heraclitus*. Madrid, Museo del Prado

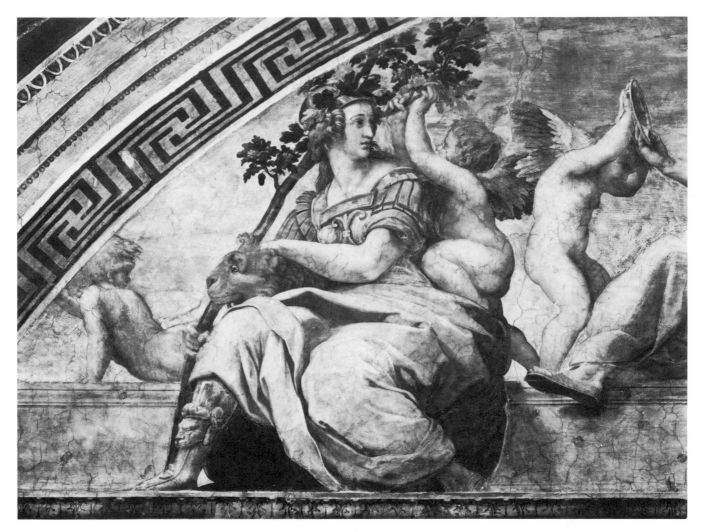

40. Raphael: Fortitude with an emblem of Charity, detail from Fig. 41

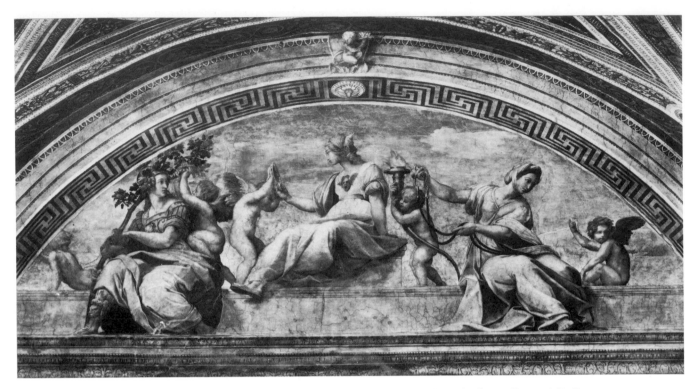

41. Raphael: *Platonic Justice* (Fortitude, Prudence, and Temperance). Palazzo Vaticano, Stanza della Segnatura

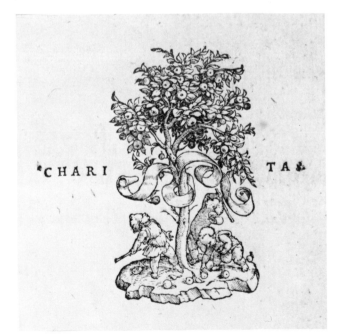

42. Holbein: CHARITAS. Signet of the printer
Reynold Wolfe, from John Leland's *Genethliacon
Eäduerdi*, 1543. Oxford, Bodleian Library

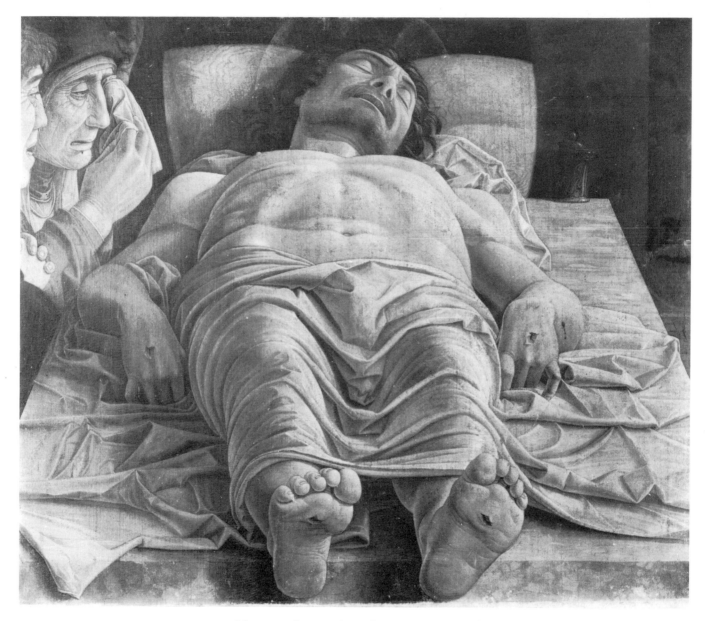

43. Mantegna: *Lamentation*. Milan, Pinacoteca di Brera

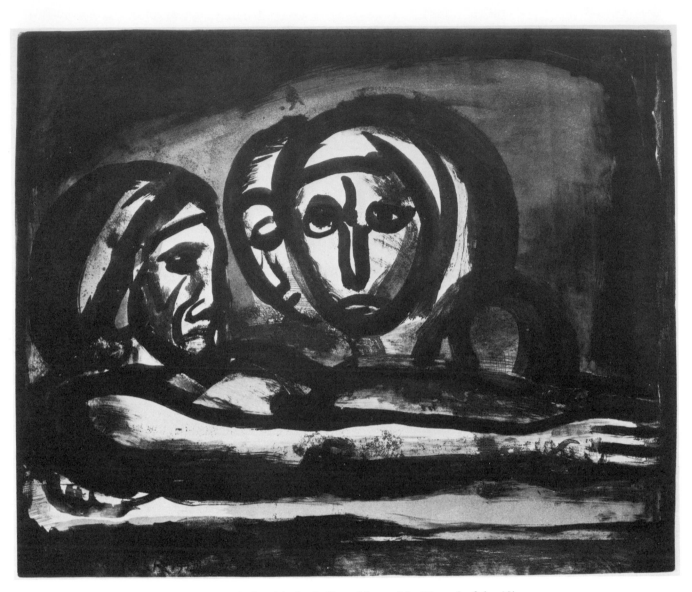

44. Rouault: *Au pressoir, le raisin fut foulé*, a trial proof for Plate 48 of the *Miserere*, 1922.
New York, The Museum of Modern Art

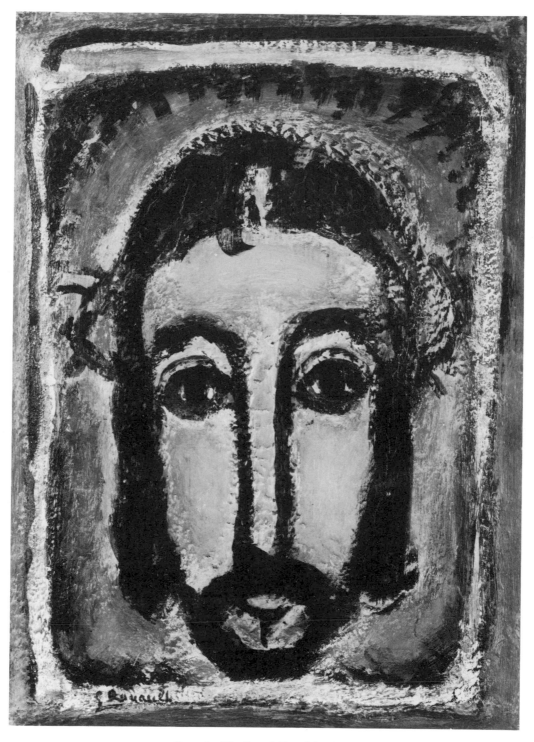

45. Rouault: *The Sacred Face*. Musei Vaticani

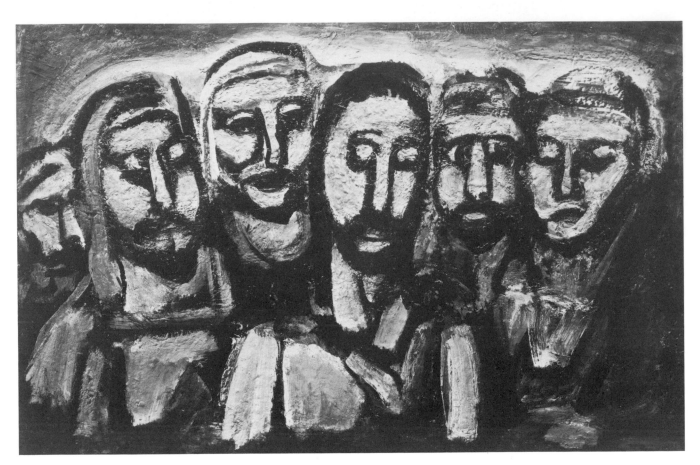

46. Rouault: *Christ*. Mexico DF, Collection Jacques Gelman

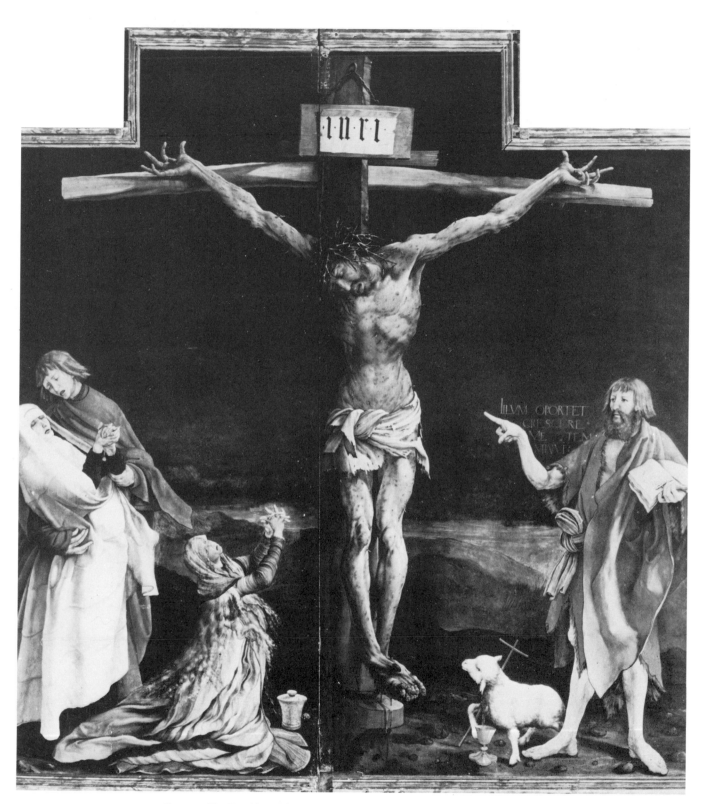

47. Grünewald: *Crucifixion*, from the Isenheim Altar. Colmar, Musée d'Unterlinden

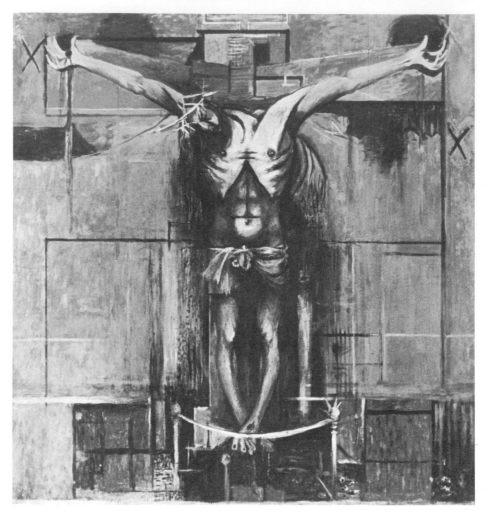

48. Graham Sutherland: *Crucifixion*. Northampton, St. Matthew's Church

49. Picasso: *Crucifixion*. Drawing, after Grünewald. Paris, Musée Picasso

son avocat, en phrases creuses,
clame sa totale inconscience...

Le condamné s'en est allé...

50–1. Rouault: Plates 18 and 19 from the *Miserere*. New York, The Museum of Modern Art

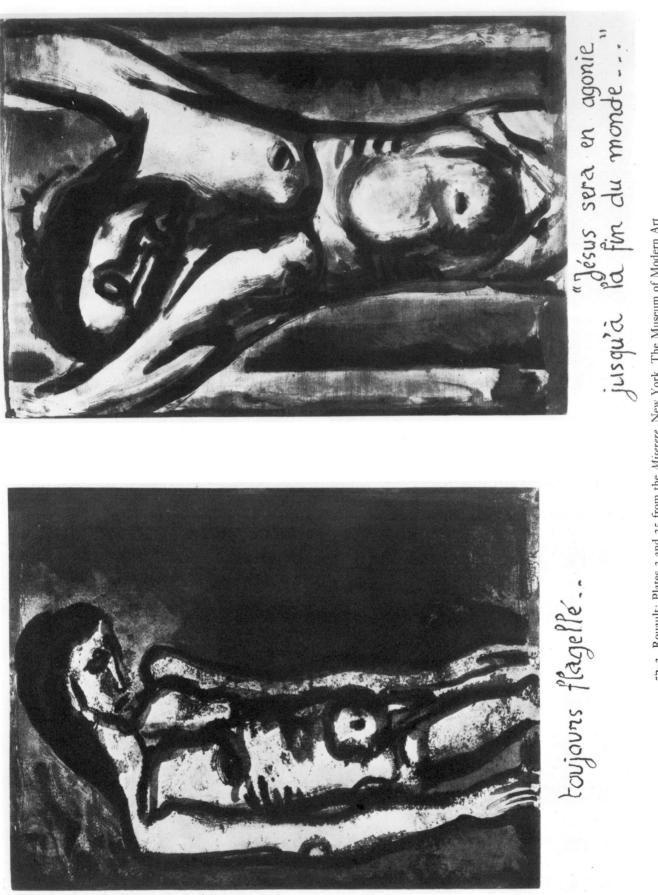

"Jésus sera en agonie jusqu'à la fin du monde..."

toujours flagellé..

52-3. Rouault: Plates 3 and 35 from the *Miserere*. New York, The Museum of Modern Art

54. Matisse: *Virgin and Child* and the *Stations of the Cross*. Painted and glazed tiles.
Vence, Chapelle du Rosaire des Dominicaines

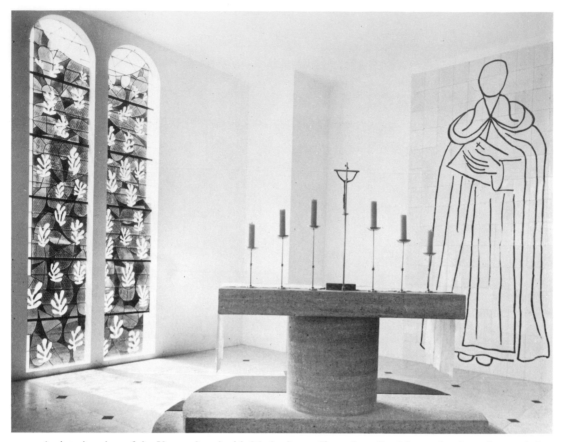

55. An interior view of the Vence chapel with Matisse's crucifix and candlesticks on the altar, the coupled windows on the left, and St. Dominic on the right

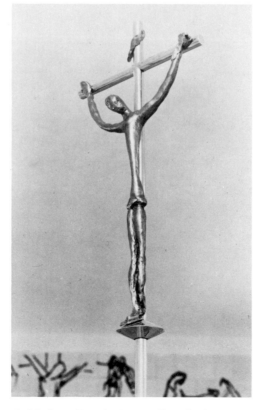

56. Matisse: *Crucifix*. Vence, Chapelle du Rosaire

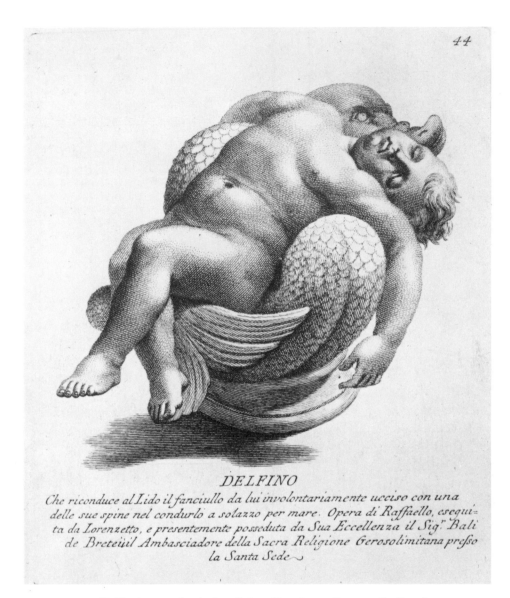

DELFINO
Che riconduce al Lido il fanciullo da lui involontariamente ucciso con una
delle sue spine nel condurlo a solazzo per mare. Opera di Raffaello, esegui=
ta da Lorenzetto, e presentemente posseduta da Sua Eccellenza il Sig.ʳ Balì
de Breteüil Ambasciadore della Sacra Religione Gerosolimitana presso
la Santa Sede

57. 'Delfino', engraving (reduced) from Bartolomeo Cavaceppi's *Raccolta
d'antiche statue*, 1768. Oxford, Bodleian Library

58. After Raphael: *Dead Child on a Dolphin*. Leningrad, The Hermitage Museum

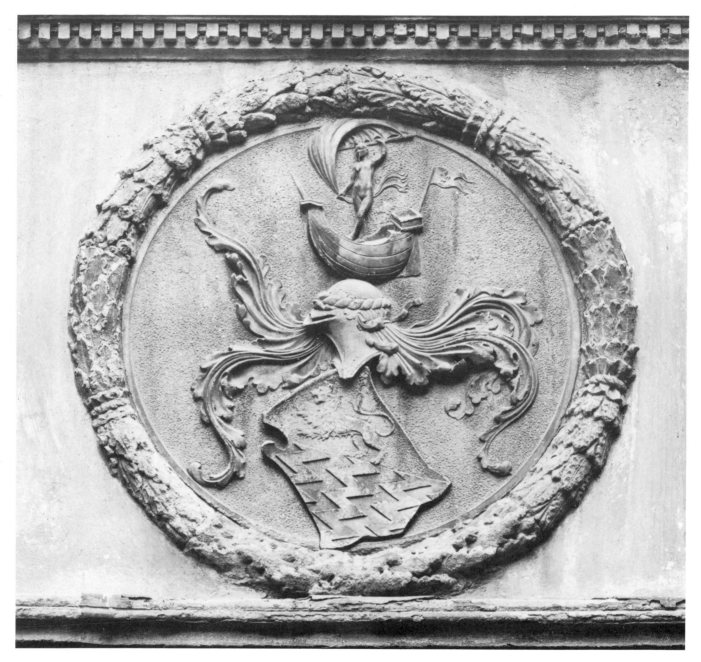

59. *Fortuna* with the Rucellai coat of arms. From the courtyard of the Palazzo Rucellai, Florence